PIMLICO

381

THE CULT OF ELIZABETH

Sir Roy Strong was educated at Queen Mary College, University of London, and the Warburg Institute. He joined the staff of the National Portrait Gallery in 1959 and became its Director from 1967 to 1973. He was Director of the Victoria & Albert Museum from 1974 to 1987 when he resigned to become a full-time writer, broadcaster and consultant. *The Story of Britain*, published in 1996 and also available from Pimlico, is already required reading for anyone interested in history. In 1980 Sir Roy was awarded the Hamburg Shakespeare Prize in recognition of his contribution to the arts in Britain. He has served on numerous committees, including the Arts Council, and is also widely esteemed as a consultant on gardens and garden design, lecturer, critic, columnist and regular contributor to both radio and television. In 1971 he married the distinguished designer Julia Trevelyan Oman. They live in Hereford where they have together created what is thought to be the largest formal garden made in Britain since 1945.

THE CULT OF ELIZABETH

Elizabethan Portraiture and Pageantry

ROY STRONG

PIMLICO

For David Piper

Published by Pimlico 1999

2 4 6 8 10 9 7 5 3

First published in Great Britain by
Thames and Hudson 1977
Pimlico edition 1999

Pimlico
Random House, 20 Vauxhall Bridge Road,
London SW1V 2SA

Random House Australia (Pty) Limited
20 Alfred Street, Milsons Point, Sydney,
New South Wales 2061, Australia

Random House New Zealand Limited
18 Poland Road, Glenfield,
Auckland 10, New Zealand

Random House South Africa (Pty) Limited
Endulini, 5A Jubilee Road, Parktown 2193, South Africa

Random House UK Limited Reg. No. 954009

A CIP catalogue record for this book
is available from the British Library

ISBN 0-7126-6481-5

Papers used by Random House UK Limited are natural,
recyclable products made from wood grown in sustainable forests.
The manufacturing processes conform to the environmental
regulations of the country of origin

Printed and bound in Great Britain by
Butler & Tanner Ltd, Frome

Contents

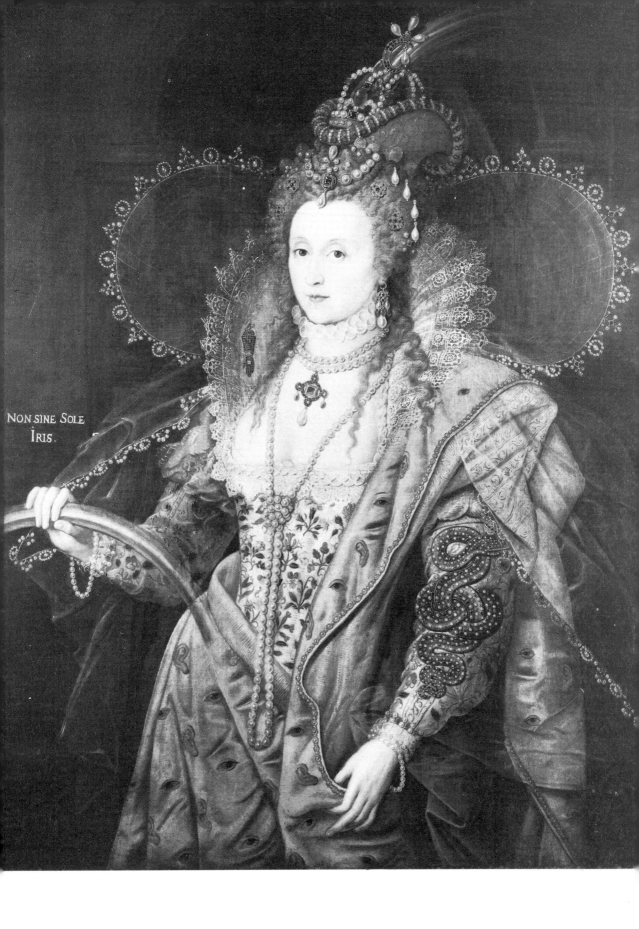

NON SINE SOLE
IRIS.

To The Queen

What music shall we make to you?
To whom the strings of all men's hearts
Make music of ten thousand parts:
　　　In tune and measure true,
　　　With strains and changes new.

How shall we frame a harmony
Worthy your ears whose princely hands
Keep harmony in sundry lands:
　　　Whose people divers be,
　　　In station and degree?
　　　　Heaven's tunes may only please,
　　　　And not such airs as these.

For you which down from heaven are sent
Such peace upon the earth to bring,
Have heard the choir of angels sing:
　　　And all the spheres consent,
　　　Like a sweet instrument.

How then should these harsh tunes you hear
Created of the troubled air
Breed but distaste – when you repair –
　　　To your celestial ear?
　　　So that this centre here
　　　　For you no music finds,
　　　　But harmony of minds.

Sir John Davies

PREFACE

The Cult of Elizabeth brings together six studies in Elizabethan portraiture and pageantry. When I first started to put this book together it was to consist only of new pieces, studies of the Procession Picture at Sherborne Castle, Hilliard's *Young Man amongst Roses* and the pageantry of the Accession Day Tilts. But as it began to take shape it became clear that these pieces were part of a thought pattern about Elizabethan portraiture and pageantry which went back to my earliest research years at the Warburg Institute. Somehow other pieces asked to be there, those on the Memorial Picture of Sir Henry Unton, the Queen's Day festivities and the Order of the Garter under Elizabeth – all articles scattered in various learned journals. These do represent early work, but I have left them virtually unchanged as part of a coherent stream of research and work on the Elizabethan period extending over fifteen years. Together these six essays round out and complement my *Portraits of Queen Elizabeth I* (1963), *The English Icon: Elizabethan and Jacobean Portraiture* (1969) and *Tudor and Jacobean Portraits* (1969). In the first of these I was primarily concerned with categorizing the hundreds of images of the Queen into some sort of iconographical order, in the second I attempted to place the study of sixteenth-century painters on to a firmer footing by reconstructing convincing groups of pictures around particular names, and in the third I tried to compile a portrait index covering the whole period down to 1625, including virtually everyone of any importance. In each case I was struggling to reduce a morass of material to some sort of antiquarian order. That process is still at an initial stage but I feel that the broad outlines at least have been laid down and one can walk those paths with a greater degree of certainty than was possible twenty years ago.

All the time that I was working on these books I was aware of the eventual implications for the overall study of the Elizabethan age, in particular the assumptions about optics and sight, pictorial space and order, the use of image and allegory and, in turn, their connection with the wider world of poetic imagery. It is still too early to write that particular book, but *The Cult of Elizabeth* represents some fitful steps along the path towards it.

Over the years many people have contributed to the make-up of this book, and I must apologise for any I may have overlooked. First and foremost I am grateful to the editors of journals who have allowed me to revise and incorporate pieces which initially appeared in their publications: *November's Sacred Seventeenth Day* in its original form was published in the *Warburg Journal* in 1959, *Saint George for England* first appeared in the *Archaeological Journal* in 1964, and *The Ambassador* belongs to my early years at the National Portrait Gallery and was published in *Archaeologia* in 1965. Over the Procession Picture I am indebted to J. L. Nevinson for information on Gentlemen Pensioners and to W. R. B. Robinson for reading the text and helping me on many points concerning the Worcester family in the later sixteenth century. The owner of the painting, Simon Wingfield-Digby, kindly opened Sherborne Castle to enable me to re-examine the picture. *The Courtier* recalls colleagues in the Victoria & Albert Museum, among them John Physick and J. Murrell, *The Ambassador* former colleagues in the National Portrait Gallery, above all David Piper. The pageantry essays evoke years at the Warburg Institute when this material was first collected, and owe much to many enlightening conversations with Frances A. Yates, whose work and teaching remain a constant source of inspiration.

As always I am indebted to Sylvia England, who has fed me with mounds of xeroxes of documents and books from the Public Record Office and the British Museum. Over the editing and presentation of this book I owe much to suggestions by Cassandra Carter. All members of my office at the Museum have had to bear patiently with it during its creation. My wife remains a constant and critical mentor, and it was she who first spotted that Elizabeth I is not carried in a litter in the Procession Picture.

Roy Strong
Victoria & Albert Museum
November 1976

PART ONE

THREE PORTRAITS

Thus we see how the Soul doth use the eyes
As instruments of her quick power of sight;
Hence do the arts optic and fair painting rise;
Painting, which doth all gentle minds delight.

Sir John Davies, *Nosce Teipsum*

Introduction THE LAST PAGEANT

Queen Elizabeth died at Richmond Palace early on the morning of 24 March 1603. A few hours later the Council assembled and drew up the proclamation of her cousin of Scotland as King James I of England. After proclaiming the new King at the court gates, the Council, attended by a great train of lords, came to Whitehall at about ten o'clock that morning. Here, close to the tiltyard, scene of many a courtly triumph in praise of Gloriana, the King was proclaimed a second time, after which the cavalcade made its way post-haste towards the City. Ludgate they found locked and barred against them, and only when adequate assurances had been given that it was indeed the King of Scots who should succeed were the great gates opened. Within the City the accession was announced in three places: before St Paul's, at the cross in Cheapside and at Cornhill. Riding on, the company came finally to the Tower, where again assurances of the Scottish King's succession were demanded before admittance was granted. In this way forty-five years of the rule of Elizabeth Tudor came to an end and a new era began.[1]

Two days later the Queen's coffin was moved by water to Whitehall Palace, a melancholy torchlight procession of black-draped barges sailing down the river Thames at night.[2] On reaching the palace, the coffin was laid in state on a bed of black velvet surmounted by huge bunches of ostrich plumes. No monarch was officially dead until the day of burial when the great officers of state broke their white wands of office and hurled them into the grave. So for over a month the old Queen's court went on, as though she were not dead but walking, as she was wont to in the early springtime, in the alleys of her gardens.

At last, on 28 April, a funeral procession of some fifteen hundred persons made its way to Westminster Abbey.[3] Nothing quite like it had ever been seen before. 'Her hearse (as it was borne) seemed to be an island swimming in water, for round it there rained showers of tears,' wrote Thomas Dekker in his *Wonderful Year*.[4] The streets were thronged with onlookers, the windows packed, even the rooftops were crowded with those who hoped for a glimpse of this spectacle which seemed in one hierarchical sweep to epitomize a civilization. When the royal chariot went by bearing the effigy of Elizabeth in crimson and ermine robes,

14

crowned and clasping orb and sceptre, a sighing, groaning and weeping went up 'as the like hath not been seen or known in the memory of man'.[5] In retrospect Shakespeare was to capture the moment succinctly in his lines

> . . . *and yet a virgin,*
> *A most unspotted lily shall she pass*
> *To the ground, and all the world shall mourn her.*[6]

Shakespeare was one of the few poets not moved to eulogy in 1603, but when at last he did recall the event it was as an 'unspotted lily' that he remembered her. The outburst of posthumous praise indeed rarely suggests the death of a human being at all. Instead we become enmeshed in a phantasmagoria of obscure and often extremely bizarre images.[7] The phoenix, we read, has finally been consumed in the flames of her own funeral pyre, and yet miraculously another has arisen. The pious pelican has plucked her breast to feed her young, spending her life-blood for their sake. The moon has gone into eclipse, the rose has withered on the briar, the maiden Astraea or Justice has fled once more from earth to heaven, Deborah, Hester, Judith, Solomon, David, Asa, the heroines and rulers of the Old Testament are no more, all have vanished with her demise. So we make our way through this index of astounding visions of Elizabeth until we come perhaps to the most revealing tribute of all:

> *She was and is, what can there more be said,*
> *In earth the first, in heaven the second maid.*[8]

What more indeed can be said, than that this withered, vain old lady of seventy should now reign as a second queen of heaven!

But the fact that no one in 1603 seemed able to refer to her as a human being is indicative of something else. Three days after her death John Hayward preached at Paul's Cross, celebrating her who was 'by many names most dear to us'.[9] Hayward recalls, in this revealing phrase, one of the most delightful of all encounters in the royal presence, that between two old men who met in a preface to Dekker's play *Old Fortunatus* (1599), when it was performed at court:

Are you then travelling to the temple of Eliza?

Even to her temple are my feeble limbs travelling. Some call her Pandora: some Gloriana: some Cynthia: some Belphoebe: some Astraea: all by several names to express several loves: Yet all those names make but one celestial body, as all those loves meet to create but one soul.

I am of her country, and we adore her by the name of Eliza.[10]

Is this garland of names woven around the Queen merely a rhetorical device, or did these various 'loves' express a reality, something deeper, images potently meaningful for those who lived through the reign? Certainly they establish a way of thinking about a monarch totally foreign to us, a structure of the psyche in which images are not merely fanciful flattering labels but embody attributes of the person concerned – a comprehensiveness in multiplicity matched only in religious cults.

And here perhaps we are touching the thread which animates this book. When, at the close of Elizabeth's reign, an Oxford scholar, Richard Haydocke, found it politic to drop any discussion of religious images from his translation of the Italian Paolo Lomazzo's treatise on art, he transferred the argument to a defence of the 'sacred' images of Elizabeth the Queen.[11] The cult of Gloriana was skilfully created to buttress public order and, even more, deliberately to replace the pre-Reformation externals of religion, the cult of the Virgin and saints with their attendant images, processions, ceremonies and secular rejoicing. So instead of the many aspects of the cult of Our Lady, we have the 'several loves' of the Virgin Queen; instead of the rituals and festivities of Corpus Christi, Easter or Ascensiontide, we have the new fêtes of Elizabeth's Accession Day and birthday.

These are the paths which we shall tread as we move towards a comprehension of the complex, diffuse and ambiguous image of Elizabeth I. We have to learn how to look at the age and its symbols through the eyes of those who created the fabric of these visions, and so begin to understand the enormous potency of this new secular mythology. This is what has concerned me most in Part One of this book, 'Three Portraits' – to show how we should approach Elizabethan paintings as just such fantastic images, as maddening, enigmatic riddles, utilizing a pictorial surface in a way utterly alien to us. What is the central 'device' – to use the correct Elizabethan word – that inspired the curious picture of Elizabeth carried as an object of worship in a litter, that gave birth to Nicholas Hilliard's supreme image of the sonnet hero, the love-lorn *Young Man amongst Roses*, or prompted the widow of a failed star in the heavens of the court, Henry Unton, to give us what has been described as the only story picture of the age? These are images rich in associations, drawing to themselves the great of the era, Essex, Leicester, Sidney, Hunsdon, Cumberland, Shrewsbury, Burghley, Cecil, and over all the Queen herself. *Eliza Triumphans* – she is, as always, the touchstone of her age, the Ariadne's thread which runs through this book. In the portrait essays she is the heroine of the Procession Picture, exalted at seventy into a springtime goddess; she it is for whom the young man languishes amidst the roses; and she it is whose profile hangs, talisman-like, around the neck of Henry Unton. All are reflections of 'several loves'. But let us begin with the first and perhaps the most magical of all the images, that of Gloriana herself encircled by her court, moving like the sun and planets in their courses, towards some unknown mysterious destination – *Eliza Triumphans*.

I THE QUEEN: *Eliza Triumphans*

From my childhood, one picture has always summed up for me the Elizabethan age: the canvas attributed to Robert Peake called *Queen Elizabeth going in Procession to Blackfriars in 1600*.[1] Borne aloft, attired in a wonderful white dress studded with jewels, this is the Elizabeth of legend. Young men in ruffs, doublet and hose seem to carry her in an exotic litter, above it a nodding canopy of cloth of silver embroidered with flowers gathered from a Tudor garden. All the men in the picture are bare-headed in her presence, *hommage à la reine*. Grandees precede her in white, green and pink satin; all are Knights of the Garter. Court ladies in farthingales, fan-shaped ruffs and the towering bejewelled headdresses of the closing years of the reign follow in her wake. Gentlemen Pensioners, halberd in hand, line the street, and ordinary citizens press forward to gain a glimpse or, more comfortably, lean out of the windows of a house along the route. This is Gloriana in her sunset glory, the mistress of the set piece, of the calculated spectacular presentation of herself to her adoring subjects. But who are the other people and where are they going? Is it to the great marriage of one of her Maids of Honour, Lady Anne Russell, to Lord Herbert at Blackfriars one summer's day in the year 1600? This is what scholarship for over a century has taught us to believe, and yet one wonders, as one's eye meanders over the picture's surface. Are the bride and groom really the two young things in white, and if so why are they in the cavalcade and not at St Martin's Ludgate awaiting the royal arrival? And in any case why is Lady Anne not attired as a bride, her hair flowing loose in token of her virginity? And the landscape beyond hardly seems to evoke Blackfriars or the lush valley of the Thames. It rather suggests a bleaker, wilder terrain, with distant mountains topped by castles. The Procession Picture is really one of the great visual mysteries of the Elizabethan age, and for nearly two hundred and forty years successive generations of scholars have tried to unravel its secret. The last such attempt was made in 1921 by Lord Ilchester, whose long article has always been looked upon as more or less the final word on the subject.[2] In it he gathered together the threads of everything that had been written since George Vertue, the antiquarian, was taken by his patron Lord Oxford to Coleshill on 16 October 1737 specifically to see the Procession Picture. And it is there that we start our detection.

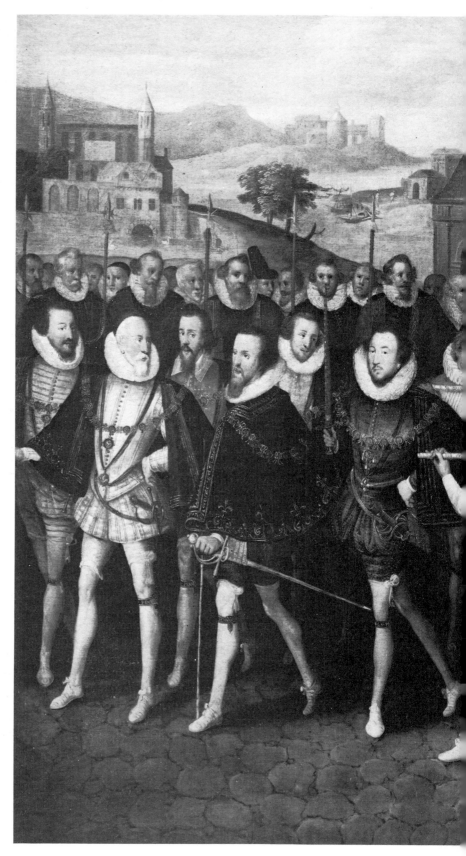

1 *Eliza Triumphans*: the Procession Picture

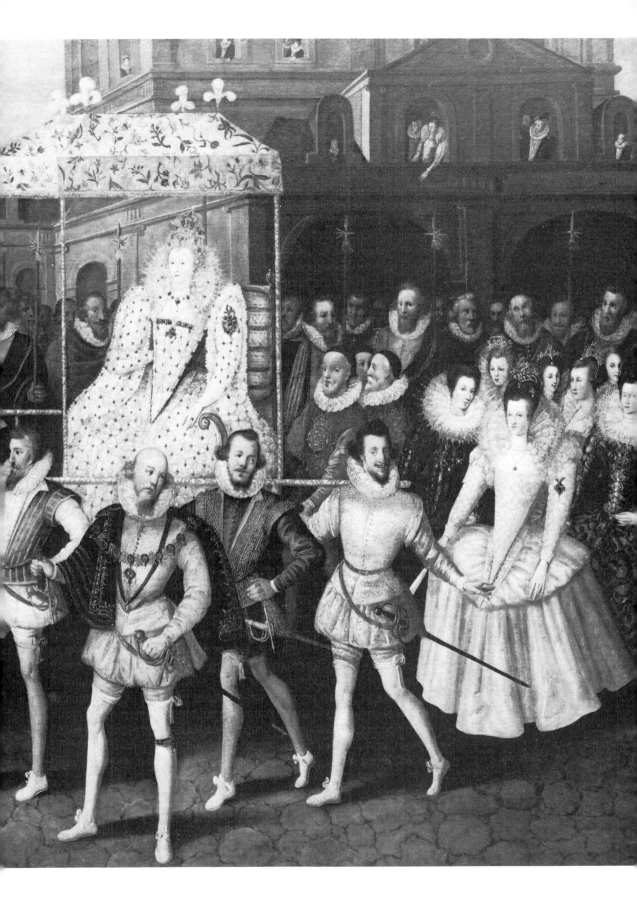

Coleshill, a house in Warwickshire, was the seat of William, 5th Lord Digby, and Vertue, considerably intrigued, recorded the event with customary thoroughness in his *Notebooks*:

> Went to Coleshill, Lord Digby's seat, to see there a large piece of painting representing Queen Elizabeth carried in a chair of state on men's shoulders, and a canopy over her head. Seemingly a procession to a noble seat or house seen at a little distance.
>
> The foremost are 6 Knights of the Garter, 2 and 2 preceding the Queen's chair, one Knight of the Garter walking beside the Queen as more particularly talking about the place or any other conversation etc.
>
> The Queen herself, sitting in a chair of a low back richly dressed; following her are some court ladies, gentlemen pensioners, guards, many spectators standing behind. The Knights of the Garter have their collars on and short black cloaks in Spanish dress like the mode of the time, pendant ribands and George; all the Knights seem to be portraits; one of the ladies following in white is said to be the bride of one of the noblemen, perhaps of the person that walks beside the Queen; it has some likeness to Dudley, Leicester?
>
> Amongst the nobles that precede the Queen (I suppose) in order, or degree of election is Howard Lord Admiral; his situation is the no. 4 in the procession. This painting being certainly valuable in respect of the representation of so remarkable a Circumstance of history, tho' the painting done on cloth in oil is not well nor ill done, the figures 15 or 16 inches high, the whole picture 7 feet long by 5 feet high.[3]

Vertue's account is worth quoting in full because it is the earliest reference we have to the Procession Picture, destined shortly to become one of the most famous visual evocations of the last years of Elizabeth's reign. The significance he attached to the picture is reflected in the sketch 2 he made of it and in his correspondence with the owner's family. In this note of 1737 it makes its entry as probably 'a procession to a noble seat' and the lady who follows the Queen attired in white is believed to be a bride.

The next year Vertue's patron, Lord Oxford, was in correspondence with the family asking for their account of the picture's history. The reply, written by the eldest son of the house, Edward Digby, on 14 June 1738, gives the family traditions:

> In answer to your questions about the picture, my father says it had been a tradition in the family from one Mr Rawlins, chaplain to the family to my grandmother, that the procession was made to St Paul's upon the victory of 1588, and this seems to be strongly countenanced by the representations in the picture itself of buildings and magistrates in their habits. But there is another, of much the same authority: and that is, a marriage of some lady of the court; for your lordship will see a

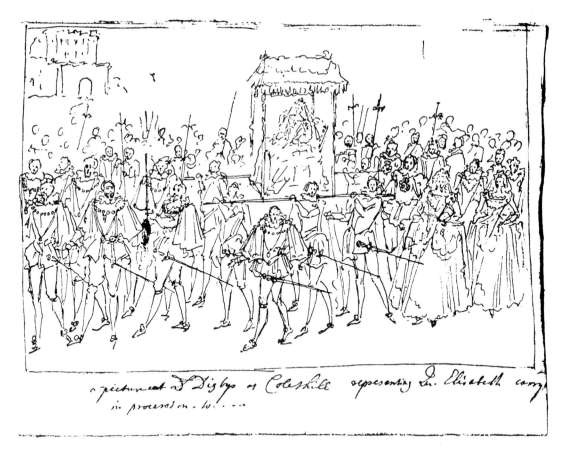

*a picture at Sr Digbys at Coleshill representing Q. Elizabeth carry...
in procession. to...*

2 George Vertue's sketch of the Procession Picture. In it he transforms the canopy into a litter

plain representation of a bride and bridegroom following the chair in which the Queen is carried.[4]

Digby goes on to conclude that the two traditions were not in themselves incompatible, supposing that the couple in question might well 'snatch this occasion' for their nuptials.

The family tradition springs, according to this letter, from Edward's grandmother Mary Gardiner, wife of Kildare, 2nd Lord Digby of Coleshill, who died in 1661. Lord Digby himself lived until 1693; the lives of this couple therefore take the history of the Procession Picture back to the years of the Protectorate. On the evidence of the costume alone, it is possible to date the picture to *c.* 1600, just half a century before the earliest ideas as to its subject-matter. Sadly, no clues can be found by tracing the family back to Elizabeth's reign, when its fortunes were laid by the two sons of Sir George Digby. The elder, Robert of Coleshill, married the heiress of the Earls of Kildare in 1600. He died in 1614, but she lived on to be created Baroness Offaly in her own right six years later and died at a great age in 1658. Robert's brother John meanwhile embarked on a career of meteoric brilliance. James I created him Baron Digby of Sherborne and three years later, in 1621, Earl of Bristol. As we

shall see, none of these have any direct connection with any of the identifiable faces peopling the canvas. Although the provenance takes us back almost within reach of Elizabeth's reign, it sheds no light on the origin of the picture. How it ever got into the hands of the Digby family remains another mystery.

Early in the summer of 1738 the Procession Picture was brought to London to enable Vertue to execute an engraving which appeared four years later.[5] The year before, however, he had journeyed into Hertfordshire to carry out research on the picture, which he concluded depicted Elizabeth visiting her cousin, Henry Carey, Lord Hunsdon, in September 1571 at Hunsdon House. It was published as such by Vertue, who was inevitably led to people the canvas with the great of the Elizabethan court of the seventies and not of thirty years later: Hunsdon bearing the sword, Burghley the Lord Treasurer's wand, Leicester in the foreground and, amidst the bevy of court ladies, Lady Hunsdon in white. By 1762 the original picture had been moved to the other Digby seat, Sherborne Castle, where it remains to this day. By then it had been copied by Renelagh Barrett for the Ilchester house, Redlynch, a picture subsequently moved to their other seat, Melbury.[6] In this version the artist, completely baffled by Elizabeth's hand tucked into the structural join of her bodice, was led to paint in a right hand of his own invention. Vertue himself seems also to have made a watercolour version which belonged to Lord Oxford and which was sold in the sale of his effects in March 1742.[7]

Four years after that, in 1746, Arthur Collins edited two volumes of correspondence from the archives of the Sidney family at Penshurst. Entitled *Letters and Memorials of State*, this was not only one of the earliest publications of actual source-material on the Elizabethan age, but contained virtually all of Rowland Whyte's gossipy letters to Sir Robert Sidney (later Earl of Leicester). Along with those of John Chamberlain, these letters give us a penetrating and intimate glimpse into happenings at court during the last years of Elizabeth's life. A decade after their publication Vertue read them and came across a letter describing the marriage of the 4th Earl of Worcester's son, Lord Herbert, to the Lady Anne Russell on 16 June 1600, to which the Queen had been carried in a litter. Vertue muddles the personnel mentioned in his jottings and Worcester wrongly becomes Shrewsbury, but he was clearly the first person to make the vital connection between the letter and the picture: 'a Litter – or chair of State, wherein the Queen was carried by 6 Knights'.[8] Vertue unfortunately died the year he spotted this and so the world of antiquarian scholarship had to wait another century for a second scholar to make the connection once more.

John Nichols, in his famous *Progresses of Queen Elizabeth* (1823), of course reproduced the picture, but still uncritically captioned it as a progress to Lord Hunsdon, and it was not until 1866, when it was lent to the first National Portrait Exhibition,[9] that it became again the subject of lively antiquarian interchange. This was only the second time it had been

publicly exhibited (it had been first seen at Leeds in 1857). By the mid-Victorian era Elizabeth's fortunes were at their nadir, and Agnes Strickland, when referring to the picture in her biography, cites it as evidence of the Queen's appalling vanity: 'the procession of a pagan goddess surrounded by her priests and worshippers . . . rather than the transit of a Christian queen in civilised times'.[10] The connection between the Whyte letter and the Procession Picture was however noted by another celebrated antiquary, J. G. Nichols, who communicated it to the exhibition's organizer and first director of the National Portrait Gallery, Sir George Scharf. Scharf published his findings in a paper in the *Archaeological Journal* of that year.[11] An almost completely new list of portrait identities appeared replacing those by Vertue but, alas, like his, nearly all are wrong. In respect of the ladies Scharf did cautiously conclude that 'we must admit that the various faces introduced are not remarkable for boldness or decision of character'.

Scharf's discoveries have only been slightly emendated and amplified since then. In 1915 Viscount Dillon, writing with the evidence of the recently published Cecil papers at Hatfield House, made an unsuccessful attempt to identify his ancestor, Sir Henry Lee, as heading the procession.[12] Six years later, in a long article in the Walpole Society's annual volume, Lord Ilchester published some of the material from Vertue's *Notebooks* but added nothing substantial to our understanding of the picture. By then photography and the half-tone block had made a more convincing amassing of portrait evidence possible. Everyone since Scharf has accepted that the great marriage of 1600 is depicted, but no one has ever really investigated the event in depth or asked why such an extraordinary picture should ever have been commissioned. I believe that we should take a slightly different line and, instead of starting initially with the Procession Picture itself, begin with the event it is supposed to commemorate: the marriage of Henry Somerset, Lord Herbert and Lady Anne Russell on 16 June 1600.

Two noble houses:
Somerset and Russell

Elizabethan marriages were politic alliances of wealth and connection. They represented accumulations of money and of land, cementing relationships between old and new families. The marriage between Lord Herbert and Anne Russell was just such an occasion, and was the climax of the dynastic policies of the bride's mother, Elizabeth Coke, the Dowager Lady Russell.

Elizabeth Coke was one of the most formidable women of the Tudor age.[13] Born in 1528, she was one of the five daughters of Sir Anthony Coke, all of them renowned for their learning and piety. To this they added masculinity of intellect and a will of iron. Two of them, Anne and Mildred, made matches which threw them into the forefront of the Elizabethan world as Lady Bacon and Lady Burghley respectively. Through these Elizabeth had powerful connections at court and, in the next generation, Francis Bacon and Robert Cecil as nephews. Elizabeth

3

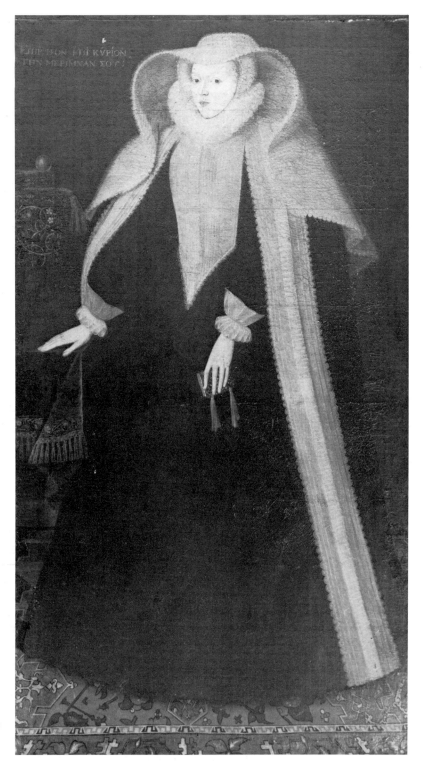

3 The bride's mother:
Elizabeth Coke, Lady
Russell

had married as her first husband Sir Thomas Hoby of Bisham; the marriage had lasted nine years when he died while English ambassador in Paris. By him she had two sons, Edward and Thomas, the latter known as Posthumous because Lady Hoby was carrying him still when her husband died. After she had been a widow for some years, her next match was seemingly destined to raise her to the height of the social hierarchy as the future Countess of Bedford: in 1574 she married Lord Russell, heir to the Earl of Bedford. By him she had two daughters, Elizabeth and Anne. Alas, Lord Russell predeceased his father in 1584, so that his wife never became a countess, though she steadfastly referred to herself as Dowager and saw that a peeress's coronet adorned her tomb effigy.

Lady Russell would have been an outstanding personality in any age. Her numerous letters reveal a woman of sharp intellect and tongue, domineering and imperious to her family, relentless in her nursing of grievance and unremitting in her self-righteousness: even at the enormous age of seventy-eight in the course of a law-suit she harangued the Court of Star Chamber as to the justness of her cause in defiance of judges and onlookers alike, 'violently and with great audacity'.[14] She lost the case and the judges did not mince their words on the defects of Lady Russell's character, 'condemning greatly the pride and willfullness of the plaintiff'. In 1600, the year of the Procession Picture, she was seventy-two, five years older than the Queen.

Influential marriages for her children much preoccupied the mind of Lady Russell as she grew older. In 1591 the untimely death of Essex's younger brother, Walter, at the siege of Rouen brought his heiress widow, Margaret Dakins, unexpectedly on to the marriage market. On this occasion it led to a trial of strength between Lady Russell on behalf of her son, Thomas Posthumous, and the Earl of Huntingdon for his wife's nephew, Thomas Sidney. The widow had been educated in the Hastings household and the Huntingdons were on the spot in the north of England. Lady Russell suggested that someone 'help to steal her away', but all such advice was to no avail, for the widow soon after married Thomas Sidney. Four years later she was widowed yet again, and once more young Hoby, now Sir Thomas Posthumous, and his mother swung into action. This time they were successful, and on 9 August 1596 he married his heiress at his mother's house in Blackfriars. This was four years before his stepsister Anne's wedding to Lord Herbert, and the occasion was a very different one. Elizabeth and Anne Russell were fetched from court by coach, bringing with them Sir Robert Sidney and Sir William Cobham, and Posthumous invited his cousin, Anthony Bacon. There were no real festivities, neither music nor dancing. 'Humour have let all alone', he wrote, 'and seek only to please the beholders with a sermon and a dinner, and myself with beholding my mistress.'[15] The marriage was a happy one.

Having married both her Hoby sons (Sir Edward, the elder boy, had married a daughter of the Queen's cousin, Lord Hunsdon, as long ago as 1582), Lady Russell began to focus her attention on her two daughters by

her second marriage. Both were eminently marriageable by birth, as granddaughters of an earl (Elizabeth, the elder, born in 1575, had the Queen and the Earl of Leicester as godparents), but neither was well provided for. Thanks to the intercession of her brother-in-law, Lord Burghley, however, Lady Russell was able to place the two girls as Maids of Honour to the Queen. In 1597 Elizabeth was just twenty-two. Lady Russell's eye had alighted upon a young man of the same age, William Somerset, Lord Herbert, heir to the Earl of Worcester. He had only just returned, having served the Queen's favourite, Essex, from the Cadiz expedition, on which he had been knighted, and in April 1597 had made overtures to the daughter of Sir William Herbert of St Julians. The lady, however, refused.[16] Whether Lady Russell knew of this passion or not, two months later she wrote to her nephew Robert Cecil asking for his aid as follows:

> This is all I have to trouble you with, but desire you in being of the Earl of Worcester's daily in Court, it will please you in your best opportunity to persuade the Earl so as my daughter, Bess, may be wife to Lord Herbert his eldest son. Her virtue, birth, and place joined to the hundred pounds of inheritance presently enjoyed and the part in reversion of my Lady Gray, joined with two hundred pounds yearly after my death till two thousand pounds be come out in ten years to her own good whether she be sole or married, will be sufficient portion for an Earl of so small a fortune and so many children as the Earl of Worcester. It is the virtue and honour of the parents joined with the young lord's best affections that maketh me thus desirous, Else I seek not. Your loving Aunt, Elizabeth Russell, Dowager.[17]

The young lord's best affections suggest a transference of passion from Sir William Herbert's daughter to Bess Russell. How far this match progressed we do not know. Any such romance reached an abrupt end some short time before 28 January 1598, when Lord Worcester's heir died.[18]

By no means deterred, Lady Russell moved her match-making to the new heir, Henry, and her younger daughter, Anne. She, like her sister, was one of the six Maids of Honour to the Queen. The annals of the reign are full of the travails which these girls of good birth underwent in tending to the needs of their ageing and frankly jealous mistress. In April 1597 Anne had disgraced herself, along with Lord Chandos's daughter, Elizabeth Brydges, who had attracted the attentions of Essex, and both girls were packed off for three nights to Lady Stafford.[19] The reason, Rowland Whyte, the letter writer, explains, 'be their taking of physic' and going in secret to watch the young men of the court playing a ball game.[20] From time to time the Queen's favour was expressed by gifts of gowns to her Maids of Honour. Two such gowns were of velvet with hanging sleeves elaborately embroidered with vine leaves in pearl and spangles. She repeated the gift a few months before the marriage, and this time the dresses were of crimson velvet decorated with silver lace.[21]

26

When Anne and Elizabeth first became Maids of Honour, the bridegroom's sisters, the Ladies Elizabeth and Katherine Somerset, daughters of the Earl of Worcester, also served the Queen. Like the Russell girls they were ill provided for, because, as the old lady had written to Robert Cecil, the Earl had too many children. They too received identical dresses in which to wait upon the Queen. In 1594–5 these were of tawny velvet and silver, three years later of velvet and white satin cut and raised over silver chamblet.[22] That year they were married, one to Henry Guildford, the other to William Petre.[23] The wedding of 1600 should be placed within the perspective of that of 1597, which Edmund Spenser, who was patronized by Worcester, celebrated in his *Prothalamion, or A spousall Verse*. The poem contains a heroic tribute to Essex, who is described as 'Radiant Hesper', and the bridegrooms actually meet their brides arriving by water down the Thames at Essex House:

> *Above the rest were goodly to bee seene*
> *Two gentle Knights of lovely face and feature*
> *Beseeming well the bower of anie Queene,*
> *With gifts of wit and ornaments of nature,*
> *Fit for so goodly stature:*
> *That like the twins of Iove they seem'd in sight,*
> *Which decke the Bauldricke of the Heavens bright.*
> *They two forth pacing to the Rivers side,*
> *Received those two faire Brides, their Loves delight . . .*[24]

Spenser's poem places the Somerset family and its connections firmly into the Essex circle during the nineties. Edward Somerset, 4th Earl of Worcester, was about fifty in 1600, the year of his eldest surviving son's marriage.[25] In 1571 he had married Frances Hastings, a daughter of the 2nd Earl of Huntingdon, a wedding to which the Queen had come, and in 1589 he had succeeded his father as Earl. As a young man he was considered 'the best horseman and tilter of his time' and, although he was a Roman Catholic, he became a great favourite of Elizabeth, who held that he 'reconciled what she believed impossible, a stiff papist to a good subject'.[26] In the years prior to 1600 he rose rapidly in favour. In 1590 he headed a congratulatory embassy to Scotland to James VI, and in the same year was made a member of the Council in the Marches of Wales.[27] He was elected a Knight of the Garter in 1593, and in December 1597 was appointed Deputy Master of the Horse in the absence of Essex.[28] En route to Ireland in 1599, Essex wrote to that 'most dear lady' asking her 'to remember that truly honest Earl that waits in my place'.[29] Worcester and Essex were also linked as territorial magnates on the Marches and into Wales. One catches an overt statement of his loyalty to Essex in the significant political grouping at a dinner at court on 29 September 1599. Essex had returned from Ireland and made his spectacular incursion into the Queen's bedchamber the day before. On the Friday the Privy Council

met and considered the problems posed by Essex's unauthorized return. Afterwards they adjourned to dine, and court observers were swift in reporting who dined with Cecil and who with Essex. Those who went to Essex's table were the Earl of Worcester and the Earl of Rutland, Lord Mountjoy, Lord Rich, Lord Henry Howard, Lord Lumley, and a number of knights. Shortly afterwards Essex was confined to York House.[30] A letter dated 13 November from Worcester to an unknown lord in distress must surely be to Essex early in the winter of 1599. Worcester bemoans the Earl's confinement 'until fortune admits our convenient meeting' and goes on to explain that he should on no account resign his offices at court because the Queen would bestow them on other people, including himself – an anticipation of Worcester's eventual succession as Master of the Horse. None the less he hopes those appointed will be loyal to the Earl in his misery. 'And now will comfort my spirits', he ends, 'by breathing out the vapours of a melancholy conceit to so noble a friend as yourself, whose good opinion neither by time, absence, nor wrong interpretation will ever be impaired.'[31]

In the light of politics at court during the opening months of 1600, a match between the Somerset family and a Russell was not without significance. Through this marriage Worcester's heir would be linked by cousinage to Mr Secretary. One senses Worcester deliberately shifting his alliance away from the Essex circle and gravitating to Sir Robert Cecil. When Essex actually rebelled, Worcester was amongst those sent to arraign him. On 20 March Essex was allowed to return to his own house, and five days before the wedding he was summoned to York House to receive his official censure. It was against these tensions and passions that the match between Henry Somerset, Lord Herbert and Anne Russell took place. For such an alliance the Dowager Lady Russell had to pay dearly: £2,000 in money at once, besides an extensive settlement in land in the future.[32] All was finally brought to fruition on 16 June 1600, when the marriage actually took place.

The great marriage On 21 April Lady Russell had written to her nephew, Robert Cecil, that on the Monday after St George's Day she intended to fetch Anne home from court so that 'she may take physic for her eyes, which in truth be very ill, before the time of her marriage, which I mean shall be before Pentecost' (11 June).[33] Delays resulted from the Queen's failing to name the day. Anne's friends stayed in town anxiously waiting, so the old Lady Russell eventually went to court hoping to persuade the Queen to proceed with all speed. Elizabeth never took kindly to the marriage of one of her maids, but the petitions of the Dowager had their effect. It was reported that she 'hopes the next day to bring her fair daughter Mistress Anne, out of court and so to go on with the celebrations of the marriage'.

From then onwards everything proceeded without interruption. On Monday 9 June both Anne and Elizabeth returned to their mother's house. The Queen, having accepted the marriage, did things in high

28

style. She commanded all the Maids of Honour to accompany the girls, as indeed did all the lords of the court. No less than eighteen coaches were needed for the court attendants and, not to be outshone, Lady Russell met her daughters similarly escorted. She was accompanied by Jane, Lady Berkeley and 'other knights, ladies and gentlewomen' besides the Earl of Cumberland, Sir Henry Lee, Sir Anthony Cope and other gentlemen. What a cavalcade it must have been! It was commented at the time that 'the like . . . had not been seen among the maids'.[34]

That evening Lady Russell gave a splendid supper for members of the bride and bridegroom's families. She had written earlier to her nephew, Robert Cecil, asking him to act as her 'husband'. The guests were to be the Earl and Countess of Worcester (parents-in-law), the Earl and Countess of Cumberland (Lady Cumberland was Lady Russell's sister-in-law), and the Earl and Countess of Bedford (her nephew and his wife, the spirited Lucy Harington). She asked Mr Secretary to bring with him 'my Lord Thomas' and 'my Lord Cobham' . . . 'being of our blood'. Henry Brooke, Lord Cobham, was Cecil's brother-in-law (his wife Elizabeth Brooke had died three years before), and Lord Thomas presumably Cecil's elder brother, Thomas, 2nd Baron Burghley, later 1st Earl of Exeter.[35]

We have an unusual amount of information about the actual wedding day.[36] It began with the arrival of the Queen by water at Blackfriars bridge or stairs. At the landing stage Elizabeth was greeted by the bride and met by a litter or 'curious chair' which had been provided by Lord Cobham. On this the Queen was carried by six knights to the wedding at St Martin's Ludgate.

The bride was escorted to church by Lord Cobham and Lord Herbert of Cardiff (soon to be 3rd Earl of Pembroke, and with his brother one of the 'incomparable brethren' to whom Shakespeare's first folio was dedicated), and from it by Roger Manners, 5th Earl of Rutland (within months to wreck his fortunes along with those of Essex)[37] and the Earl of Cumberland. At Lady Russell's there was a dinner. In the withdrawing chamber of her Blackfriars house she and her 'husband' Cecil presided over one table, while elsewhere the new Lady Herbert sat down with another assemblage of guests. In the evening the Queen proceeded to Lord Cobham's house hard by within the precinct of the priory of Blackfriars. Cobham's house included the porter's lodge and part of the guest house of the monastery block, 'fair great edifices', as a contemporary described them. There the festivities reached their final climax in a stately masque.

Two days before the wedding Rowland Whyte had already reported that there was to be 'a memorable masque of eight ladies'.[38] These were the bride's sister, Bess Russell; her sister-in-law, Lady Blanche Somerset; Lady Dorothy Hastings; another Maid of Honour, Mary Fitton (soon to be disgraced as Lord Herbert of Cardiff's mistress); and mistresses Cary, Onslow, Southwell and Darcy. They wore skirts of cloth of silver, embroidered waistcoats, a mantle of carnation taffeta looped

under the arm, their hair elaborately dressed and hanging loose as maids. After supper these eight ladies made their entrance to the music of Apollo and a speech followed, the drift of which was that they were eight out of nine muses seeking their lost sister, a plot much to the 'honour and praise' of the royal visitor. Mary Fitton led the masquers, who performed 'a strange dance newly invented'. Afterwards, as was customary, they invited eight ladies from the audience to launch the general dancing. Mary Fitton approached the Queen and there followed a celebrated interchange: 'Her Majesty asked what she was? *Affection*, she said, *Affection*, said the Queen, is false.'[39] Everyone knew that it was Essex she had in mind – the missing splendid presence at this great gathering. In the words of the French ambassador who had also been asked, she arose and danced 'gayement et de belle disposition'.[40] This was Elizabeth at sixty-seven. Amidst such a scene of brilliant revelry what contemporary observers referred to as the 'great marriage' came to its end.

A fortnight later, on 1 July, John Chamberlain wrote as follows: 'Mistress Elizabeth Russell lies at the last cast is either dying or dead. The Lady of Warwick and Cumberland have watched with her by turns and give her over as past hope: if she go, she will mend the new bride's marriage.'[41] Festival to funeral within a matter of days. What a tableau this paints: the two aunts tending the dying Maid of Honour, who only a fortnight before had danced in the grand masque which was the culmination of her sister's wedding; and the gossips hoping that she would 'go', which in fact she did. Bess Russell kneels in marble ruff and spreading farthingale in a side chapel in Westminster Abbey, a monument to long vanished hopes.

Lady Russell gave way to grief. In December she still could not bring herself to go to court. 'I there still come in tears in remembrance of her that is gone,' she wrote to her nephew, Robert Cecil.[42] She would visit him, she said, but it would have to be by boat, since the 'great marriage' had left her a beggar unable to support horses for her carriage. Yet she remained indomitable to the end; her stream of letters to Mr Secretary is full of endless complaints of wrongs received. She outlived the Queen, but now her Puritan piety centred on the gathering of the dead in the great Hoby chapel in the church at Bisham. There she still presides, rapt in prayer, shrouded in her widow's weeds, her family arranged around her, the dead separated from the living. Pride of place is given to her daughter Anne: coroneted as Lady Herbert and future Countess of Worcester, she embodied the culmination of all the aspirations of her remarkable mother.

The procession to Blackfriars

Such are the historical facts of what was the social event of the summer of 1600, a summer when there was no formal progress as such. Processional order was of crucial importance to the Elizabethan court. The Procession Picture reflects this. It mirrors the gradations in rank of officers of state,

nobility, gentry and attendant ladies, focusing upon the Crown. Whether the Queen and her company were on horseback or on foot, the demands of rank and precedence remained the same. Two descriptions by French diplomats at the close of the century give verbal expression to the visual content of the picture. The first is by Monsieur de Maisse, who came to England some three years before it was painted and was greatly intrigued by the stage management of the Queen:

> When the Queen goes abroad in public the Lord Chamberlain walks first, being followed by all the nobility who are in court, and the Knights of the Order that are present walk after, near the Queen's person, such as the Earl of Essex, the Admiral and others. After come the six heralds who bear maces before the Queen. After her march the fifty gentlemen of the Guard, each carrying a halberd, and sumptuously attired and after that the Maids and Ladies who accompany them, very well attired.[43]

What de Maisse is saying is that the procession was headed by the Lord Chamberlain, George Carey, 2nd Lord Hunsdon, in his capacity as chief officer of the royal household. After him came the nobility, then the Knights of the Garter, next the Heralds, Her Majesty, the Gentlemen Pensioners, the Maids of Honour and court ladies.

Two years afterwards Jean de Thumery, Sieur de Boissise, described Elizabeth's entry into London, in which she rode in a litter. This took place only a few months before the wedding, and Worcester, father of the bridegroom, is described standing in for the disgraced Essex as Master of the Horse, leading the Queen's horse by the bridle. The Earl of Derby carried the sword of state before her, and around the Queen rode the great officers of state, the Admiral (Lord Howard), the Lord Treasurer (Lord Buckhurst) and the Lord Chamberlain (Lord Hunsdon).[44]

How does all this square with the Procession Picture? In the first place, we are looking at only part of a procession. Its beginning and end are not there; instead we open with its climax, the Queen and the great ones of the court. Six Knights of the Garter walk directly before the royal litter, 6 one of them bearing the sword of state in a crimson scabbard embroidered with gold. The Garter Knights are by far the easiest to identify. Lord Sheffield, later created Earl of Mulgrave, had served in the Low Countries as Governor of Brill and was elected KG in 1593. A miniature by Isaac Oliver, executed early in James I's reign, and an 4 engraving by Elstracke from slightly later show the same oblong face and 5 beard. The next three Knights are all familiar faces: Lord Howard of Effingham, the Lord Admiral, in silvery white (a miniature by Hilliard 7 painted three years later exists);[45] George Clifford, 3rd Earl of Cumberland, peering over the shoulders of the other two (a face known 8 from several Hilliard miniatures);[46] and the Lord Chamberlain, Lord Hunsdon, carrying his white rod of office. Hilliard painted him the following year (then aged fifty-four) with the same furrowed face. 9

4 Lord Sheffield,
c. 1600–1605

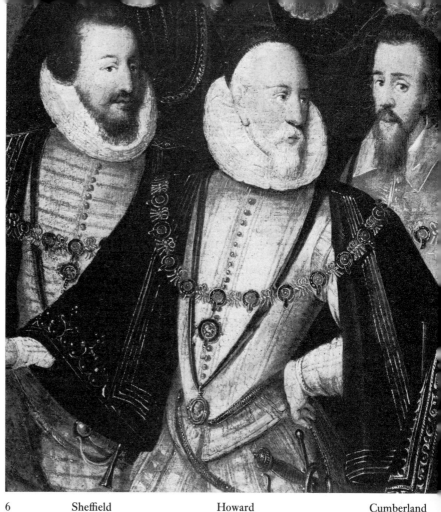

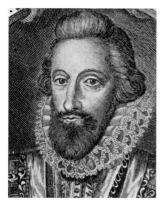

5 Lord Sheffield,
c. 1610–15

6 Sheffield Howard Cumberland

**Six Knights of the Garter precede the
Queen. All except one are identifiable**

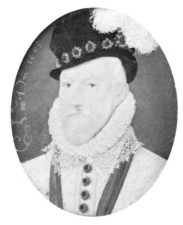

7 Lord Howard of
Effingham, 1605

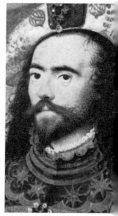

8 The Earl of
Cumberland, *c.* 1590

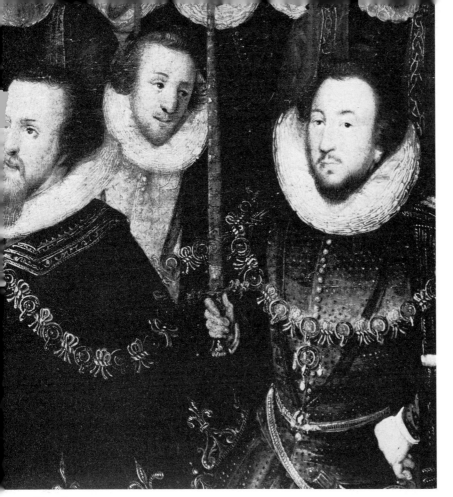

Hunsdon unknown Shrewsbury

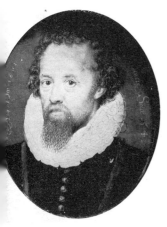

9 Lord Hunsdon, 1601

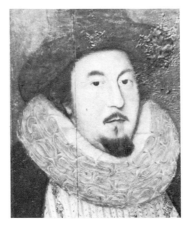

10 The Earl of
Shrewsbury, 1596

Then comes a puzzle, a dreamy young man dressed in white, by far the youngest of the Garter Knights in the picture. Of those created in the nineties the youngest were Northumberland (thirty-seven in 1600), Lord Howard de Walden (thirty-nine), the Earl of Sussex (twenty-six), Lord Cobham (thirty-three) and Lord Scrope (also thirty-three). The portrait evidence eliminates Northumberland and Sussex, both dark, but it is extremely uneven, if existent at all, for the other three. The man who ought to be there is Henry Brooke, Lord Cobham, the extravagant aristocrat who provided the embroidered canopy and rich litter to carry the Queen. He was Warden of the Cinque Ports and a close political ally of his brother-in-law, Robert Cecil, the bride's cousin. On the uneven iconographical evidence we have on these sitters it is unlikely that any conclusive identification will ever be made.

Of the identity of the sword-bearer there is no doubt. He is Gilbert Talbot, Earl of Shrewsbury, created a KG in 1592 and sent four years later to bear the Garter to Henri IV at Rouen. A portrait painted four years before the marriage shows him in the same vein, putting on weight and coarsening in feature. There is a seventh Knight who occupies the most prominent position of all, in the very centre of the picture, holding gloves in his right hand, his head inclined to one side. He is by far the most important person in the picture next to the Queen, who rises above him. This is the bridegroom's father, Edward Somerset, 4th Earl of Worcester, in his forty-seventh year. As Deputy Master of the Horse he carries out the function (normally performed by Essex) of actually escorting the Queen on her ceremonial progresses. Scharf first identified this figure as Worcester on the basis of a picture at Badminton of him in old age, by then in his sixties, balding and white-haired. The only earlier picture of Worcester is one at Ingatestone, his son-in-law's house, depicting him as a much younger man, about thirty – fifteen to twenty years before the wedding – and already thinning a bit across the temples. The identification is utterly convincing.

These people are all certainly identifiable; but why are they there? How does their presence square with the great marriage of 1600? The answer is, of course, that it does not, and it is at this point that we should seriously begin to reconsider whether indeed a connection exists, and, if so, what kind of connection. Worcester, the bridegroom's father, is in the central position, but he is there primarily as Master of the Horse, in direct proximity to the Queen. Of the five identifiable Garter Knights, only Cumberland was actually concerned with the events of June 1600. There is no reason for any of the others being present at all.

We are moving from left to right across the picture, and our focus now centres on Worcester himself and on the four young men who are grouped around the Queen, always identified as the bearers of Lord Cobham's curious chair or litter from the Blackfriars riverside. If we are beginning to think that the Procession Picture does not necessarily refer specifically to the marriage, perhaps a closer look at the structure always accepted as carrying the Queen might take our thoughts a stage further.

34

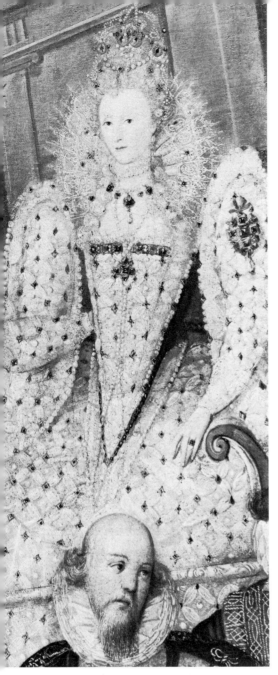

11 *Eliza Triumphans* and her Master of the Horse

Edward Somerset,
4th Earl of Worcester,
Elizabeth's last Master of the Horse

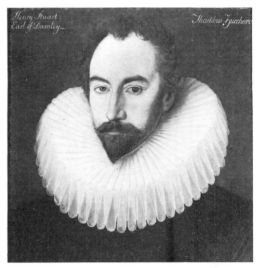

12 Worcester, *c.* 1590
13 Worcester, *c.* 1620

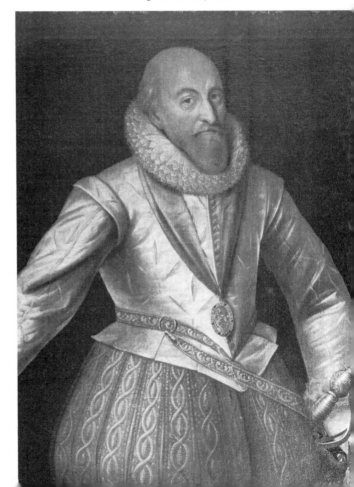

Ever since 1737 this picture has always been seen as showing Elizabeth carried in a litter, an assumption strengthened by the references to the curious litter in the letters of Whyte and Chamberlain. Vertue, Nichols, Scharf, Ilchester, all the scholars who have attempted to unravel the meaning of this picture have assumed this. But is it a litter? Let us try to look at the structure which surrounds the Queen in greater detail. The flower-spangled canopy is mounted on a framework of wooden or – which is less likely – metal rods. It is constructed so that the horizontal support extends on each side beyond the confines of the vertical ones, thus enabling it to be carried by four canopy-bearers. There is simply no room for three each side, and the man in green immediately behind Worcester is surely the fourth canopy supporter brought round from the furthest hidden corner to the front. The canopy then is only a canopy, not a litter. There are no crossbars, no bars descending vertically so that when it was set down the canopy would still rise above Her Majesty. In other words, we are looking at two quite distinct structures, a canopy and something else on which the Queen rides. This brings us to some of the most puzzling members of the royal entourage, the so-called Yeomen of the Guard immediately behind the chair.

Again, everyone has assumed that they are Elizabethan Yeomen of the Guard, but any study of their uniform as recorded amply in other sources proves that this cannot be the case. Without exception, Elizabethan Yeomen of the Guard wore tunics with puffed sleeves on the upper arm and skirts, the whole braided with black velvet. What we have here is something quite different, men in black skullcaps and crimson tunics embroidered with gold. The wardrobe accounts tell us who these people must be. A typical recurring warrant is the one of July 1601 for uniforms for the Queen's eight ordinary footmen, four grooms for coaches and four for litters. The footmen have crimson velvet running coats, the grooms identical uniforms, jerkins with sleeves of crimson velvet with 'our letters before and behind having the crown embroidered over the said letters' and velvet night caps at four shillings a piece.[47] These three old men must surely be not Yeomen of the Guard but 'grooms of our coaches or litters'. One of them, the man immediately behind the Queen, is extending his arms downwards in a position which can only mean he is pushing something. This surely is precisely what he is doing – Elizabeth is being pushed along from behind on some sort of triumphal car with a chair of state upon it. And if one peers into the dark shadows between the legs of Worcester and the canopy-bearers, evidence of wheels and their hubs can be discerned. In other words, what we are looking at is an Elizabethan version of an *à l'antique* triumph. For a visual reference to throw this extraordinary spectacle into focus, we can go back to one of the most famous and earliest of all Renaissance re-creations of classical antiquity, Francesco Laurana's frieze over the gateway to the castle at Naples depicting the entry of Alfonso the Great in 1443. His wheeled chariot is drawn by four horses but the principle is the same and the canopy, as in the Procession Picture, is carried separately by great nobles.

14

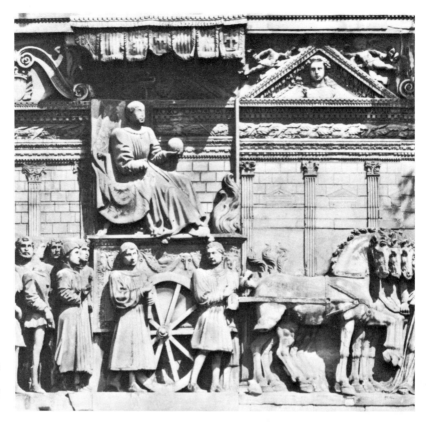

14 The triumphal entry
of Alfonso the Great into
Naples in 1443. The
Renaissance revival of the
antique triumph also
inspired the apotheosis of
Elizabeth

In this sculpture we are at the fount of hundreds of such monarchical
triumphs which were re-enacted all over Europe for the next two
centuries. It was a leitmotif of the Renaissance court fête.[48]

Such visions of antique triumph were not unknown to the
Elizabethans. The account of Elizabeth giving thanks for the defeat of the
Spanish Armada describes her as riding to St Paul's on a chariot which
had a canopy supported by four pillars surmounted by the imperial
crown.[49] And with this revelation, oddly enough, we are back to what the
owners of the picture in 1737 actually believed the picture represented.
In other words, before there was a tradition of marriage celebration, there
was a tradition of triumph.

Now let us return to the remaining unidentified members of Her
Majesty's entourage. Lining the route are Gentlemen Pensioners, twelve
of them clearly portrayed with ten halberds visible. J. Nevinson in his
study of the costume of Gentlemen Pensioners suggests that the twelve
heads inserted between are also portraits of the Pensioners who lined the
route on the opposite side, and goes on to print the list of almost fifty
Pensioners in service of Elizabeth at Michaelmas 1600.[50] The certain
identification of these minor gentlemen of the court is a virtual
impossibility.

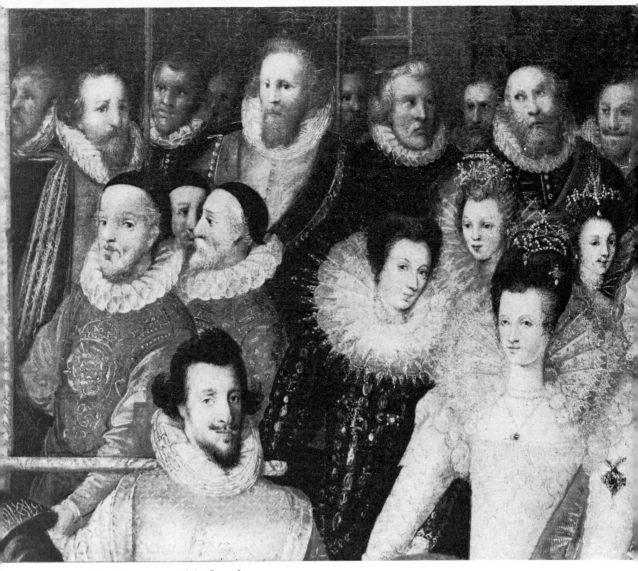

15 Note the three grooms of the Queen's
litters and coaches, one of whom is
pushing the royal triumphal chair

One canopy-bearer and the eight ladies who follow the Queen

16 The bridegroom: Henry Somerset,
Lord Herbert of Chepstow, c. 1620

17 The bride: Anne Russell, c. 1600

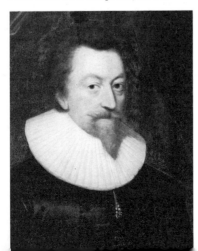

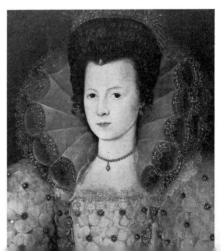

So too is that of the remaining members of the procession. It is tempting to turn the canopy-bearers and ladies into members of the Somerset family.[51] There are four bearers, and Worcester had four surviving sons in 1600: Lord Herbert; Thomas, later Viscount Somerset of Cashel; Sir Edward, and Sir Charles. The man in green immediately behind the Earl bears a strong facial resemblance to him. He could easily be Worcester's second surviving son, Thomas. But the two youngest sons would only have been ten and thirteen in the year of the marriage. In the case of the eight ladies it would be coherent if they were Lady Worcester, her new daughter-in-law Anne, and her six daughters, Elizabeth, Lady Guildford, Katherine, Lady Petre, Anne, Lady Winter, Frances, Mrs Morgan, Catherine, Lady Windsor, and Blanche, Lady Arundell of Wardour. Their dates of birth are for the most part covered in obscurity, but it is doubtful if the two youngest would have been old enough to be present. Again, one can spot a strong facial resemblance among the frieze of ladies at the back. Are members of the Somerset family there at all? This must be left to the judgment of the reader based on inadequate portrait evidence. There is a portrait of the bridegroom fifteen years later, heavy-lidded and ageing fast. He could be the furthest canopy-bearer in white, traditionally identified as the bridegroom. There are portraits at Badminton also of the bride and her mother-in-law, Lady Worcester, who could be the lady in white, supposedly the bride, and the elderly lady following her with a rose in her hand. There are also portraits of Spenser's 'swan' brides, one of Lady Petre by Gheeraerts, datable to 1599, and one of Lady Guildford painted much later, about 1625. The sisters are very striking with their long faces, slightly pop eyes and pouting lips. They could be two of the indeterminately featured ladies following the Queen, but one could never be quite sure.

At this point we should pause, and ask who commissioned the Procession Picture, and why? It is an unanswerable question, and yet

15

16

17, 18

19
20

18 The mother-in-law: Lady Worcester, c. 1600

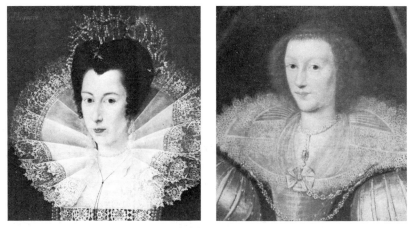

19, 20 The bridegroom's sisters: *left*, Katherine Somerset, Lady Petre, 1599; *right*, Elizabeth Somerset, Lady Guildford, c. 1625

one's eye settles inevitably on the presiding master of ceremonies, Elizabeth's last Master of the Horse, Edward Somerset, 4th Earl of Worcester. The best tilter of his age and a brilliant horseman, he was a man who clearly had an instinctive feeling for pageantry and ceremonial. Not only did he succeed Essex as Master of the Horse in 1601, but in the new reign he was appointed Earl Marshal for the coronation, for James I's state entry into London in 1604, for the christening of the Princess Mary in 1605 and for the creation of Henry as Prince of Wales in 1610. This is abundant evidence that he was regarded as expert in all matters pertaining to the organization of court spectacle. So beyond the 'great marriage', perhaps the specific event celebrated in the picture, there opens up a wider world of allusion. It is this wider world in the context of Somerset which I now wish to pursue.

Taking Worcester as the key figure immediately opens up new vistas of thought. The feet of the company move across a stone-paved surface, but the crowd is silhouetted against a large building from the upper windows of which lean beruffed ladies looking down at the Queen. It is a strange, even architecturally impossible structure, and its vocabulary is that of the fantastic buildings found in the pattern-book engravings of Vredeman de Vries.[52] But beyond it the landscape is still more peculiar – nothing like the river Thames as viewed from Blackfriars steps where Her

21 The house in the background of the Procession Picture uses the fantastic architectural vocabulary found in the engravings of Vredeman de Vries

Majesty landed on the great day with which successive scholars have unsuccessfully tried to identify it. It is dominated by two buildings, both castle-like. One, in the foreground left, is rose-pink with a bridge giving access; turrets and a hall rise in the midst; swans swim in the river or moat which encircles it. The other is on a remote height, grey with a great tower in the centre, to the left a vista of barren mountains. Every detail in this picture is so specific that these buildings at once undermine the theory of an allusion to June 1600. I believe that they teach us to look at the picture in another, more complex way.

Worcester again is our clue. The Somerset family had, at the close of Elizabeth's reign, probably as many as four residences – Worcester House in the Strand, Worcester Lodge at Nonsuch, Raglan and Chepstow Castles in Monmouthshire in the Welsh Marches. Raglan Castle had belonged to the Somersets from the beginning of the century.[53] Edward's father had transformed the medieval castle into a magnificent Elizabethan mansion. Edward continued his father's work. A great walk around the moat was created, with statues of Roman emperors in shell niches, and a fountain called the White Horse was erected in the castle courtyard in allusion to his Mastership of the Horse. Raglan, later left a heroic ruin by the siege of 1646, was then at its apogee, a splendid country house surrounded by bowling green, terraces and gardens, fishponds and parks. This was the family's principal seat, but Chepstow, some fifteen miles south commanding the Severn estuary, was also a Somerset house and, likewise, had been adapted to new standards of ostentation and comfort during Elizabeth's reign.[54]

The parallel between the two castle-like structures set into a remote and bleak landscape and the Somerset seats of Raglan and Chepstow on the Welsh borders is too much of a coincidence for a link between them not to be posed at least as a hypothesis. Neither representation – if representations they are – seems to me to be based on any detailed topographical or architectural information, but nor are the very specifically labelled cities, towns and country houses in a picture which we shall come to later in this book, the memorial painting of Sir Henry Unton. Topographical exactitude was not part of the Elizabethan way of thinking, strange though this may seem to us. Is it, therefore, Chepstow in the foreground with the Wye encircling it? Is it Raglan with its great tower in the distance with the bleak western mountains of the Welsh border behind? The interpretation may seem fanciful, but in the light of Elizabethan visual conventions it could be right. If so it would fit snugly into the context of an apotheosis of Edward Somerset, Earl of Worcester.

And what of the strange house in the foreground? Is it another Worcester house? The only Worcester house we know about in detail is that at Nonsuch, of which Robert Smythson made a plan during his London visit of 1609. Worcester was Keeper of Nonsuch Great Park, and the house stood until demolished by the rapacious Duchess of Cleveland in 1671.[55] Whatever the buildings in the background are, the fact that we can think of them as several different places brought together in an

22 Two castles dominate a remote and barren landscape

The Somerset family had two
principal residences in the
Welsh Marches, the castles of
Raglan and Chepstow

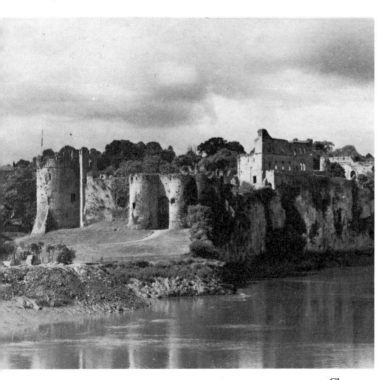

24 Raglan

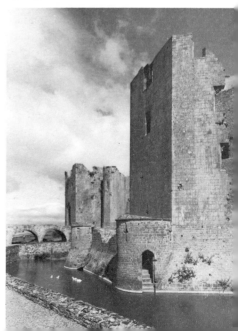

23 Chepstow

impossible spatial relationship makes us yet again challenge the conventional reading of the Procession Picture as the eye-witness record of a single event.

What we have in the Procession Picture is what modern literary scholars have been so concerned about in Spenser's *Faerie Queene*, the reconstruction of a lost sense of sight, of how the Elizabethans actually *saw* things.[56] We shall probably never be able to recreate that sense exactly, but we are able to deduce certain facts about it. Although Spenser's characters are trapped in all the abstruse permutations of late Renaissance allegory, they are deployed within a narrative framework which can only be called neo-Gothic. There is no understanding or use of scale in relation to optical distance, or of the placing of characters and objects within a homogeneous geometric totality governed by the new laws of perspective. This also applies to the Procession Picture, as indeed it does to all Elizabethan works of art. There is no notion that a picture's surface should encapsulate a given viewpoint at a single moment in time. The new convention of Renaissance art, the making of a mathematically homogeneous space, was, as John White writes, 'the creation of a new and powerful means of giving unity to the pictorial design',[57] but it was not known to Elizabethan England. The Procession Picture belongs to an earlier neo-Gothic convention of space as a constant alternation or movement in the subjective experience of the observer as he views the elements of the work successively in time. In this light we need to examine the Procession Picture again.

We shall never know how Worcester saw this picture in his own mind, how his eye actually ran over its component parts, but a glance at another Eliza-worship icon might help us to try finally to break down our preconceived notion of the Procession Picture as snapshot reportage of a single historical event. The Armada Portrait at Woburn Abbey, painted a decade before, is a more straightforward instance of the Elizabethan placing of individual visual phenomena; each item is intensely charged with significance, and yet as a whole they are linked neither by unity of time nor in a space defined as a geometric totality. Elizabeth rises between two windows, each of which has a view governed by separate laws of distance and space, showing the arrival and defeat of the Spanish Armada. What they depict together is an impossibility; nor do they in any way relate geometrically to the room in which the Queen presumably stands, oddly surrounded by two tables and a throne. Each of these is observed separately. The table with the diadem upon it is viewed straight on, the other upon which the globe rests is tipped up at an angle towards the viewer, while the throne to the right displays back and chair arm simultaneously. These images are attributes defining and expanding the central figure. The Armada Portrait has the quality of a strip-cartoon. The *Armada* advances and is repelled by the mighty *Monarch* whose *Crown* and *Throne* have vanquished the forces of evil and whose imperial hand now extends to grasp the whole *World*. And yet each part of the story may be contemplated separately within itself.

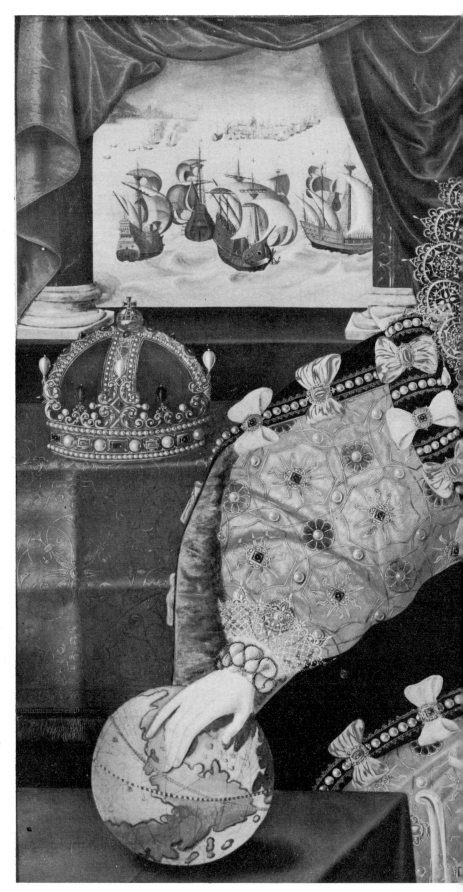

25 Elizabeth I:
the Armada Portrait,
c. 1588. The unities of time
and space were unknown
to the picture-makers
of Elizabethan England

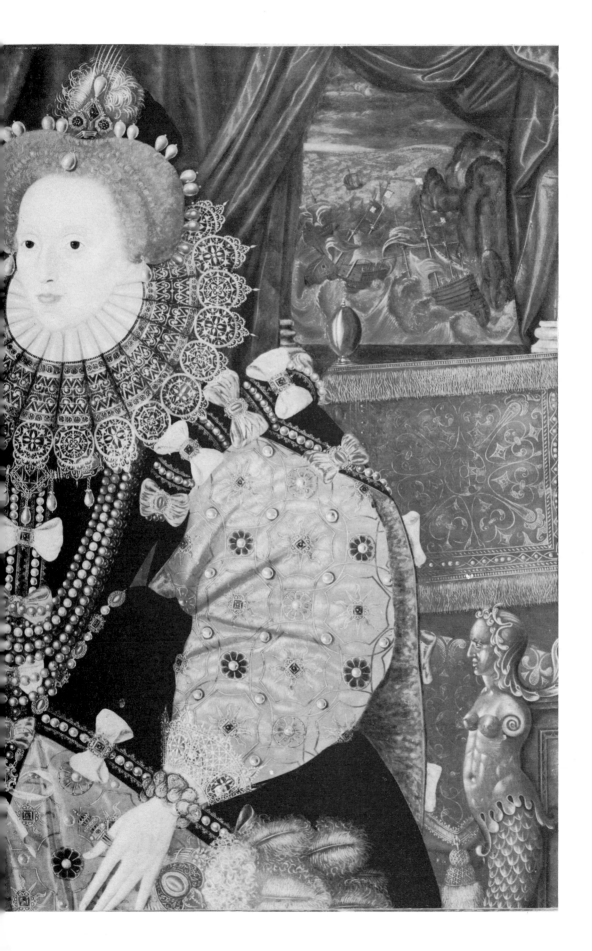

Let us return to the Procession Picture. I believe that we have in this canvas something much more than an allusion to the celebrated marriage of 1600. I believe that we should probably move the date of the picture on at least to April 1601, when Worcester was appointed Master of the Horse in succession to the deceased Essex. This was followed in December of the same year by his appointment as Joint Commissioner for the office of Earl Marshal, a role he occupied again and again at the Jacobean court. Worcester, famed as a horseman and tilter, hailed as 'a great favourer of Learning and good Literature', was as we know a master of court ceremonial. This is what the Procession Picture commemorates: Worcester in his role as Queen's favourite and master of ceremonies at the Elizabethan court. The idea of a picture being direct reportage of a single event was utterly alien to the Elizabethan mind. A picture was a 'heroical device', and the Procession Picture has been reduced in status through this misreading of its contents. It is *Eliza Triumphans*, and it is to this 'idea' of Elizabeth as it was conceived by her last master of ceremonies, Edward Somerset, 4th Earl of Worcester, that we must now turn.

Sir John Davies and 'our glorious English court's divine image'

What we are looking for, therefore, is the 'idea' of the English court and its Queen as it was projected in the last two years of the reign, that period following Essex's execution in February 1601. If I had to choose one single source to re-create this image, it would be the poetry and pageantry written by an up-and-coming lawyer, John Davies. Although his work really began when he published *Orchestra* at the age of twenty-seven in 1596, it is the material which he produced under the direct patronage of courtiers, beginning in the winter of 1600, which we need to study.[58] These are the final poetic cadences of the Eliza-cult, coincidental with the painting of the Procession Picture. They are prefaced by twenty-six acrostics in Elizabeth's praise, *Hymns to Astraea*, published in 1599, followed in December 1600 by a *Conference between a gentleman usher and a poet the Queen being at Mr Secretary's House*, which argues patronage by Sir Robert Cecil. The following year Mr Secretary was negotiating with Davies for speeches for a tournament. Then follows the ode *Of Cynthia*, which was almost certainly his, printed in Francis Davison's *Poetical Rhapsody* (1602) with the commentary that 'This Song was sung before her sacred Majesty at a show on horseback, wherewith the Right Honourable the Earl of Cumberland presented Her Highness on May Day last.' This presumably was the fête organized by the Queen's Champion at the tilt, George Clifford, 3rd Earl of Cumberland, on May Day 1602 at Sir Richard Buckley's at Lewisham. In August Davies was employed by the new Lord Chancellor, Sir Thomas Egerton, for his entertainment of the Queen at Harefield. Cecil made use of him again a few months later to write for what was to be the last great festival of the reign, Mr Secretary's entertainment of Elizabeth at Cecil House in the Strand on 6 December 1602.

Davies projects an utterly coherent image of the Queen, giving vitality, elegance and life by drawing together all the complex mythological threads which for over forty years had created the image of the Virgin Queen. The ethereal Elizabeth of the Procession Picture, glittering with jewels but attired in virgin white, her appearance like that of a young girl, must be read as a direct visual reflection of Davies's eulogies. *Hymns to Astraea* is the best guide to aspects of the cult. Astraea, one of the most constant of all the names used for the Queen from her accession onwards, is the just virgin of Virgil's *IVth Eclogue*, whose return to earth inaugurates the golden age, bringing not only peace but eternal springtime.[59] For Davies this spring is our 'state's fair spring'. May is a month particularly sacred to Astraea because, surprisingly, she is also 'Queen of Beauty'. In other words Elizabeth–Astraea–Virgo is also Venus, goddess of love and beauty, whose attribute, the rose, is another of Davies's themes, symbolic not only of the union of York and Lancaster but of her role as 'Beauty's Rose'. The twenty-six acrostics are made up of two groups, the second of which embarks on a definition of Elizabeth as the object of an intellectual cult. He celebrates the structure of her mind, its wit, will, memory, fantasy, passions and virtues, followed by more usual *topoi*, her wisdom, justice and magnanimity. She 'treads proud Fortune under':

> *Beauty's crown though she do wear,*
> *Exalted into Fortune's chair,*
> *Thron'd like the Queen of Pleasure . . .*
>
> (xxv)

This evocation of a triumph of Venus riding in her chariot should lead us back to contemplate anew the astoundingly rejuvenated face of the Queen in the Procession Picture. The painter, no doubt under direction, is surely giving direct visual expression to Elizabeth's role as 'Queen of Beauty', 'Beauty's Rose' and 'Queen of Pleasure'.

So the Procession Picture is in part a triumph of Venus as well as the usual triumph of chastity. This is an aspect of Astraea which comes as something of a shock. How can Elizabeth, the promised virgin of imperial reform, be also the goddess of love? It is less curious in the context of Renaissance monarchical mythology, which tries by the use of extreme forms of contrasting imagery somehow to reconcile the dual nature of royalty, divine and human, soul and body, mind and passions. The Elizabeth cult is held together by such paradoxes. Edgar Wind points to the definitive text for the cult of Venus–Virgo, the appearance of the goddess of love as a nymph of Diana in the *Aeneid*. Through this the 'union of Chastity and Love through the mediation of Beauty is . . . expressed by one hybrid figure in which the two opposing goddesses, Diana and Venus, are merged into one'.[60] In Venus–Virgo, Renaissance Platonism found the confirmation of its doctrine of the union of love and chastity. In northern Europe the theme was expanded and developed,

first in the imagery surrounding Diane de Poitiers, but above all in the symbolism of the Elizabeth cult. Spenser uses it in his *April Eclogue* as early as 1578, but it is not until the last decade of the reign that we find overt celebrations of Elizabeth as 'Queen of Love' and 'Queen of Beauty'.

While there seems to be absolutely no mythological precedent for associating Venus with Astraea, there was ample justification for identifying her with Diana, and hence the cult of the Queen as the moon goddess, Cynthia or Belphoebe. The moon cult, begun by Raleigh in the eighties as a personal, private one, became public in the nineties. That it was in some of its aspects a celebration of Elizabeth as Venus–Virgo there is plenty of evidence. A song by John Dowland, presumably for a court fête, makes a rudimentary assertion of such a role. Elizabeth is hailed as 'Queen of Love and Beauty', and an inquiring Cupid is told that if he wishes to contemplate such a goddess he must:

> *See the moon*
> *That ever in one change doth grow*
> *Yet still the same; and she is so;*
> *So, so, so, and only so.*
> *From heaven her virtues she doth borrow.*
> *To her then yield thy shafts and bow,*
> *That can command affections so.*
> *Love is free;*
> *So are her thoughts that vanquish thee.*
> *There is no Queen of Love but she,*
> *She, she, she, and only she,*
> *She only Queen of Love and Beauty.*[61]

Elizabeth–Diana–Venus–Virgo is ever young and ever beautiful. Her youth is perpetually renewed, like the waxing and waning of the moon. Davies's ode *Of Cynthia*, for the May Day fête of 1602, is a celebration of Cynthia–Venus–Virgo whose youth is eternal:

> *Time's young hours attend her still,*
> *And her eyes and cheeks do fill,*
> *With fresh youth and beauty;*
> *All her lovers old do grow,*
> *But their hearts, they do not so*
> *In their love and duty.*[62]

Such eulogies provide the key to the amazing images of Elizabeth painted by Nicholas Hilliard, the court miniaturist, in the last decade of the reign. One depicts her as a young girl, her hair falling on to her shoulders like a bride, while others show her equally young but with the crescent moon of Cynthia in her hair.[63]

26
27

48

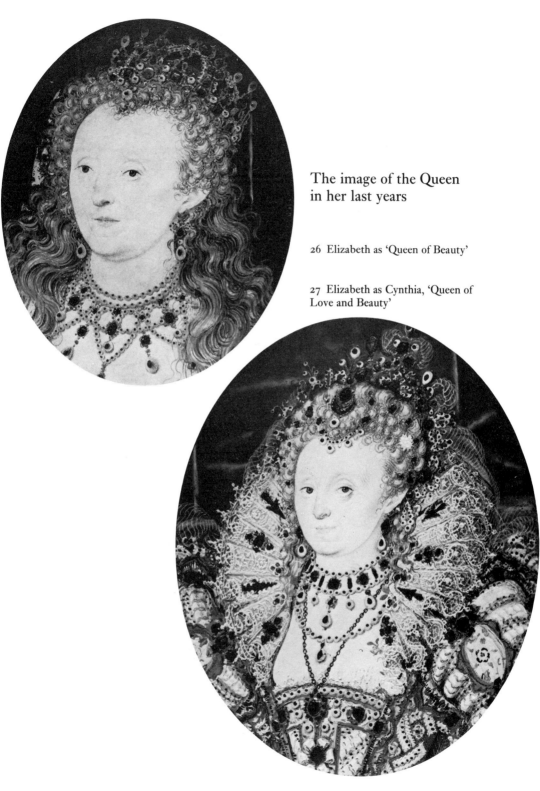

The image of the Queen
in her last years

26 Elizabeth as 'Queen of Beauty'

27 Elizabeth as Cynthia, 'Queen of
Love and Beauty'

We can pursue this even further in a picture which directly relates to Davies's chief patron, Robert Cecil. At Hatfield House still hangs the most amazing of all these final visions of Elizabeth as 'Queen of Love and Beauty', the Rainbow Portrait.[64] This is worth examining in some detail as the perfect visual complement to the Procession Picture. The latter celebrates Elizabeth within the context of her court, the former celebrates her within the many facets of herself. This is a portrait which has always been in the possession of the Cecil family, and it was painted during those vital two or three years when Davies was employed by Cecil as court pageant poet. So close is it in content to his *Hymns to Astraea* that one might reasonably conclude that the programme was actually drawn up for the artist by Davies. The rejuvenated face is that of 'Astraea, Queen of Beauty' (iv), whose return to earth brings the flower-decked springtime of the golden age:

> E *arth now is green, and heaven is blue,*
> L *ively spring which makes all new,*
> I *olly Spring doth enter;*
> S *weet young sun-beams do subdue*
> A *ngry aged Winter.* (iii)

The bodice of her dress is embroidered with spring flowers – pansies, gillyflowers, cowslips and honeysuckle – in allusion to this springtime theme and also to her as Flora, 'Empress of Flowers' (ix). The Queen is the sun who brings the rainbow, which she holds, promising peace after storms: *Non sine Sole Iris* (no rainbow without the sun).

> R *oyal Astraea makes our day*
> E *ternal with her beams, nor may*
> G *ross darkness overcome her;*
> I *now perceive why some do write*
> N *o country hath so short a night*
> A *s England hath in summer.* (vi)

She embodies 'the true beams of majesty' (viii), her mind is hailed as 'Rich sun-beams of th'eternal light' (xiv), her wit, like the rays of the sun, 'Into all things prieth' (xv), and the State which she rules sits 'sun-like . . . above the wind' (xxiv).

On her left sleeve is embroidered a serpent from whose mouth hangs a 28 heart. The heart is symbol of the passions, the serpent of wisdom:

> B *ut since she hath a heart, we know*
> E *ver some passions thence do flow,*
> T *hough ever rul'd with Honour;*
> H *er judgement reigns, they wait below,*
> A *nd fix their eyes upon her.* (xx)

28 Detail of the Rainbow Portrait (*page 8*): the serpent of wisdom rules the passions of the heart

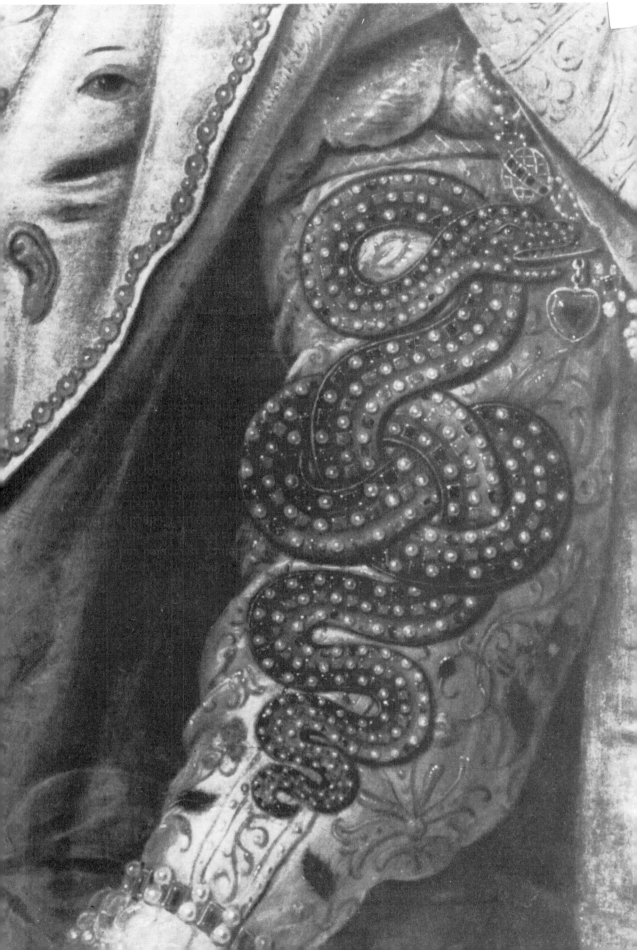

Elizabeth, Davies tells us, rules the passions of her heart by her wisdom:

> B *y this straight rule she rectifies*
> E *ach thought that in her heart doth rise*
> T *his is her clean true mirror,*
> H *er looking glass, wherein she spies*
> A *ll forms of Truth and Error.* (xxii)

The armillary or celestial sphere hanging above the serpent is 'heaven's axeltree' which, Davies recounts, along with pillars and rocks, 'exemplify her constancy' (xxiv). An orange cloak covered with eyes and ears, symbolizing those who watched and listened to purvey their intelligence to her, envelops the Queen:[65]

> E *ye of that mind most quick and clear,*
> L *ike Heaven's eye, which from his sphere*
> I *nto all things prieth;*
> S *ees through all things everywhere,*
> A *nd all their natures trieth.* (xv)

Davies might almost have been describing this cloak in the passage in his first entertainment for Cecil in 1600 in which he compared the use that the Queen made of her servants to that of the mind and the senses: 'many things she sees and hears through them, but the Judgement and the Election are her own'.[66]

In her hair rests the crescent moon alluding to her as 'Cynthia, Queen of Seas and Lands', and on her ruff a jewelled gauntlet, a chivalrous emblem, places her as the heroine of her knights. And if I had to suggest the occasion which evoked this extraordinary votive image I would turn to the last spectacle of the reign, Elizabeth's visit to Robert Cecil in December 1602. For this Davies composed a re-statement of his Eliza mythology in a courtly contention between a wife, a widow and a maid. These three meet en route to 'Astraea's shrine', upon which tapers are burning in honour of this 'saint' 'to whom all hearts devotion owe'. Is it too fantastic to suggest that this shrine centred on the Rainbow Portrait? No other setting seems to provide a context better suited to the religious overtones of this sacred icon in which Royal Astraea is unambiguously presented as an object of worship, attired in a bridal headdress, her hair worn loose as a virgin, standing silhouetted within a church-like arch.

The Rainbow Portrait expands our vision of Elizabeth in the Procession Picture: queen of beauty, queen of love, the just virgin of the golden age returned, whose mind is an object for contemplation by her votaries. Such is the staggering image of Elizabeth; but the Procession Picture, unlike her other portraits, places her in relation to her worshippers. It is an image of her and of her court. In this it becomes a visual statement on the Elizabethan state, on order, the order of the body politic which she animates.

B *y instruments her power appear*
E *xceedingly well tun'd and clear:*
T *his lute still in measure,*
H *olds still in tune, even like a sphere,*
A *nd yields the world sweet pleasure.*　　　　　　　　(xix)

This picture is of Elizabeth and her 'instruments', and if we wish to develop the musical analogy further John Davies again provides us with the thread in his poem *Orchestra* (1596).

The poem is devoted to the harmony of the cosmos, created by love, descending through the hierarchies of creation from the dance of the fixed stars, the planets, and the elements below the planets to the lowest of earth's elements: streams, flowers, animals all have their proper dance also.[67] Through the mouth of Love, Davies puts forward the idea that dancing is the organizing principle of society:

If sense hath not taught you, learn of me
A comely moderation and discreet,
That your assemblies may well order'd be;
When my uniting power shall make you meet,
With heavenly tunes it shall be temper'd sweet
And be the model of the world's great frame,
And you, earth's children, Dancing shall it name.[68]

Subsequently he elaborates this thesis that all the rituals of an ordered and well governed society are related to the dance:

Since when all ceremonious mysteries,
All sacred orgies and religious rites,
All pomps, and triumphs, and solemnities,
All funerals, nuptials, and like public sights,
All parliaments of peace, and warlike fights,
All learnèd arts and every great affair,
A lively shape of dancing seems to bear.[69]

The Procession Picture is such a dance of state. Love created the universe and social order and he invented the dance. Dance cannot exist without music, and the idea of society as musically ordered, of political unity as musical harmony, of ritual and dance as physical expressions of such order, are commonplaces of Renaissance thought.

Davies goes on to find the perfect mirror of this order in a vision of Elizabeth and her court, she like 'the bright moon . . . in majesty', her court shining about her like 'a thousand stars'. Penelope sees this vision in a magic looking glass:

And yet she thought those stars mov'd in such measure,
To do their sovereign honour and delight,
As sooth'd her mind, with sweet enchanting pleasure,
Although the various change amaz'd her sight,
And her weak judgement did entangle quite:
Beside, their moving made them shine more clear,
As diamonds mov'd more sparkling do appear.

This was the picture of her wondrous thought . . .
And there did represent in lively show
Our glorious English court's divine image,
As it should be in this our Golden Age.[70]

Davies, I think, provides us with what might be described as the 'idea' of the Procession Picture as an image of 'our glorious English court . . . in this our Golden Age'. It is Worcester casting himself into his role as the successor of Essex escorting, not the reality of a seventy-year-old woman, but the *idea* – Eliza the sun, the moon, the pelican, the phoenix, the rainbow – fragile like a young girl in virgin white, like Spenser's vision of her as Cynthia, 'a crowne of lillies/Upon a virgin brydes adorned head'.[71] This is what gives the picture its hypnotic power across the centuries. Not every problem, not every enigma and allusion has been unravelled, nor will it ever be. The evidence we need probably vanished when Raglan Castle and its splendours surrendered to the Parliamentarians in 1646, bringing the Somerset family into momentary eclipse.

Eliza Triumphans We have travelled a long way from the antiquarians of eighteenth- and nineteenth-century England and from the marriage of a great nobleman's son. This in itself has given us an idea of the unravelling of attitudes which must occur before we can even begin to read these hypnotic 'heroical devices' correctly. If there is any allusion at all to the 'great marriage', it is a peripheral one. Our new way of looking at the Procession Picture is infinitely more enriching and extraordinary. It makes it into one of the most astounding visual documents of the age. Like every other aspect of the Elizabeth cult, the claims it makes are bold and extravagant, total and utterly uncompromising. The gap between idea and reality was truly enormous. The reality of Elizabeth as she entered the new century was a far different one. It was that of a rapidly ageing, tired and lonely old lady kept going by a will of iron and unflagging determination. She could still ride, walk and dance, but suddenly she would have to call for a stick to climb up stairs or would give way under the weight of her robes. Even the state appearances, still supremely stage-managed, began to fail to exert their magic on a younger generation. But this is not what we are asked to think about when we contemplate the Procession Picture, although it is difficult for us not to, brought up as we are to see the Elizabethan age so

54

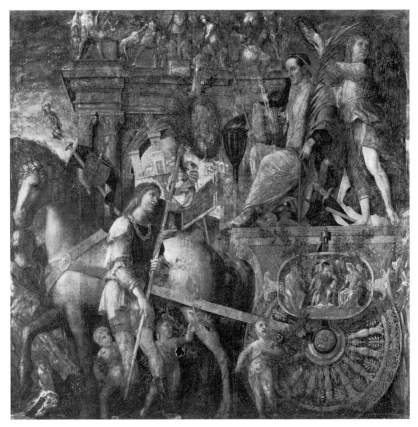

29 Mantegna's *Triumph of Caesar* shares the vocabulary of the Procession Picture but presents it enhanced by the discoveries of Renaissance antiquarianism and the rebirth of pictorial space

strongly in terms of intimate biography and political, economic or social history. Mantegna's *Triumph of Caesar* is not exactly the first thought to cross our minds when viewing the Procession Picture. And yet it should be. In order to read it aright, we need to soak ourselves in the mythology of court pageantry as it crossed into the new century, a century in which such spectacle was to prove a fatal mirror of distortion into which Elizabeth's successors looked. The cracks and flaws in the system were still to come in 1600. All could yet join in paeans to the Divine One who alone seemed capable of holding together the world they knew. The chorus that moves in stately gait escorting this goddess on her final triumph gives silent expression to Davies's hymn of dedication: 29

> *Oh! many, many years may you remain,*
> *A happy angel to this happy land:*
> *Long, long may you on earth our empress reign,*
> *Ere you in heaven a glorious angel stand.*
>
> *Stay long (sweet spirit) ere thou to heaven depart,*
> *Which mak'st each place a heaven wherein thou art.*[72]

II THE COURTIER
Nicholas Hilliard's *Young Man amongst Roses*

Nicholas Hilliard's miniature of an unknown *Young Man amongst Roses* 30
in the Victoria and Albert Museum is perhaps the single most famous
portrait of the Elizabethan age. It seems to sum it all up, not only as a *chef
d'oeuvre* of Hilliard's art, but as somehow distilling in one image all the
splendour, romance, poetry and wistful sadness of England's greatest
age. It is all there, encompassed in a miniature small enough to hold in the
palm of one's hand, and epitomized by one youth. Tall, with handsome
features, curly dark brown hair and an incipient moustache, elegant in a
black and white costume, he leans lovesick on the trunk of a tree, while a
bush of white roses twines around him. It remains the most hypnotic of
images. Who is he? Why is he lovesick? Why do we find him sighing in
the shade of the greenwood tree? So far the miniature has kept, sphinx-
like, its tantalizing secret.

But images are meant to be read. They were at the time. I believe that
this miniature still can be read. What we have to do is learn how to study
every detail of costume and accessory, attitude and motto, which might
unravel the riddle. Although so celebrated, the miniature has only been
publicly known since 1910, when it came to the Victoria and Albert
Museum as part of the Salting Bequest. Salting had been sold it by Fritz
Lugt, who had acquired it in turn from a Dutch bourgeois family.[1] No
apparent clues can be gleaned here. Nor has much headway been made in
the subsequent literature. By 1933 it was already recognized by Collins
Baker as Hilliard's masterpiece.[2] Ten years later Carl Winter, in his
Elizabethan Miniatures, was the first to comment on the subject-matter:
'He can be taken for any courtly Corydon with "a pair of stockings white
as silk upon his legs so tall" ', and went on to recognize other portraits of
the same man.[3] To these we shall shortly return. Winter, then, saw the
subject-matter as romantic and pertaining to the court. So too did
Graham Reynolds in 1947, when he wrote: 'The theme of his love-
sickness and the symbolism of the roses is redolent of Elizabethan poetry
and court life.'[4] Reynolds was the first to mention that the roses might
have a meaning. Dr Auerbach, in her important study of Hilliard's life
and work two decades later, remained baffled and uncertain. 'The
allusion is lost to us now,' she sadly concludes.[5] But is it? David Piper, in

an article in 1959, made the daring suggestion, based on his researches into the early portraiture of Elizabeth I's favourite, Robert Devereux, 2nd Earl of Essex, that he was the mysterious young man.[6] I believe he is right. But the evidence which bears this out belongs to a wider context than that of physiognomical likeness alone. Hilliard's *Young Man* is an image rich in allusions. It has to be placed in the context of the court of Elizabeth I during the years immediately before and after the Armada. It has to be read as part of a pattern of court ceremonial and emblematic allusion, of poetic tribute and political manoeuvre. Above all, it has to be seen as the supreme artistic expression of one of the greatest and most passionate romances of the age, that between a lonely ageing female ruler in her middle fifties and a dashing aristocratic youth of twenty.

Valois and Tudor But before we take the curtain up to pursue the mystery of allusion and identity, the miniature needs to be placed within the context of the art of the Elizabethan court of the fifteen-eighties. There is nothing like it in Hilliard's work before, nor can it be paralleled by anything else produced in England at the time. It stands unique, and yet not totally isolated, because it can actually be placed as an object within a very decided art-historical context. Without doubt the most dominant influence on Hilliard's art during the seventies and eighties was the work of the French court. This has long been recognized.[7] Hilliard himself was in France for something like two years, partly in the English embassy in Paris and elsewhere, and partly in the service of Elizabeth's last suitor, François, Duke of Anjou. We know that he was an intimate of the artistic circle which centred on the precocious last Valois king, Henri III. He stayed with the painter of the Queen Mother, Catherine de' Medici, and with the court sculptor and medallist Germain Pilon. He spoke fluent French and was able to converse with the great French poet Ronsard. And Hilliard's French connections continued long after his return.

While in France, Hilliard would have seen the Valois court at its most extravagant and brilliant, as it is so compellingly evoked in the great series of tapestries in the Uffizi which record court fêtes. One palace, Fontainebleau, still epitomizes the artistic achievements of the Valois; and it is amongst the frescoes and stucco decoration of that great château, then in their pristine glory, that we find the origins of that most English of images, the *Young Man amongst Roses*. It is in the work of Primaticcio, the [30] Italian whose style of lavish mannerist decoration dominates the interior, that such attenuated figures with their legs crossed elegantly at the ankles recur. Two examples will suffice to make the point: one is the figure of a man in a fresco of 1535 of *Hercules being dressed as a Woman by Omphale* [31] for the Porte Dorée;[8] another, this time female, is provided by the stucco figures supporting strapwork in the room of the Duchesse d'Etampes.[9] [32] These surely are what Hilliard was recalling when he evolved his love-lorn youth. And via Primaticcio the pose goes back to classical antiquity. [33]

The sources of the
Young Man amongst Roses

From left to right:

30 The *Young Man amongst Roses*

31 Primaticcio, figure from a drawing for a fresco at Fontainebleau, *c.*1535

32 Primaticcio, stucco figure at Fontainebleau, *c.*1541–4

33 Antique statue

34 Maître de Flore, *The Triumph of Flora, c.*1560

35 Anonymous *Allegory of Love, c.* 1560–70

59

But none of these has an erotic connotation. For such an allusion we must look at other works done at a later date – in fact, the sort of strange erotic mannerist fantasies being executed when Hilliard was actually in France. The *Young Man amongst Roses* recalls directly a number of highly stylized erotic paintings executed during the fifteen-seventies and eighties for the Valois court. At the moment these centre on the work of an anonymous master called the Maître de Flore. His *Triumph of Flora* epitomizes this world of sinuous elegance and courtly preciosity which, in its turn, in the scattering of flowers across the picture's surface, reflects directly the poetry of Ronsard and the Pléiade.[10] One finds a parallel mood in a mysterious *Allegory of Love*,[11] probably painted by a northern artist in France in the decade 1570–80 but responding to the same iconographic demands of the court as did the Maître de Flore. Such inbred, intimate fantasies must be behind the rose-encircled *Young Man*.

34

35

For the court of Elizabeth in the mid-eighties, this would have been exactly right. The *Young Man amongst Roses* was painted just five years after that high point of rapprochement with the Valois court, the match of Hilliard's former employer, Anjou, with Elizabeth I. In April 1581 Henri III sent commissioners to treat for the marriage, and the English court set out to compliment their guests with entertainments in the French manner, magnificent fêtes such as we see in the Valois tapestries. The first of these was probably devised by Essex's friend, Sir Philip Sidney, who led the Four Foster Children of Desire to assault the Fortress of Perfect Beauty, in which sat the Queen as that 'unattainable beauty'. The allegory was elaborate and obscure, but touches such as footmen climbing little ladders to scale the fortress and pelting it with roses seem already to anticipate the imagery of the miniature.[12] Roses are the flowers of Venus and of Elizabeth Tudor – but to this we shall come later. On New Year's Day there was another spectacle in the French style, a tournament in which Anjou came chained to a rock, the chains held by Love and Destiny who sang to the Queen, telling her how she had reduced this mighty prince to the level of a captive.[13] This was the Elizabethan court emulating the Valois in allegorical spectacles of romantic chivalry focusing on a Virgin Queen. And it was into this frenchified world of courtly compliment in honour of Elizabeth that the young Essex was to step so dramatically just two years later when his stepfather, Leicester, led him into the Queen's Presence Chamber. But before we come to that we must turn our attention to the features of our *Young Man* so carefully composed in devotion to his mistress. Is this or is it not the face of that seventeen-year-old youth whose personal beauty and magnetic charm attracted Elizabeth so intensely at fifty?

The sitter: in pursuit of identity

The first person to make a contribution towards identifying the *Young Man* was Carl Winter, who pointed out in 1943 that the sitter was identical with that in two other miniatures by Hilliard of about the same date.[14] The first is in the Metropolitan Museum of Art, New York, and is

60

inscribed with the date and age of the sitter: *Ano. Dni. 1588 Aetatis Svae* 36
22.[15] It depicts a youth with an incipient moustache, less dreamy in mood than the *Young Man*, more alert about the eyes, wearing a slashed doublet and a falling lace collar. The second miniature is at Belvoir Castle, wrongly entitled *Fulke Greville*, and this time shows a youth wearing 37
armour and an earring.[16] In 1959 David Piper, approaching these miniatures from his study of the iconography of the 2nd Earl of Essex during the period 1590–96, made the suggestion that these two miniatures and the *Young Man* could all be Essex.

Likeness in portraiture is one of the most treacherous of all things to argue about. Erna Auerbach, for instance, was still reluctant to accept that these are all of the same man. Over the Belvoir Castle miniature I am less certain, but its provenance points to some extent to Essex, Belvoir being the seat of Roger Manners, 5th Earl of Rutland, who foolishly involved himself in Essex's disastrous uprising of 1601. In the case of the Metropolitan Museum miniature I feel much greater certainty, and this is the key image, for Essex really was twenty-two in 1588, the year it was painted. The provenance of the miniature fits the Earl well also, for it came from Warwick Castle, seat of his friend Fulke Greville, later Lord Brook. The fact that more than one miniature exists of any given sitter argues too his high standing within the social hierarchy.

There is no lack of evidence to link Essex and the painter, Hilliard, during the late eighties.[17] Hilliard painted Essex's sister, Penelope, Lady Rich, a miniature long lost but celebrated in a poem by Henry Constable. Already, by 1590, Penelope had become the mistress of her brother's friend, Charles Blount, Lord Mountjoy, and of him there is a brilliant miniature dated 1587 and inscribed *Amor amoris premium*. Hilliard later painted, more than once, Essex's brother-in-law Northumberland, and in 1594 the Earl's great ally, the young Southampton. Even John Donne's famous tribute to the miniaturist occurs in a poem evoked by a voyage in which the poet 'waited on his lordship'. And in 1595 Essex gave Hilliard the large sum of £200 to save his house in Gutter Lane.

None of this, of course, means that we can yet substantiate the equation of our *Young Man* with Essex, but it is suggestive. Hilliard, we know, certainly painted him at a later date, so that it would be correct at this juncture to widen our horizons to examine the whole question of the portraiture of Essex.[18] The face of Essex everyone knows best is that in the famous full-length portrait by Marcus Gheeraerts at Woburn Abbey. 38
It shows him carrying a marshal's baton, standing on the seashore with a city in flames in the distance. This must surely allude to the Cadiz expedition of 1596. On this voyage he grew a beard – one which turned out to be bright ginger – finally forming a mature face which at first sight is difficult to reconcile with the *Young Man*. The legs could be the same, slim and clad in virgin white, but the beard and moustache conceal the jawline, his brown hair is cut in a different, later style, the face is that of a man and not a youth, elongated, care-worn, even a little furrowed. This is Essex at thirty.

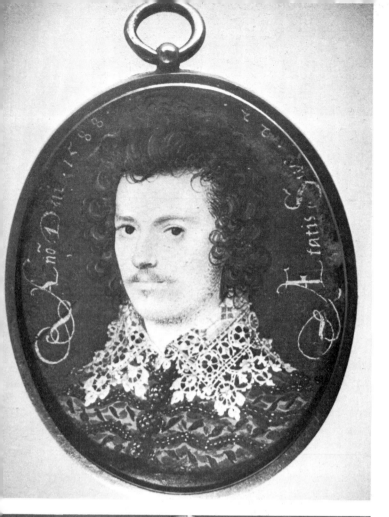

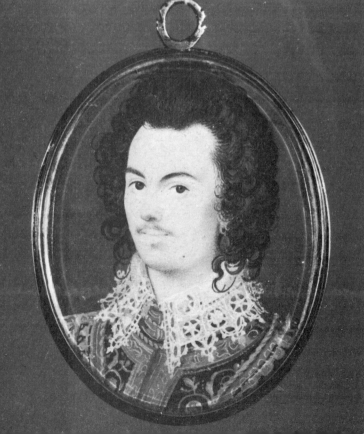

In pursuit of the identity of the *Young Man amongst Roses*

36 Young man aged twenty-two in 1588

37 Young man, *c*. 1588

38 Robert Devereux, 2nd Earl of Essex, *c*. 1596: Essex at thirty. The portrait celebrates the Cadiz expedition, on which he grew a beard

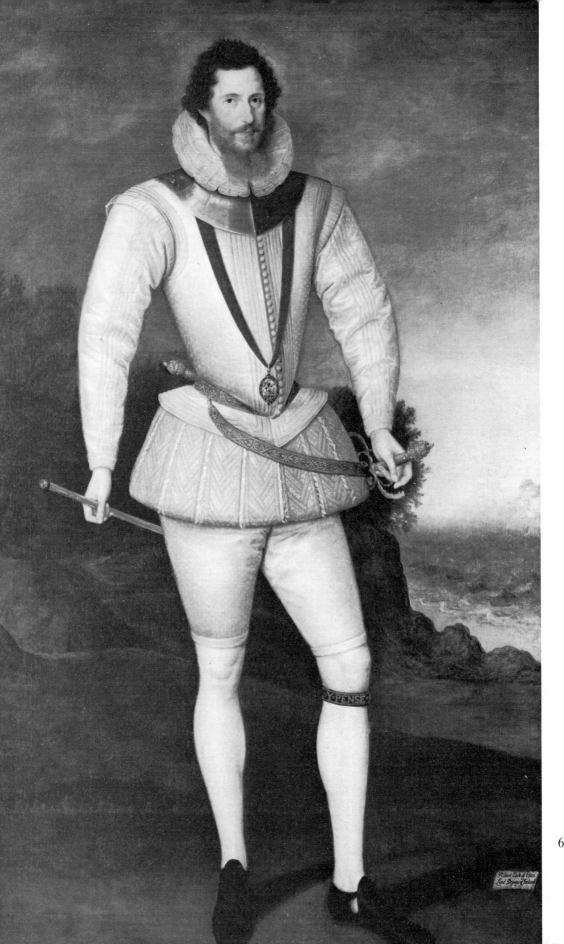

63

To make him the *Young Man* we need to know what Essex looked like between 1586 and 1596. There are only two verbal descriptions of him, and they too are late. One is by a Venetian in 1596: 'Fair-skinned, tall but wiry; on his last voyage he began to grow a beard, which he used not to wear'; a second is by a Frenchman in 1598: 'very tall and verging on ruddy'.[19] These are a decade after the *Young Man*, but the tallness and the fair skin would be right.

There are no certain portraits of Essex before 1590, although Vertue records a miniature dated 1588 which could be the one in the Metropolitan.[20] We need, therefore, to focus our attention on the earliest available likenesses of Essex between 1590 and 1595. They shed a not uninteresting light on him and the way he presented his image to the public, and in turn lead us back to the *Young Man* and his symbolic attributes.

I *Dated 1590. By Sir William Segar (National Gallery of Ireland)* 39

This is the earliest identifiable portrait of Essex, at the age of twenty-four.[21] It must have been in a collection of John, Lord Lumley, as it bears a form of *cartellino* which he had painted upon pictures in his collection. It is inscribed *Robert Devereux Earle of Essex 1590*, and is recorded in the inventory of that year as 'done by Segar', who was William Segar, later Garter King of Arms. This likeness is important, as it shows Essex two years after he became a Knight of the Garter, and yet he is not wearing the Lesser George. The absence of this, which recurs later in a similar picture, must be due to the fancy-dress connotations of the occasion depicted. His pearl-embroidered surcoat is so fantastic that it is likely that this portrait records the Earl's sensational appearance at the Accession Day Tilt of that year, to which he came in full mourning black (see p. 152 for details). It is Essex of the 'heroical devices'.

II c. *1590–92. Attributed to Sir William Segar (Museum of Fine Arts, Boston)* 40

Essex is here in civil dress as a courtier and wears the Lesser George of the Order of the Garter. The fullness of face, still evident in the 1590 portrait, is here becoming more angular, making it probably slightly later in date.[22]

III c. *1590–92. Attributed to Sir William Segar (The Earl of Jersey)* 41

This seems to be making use of a face mask identical to No. II.[23] It commemorates Essex in his capacity as a military commander, with a baton of command, and almost certainly must allude to his leadership of the English campaign in Normandy in 1591 in aid of Henri IV.

IV c. *1593–95. By Nicholas Hilliard (Private collection)* 42

George Vertue first recorded this miniature in 1750 when it was in the

collection of James West, wrongly labelled *Sir Philip Sidney*.[24] The identification of it as Essex was suggested by David Piper and clinched by the reference to an *impresa* or emblematic device borne by Essex and recorded by Camden in his *Remaines* (1605): 'The late Earl of Essex took a Diamond only amidst his shield, with this about it, "Dum formas minuis". Diamonds, as we all know, are impaired while they are fashioned and pointed.'[25] This *impresa* occurs among a list of those carried by knights who tilted in honour of the Queen on her Accession Day, 17 November. In other words, this is the romantic Essex of the tournaments again. Each knight presented the Queen on that occasion with a pasteboard shield of a type we can see in Hilliard's miniature of George Clifford, 3rd Earl of Cumberland. As in the case of No. I, fancy dress at the tilt precludes wearing the Garter George, for the Earl is in disguise. The device Camden describes we can see embroidered on either side of his bases in the midst of a formalized pattern of eglantine roses. It is now damaged, and the motto is only partly decipherable. To his right arm a glove is tied as a favour. Elizabeth bestowed her glove as an opening to tilt proceedings, and in 1595 we know it was presented to Essex. This miniature could even commemorate the spectacular Philautia tilt of 1595, his 'darling piece of love and self-love' to which we shall come later in the book. In the background his horse is being led in by a groom in a plumed hat and a black and white striped tunic. It was customary at the tilt for a knight to be escorted by squires and pages in fancy dress. The face by now is more angular, and the moustache has been grown to turn upwards on to the cheekbones.

75

V c. *1593–95. By an unknown artist (C.O.V. Keinbusch)* 43

As in the case of No. IV, this has wrongly been called *Sir Philip Sidney*.[26] The face is derived from that in the full-length miniature No. IV. This is the one portrait I have not seen, but if it is contemporary or nearly contemporary it should record his costume at another Accession Day, possibly that of 1593, again in tournament fancy dress and again with the Queen's glove tied to his tilting arm.

This detailed examination of Essex's portraits shows the development of the features of a youth into the masculinity of manhood. They reveal him as up-to-the-minute in fashion in respect of hair and clothes. Further, the portraits tend to be commemorative. They project him as the ideal courtier elegant in black, as the heroic naval and military commander holding batons of command. Above all, they commemorate the role he exulted in above every other, the chivalrous knight of romance in defence of the Queen. Even the Woburn portrait painted on his return from the Cadiz expedition continues this tradition, for he is dressed in virgin white in allusion to her. And in all of them the eyes of the Queen's 'sweet Robin' are brown.

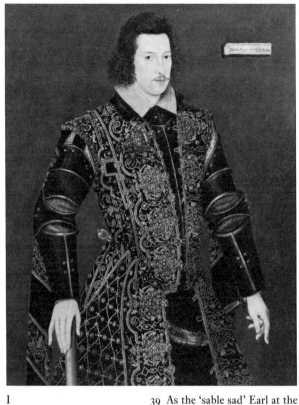

I

39 As the 'sable sad' Earl at the Accession Day Tilt of 1590

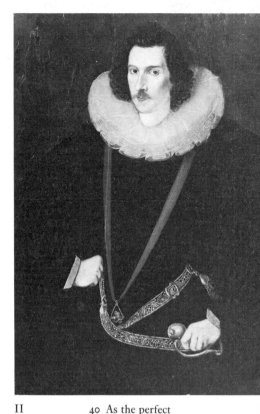

II

40 As the perfect courtier, *c.* 1590–92

41 As the military commander, *c.* 1590–92

III

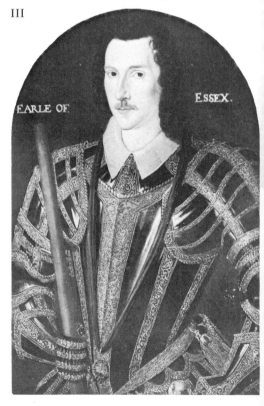

The changing face of Essex, 1590–95

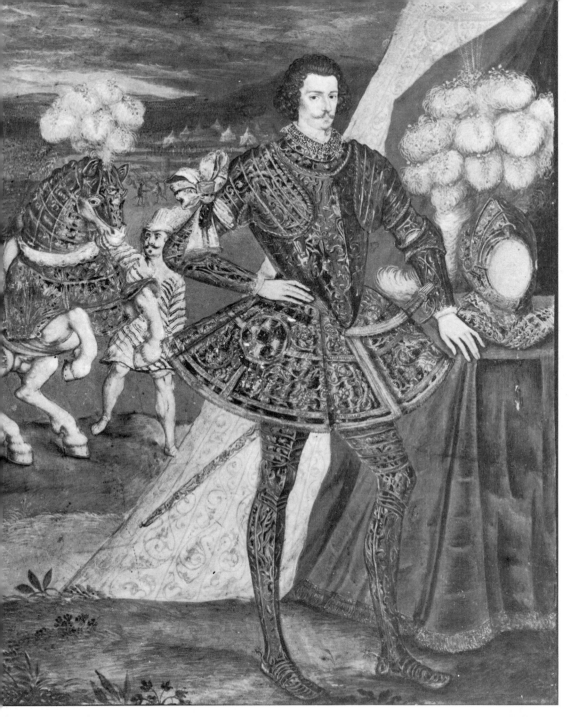

42 In fancy dress as the Queen's Knight, her glove tied to his arm, his bases over his armour embroidered with eglantine, *c.* 1593–5

43 A variant of no. IV

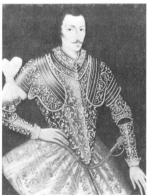

Let us now return to the face of the *Young Man*. On the basis of physiognomy I find this right for Essex. It would have to precede his election in the spring of 1588 to the Order of the Garter (which he would have worn with civil as against fancy dress), and follow his return to England from the Low Countries in 1586. Ideally it should be the expression of the first fruits of romance between Essex and the Queen, as he captured her heart during the summer months of 1587. The *Young Man* is a man in love, but in order to understand why I must ask the reader to tread another path.

Eglantine
I most honour

Let us begin by looking into this miniature, for every detail is crucial and may provide us with vital clues to push the identity either towards or away from Essex. Whoever the youth is, he is standing in the midst of a bush of white roses. They spring up around the trunk of the tree, they touch his milk-white stockings, and a branch even springs up in front of him, crossing the cloak and bending towards his head, following the 44 shape of the miniature. The white flowers and the thorns of this rose are meant to be read, but as what? Roses are, of course, the flowers of Venus, goddess of love, and Graham Reynolds, as we have seen, as early as 1947 wrote: 'The theme of his love-sickness and the symbolism of the roses is redolent of Elizabethan poetry and the atmosphere of court life.'

But it is not quite as simple as that. These are not ordinary roses; they are single white five-petalled roses, commonly referred to as eglantine. Elizabethan literature is positively littered with references to eglantine. Spenser in *The Faerie Queene* describes the Bower of Bliss thus:

> . . . *art, striving to compayre*
> *With nature, did an Arber greene dispred,*
> *Framed of wanton Yvie, flowering fayre,*
> *Through which the fragrant Eglantine did spred*
> *His prickling arms, entrayled with roses red . . .*[27]

Richard Barnfield delineates another such bower in *The Affectionate Shepherd* (1594):

> *And in the sweltering heat of summer-time*
> *I would make cabinets for thee, (my love:)*
> *Sweet-smelling arbours of Eglantine*
> *Should be thy shrine . . .*[28]

Roses are the flower of Venus, but roses too are *par excellence* the flower of the Queen. She is both the white rose of York and the red of Lancaster; she is the double Tudor rose epitomizing in her person the Tudor *pax* brought about by the union of the two houses. But the white rose in particular, as used by Elizabeth, takes on an extra nuance. White is the colour of virginity. The reign of Elizabeth is foretold as the age of the white rose, to whom other garden flowers make obeisance.[29] So Green

makes Roger Bacon in *Friar Bacon and Friar Bungay* (*c.* 1589) foretell the
advent of the virgin rose descended from the royal House of Troy:

> *From forth the royal garden of a King*
> *Shall flourish out so rich and fair a bud,*
> *Whose brightness shall deface bright Phoebus' flower,*
> *And overshadow Albion with her leaves.*
> *Till then, Mars shall be Master of the field;*
> *But then the stormy threats of war shall cease;*
> *The horse shall stamp as careless of the pike,*
> *Drums shall be turn'd to timbrils of delight;*
> *With wealthy favours plenty shall enrich*
> *The strond that gladded wandring Brute to see,*
> *And peace from heaven shall harbour in these leaves,*
> *That gorgeous beautifies this matchless flower.*
> *Apollo's Heliotrope then shall stoop,*
> *And Venus' Hyacinth shall vail her top,*
> *Juno shall shut her gillyflowers up,*
> *And Pallas' bay shall bask her brightest green,*
> *Ceres' Carnation, in consort with those,*
> *Shall stoop and wonder at Diana's rose.*[30]

There is no shortage of references to Elizabeth as the rose, as the white
rose, but are there any to her specifically as the eglantine? As a virgin
rose, used in medieval religious art to celebrate the Virgin Mary, the cult
of Elizabeth as the eglantine would be a logical extension of her rose
imagery. The most outright glorification of her as the eglantine is in a
pastoral by one of her Gentlemen Pensioners, Sir Arthur Gorges, written
in the fifteen-nineties.[31] He had begun a poem initially in honour of his
wife, but later, under Spenser's influence, re-cast it as a tribute to
Elizabeth under the title of *Eglantine of Meryfleur*. In this fragment the
nymphs of Diana gather to listen to the songs of a swain wearing on his
head a chaplet of red and white roses with eglantine on the top of it:

> *But when of Eglantine he spake,*
> *His strings melodiously he strake.*
> *The Albion flower so fair, so pure,*
> *Whose excellence doth well declare*
> *What worthy branch this blossom bare*
> *She woons in pleasant Meryfleur.*
>
> *Great Flora, Summer's Sovereign Queen,*
> *To make her glory to us seen*
> *From Paradise did fetch this flower.*
> *It first was planted in that place,*
> *And after graft in human race,*
> *But still inspired with heavenly power.*

Then her high lineage he rings,
Derived from the Dardan Kings,
Descending to the conquering line,
Where stately strife he doth recite,
Between the red rose and the white
Appeased in this brave Eglantine.[32]

For Gorges, Elizabeth as the eglantine is the queen of flowers, a descendant of the Trojan kings, the flower that unites the roses of York and Lancaster.

Gorges' apotheosis of Elizabeth is the most specific, but it provides a fruitful Ariadne's thread for others. By the fifteen-nineties eglantine was widely used in reference to the Queen. Bess of Hardwick, using the Cavendish stags, expressed the loyalty of that family in an inscription on a table at Hardwick: 'The redolent smell of Eglantine/We stags exalt to the Divine.' George Peele, celebrating Elizabeth's birthday in 1595, exhorts:

. . . Wear eglantine,
And wreaths of roses red and white put on
In honour of that day . . .[33]

William Rogers's engraving of the Queen as *Rosa Electa*, in which a portrait of Elizabeth is suspended with double Tudor roses banked to the left and single eglantine roses to the right, is close in date.[34] Earlier, in 1588, this motif had been used in a frontispiece to Henry Lyte's *Light of Britaine*,[35] and it appears again in a glass painting of the royal flowers at Loseley House. A basket, inscribed with the royal mottoes *Foelicior Phoenice* and *Rosa Electa*, is full of lilies, roses and eglantine.

The cult of the Queen as the eglantine probably goes back still further. The Phoenix Jewel in the British Museum is a badge of gold bearing a profile image of the Queen and is based on a medal struck in the mid-seventies.[36] Once again double Tudor roses and eglantine encircle the royal image. In 1584 George de la Mothe, a Huguenot refugee, dedicated a *Hymne* to the Queen profusely illustrated with complimentary emblems. The opening dedicatory portrait of the Queen shows her enthroned, the margins full of royal symbols – the phoenix, the Beaufort portcullis, the lion and griffin, the Irish harp and, to the left, the white eglantine.[37]

So enmeshed did the flower become with Elizabeth's mythology that it was used in court pageantry. At the Accession Day Tournament of 1590 – at which Essex tilted – that flower of chivalry, Sir Henry Lee, resigned his office as Queen's Champion to George Clifford, Earl of Cumberland. This ceremony took place in front of the Temple of the Vestal Virgins, before which stood a pillar embraced by an eglantine tree.[38] How like the eglantine encircling the pillar-like tree in Hilliard's miniature! Six months later the royal eglantine was again brought into play when the Queen visited her Lord Treasurer, Lord Burghley, at his house Theobalds in Hertfordshire. Burghley cast himself in his entertainment

48

46

45

47

49

as a hermit reluctant to return to public life (his wife had died in 1589), but one of the speeches is by a gardener who talks to the Queen of a garden he is creating for Burghley's youngest son, Robert Cecil, at Pymms, a Cecil property at Edmonton. In one quarter he has planted:

... all the Virtues, all the Graces, all the Muses winding and wreathing about your Majesty . . . one Virtue we've done in roses . . . the Graces of pansies parti-coloured . . . the Muses of nine several flowers. . . . Then I was commanded to place an arbour of eglantine, in which my master's conceit outstripped my cunning.

'Eglantine', quoth he, 'I most honour, and it hath been told me that the deeper it is rooted in the ground, the sweeter it smelleth in the flower, making it ever so green that the sun of Spain at the hottest cannot parch it'.[39]

One final instance, curiously enough, takes us back to the Procession Picture and the heroine of the great marriage of 1600, the Lady Anne Russell. Nine years before this the Queen had visited their formidable mother, the Dowager Lady Russell, at her house at Bisham, and the two girls had welcomed the Queen, seated at the top of the hill leading down to the house, dressed as shepherdesses tending their flock and fending off the advances of a wanton Pan. Bess and Anne were busy embroidering samplers; on one there were depicted the follies of the gods in love and men's tongues, 'not one true', on the other virgin goddesses encircled by the Queen's flowers, roses, pansies – and eglantine.[40] Everyone in the court circle and beyond it knew of the Queen's use of eglantine as especially her flower. She *was* the eglantine.

Let us now return to the *Young Man amongst Roses* – or, to be accurate, eglantine. This elegant man with his nascent moustache is clutching his heart amidst the Queen's flower. He is surely telling us of his love for her; but it is a secret, lyrical and courtly demonstration quite different from Cumberland's overt tribute as Champion, her glove pinned to his hat, his gauntlet thrown down in challenge against all comers. One final nuance clinches that this indeed is the supreme visual expression of the chivalrous cult of the Queen as the sonnet heroine.

Leslie Hotson noted that, with the exception of the golden-brown shadow hatching on the white peascod doublet, the *Young Man* wears only two colours, the personal ones of Elizabeth I, black and white: black cloak, white ruff, cuffs, legs and shoes, black and white doublet and trunk hose.[41] Black and white was worn, for instance, by Elizabeth's Champions in the tiltyard and by dancers in court masques. At Sandwich in 1573 the whole town had been hung with black and white in her honour, and she was met by two hundred men attired in white doublets, black trunk hose and white garters[42] – in other words, dressed like our *Young Man* in tribute to the Queen. White is the colour of virginity, black of constancy. Both were attributes of the Queen.[43] Hilliard's young man is not the only courtier to wear black and white in direct tribute to her.

44 Eglantine surrounding
the *Young Man*

The Royal Eglantine

45 The Queen's flowers:
roses, lilies and eglantine

50 The rival of the *Young Man amongst Roses*, 1588: Sir Walter Raleigh in the Queen's colours of black and white embroidered with virgin pearls, with the crescent moon of Cynthia in the top left-hand corner

Sir Walter Raleigh was painted in 1588 in a portrait deliberately complimentary to the Queen. In the top left-hand corner hover a crescent moon, attribute of his heroine Elizabeth as the moon-goddess Cynthia, lady of the seas, and the motto *Amor et Virtute*.[44] He too wears nothing but black and white: white doublet, collar and cuffs; black cloak, sword-strap and trunk hose; and everywhere another symbol of the Queen, virgin pearls. Raleigh's portrait was painted at the same time as Hilliard's miniature. Both subjects are rival courtiers declaring their love for the Queen. Later, Essex definitely uses the Queen's colours: in Hilliard's miniature of him attired for the tilt his groom is dressed to accompany this royal knight in the sovereign's colours of white and black.

But closest of all in mood comes an unexpected evocation of Elizabeth by Essex's hero, Sidney, 'fairest shepherd of our green'. In the revised

version of his *Arcadia* Sidney overlays his earlier romance with trappings directly reminiscent of the court spectacles in which, as a young courtier, he had acted. They come in our first glimpse of Elizabeth cast as Queen Helen of Corinth, a strong-minded ruler of a people 'mutinously proud' but to whom she had brought peace when 'many countries were full of wars'. She of course was a virgin queen – but she was not devoid of passion. In the first book Palladius and Clitophon encounter her coach which they sight and recognize from afar, splendid with outriders and magnificent trappings, but identifiable because the whole cortège wears her colours of black and white. Overcome by her escort, they are led towards her and find the Queen inside the coach wrapped in grief, contemplating the portrait of 'a goodly gentleman', Amphialus, whom passion has moved this virgin queen to pursue. And, we are told, 'love tied her senses to that beloved picture'.[45] In this astounding tableau of Elizabeth of England held enslaved by the portrait of the man she loves, we are moving close to the enigmatic world of the *Young Man amongst Roses*.

But what of the tree against which the Young Man leans? It is of indeterminate species, but it has a firm, straight trunk. We have already found eglantine entwining a pillar at the 1590 Accession Day Tilt, and the pillar was used by Sir Henry Lee as an emblem of Elizabeth's constancy. Like the pillar, the tree trunk is a frequent device in books of *imprese* to represent constancy.[46] Henry Peacham in his *Minerva Britanna* (1612), the book which celebrates in retrospect the *imprese* of Gloriana and her knights, in describing an emblem of a weight-laden cypress tree alludes to its trunk: 51

> *And since the body doth resemble best,*
> *A column strong and stately from the root;*
> *The ancients would it should the Imprese be,*
> *Of Resolution and true Constancy.*[47]

51 The tree trunk as an emblem of constancy

52 Lovesickness in Arcady, *c.* 1590. *The Shepheard Buss* seeks the solace of the greenwood tree away from the darts of 'false Cupid', who 'hath wounded hand and heart'

Constant and resolute in his love is the gallant of Hilliard's masterpiece. The cross-legged languishing lovesick pose with a hint of fashionable melancholia is a formula caught in another cryptic Elizabethan image of unrequited love, an embroidered coverlet in the Victoria and Albert Museum. It depicts *The Shepheard Buss* surrounded by emblems on the dangers and perils of love. The wide outside border contains a long inscription punctuated by rebus devices:

52

> *False Cupid with misfortunes wheel hath wounded hand and heart*
> *Where siren like did lure me with lute and charmed harp.*
> *The cup of care and sorrow's cross do clips my star and sun*
> *My rose is blasted and my bones, lo, death inters in urn.*[48]

It was embroidered after 1591 (the emblems are from the 1591 translation of Paradin's *Devises*), but its spirit is directly that of Elizabethan Arcady as expounded by every poet from Edmund Spenser's *Shepheard's Calendar* onwards. The shepherd is typical of innumerable lovesick swains seeking the solitude of the greenwood tree. He has a shepherd's

76

spud, scrip and flask and musical instruments. Diminutive rabbits and sheep nibble the grass, and his dog is looped to him by a lead. Hilliard's *Young Man* shares this mood and its allusions to lovesickness in Arcady.

Like a Renaissance medal, an Elizabeth portrait miniature, with its likeness, emblematic attributes and motto, is meant to be read as a single statement expressing the ideals and aspirations of one particular person at a moment in time. William Camden, herald and antiquarian, defines its aim as follows:

> An *Impress* (as the Italians call it) is a device in Picture with his Motto or Word, borne by Noble and Learned Personages, to notify some particular conceit of their own, as Emblems . . . do propound some general instruction to all. . . . There is required in an *Impress* . . . a correspondency of the picture, which is as the body; and the Motto, which as the soul giveth it life. That is the body must be of fair representation, and the word in some different language, witty, short and answerable thereunto; neither too obscure, nor too plain, and most commended when it is an Hemistich, or parcel of a verse.[49]

We have studied the picture – 'the body' – but what of the word – 'the soul'? Inscribed around the top of the miniature there is a Latin tag: *Dat poenas laudata fides.* The sitter, as was first pointed out by Miss Carolyn Merion,[50] has chosen for his motto a half-verse from a famous speech out of Lucan's *De Bello Civili* in which the eunuch Pothinus counsels Pompey's death:

> *Dat poenas laudata fides, dum sustinet inquit,*
> *Quos fortuna premit*[51]

Ben Jonson translates this as:

> *. . . a praised faith*
> *Is her own scourge, when it sustains their states*
> *Whom fortune hath depressed.*[52]

Or, according to Sir Arthur Gorges in 1614:

> *Observed faith so much commended*
> *Hath with repentance often ended,*
> *When men strive to elevate*
> *That Fortune means to ruinate.*[53]

Whatever the exact translation, the drift of the motto is clear: faithful love and loyalty bring their own pain and suffering. Our passionate and loyal lover is doubtful of the fruits of such devotion. The wilfulness of the goddess Fortuna could ruin the faithful devotion of this knight, however much commended by his sovereign.

There is in this motto, by inference, as Leslie Hotson observed, an identification of the sitter with Pompey the Great, whom the Elizabethans would have known most about from Sir Thomas North's translation of Plutarch's *Lives*. Pompey was a great military commander,

a general at twenty-three, awarded two Roman triumphs by the age of twenty-five, besides being a popular hero of the citizens of Rome. The image of Pompey the Great, one of the Nine Worthies, is caught at the opening of Plutarch's account:

> The Romans seem to have loved Pompey from his childhood . . . never any other Roman (but Pompey) had the people's earnest good wills so soon, nor that in prosperity and adversity contrived longer constant, than unto Pompey. . . . Pompey . . . was for many occasions beloved: as, for temperance of life, aptness to arms, eloquence of tongue, faithfulness of word, and courtesy in conversation. . . . For he gave without distain, and took with great honour. Furthermore, being but a child, he had a certain grace in his look that won men's good-wills before he spake: for his countenance was sweet, mixed with gravity, and being come to man's state, there appeared in his gesture and behaviour, a grave and princely majesty.[54]

Hilliard's young man is casting himself into this heroic role. In order to grasp how well this fits the passionate, chivalrous Essex, who was just twenty in 1586 when he proved his prowess on the field of Zutphen and took up the sword of Philisides, the Shepherd Knight, we need to take another approach, to examine the events of his life between the crucial years 1586 and 1590 and, most important of all, the image which he was deliberately projecting as we find it reflected in literature and court pageantry.

The Shepherd of Albion's Arcadia

Robert Devereux, 2nd Earl of Essex, was the son of Walter Devereux, 1st Earl of Essex, and Lettice Knowles, daughter of Sir Francis Knowles and his wife Mary, niece of Anne Boleyn.[55] Walter Devereux, who was a favourite of Elizabeth's, was created Earl of Essex in 1572 and died four years later while involved in the hopeless task of reducing and colonizing Ireland. He left four children: Penelope, aged thirteen; Dorothy, eleven; Robert, nine; and Walter, seven. Lettice became the subject of another's devotions, for she attracted the advances of Elizabeth's favourite, Robert Dudley, Earl of Leicester, whom she secretly married on 21 September 1578. Four months later the news was deliberately leaked to the Queen. Lettice Knollys was never forgiven.

Essex was a ward of Lord Burghley's, and made his first appearance at court in 1577, when he was ten. He was uneducated and unsophisticated, but he had stunning good looks and already an abundance of pride. The Queen, then forty-four, expressed a wish to kiss this angelic child, but he retreated and refused. It was a scene which foreshadowed much of what was to come. Essex was subsequently sent to Trinity College, Cambridge, for five years and took his MA in 1581. After this he retired to his estates in Pembrokeshire for three years until, in 1584, yielding to the entreaties of his disgraced mother, he was induced to come to court. Essex was led into the Presence Chamber by his stepfather Leicester, and

78

presented to Elizabeth. As on the former occasion, she was immediately attracted. To his good looks he had now added charm and urbanity of manner. Subsequent events were to push this seventeen-year-old youth even more into the centre of the stage.

Shortly after this Essex left for the Low Countries as General of the Horse under Leicester in the campaign which culminated in the battle of Zutphen. During that campaign Essex became the closest friend of Sir Philip Sidney; so close did they become that Sidney, on his deathbed, asked Essex to marry his pregnant wife, Frances Walsingham, and protect his young daughter. To seal this verbal covenant he left Essex his 'best sword', thus deliberately casting him into the role of the new Sidney.

We are now entering the period from the Earl's return to England in the autumn of 1586 until 1590, during which the miniature was painted. Essex in fact did marry Frances Walsingham six months after her husband's death, but the marriage was kept secret; Essex continued to live in great splendour at Essex House, while Frances remained out of the public eye in her father's house. Nothing upset this arrangement until Lady Essex's father died on 6 April 1590. Lady Essex was found to be pregnant and admitted to the marriage. Essex acknowledged both it and the child. The Queen disapproved of the match, but her *froideur* was appeased by Essex, who continued to pay abject tribute to her as though nothing had happened. Elizabeth, however, never forgave Frances Walsingham, who was banished from court and forbidden ever to set eyes on the Queen.

Hilliard's *Young Man* belongs to the years of the secret, to the period 1587–8 when Essex's star rose to its apogee at court. It was during the summer of 1587 that Essex conquered Elizabeth's heart. He cast a romantic aura of enchantment around her at the moment when she was at her lowest ebb, recovering from the agonies evoked by ordering the execution of Mary Queen of Scots. 'When she is abroad, nobody near her but my lord Essex . . . he cometh not to his own lodging until birds sing in the morning,' wrote Antony Bagot, who was in the Earl's household, to his father.[56] As the heir apparent to the political power of his stepfather, Leicester, and as the reincarnation of that flower of chivalry, Sidney, Essex swept all before him. Above all he countered the rise of Sir Walter Raleigh, not without scenes of pride and petulance such as no other courtier would have dared before the Queen. In July 1587 he quarrelled with Elizabeth, accusing her of acting 'only to please that knave Raleigh', and rode off from court only to be intercepted and brought back. Essex was forgiven, and at the end of the year he was rewarded with the office of the Master of the Horse. In 1588 he helped defend England against the Armada, and the following year took part in the abortive expedition to Portugal in support of the exile Don Antonio.

These are the years of Hilliard's *Young Man*, the vital three years which began with Essex's first entry into the hot sunshine of royal favour in the summer months of 1587, closing with the revelation in the spring of

1590 of his secret marriage to Frances Walsingham. No visual image, surely, could better represent Essex's 'idea' of his relationship with the Queen. And it is this idea of Essex we must finally follow.[57] During those same years Essex emerged as a popular hero, deliberately casting himself in public as a military commander, zealous in the cause of the Gospel, and in his courtly aspect living out the role of a knight of romance, the successor of Philisides the Shepherd Knight.

For the official public image of Essex, George Peele's *An Eglogue Gratulatorie*, written as a welcome to Essex on his return to England from the Portugal expedition in 1589, is an excellent guide. Essex is at once cast into Sidney's role as the Shepherd Knight:

> *Fellow in arms he was in their flow'ring days*
> *With that great shepherd, good Philisides;*
> *And in sad sable did I see him dight,*
> *Moaning the miss of Pallas' peerless knight;*
>
> > *Iō, iō paean!*
>
> *But, ah for grief! That jolly groom is dead,*
> *For whom the Muses silver tears have shed;*
> *Yet in this lovely swain, source of our glee,*
> *Mun all his virtues sweet reviven be;*
>
> > *Iō, iō paean!*[58]

This rudimentary statement is reiterated by Peele in his evocation of Essex as the epitome of vigorous Protestant knighthood, 'fair branch of honour, flower of chivalry', as Spenser was later succinctly to categorize the Earl in his *Prothalamion* for Lord Worcester's daughters. The tributes to Essex during these years when he was emerging as a major public figure, shortly to embark, with the aid of Francis and Anthony Bacon, on his pursuit of 'domestical greatness', are all couched in this way. He is praised for his 'love of chivalry', his zeal for the Gospel, his boldness in the cause of his faith and the Queen.[59]

> That the noble Earl of Essex is behind none, but afore the rest, ever ready and more forward than the forwardest in God's battles and his Prince's quarrels with horse and spear to overthrow, to overrun God's foes and her enemies, even in their own gates. . . .[60]

So runs one tribute, recalling his romantic gesture before Lisbon when he thrust his pike into the town gate 'demanding aloud if any Spaniard mewed therein durst venture forth in favour of his mistress to break a lance'. Essex succeeded Sidney in popular mythology as the ideal courtier. No one had been quite so extravagant in gesture before. The bravado must, at the time, have been disarming and exhilarating. It totally bewitched the ageing Queen. 'There was in this young Lord', wrote Naunton, in his *Fragmenta Regalia*, 'a kind of urbanity or innate courtesy which both won the Queen, and too, much took upon the people to gaze upon the new adopted son of her favour.'[61]

But there is one more layer beyond these public faces of Essex, the most private and impenetrable of all. In order to succeed in his relationship with Elizabeth, Essex had to embark on a complex intimate romance with her on the lines laid down by his predecessor as royal favourite, Raleigh. He had to frame his devotion with the attitude of the sonnet-writing gallant. It is to this secret enclosed world that the miniature belongs.

Essex as the lovesick *Young Man amongst Roses* pertains to the most private aspect of his role as the ideal courtier, his romance with the Queen. This was expressed not only in the public spectacle of the tilts and the heroic challenges in his military expeditions, but in the private world of the sonnet-writer. How much help Essex had with his literary composition we shall probably never know, but he was celebrated in his youth as a scholar and an author.[62] Ben Jonson praised his poetry. Anthony à Wood referred to him as 'one of the best poets among the nobility of England', and Gabriel Harvey listed his work amongst other 'preserved dainties' which deserved praise. Today we would hardly rank Essex high as a poet, but such praises were evoked at the time by circumstances at court which led him to put pen to paper and, afterwards, to cause the result to be set to music and sung to the Queen. Sir Henry Wotton records an incident of this sort when Essex feared that the Queen's favour was about to fall on the young Southampton:

> . . . my lord of Essex to evaporate his thoughts in a Sonnet (being his common way) to be sung before the Queen, (as it was) by one Hales, in whose voice she took some pleasure, whereof the couplet, methinks had as much of the Hermit as of the Poet,
>
> > *And if thou should'st by her now be forsaken*
> > *She made thy Heart too strong for to be shaken.*[63]

Wotton's anecdote is important for showing that this was Essex's 'common way' of addressing the Queen. No other contemporary source reveals this important fact.

Two other pieces by Essex throw, I believe, new light on Hilliard's miniature. The first is a poem by him or, if not by him, written as though by him, 'in his first discontent in the months of July and August'. It is a bitter satire on the court and rival courtiers who jostle for the Queen's favour. Essex casts himself as a bee rejected from the swarm:

> *Whilst all the swarm in sunshine taste the rose;*
> *On black fern's root I seek and suck my bane:*
> *Whilst on eglantine the rest repose*
> *To light on wormwood leaves they me constrain;*
> > *Having too much they still repine for more*
> > *And cloyed with sweetness forfeit on their store.*[64]

There is no clearer statement than this. Essex is the bee, the Queen is the eglantine. And the mood is one which permeated all Essex's poetry, pastoral with a tinge of melancholy bursting into frustration. What could

be more explicit? It *is* the young man amidst the eglantine who writes. But there is one more poem, a sonnet, which is even more convincing. It was published in 1610 in Robert Dowland's *A Musicall Banquet*. The music was written by Daniel Batchelar, Philip Sidney's page and later a Groom of the Privy Chamber. There is no way of dating it, but it is addressed to 'her that can love none' – surely the Queen. The attitude of lovesick anguish and the motto 'My praised faith procures my pain' should be borne in mind as the sonnet unfolds its emotional attitudes of love and rejection. Above all, it opens with a line which is the slightest variant on the Latin motto of the miniature, *Dat poenas laudata fides*:

> *To plead my faith, where faith hath no reward;*
> *To move remorse, where favour is not born;*
> *To heap complaints, where she doth not regard,*
> *Were fruitless, bootless, vain and yield but scorn.*
> *I loved her whom all the world admired.*
> *I was refused of her that can love none;*
> *And my vain hope, which far too high aspired,*
> *Is dead and buried and forever gone.*
> *Forget my name, since you have scorned my love,*
> *And womanlike do not too late lament;*
> *Since for your sake I do all mischief prove,*
> *I none accuse nor nothing do repent.*
> *I was as fond as ever she was fair*
> *Yet loved I not more than I now despair.*[65]

This sonnet sums it all up. One could almost imagine it accompanying the miniature presented to Elizabeth, speaking of the faith and love which was alternately given and withheld. The relationship of Essex and Elizabeth was always couched in these extremes of acceptance and rejection, of faith and unfaithfulness, of the anguish caused by her disloyalty in bestowing her affections on any other courtier except him.

> *Love no more since she is gone!*
> *She is gone and loves another.*
> *Having been deceived by one,*
> *Leave to love, and love no other.*
> *She was false, bid her adieu;*
> *She was best, but yet untrue.*[66]

So Essex writes in yet another poetic dramatization of his romance with Elizabeth. The *Young Man amongst Roses* is a visual statement of exactly such an emotional state, of loyalty and suffering, of constancy and inconstancy, in that inmost of inner worlds of the Elizabethan court, a platonic affair with the Queen.

So much of what we know about Essex belongs to the last years of his life – the Earl as he was when he began to tread the slippery path downwards after his return from the Islands Voyage in 1597 – that it is difficult to place the young Essex in focus. From this period he emerges

as lazy, inefficient, stubborn and bellicose, a hopeless judge of character, with an arrogance which was to be his final undoing. Yet the charm remained, the magic with which he held the Queen captive and made her relent even up to the last minute. All this lay in the future when the miniature was painted, and yet a decade later we seem perhaps to catch one final echo which, one might imagine, recalls the vanished idyll of the *Young Man amongst Roses*. In the summer of 1598 the first of a series of terrible incidents took place in the Queen's presence. Essex, Cecil, the Lord Admiral and Thomas Windebank were discussing Irish affairs when Elizabeth overruled Essex on an appointment. He turned his back on her. She, with typical Tudor rage at such effrontery, boxed his ears. Essex, in reply, dramatically seized his sword hilt, but the Admiral threw himself between them. Utterly out of control, swearing that not even from Henry VIII would he have suffered such an indignity, Essex, trembling with passion, left the room. This was high treason. Essex languished insolent and unrepentant away from court. It was the beginning of the end. In a letter to the Lord Keeper, Sir Thomas Egerton, in the August of that year he proudly wrote: 'Princes may err and subjects receive wrong . . . but *I will show constancy in suffering.*'[67] Is this a distant echo of how he had first conceived his romance with the Queen, epitomized in the motto 'My praised faith causes my suffering'? Hilliard's *Young Man amongst Roses* keeps its tantalizing secret.

III THE AMBASSADOR
Sir Henry Unton and his Portrait

One of the best-known pictures in the National Portrait Gallery is the portrait of Sir Henry Unton.[1] He sits at his desk, pen in hand, looking out at us. The face is rotund, the eyes alert and intelligent. He seems the perfect civil servant poised to jot down instructions. There is no doubt about the ultimate source of such orders, for carefully laid on the table before him is a jewel bearing the unmistakable profile of Elizabeth Tudor. He sits as though suspended amidst memory images: flashes from the past cascade across the picture. We see him as a baby nursed by his mother; as a soldier accompanied by the panoply of war with tents, horse, armour, and attendant squires; on horseback, sunshade in hand, riding through Italy, or escorted by trumpeters and servants into France. There are scenes of banqueting, masquing and revelry; but the mirth of festival gives way to counsel with learned divines and the solitude of study. There are sombre tableaux: a death-bed surrounded by weeping and praying servants, a hearse draped in black being drawn through the bleak English countryside, a gaunt procession of black-clad mourners. These are making their way towards a steepled church where a large congregation listens to a sermon, and before which there stands a splendid tomb, tricked out in scarlet, black and gold, with the recumbent effigy of a knight presided over by a lady attired in widow's weeds. All these relate in some way to the subject of the picture, Sir Henry Unton; in correct sequence they form a selective visual biography, and in this way the picture has value not only as a record of the sitter's features but as a unique historical document.

The Unton picture is a memorial portrait, a genre which enjoyed a considerable vogue in Elizabethan and Jacobean England. As a phenomenon, the memorial portrait occupies a curious hinterland between the living portrait and the funeral or tomb effigy. Most fall into the category of the *memento mori*; others, more rare, are deliberately designed propaganda documents.[2] Elements of both these traditions mingle in the Unton picture: it is a *memento mori* – Death grimly cavorts and dances while he claims his victim; and it has a didactic purpose – inset scenes recall the glories attained by the house of Unton under Sir Henry. The picture is, in addition, a Triumph of Fame, who blows her

53

trumpet and proffers her crown towards Sir Henry's right ear. His figure is conceived like some which occur on tombs – seated upright, in the act of writing, just as in the familiar monuments of John Stow or Shakespeare. And the meticulous rendering of the funeral procession and of the numerous and complex coats of arms suggests that the picture may well be the work of a herald, whose task it would have been to supervise the correct rendering of his achievements, both during the funeral ceremonies and upon his monument.

In the main, the picture is to be read from right to left, although it also on occasion works up and down, and its structure, with a dominating central figure surrounded by incidents and scenes from his life, belongs, as in the case of the Procession Picture, to a pre-Renaissance arrangement of pictorial space. There are no concessions to, or awareness of, the Renaissance discovery of scientific perspective. The division of the surface is elementary: to the right the sun sheds gilded beams across the day-time of Unton's life while, on the left, a crescent moon presides in the night-sky over his funeral and his tomb. A dividing line occurs immediately beneath the table upon which Unton is writing, where his coffin is solemnly borne away from the ephemeral light of life into the darkness of death. The portrait is also grouped to reflect the twin aspects of Unton's history – his public as opposed to his private life, his role as traveller, soldier and ambassador as contrasted with his part as a scholar, man of piety, musician and genial host.

'This worthy and famous gentleman': the career of Sir Henry Unton[3]

The biography begins at the bottom right-hand side of the picture at Wychwood in Oxfordshire, where Henry was born, about the year 1557. In a room with lattice windows in the manor house, his mother sits in an armchair nursing her child, attended by a nurse and two gentlewomen. On the ground, close to her feet, stands a cradle. In a picture whose sense of scale is almost wholly dominated by social precedence, Sir Henry Unton's mother assumes gargantuan proportions which are modified only by her seated position. If she were standing, the two ladies and the nurse would be dwarfed by her. Of her noble rank we are left in no doubt, for the coat of arms above her head bears the coronet of a countess and the inscription which flanks it read, when it was legible, as follows:

> This worthy and famous gentleman, Sir Henry Unton, was son unto Sir Edward Unton, Knight . . . and also his mother, the most virtuous Lady Anne Seymour, countess of Warwick, eldest daughter to the Lord Edward Seymour, duke of Somerset, uncle to King Edward [VI] and so protector of his person, and the realm. Her uncles were Thomas and Henry Seymour, which Thomas was Lord Admiral of England and married unto Catherine Parr, last wife of King Henry VIII. Her mother was duchess of Somerset; her aunt was the Lady Jane Seymour, queen of England.[4]

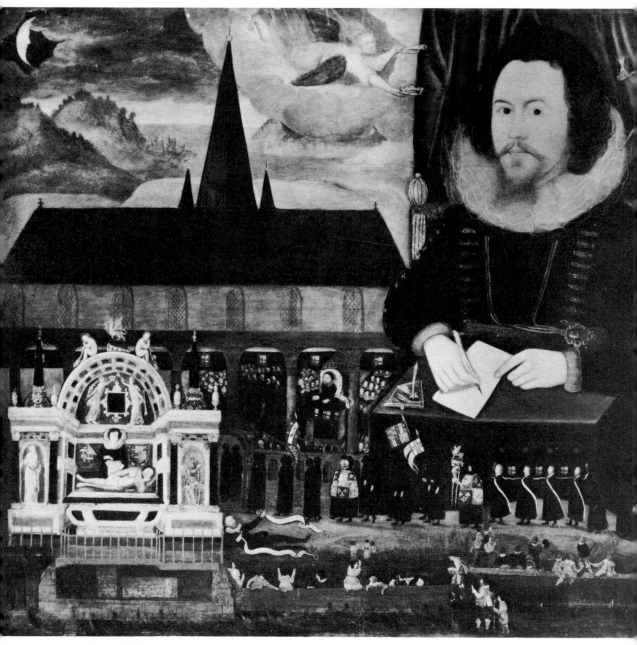

53 Memorial Picture of
Sir Henry Unton, *c.* 1596

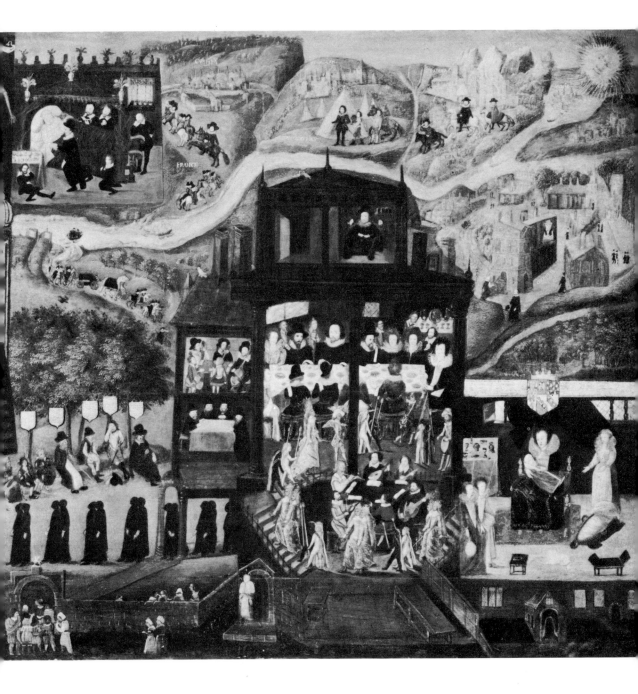

From this we learn that Unton's mother was the Lady Anne Seymour, one of the six daughters which the Duke of Somerset, Lord Protector of England, had by his second marriage to Anne, daughter of Sir Edward Stanhope.[5] She and her sisters belonged to that generation of bluestockings which included the young Elizabeth I and the Dowager Lady Russell of the Procession Picture and her sisters. Their education had been a humanist one under the guidance of a Frenchman, Nicolas Denisot, who was poet, painter and engraver besides being an intimate of French literary circles.[6] When the Queen of Navarre died, Denisot suggested that the sisters should write a poem in her memory; the result was the *Hecatodistichon*, which Denisot carried to Paris and which inspired French poets, including Jean Dorat, du Bellay and Ronsard, to produce a volume of memorial verses in honour of the deceased queen. *Le Tombeau de Marguerite de Valois Royne de Navarre*[7] centres on the poem written by three of the sisters, whose praises are sung as the *tria lumina Angliae*. Anne's background was therefore a distinctly reformist one. John Calvin even wrote to her from Geneva, saying that he had heard not only of her liberal education but that she was so conversant 'in the doctrine of Christ, as to afford an easy access to his ministers'.[8] She was an aristocratic lady of the highest birth and social connections, from a family at its apogee for a fleeting moment when her father was Edward VI's Lord Protector. The triumph was short-lived. In 1550 Somerset was deposed from the protectorship, and power passed into the hands of the ambitious John Dudley, Duke of Northumberland. His policy at first was one of appeasement towards the rival house, one which reached its climax in Anne's marriage to his eldest son John, soon to be Earl of Warwick, which took place in the presence of the King and in the midst of splendid festivities at the palace of Sheen.[9] Just over a year later, Northumberland had Anne's father executed on a trumped-up charge of conspiracy, leaving her a living testimony to an alliance which no longer had any political validity.

Nor was her husband's family to fare better in reversals of fortune; with the accession of Mary, Anne's husband, the Earl of Warwick, along with his father and brothers, was arraigned and condemned on a charge of treason for his part in attempting to establish Lady Jane Grey as queen. Warwick languished in the Tower for more than a year, until October 1554, when, thanks to the clemency of Mary, he was released, only to die ten days after. Six months later the widowed Countess of Warwick was married in a small sequestered church at Hatford to Sir Edward Unton of Faringdon.[10] How this match came about we do not know: the collapse of Anne's fortunes had been so dramatic that the discrepancy in rank between a countess, who was a Seymour by birth and a Dudley by marriage, and a Berkshire gentleman of no great lineage, was less apparent in 1555 than it would have been in earlier, grander times. Perhaps, too, Anne had already begun to betray that weakness of mind that was finally to overcome her. Lapses into mental derangement probably began as early as 1566,[11] and after Sir Edward's death his son

Henry had the melancholy task of securing his mother's custody.[12] The tragic loss of her father, of her first husband, and of two of her sisters may well have weakened the mind of this pious lady, who finally went to her grave in the year of the Armada, when she was mourned as 'a noble lady, a faithful wife, a virtuous woman, and a godly widow'.[13]

The village of Ascott-under-Wychwood, where Unton was born, was six miles north-east of Burford, which Sir Edward Unton held for the maintenance of his wife as part of the lands of her first husband, the Earl of Warwick. The Unton house was at Langley on the west side of the forest of Wychwood.[14] Sir Henry Unton obviously owed his noble lineage to his mother, but what of his father's family? The Untons were Oxfordshire and Berkshire gentry who had risen to prominence at the end of the fifteenth century.[15] Pedigrees of the family begin with Hugh Unton, who married Sybell, daughter and heiress of William Fettiplace, and thereby acquired extensive estates in those counties. Thomas Unton, Henry's grandfather, was sheriff of the counties of Berkshire and Oxfordshire and in 1533 was one of those 'knights made with the sword' at the coronation of Anne Boleyn. Two months later he died, and he was the first of the Untons to be buried in the north aisle of Faringdon church.[16] He was also the first to bear the arms which are scattered in varying combinations across the picture, being granted the armorial coat of azure, on a fess engrailed or, between three spearheads argent, a greyhound current sable. His son Alexander was one of the knights created on the occasion of Edward VI's coronation, a dignity which he did not live long to enjoy, as he died just ten months later on 16 December 1547, to be buried also in Faringdon church. His will reveals that the Unton lands were now spread through not only Berkshire and Oxfordshire, but also Wiltshire and the Isle of Wight.

With the accession of Queen Elizabeth I the Untons prospered, and through the Countess of Warwick's first husband they could claim kinship with the Queen's favourite, Robert Dudley, Earl of Leicester. The latter in fact was to die at Cornbury Park, his house adjacent to Dudley lands which the Untons held and administered for his former sister-in-law.[17] Sir Edward[18] was knighted at the Queen's coronation, was sheriff of the county in 1567, sat for parliament in both 1566[19] and 1572, and received Elizabeth at Langley in 1574 during the memorable Bristol progress,[20] when he presented her with a 'jewel of gold garnished with diamonds and rubies and five pearls pendant, one bigger than the rest'.[21] He was a well read and well travelled man, and the diary of his continental tour remains one of the earliest and most picturesque accounts of Italy as seen through the eyes of an Elizabethan.[22]

The Countess bore a numerous family to Sir Edward. Three children died young, but two sons, Edward and Henry, and two daughters, Anne and Cecily, survived. Henry was the younger of the two sons. Of his childhood we know nothing, but it was presumably passed at both the family houses, at Langley and at Wadley – that house to the right in the Memorial Picture. In October 1573 Henry supplicated for the degree of

Bachelor of Arts at Oxford,[23] information which harmonizes admirably with our visual documentation, for the next scene, immediately above that of his childhood, is labelled OXFORD. A beardless and youthful Henry, his hat on his head, sits reading a book. The building which he occupies presumably represents his college, Oriel, where he was tutored by Richard Pigot.[24] Henry did not take his Master's degree but finished his education, as was customary in the Elizabethan age, at the Inns of Court, where he became a student at the Middle Temple in 1575. Soon afterwards he travelled extensively in France and, following his father's precedent, in Italy and possibly as far afield as Hungary. The dates of his visit abroad are not known, and nor are the places that he visited, apart from Venice and Padua which appear in the top right-hand corner of the picture. Padua had its university, where Unton may well have studied for a short period – it was perhaps the only Italian university open to English Protestant visitors. Of his fluency in the Italian tongue, a *sine qua non* for diplomacy, we have evidence in the help he accorded his friend and travelling companion Charles Merbury[25] in compiling a collection of Italian proverbs attached to his *Discourse of Royall Monarchy* (1581). To this publication Unton contributed a prefatory address to the reader in which he recommends Charles Merbury 'whom', he states, 'I have long, and much loved'.[26]

On 14 June 1582 an agent of the Secretary of State, Sir Francis Walsingham, wrote in much distress to his master from the Unton house at Wadley. The letter is an important one in our story. Old Sir Edward Unton, he wrote, had been desperately ill; one of his legs had been amputated and he lay on his death-bed. In the extremity of his misery he had made his will and given Christian counsel to his children. 'I perceive', it was reported to Walsingham, 'that he wishes to do a good deal for his younger son Mr Henry, especially in ready money, because he cannot make him his heir to the prejudice of his elder brother, and indeed Mr Henry deserves it, being of as good parts as any gentleman of his age that I know.'[27] Besides, he adds, Henry's wife was a relative of Lady Walsingham, Henry having married in 1580 Dorothy, daughter of Sir Thomas Wroughton of Broad Hinton, Wiltshire.[28] Sufficient to say that the Untons were bound in friendship to the Walsinghams – one of their sons had been christened Francis[29] – and that they were linked by a common devotion to the Protestant cause. For three months Sir Edward languished in agony, until in September he died. In his will he kept to his resolution, and the few estates which came the way of Henry were bolstered by Sir Edward's bequest of 'all the residue of my goods and chattels, as well movable as immovable'.[30]

Sir Edward was finally buried in Faringdon church over two months later, on 6 December.[31] His elder son Edward was at that time in Italy. A delay of two months in the staging of the obsequies should have enabled the heir to the Unton estates to make his way homewards in time for his father's funeral, but such hopes speedily faded, for while journeying from Padua Edward Unton was suddenly seized by the Inquisition and

54 Unton at Oriel College, and travelling in Italy

54

90

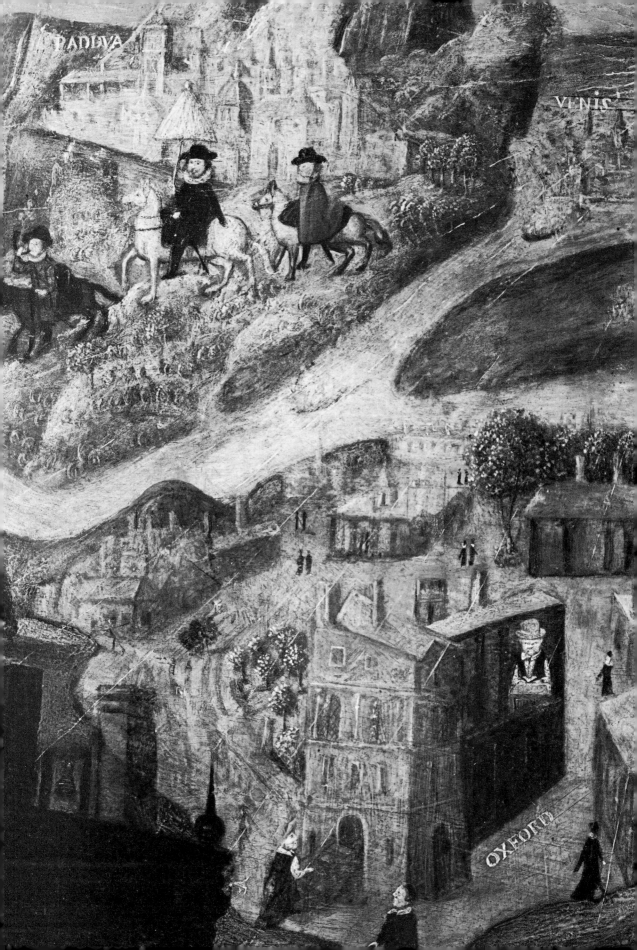

clapped into prison in Milan. The incident produced more than a ripple on the surface of the troubled waters of English diplomacy. In the life of Henry Unton it may be said to be the turning-point, for through the tangled negotiations which attended this event he gained an entrée into the underworld of Elizabethan diplomacy.

He made his début under the auspices of a relative, the Earl of Leicester, and of Sir Christopher Hatton.[32] At the time he was described as Hatton's 'servant'.[33] Equipped with letters of introduction from Walsingham to Cobham, English ambassador in France,[34] Unton crossed to Paris and then travelled directly on to Lyons, the axis of Franco-Italian relations.[35] For over three months he was engaged in frantic efforts to extricate his brother from the dungeons of the Inquisition: bribery, the machinations of spies, letters of intercession by the French King, besides the threatened seizure of the Spanish ambassador and other Catholics in England, were all successively brought into play.[36] An agent called Pyne promised to gain Edward's release, but the end of April came with no apparent results in spite of the fact that over fifteen hundred crowns had been expended.

Pyne proved a broken reed, and Unton eventually disposed of him by dispatching him bearing letters to England. At this point his luck changed, for he succeeded in winning over to the English government one Solomon Aldred,[37] the Catholic agent who had been sent to Lyons to negotiate with him for his brother's release. Unton refers to him as 'the player of my brother's tragedy', so that he may in some way have been connected with the seizure of Edward Unton. Now he changed sides, although of course at first not openly, and so there emerged a curious double game in which Aldred continued to play papal agent. He left Lyons for Milan to obtain, by means of underhand intrigue, Edward's release.[38] How exactly this was brought about we do not know, but it must have involved a huge sum of money: 'bonds of great sums' had been entered into, Henry reported to Walsingham.[39] Imprisonment had left Edward Unton a man sick in body as well as mind, and the English ambassador in Paris suspected that he had been won over to the Catholic cause.[40] Just over a year later, however, we find him hauling up recusants before the magistrate.[41]

At this point in the saga, it would be as well to dispose of the remainder of Edward's sorry life. His own dissipation, together with the vast sums involved in his ransom, wrought havoc with his patrimony. Estates were sold,[42] and this was followed by an attempt to recoup his fortunes in the colonization of Munster,[43] but all to no avail. In January 1588 the Privy Council had to intervene to prevent his seizure and imprisonment for debt.[44] A year later he was 'slain in the Portugal voyage', death thus averting total ruin.[45] On this apparently rash and unreliable character, who was reluctantly recognized as heir to the family estates by his father and who then proceeded to waste them away, there is a deliberate silence in the Memorial Picture. On his death what was left of the Unton estates passed to his brother Henry.

Letters to Sir Francis Walsingham from those in France during the Edward Unton incident bear testimony to Henry Unton's skill and integrity; twice William Parry wrote entreating the secretary to find 'a gentleman fully furnished with all the parts of a dutiful and loyal subject' a position which would ameliorate his poor estate.[46] Unton himself anxiously followed up any line into Walsingham's favour with epistolary fervour: 'How much I am bound to your lordship for my brother, and he for himself, I had rather my service and his deserts should manifest, than naked words . . . acknowledging the everlasting good of our house to depend upon your lordship's goodness.'[47]

The story now shifts from right to left along the top of the painting, from Italy to the Low Countries. In August 1585 a treaty was signed between Queen Elizabeth and those provinces of the Netherlands which were in revolt against the tyranny of Philip II of Spain. Under the terms of this alliance Elizabeth dispatched an expedition under Robert Dudley, Earl of Leicester. The latter was received with great splendour by the provinces and proclaimed governor. In reality the whole episode was a fiasco; Leicester was soon hated, added to which he led a lamentable campaign during the summer of 1586. Outwardly, though, it had its glittering moments, for along with Leicester travelled the flower of English chivalry, especially those who were in some way aligned to the Leicester connection, and amongst them the young Henry Unton.[48] We hear that he was in the forefront of the assault on the town of Axel on the Scheldt estuary in Flanders, at the siege and surrender of Doesburg early in September,[49] and finally, early in October, at the battle of Zutphen, where Sir Philip Sidney fell, to be lamented by friend and foe alike. Unton's prowess on the field of Zutphen was such that he was knighted by Leicester after the battle.[50] The Earl sent him to England bearing letters in which the newly dubbed knight was recommended as an 'honest and rare gentleman . . . who, with his companion, Sir William Hatton, hath not failed any journey since they came over hither, either on horseback or foot'.[51]

William Hatton was the adopted heir of Unton's old patron and friend, Sir Christopher, and his closest friend.[52] Leicester's allusions to their journeys suggests that their soldiering was combined with carrying dispatches and generally being caught up in the more routine aspects of diplomacy.[53] But to what does the Memorial Picture allude? It depicts a town before which a battle is raging; the town is labelled *Nimingham*, presumably Nymegen. The latter was held for Philip II and was not taken until five years later in 1591, when it fell to Maurice of Nassau, an action at which Unton was certainly not present. Nymegen was further south than either Doesburg or Zutphen, and although Leicester's forces had circled around it and threatened it at the opening of that summer's campaign, no engagement was fought there. The compiler seems to be telescoping all the battles of the campaign into one composite image – a pictorial principle which we first encountered in the Procession Picture. This story ends on 16 February 1587 when the two chivalrous friends,

55 Unton aged about thirty, probably painted to commemorate his knighting after the battle of Zutphen, 1586

Unton and Sir William Hatton, walked together as 'knights of his kindred and friends' in the funeral procession of that pattern of all the knightly virtues, Sir Philip Sidney.[54] A portrait of Unton now at Arundel Castle depicts him at this period of his life: a self-assured young man in a jaunty black-feathered hat, white doublet, and gold-braided scarlet cloak.[55]

55

For the next five years Sir Henry Unton lived the life of a country gentleman, one of the pillars of government administration in Oxfordshire and Berkshire.[56] In the year of the Armada both he and his brother Edward rallied county forces to the aid of the Crown in the event of a foreign landing.[57] Over these events the Memorial Picture does not linger but hastens on – again moving from right to left – with marked rapidity to his journey into France towards a town labelled *Cvshia*. This could only refer specifically to his visit to the French court as English

ambassador from 1595 to 1596, but, as in the case of the Netherlands campaign, there is a tendency to telescope. As with the Procession Picture, the operative dimension is that not of space but of time: Italy, for a member of the Unton family, would allude not only to Sir Henry's visit, for beyond would loom the disastrous entanglements of Colonel Edward and the distant memory of Sir Edward's colourful tour; Oxford refers to Henry's education at Oriel, but from this the onlooker's mind would run on to his brother's education there also,[58] to the family house at Wadley, the manor of which was leased from Oriel, to Sir Henry's patronage of Oxford scholars and divines, and to other lost nuances. So too the little procession which winds its way into France, I would suggest, represents both embassies, that of 1591–2 and that of 1595–6.

While in the Netherlands Unton had made friends with Leicester's stepson Robert Devereux, 2nd Earl of Essex. He was, remotely, a kinsman. Unton's wife was in some way related to Lady Walsingham whose daughter Frances, widow of Sir Philip Sidney, married Essex as her second husband. Through Essex's influence, in July 1591, Unton was appointed ambassador to Henri IV to replace Sir Edward Stafford. France at this time was torn apart by civil war between the forces of the Catholic League aided by Philip II, who refused to recognize the Huguenot Henri de Navarre as king, and the royalist forces made up of Huguenots and loyal Catholics supplemented by foreign mercenaries.[59] As Unton wrote to Queen Elizabeth: 'He is a King without a crown and he maketh wars without money.' Unton crossed to France with the troops the Queen was sending to the French King's aid, which were headed by the chivalrous *Young Man amongst Roses*, Essex. No sooner had they arrived at Dieppe than the former was struck down by a burning fever combined with yellow jaundice. The time could hardly have been more inopportune; on 17 August Unton was seized by a violent fit and seemed on the point of death. The inset scene at the top of the Memorial Picture of Unton in bed having his pulse taken, surrounded by his entourage, could allude to this occasion, while at the same time it refers to his death on the second embassy. By the end of August he had recovered and was able to ride abroad and take the air in his coach. 56

Elizabeth had issued strict orders that the troops were to remain at Dieppe until the ratification of the financial agreement with Henri IV, after which they were to be employed in besieging Rouen; but, as in the case of nearly all Elizabethan interventions abroad, there emerged a curious dichotomy between the Queen's written instructions and what actually happened. The English army remained in Dieppe while Henri IV continued the siege of Noyon. Essex incurred the Queen's wrath by not writing to her and by galloping a hundred miles through enemy country to visit the French King. As Elizabeth bitterly but accurately concluded: 'And now where he is, or what he doth, or what he is to do, we are ignorant.'[60] Unton speedily followed Essex in being denounced by Elizabeth; he had ridden to Louviers to be received by Henri for the first time. It was an act which the Queen never quite forgave, and one which

she harped on when contemplating his reappointment as ambassador in the autumn of 1595: 'princes', she dictated, 'will not be capitulated with by their servants'.[61] Unton immediately established a lasting friendship with Henri. 'He is a most noble, brave, King', he reported, 'of great patience and magnanimity; not ceremonious, affable, familiar and only followed for his true valour.'[62]

Elizabeth's wrath descended upon both general and ambassador once more when the English troops, contrary to orders, helped Henri to besiege Gournay. Unton's friends at court, notably Sir Christopher Hatton,[63] succeeded in placating the Queen, whose anger finally subsided when the joint English and French forces at last laid siege to Rouen early in October. The operation ended in failure, for in the April of the following year Philip II ordered the Duke of Parma to march his army out of Flanders and relieve Rouen. This he succeeded in doing, which led to the abandonment of the siege and, early in June 1592, much to the regret of the French King but to the financial relief of Unton, to the ambassador's recall to England.

While in France Unton challenged to single combat the young Duke of Guise. The latter, in line with Catholic League propaganda, had not minced his words as to what he thought of the Virgin Queen. Although the actual encounter never materialized, the challenge is an interesting document when read in relation to the Memorial Picture, for Unton there displays his pride in his ancestry. 'Nor would I have you to think', he wrote to one of the greatest of French aristocrats, 'any inequality of person between us, I being issued from as great a race and house (every way) as yourself.'[64] It was Unton appealing through his Seymour descent to his kinship with kings and queens.

During both the period of his embassy and the years immediately before it, Unton had lost many of his most important patrons: death had removed Leicester, Walsingham, and Hatton, so that henceforth his career depended wholly on the favour of his 'most true friend', the Earl of Essex. Seven months after returning from his embassy Unton was returned to parliament as a member for Berkshire.[65] The house assembled on Monday, 19 February 1593, and after the usual preliminaries got down to business. On the part of the Crown the main part of that business was an appeal for a subsidy, which was launched on 26 February by a bevy of speakers all singing the Queen's praises. A committee of 150 members agreed to a double subsidy as in the previous parliament, but on 1 March Lord Burghley, via the Lords, moved a triple subsidy. The proposal led to a crisis in the lower house, and to what amounted to a point-blank refusal. Among those who spoke on behalf of moderating the subsidy was Unton.[66] The Queen's wrath knew no bounds: Essex did all he could to mollify her, but to no avail, for details of Unton's caustic comments had already reached her ears.[67] 'I told her', Essex opines, 'that it was an ill example to other men that for one displeasure or misconceit all the merit or service of a man's life should be overthrown.'[68] Parliament ended on 10 April with Unton still in

disfavour. Vainly did all his friends intercede for him at court. Unton was in disgrace.

For over two years he was to languish in involuntary exile from court. During that time repeated efforts were made by Essex to reinstate him in royal favour, but the Queen remained adamant in August 1593,[69] and when Unton was presented to her at Windsor two months later all he received for his pains were 'very bitter speeches'.[70] Over this episode the Memorial Picture, as one would expect, preserves a discreet silence; Unton had good cause to regret what he referred to as his 'clownish life',[71] barred from advancement at court and forced to lead the life of a country gentleman.[72] It was not until the autumn of 1595 that Elizabeth at last relented, when, on the death of Sir Thomas Heneage, the vacancy of the office of Treasurer of the Chamber led to a trial of strength between Essex and Lord Burghley.[73] Essex backed Unton for the post, Burghley Sir John Stanhope. The competition caused much gossip at court and remained unresolved until 20 December, when Rowland Whyte reported that 'the Queen hath promised him [Unton] the Treasureship of the Chamber, and stands constant in it, and at his return to have it'.[74] The allusion to Unton's return referred to his appointment once more as ambassador to Henri IV.[75] Unton owed this renewal of favour not only to a change of heart on the part of the Queen, and to the importunities of Essex,[76] but above all to the crisis towards which the Anglo-French entente was heading, which an ambassador who was *persona grata* with the French king, it was mistakenly thought, might allay.

Unton's embassy seemed doomed to disaster almost from its inception; he was, it was reported, 'most unwilling to go this journey'.[77] After a lull in hostilities following the dislodgment of Spanish troops from Brittany, the invasion of Picardy and the fall of Dourlens in August 1595 caused Henri IV to turn once more to Elizabeth for military aid. She, in her turn, refused it unless English troops were allowed into Calais. Meanwhile Cambrai fell and a fruitless embassy to the English court provoked further fury on the part of Elizabeth.[78] The Queen had in fact overplayed her hand; Unton realized this immediately he reached the royal camp, which was pitched near to the town of Coucy La Fère on the river Oise – the *Cvshia* seen in the Memorial Picture. Unton had no sooner arrived than it was apparent just how unwelcome an English embassy was at that juncture: peace negotiations were in the air and the talk was all of the coming of Cardinal Joyeuse from Rome, who would open a way for a truce between France and Spain. The secret instructions he had from Essex, who represented the war party, asked him to report to the Queen that his reception had been cool, the more to urge her to action. He reported, in virtually the very words of the secret instructions, that the King had agreed to receive him as Monsieur Unton and make his complaints to him as ambassador.[79] In other words, Henri welcomed him as a friend but not as an emissary of Elizabeth. The coolness was more than a political fiction – it was a living reality. He had only been at Coucy just over a week when he wrote the first of his laments to Essex

asking him to move heaven and earth for his revocation. 'I do hide my head for shame,' he bitterly complained,[80] and in fulsome and flattering letters to Elizabeth he similarly worked for his recall.

The correspondence continued until, on 24 February, he suffered a fall from his horse.[81] Although he managed to tour the earthworks of the beleaguered La Fère in the company of the King, by the following day he was forced to take to his bed. The fever which seized him had already decimated the troops in the camps, and Unton's deterioration was rapid. On the 29th Henri deliberately stayed his journey to St Quentin to visit him: 'he had not hitherto feared the arquebus shot', the King characteristically remarked, 'and did not now apprehend the purples' (as fever was called by the Elizabethans).[82] A visit from the royal physician, Andreas Laurentius,[83] followed the next day, perhaps that commemorated in the Memorial Picture where the stricken Sir Henry lies on his sick-bed, surrounded by attendants, while a physician kneels at his bedside. The cure he prescribed was a *confectio alcarmas*, compounded of musk, amber, gold, and unicorn's horn, with pigeons applied to his side, but all to no avail.[84] On 20 March Unton wrote his last dispatch to Lord Burghley,[85] an effort which reduced him to a state of utter weakness,[86] and in this way he lingered for two days until on the 23rd he finally expired.

'It was his desire at his first falling sick,' wrote Dudley Carleton, who had watched over him, 'when he had apprehension of death, to have his body carried into England, which will be performed.'[87] A memorandum preserved in the College of Arms takes up the story and reads like a scenario for the scenes which follow in the Memorial Picture:

> The said Sir Henry Unton, Knight, died Lord Ambassador resident in France, in the French King's camp lying before La Fère from whence he was brought over to London, and from thence he was

56 Illness and death

worshipfully accompanied and carried in a coach to Wadley . . . and in the parish church there buried on Thursday the 8th day of July 1596, with a Baron's hearse, and in the degree of a Baron, because he died Ambassador Leger for France.[88]

All this can be followed in the picture: below the death-bed scene a mourning ship makes its way across the Channel towards a port; a hearse travels along a road towards Wadley, and a splendid funeral procession crosses from right to left from the house to Faringdon church bearing his coffin. Within the church a packed congregation listens to the customary funeral sermon. The preacher may well have been Unton's chaplain, Robert Wright.[89] He it was who organized the official publication bemoaning his master's demise, the *Funebria*, a collection of memorial verses published by the university of Oxford in 1596.[90] Only Sir Philip Sidney had hitherto been accorded such an honour, and the ghost of Philisides, who had similarly died abroad and had his body brought back to England, runs through the work of the fifty-six contributors to this volume. The manner of Unton's death, as opposed to Sidney's on the field of battle, however, left the authors sadly bereft of those ingredients necessary to cast their subject in the heroic mould. A truer measure of Unton's worth than these trite encomiums is Henri IV's letter to Elizabeth, where he genuinely regrets the passing of one for whom he had always held a 'particular affection'.[91]

The forlorn beings who sit under the trees watching the funeral procession in varying attitudes of woe and despair are no doubt intended for those poor who had benefited from the munificence of Sir Henry; the few decipherable words on the shields above support this: 'This life grows worse and worse, he's dead and gone' and 'Never greater grief'. Unton had in 1591 leased $33\frac{1}{2}$ acres of land in Westbrook, the rent from which was to be employed for a number of charitable purposes, including 'easing the poor . . . from taxes and payments . . . setting out soldiers . . . conveying passengers and cripples . . . the overplus to be kept for increase of stock . . . to be lent, on good security, to some young hopeful tradesman . . . and the profit therefrom to be employed in setting out poor and friendless apprentices to husbandry or honest trade'.[92]

Unton, like many other Elizabethans, suffered from one of the most familiar paradoxes of his age, that service to the Crown could be the cause both of prosperity and of ruin. As in the case of his friend Hatton, he died leaving a 'broken estate and great debts'. The expense of the last embassy had been crippling: 'if I continue here long', he had lamented to Sir Robert Cecil, 'I shall ruin myself'.[93] The ordinary expenses of his household alone, he claimed, amounted to seventeen pounds a day, almost six times as much as the equivalent cost for the 1591 embassy, and he had further been forced to expend large sums in bribery. Little wonder that he died in debt to the sum of £23,000; what was more he had died intestate, which led to all kinds of legal wrangles.[94] The family itself was divided. His brother-in-law Valentine Knightley eventually made good a

claim to the family home at Wadley on behalf of his three daughters by Unton's sister Anne, in spite of the counter-claim of John Wentworth on behalf of his wife Cecily, Unton's other sister.[95] A similar suit was brought by the same parties over another Unton house, Faringdon, which ended in its being bestowed for life on Sir Henry's widow, Dame Dorothy, after which it was to pass to John and Cecily Wentworth.[96] In the midst of a sea of family quarrels the Unton estates were sold and broken up and the Untons of Wadley, once one of the most conspicuous and affluent of Oxfordshire and Berkshire families, for want of a male heir disappeared from history.

The Muses' friend

The right-hand side of the picture is in itself divided into two parts, those scenes which reflect Unton in his public capacity and those which allude to his private life. The latter find their setting in the Unton ancestral residence at Wadley in Berkshire. The manor of Wadley had been granted by Henry VI to the Provost and scholars of Oriel College, Oxford.[97] They, in turn, leased it to the Untons, who had been at Wadley from as early as 1514, and from then onwards the manor descended to the Unton heirs until 1589 when, on the death of Colonel Edward Unton, it passed to his brother Henry. In the inventories of Wadley and of the second Unton house, Faringdon, compiled in 1596, the total value of the contents of the houses, excluding jewels and plate, was estimated at nearing £1,500.[98]

The house at Wadley was particularly rich in its effects. The parlour was furnished with two tables, a livery cupboard, three green carpets, two green cloth chairs, 'one black wrought velvet chair laid with silver and gold lace, three long cushions laid with gold lace, thirteen green cloth stools, six leather field stools, two cushions, one of Turkey work, a pair of bellows and tongs'. The contents of the study – to be seen in the Memorial Picture – are also listed: seven hangings of gilt leather, one table, shelves, a chest, and 'many books of diverse sorts, to the number of CCXX'. The inventory continues via the long gallery and armoury to the household offices and bedrooms. Of these the most sumptuous was the Drawing Chamber, which boasted a bed 'with a cover of yellow satin laid with silver lace', besides 'five pieces of Arras hangings' and chairs and stools covered with yellow velvet – probably made for the Queen's visit to Langley in 1574. The Great Chamber – possibly the setting for the masque in the picture – contained two tables, a velvet chair, a plate cupboard, and half a dozen stools. The second Unton residence, Faringdon, was less richly furnished. Faringdon – which no longer stands – was situated in the town of the same name and was within walking distance of the house at Wadley. It had been the property of the Pleydell family until sold by John Pleydell in 1590 to Sir Henry who, five years later, settled it on his wife the Lady Dorothy.[99] She, on her husband's demise, inherited it as a dower house. The hall contained 'one pair of virginals' – the only hint in the inventories of the musical activities of the

100

Untons – and the contents of the parlour provide an inkling of the luxury which Faringdon was to achieve under the auspices of the indomitable Lady Unton during the years of her widowhood.[100]

Under the judicious management of Sir Henry the Unton estates had prospered; it was not without cause that he was recorded as being 'so cunning a bargainer for lands that they which dealt with him were commonly great losers'.[101] His brother had in 1585 conveyed to him the manor of Wick,[102] and from Edward also came Hatford and Faringdon rectory in 1589,[103] and after his death the remaining Unton lands. From Basil Fettiplace, to whom he sold the manor of Marcham, came Shrivenham and Radcott in Oxfordshire, and finally, in 1590,[104] Faringdon was purchased from the Pleydells.[105] In this way Unton was able to compensate for the loss of estates such as Burford, which had been part of his mother's lands but which on her demise returned to the Crown. Through purchases and exchanges the Unton estates came to form an impressive block in north-west Berkshire, stretching up into the Burford area of Oxfordshire. The Untons were up-and-coming gentry well able to indulge in the cultivation of the gentle civilizing arts.

Of his patronage of men of learning and piety we have abundant evidence in the eulogies which make up the *Funebria*, for Unton, in the words of Robert Ashley – who dedicated to him his translation of Du Bartas – followed not only Mars but Mercury and the Muses.[106] Matthew Gwinne,[107] his physician, had originally lectured on music at Oxford until forced to abandon the subject for lack of 'suitable books'; when Elizabeth visited Oxford in 1592 it was Gwinne who organized the staging of plays for the occasion. Thereafter he was engaged in the study of medicine and in this capacity travelled with Unton; he was appointed, just under a year after his master's demise, first Professor of Physic at the newly founded Gresham College. Gwinne, with his love of music and revelry, would have been a welcome visitor to the Unton household at Wadley. Nor was there lack of divines with whom Sir Henry could engage in spiritual counsel, as he would seem to be doing in the little scene in the Memorial Picture where they sit gravely around a table in conference. One Lewes, an Oxford man, dedicated his Paul's Cross sermon to Unton in 1594 in token of his generosity to 'that learned Preacher, Master Jennings, that grave Divine, Master Sheward, that zealous trumpeter of God's word, Master Wright, with others of good note in that famous university'.[108] The zealous trumpeter was Robert Wright,[109] later successively Bishop of Bristol, Lichfield and Coventry, but in 1591 chaplain to Unton in his capacity as ambassador at the French court.[110] Unton thought highly of him; in his opinion he was 'a very honest man and of great learning and discretion, and the greatest comfort of my life'.[111] Later sources offer less favourable verdicts.

Ashley in his dedication refers to Unton's *De Legatione*, probably identical with that recorded by Wood as 'A Discourse of ambassages, compiled by Sir H. Unton, which treats of the good gifts an ambassador must be endowed with, both as to the body and fortune, etc. Lastly of the

privileges of ambassadors in their own country after their return.' The manuscript was still extant in 1715 when it was recorded as part of the Thoresby collection.[112]

In a dedicatory verse, published in 1582, a learned Hungarian, Stephanus Parmenius of Buda, offers a long Latin poem on the 104th Psalm to Unton as his patron.[113] The poem implies that Sir Henry had travelled in Hungary – possibly in the late seventies – and the two may well have met there and travelled back to England. It is certainly difficult otherwise to account for the presence of a Protestant Hungarian poet in Oxford Puritan society at the beginning of the eighties. He was held to be a most 'rare poet of our time', and his country of origin was enough to ensure his success, even if only as a curiosity. It is evident, however, that he was a man of learning, able to move with some assurance in the learned Oxford circles of the day. Richard Hakluyt knew him well, and having long hoped that a man of intellect would accompany a voyage of exploration, introduced him to Sir Humphrey Gilbert. The latter was in the final stages of organizing his expedition to colonize Newfoundland, so that Parmenius accompanied him on the voyage in the capacity of an official observer. Gilbert had had a hard time raising the capital for the venture, and a chance reference to the 'profitable' nature of the business implies that Unton had sunk some of his cash into the scheme. Newfoundland was reached and Parmenius wrote a long letter of description to his friend Hakluyt, dated 6 August 1583, which ends by entreating for news of 'how my patron and master, Henry Unton, doth take my absence'. The expedition ended in disaster. The attempt to colonize collapsed in chaos and poor Parmenius was consigned to a premature and watery grave when the ship, the *Delight*, foundered and sank on the way back. The fragments of the whole episode remain tantalizing, as they reveal Unton not only as the patron of a refugee Hungarian poet but as a friend of the chronicler of Elizabethan colonial enterprise.

In the top left-hand corner of the house as shown in the Memorial Picture, Unton appears as one of a quartet of viols accompanying a boy singer. The consort song, for treble voice accompanied by a quartet of viols, was a class of solo popular in England before the triumph of the madrigal in the nineties. Such songs figured prominently in the choirboy plays, and Parson's lament 'Pandolpho' and Farrant's 'O Jove from stately throne descending' are two well-known examples.[114] Two of the other members of the quartet are gentlemen, as they wear hats. Unton had connections with at least one family which was notably musical, the Walsinghams.[115] Probably through his friendship with the Hattons he met John Case, Aristotelian, musician and doctor, who dedicated to him and his friend Sir William Hatton his *Apologia Musices* (1588), in which he praises Unton for his musical skill.[116] We know too that there was some sort of connection between him and John Dowland, who includes a piece entitled 'Sir Henry Unton's Funeral' in his *Lachrymae* published in 1604. The stress on the role of music in the life of Unton's household is

evocative of that patronage of music amongst the Elizabethan gentry made familiar by the Kytsons at Hengrave.

The private life of Sir Henry at Wadley is dominated by a banquet scene: guests are seated on chairs and stools around a table, being waited upon by dwarf-like servants. In the centre sits Sir Henry and at the head of the table is his wife, Dorothy Wroughton, identifiable as she reappears to the left of the picture on the knight's tomb. The rest of those seated around the table facing the spectator would also appear to be portraits, probably members of the Unton family and their wives and Henry's sisters, Cecily and Anne, with their husbands, John Wentworth and Valentine Knightley. No portraits survive, so that we cannot tell exactly who makes up this gathering at Wadley. A glance at the family tree and its ramifications tells us much of the circle in which Sir Henry moved.

58

57 The Unton family tree

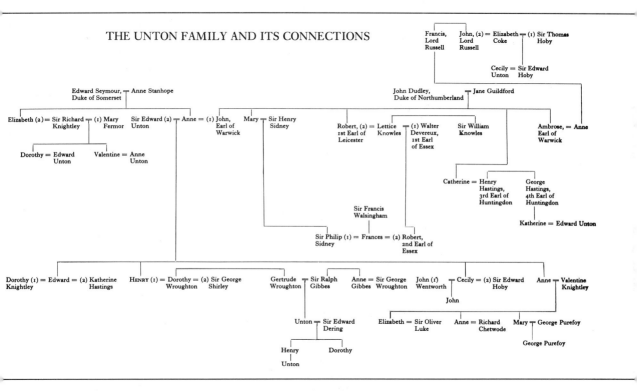

The Dudleys always cared for the family of their sister-in-law, the Countess of Warwick. An Ambrose Unton, who appears in the church registers of Hatford but whose exact place in the Unton pedigree has not been established, was doubtless named after Ambrose Dudley, Earl of Warwick.[117] Edward Unton's second wife, Katherine Hastings, was a niece of Catherine Dudley, Countess of Huntingdon. To the Dudleys and their connections, the Walsingham and Devereux families, Unton owed much of his career. But his life was also coloured by deep and lasting friendships. The Hattons, both Sir Christopher and his nephew

William, were long acquainted with Henry and Dorothy Unton; so too, one may gather, was that formidable lady, Elizabeth Coke, Lady Russell, of whom Sir Henry writes that he was 'as respective as of my own mother'.[118] Her son Edward, by her first marriage to Sir Edward Hoby of Bisham, was to marry Henry's sister Cecily. Other names which occur in the lists of letter recipients and in the diary[119] of his second embassy fill out the circle: that doyen of the diplomatists, Sir Thomas Wilkes;[120] Unton's Oxfordshire neighbour the chivalrous Sir Henry Lee, Ranger of Woodstock and Master of the Armoury; Anne Russell, Countess of Warwick; and Sir William Knowles, again with Oxfordshire connections and probably friendly with Unton as far back as 1586 when they were both knighted at Zutphen. Through these relationships and friendships we obtain some idea of the people who would have made up such a group as takes part in the feasting in the Memorial Picture.

Adjoining the gathering around the table is a scene of exceptional brilliance recorded in a unique visual document, the so-called 'wedding masque of Sir Henry Unton on the occasion of his marriage to Dorothy Wroughton in 1580'. The suggestion that there might be any connection with the marriage made its appearance as late as 1776, when Joseph Strutt published an engraving of the masque in his *Manners and Customs of the People of England*.[121] There is nothing to substantiate the link; no Elizabethan bride would dress in black on her wedding day. The masque, like the other scenes, is one of a series meant to reflect the rhythm of life within the Unton household.

The glittering procession is headed by Diana, goddess of the moon and the chase, wearing a crescent moon in her headdress and clasping a bow and arrow. She is ushered into the presence of the feasters by Mercury, messenger of the gods. Behind her walks a train of six maidens in pairs carrying bows and garlands, their heads crowned with flowers, wearing grey-green robes and white skirts patterned with red flowers; they are further attended by torch-bearers, perhaps intended to be black and white pygmies, attired in sashes of greenery with red and white ribbons on their heads. It is in no way a grand masque, but such a performance as would befit the house of a country gentleman: the simple entrance of masquers who, after having their device explained by a presenter – he can be seen giving a paper to Lady Unton – would dance and perhaps take out the banqueters to engage in general revels. There is no scenery, and the theme of the show is not apparent, although the presence of Mercury and Luna may reflect an astrological motif – or, could we suggest, an allusion to the Queen, Elizabeth, as the moon goddess? The masque, although intended to be retrospective, is of circa 1596, just under a decade before the *Masque of Blackness* inaugurated that great series of spectacles under the direction of Ben Jonson and Inigo Jones.[122] In fact all the costumes in the Memorial Picture, irrespective of the dates of the events depicted, are of the last five years of the sixteenth century.

The masquers move to the strains of music, and a group of professional musicians seated around a table are playing the treble viol, the flute, the

58 Feasting and masquing at Wadley

104

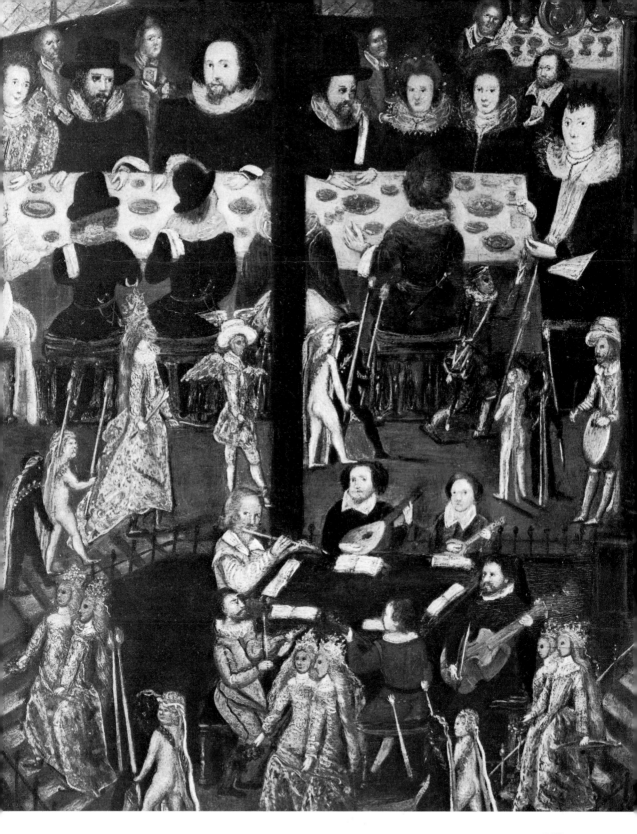

cittern, the lute, the bass-viol and the pandora, the latter partially obscured by the back of one of the players. Artistic licence has also been taken with the positions of the flautist and bass-violist. Together these formed a broken consort, a combination of instruments which enjoyed a considerable vogue in Elizabethan England. The broken consort was an orchestra in embryo which had developed out of the consorts used in the playhouses. Structurally it consisted of two contrasting and blending groups of instruments each with its own bass, 'a mixed choir of "single-voiced" instruments (treble and bass-viols, with lute as inner voice) clearly delineating the essential three-part structure; and a mixed choir of plucked or "full-voiced" instruments (treble lute, cittern and pandora) maintaining a solid rhythmic and harmonic support, reinforcing the melodic instruments with a rich sonority that gives substance and dimension to the whole fabric'.[123] *The First Book of Consort Lessons* published by Thomas Morley in 1599 was the first printed collection of pieces designed for just such a consort as that in the Unton masque; indeed, the collection includes pieces specially written for masques for Lord Zouche and the Earl of Oxford.[124]

Like the scenes from Unton's public life, those depicting the pursuits of his household are of a selective nature. The more one studies them and, as it were, becomes drawn into the house and its activities, the more intensely personal each item becomes. Only someone very close to Sir Henry Unton could have understood the now obscured nuances which lie behind each little scene, would have known the guests at the banquet, the allusions in the masque scene and the identity of the musicians, preachers and servants who make up its little world. In this light the picture has something of the intimacy of a private memoir or diary. The Memorial Picture could take on its rightful life as a series of memory-evoking images in only one way: when each fragment of its biographical mosaic was being contemplated by its compiler, the widowed Dorothy, Lady Unton.

An honourable widow Not only did the tears of the Oxford Muses flow freely in honour of this illustrious knight: his widow, Dame Dorothy, proved inconsolable. Visiting her at her father's house at Broad Hinton in Wiltshire five months after Unton's death, Dudley Carleton described how 'She has very well beautified her sorrow with all the ornaments of an honourable widow. Her black velvet bed, her Cyprus veil, her voice tuned with a mournful accent, and her cupboard (instead of casting bottles) adorned with prayer books, and epitaphs do make her chamber look like the house of sorrow.'[125] Carleton, later ambassador at Venice and The Hague for James I, had been part of Unton's train on his last French embassy. He remained a friend of the family, and it is through his correspondence with that great gossip, John Chamberlain, that we learn most about the hitherto inscrutable Lady Unton.[126] Amongst the ornaments of widowhood with which that mournful lady adorned her bereavement was

the Memorial Picture, which was listed on her death amongst her 'story pictures' and which, in costume, certainly belongs to this period. Her devotion to her husband's memory took more concrete form in the monument in Faringdon church over which she presides to the left of the picture. The tomb was not finished until 1606, so that the picture incorporates an early design: Faith and Hope stand in niches flanking the central sarcophagus, on which lies the recumbent effigy of the knight, with Fame and Victory hovering above him.

In spite of debts and family quarrels Dorothy was left a wealthy widow. On Unton's death Faringdon and its parsonage, Shrivenham, Wyke, Radcott and Westbrook were to be administered in the interests of Dame Dorothy until such time as a son of his sister Anne should come of age.[127]

Widows with large fortunes were a much-sought-after commodity in Elizabethan England, so that in June 1597, barely a year after her husband's demise, Chamberlain reports that Lady Unton was 'in parley with Master George Shirley of Northampton or Leicestershire'. The wooer was ardent, the widow reluctant.[128] She stood upon terms, Carleton wrote to Chamberlain in March 1598: 'First she requires to reserve her own living to herself, and to bestow it without any control; second, she demands a jointure of £1,000 a year; thirdly, £500 in land to be tied upon her son if there should be one; fourthly, if it should happen that she and her husband fall out, she requires £500 a year out of his living, and to live apart from him, with that added to her living of Faringdon; and fifth, if she chance to find fault with her husband's unsufficiency to choose another bedfellow.'[129] In spite of conditions enough to daunt even the boldest of prospective bridegrooms, the marriage took place towards the end of 1598. Chamberlain tartly remarked that for his part 'as poor a man as I am I would not buy such another of the price'.[130] The bridegroom, who was thirty-nine, notoriously suspect as a papist, had just emerged from three years as a widower after the death of his first wife, who had been a 'woman of rare wit ... religious, sincere, chaste, charitable, humble and discreet, having a sweet and royal nature'.[131]

Dame Dorothy and her husband fell out two years later when she held court at her dower house at Faringdon.[132] Thereafter there are only passing references to her, usually at Faringdon or Astwell, her husband's house, which he rebuilt in splendid style at the beginning of the next century, and from which he dazzled his contemporaries by the munificence of his almsgiving. In 1622 he died 'in the bosom of his mother the Roman Catholic Church',[133] and Dorothy once more found herself a wealthy widow. Rumour had it that she would strike a match with her old servant, Sir Thomas Edmondes,[134] the diplomatist, who, like Carleton, had spent the early part of his career as secretary to her first husband on his 1591 embassy. A note on the fly-leaf of a copy of Inigo Jones's study of Stonehenge in the possession of Philip, Earl of Pembroke, states that 'my Lady Unton was Sir Thomas Edmondes' mistress at Paris'.[135] Lady Unton was never in Paris, but the imputation may not have been without

some grounds, for together with her brother, George Wroughton, he administered Faringdon for her, and it is his name which heads the list of personal beneficiaries in her will, when as her 'honourable friend' he received an 'agate cup'.[136] Dorothy did not remarry, but passed her remaining years at Astwell and her own dower house at Faringdon. An inventory of 1620 gives an accurate impression of the rich contents of the latter, in particular her large collection of pictures. In the gallery there were 'fifteen English pictures, hanged in tables' and 'XXVIII pictures of Romans and Emperors' besides 'thirteen tables of pictures in frames' in the parlour[137] and a further 'XXIIII pictures' at Astwell,[138] making a total of eighty in all.

Lady Unton died in 1634 at Faringdon. In her will she left instructions that she should be buried 'without any pomp or solemnity, and with as small charge as may be, in the night', and that she was to be laid alongside her first husband, Sir Henry Unton, in that tomb which she had so piously raised to his memory.[139]

The story does not end there, however: ten years later, in March 1644, Faringdon was occupied by royalist forces who garrisoned Faringdon House and held it against its rightful owner, Lady Unton's friend, Sir Robert Pye, to whom it had been conveyed in 1623 by Sir John Wentworth. In April of the following year Cromwell marched on Faringdon and seized the royalist commander, the rest surrendering, only to have the house captured and held once more for the King until, on 24 June 1646, the garrison surrendered under the terms of the Articles of Oxford to Sir Thomas Fairfax.[140] The violence and bloodshed of civil war had done much to eclipse the former glories of the Untons, for not only were the walls of Faringdon House battered and reduced to ruins, but so were the spire and south transept of the parish church, and along with them the tomb of Sir Henry Unton. Of that elaborate structure, replete with allegorical figures, pilasters, pyramids, painted and gilded coats of arms and recumbent effigy, there remains little today save the solitary figure of Lady Unton herself, a widow kneeling in prayer.[141] 60

This tragic bombardment, of course, explains why the church has a spire in the painting but none today; in fact this spire, together with attempts to depict the clerestory lights and the transitional arcading in the nave, are about the only features which hint that the artist might actually have seen Faringdon church at all. Apart from a new nave roof and south nave aisle, Faringdon church today is largely as it was left in 61
1646.[142]

The historian and divine Thomas Fuller writes in his *History of the Worthies of England*, published in 1662, that 'This ancient and worshipful name [of Unton] was extinct in the days of our fathers for want of issue Male, and a great part of their lands devolved by an heir-general to G. Purfue [Purefoy] of Wadley, Esquire, whose care is commendable in preserving the Monuments of the Untons in Faringdon Church, and restoring such as were defaced in the war to a good degree of their former fairness.'[143] George Purefoy was the grandson of Sir Henry

An honourable widow:
Lady Unton

59 The tomb as it was first conceived

60 The tomb today: Lady Unton kneels before her husband's epitaph

61 Faringdon church today. The spire, the south transept and the Unton tomb were destroyed in the Civil War

Unton's sister Anne, wife of Valentine Knightly, whose daughter Mary had married George Purefoy of Drayton, county Leicester. Besides the kneeling figure of Lady Unton there yet remained the slab bearing the inscription seen in the Memorial Picture above Lady Unton's head, between the figures of Fame and Victory. In 1658 George Purefoy incorporated this tablet into a wall monument, flanking it with two Corinthian columns, also apparently salvaged from the original tomb, and surmounting it by a shield charged with the arms of Unton impaling those of Wroughton.

But what of the subject of this chapter, the Memorial Picture? In her will dated 18 July 1634, Lady Unton left to Sir Robert Pye 'all my story pictures . . . unless the Picture of Sir Henry Unton, which I do give and bequeath to my loving niece the Lady Dering'.[144] Lady Dering, whose Christian name was Unton, was a daughter of Sir Ralph Gibbes of Surrenden and third wife of Sir Edward Dering. She died in 1676, leaving a son, Henry, of Pevington, county Kent, and a daughter, Dorothy, who married Thomas English of Buckland, also in Kent. The choice of the names of Henry and Dorothy was undoubtedly a reflection of Lady Dering's devotion to the Untons, and her son Henry carried the tradition well into the eighteenth century with a son called Unton. There is, however, no mention of the picture until it reappears in a sale of 'A Collection of Paintings belonging to a gentleman deceased' at St Paul's Coffee House in December 1743 or 1744.[145] In spite of the numerous inscriptions which covered the picture, it was catalogued as 'an old original historical picture of the late Sir John Unton, who married Anne Seymour of the Somerset family, and had the honour to be Secretary of State, Ambassador to France and Spain, and to hold many other great places under King Edward III. In this picture is represented the whole history from his cradle to his grave.' In the midst of this jumble of fact and fiction the Unton Memorial Picture made its entrance into the learned world of the eighteenth century. At the sale it was probably purchased on account of its Seymour connections by Algernon Seymour, Lord Hertford, later Duke of Somerset (d. 1750), in whose possession it was seen by Vertue in 1748.[146] He notes that it was 'but meanly done in oil colours' and that it was subsequently sold by auction to a 'Mr Reade', a descendant of one of the Unton ladies. From thence it passed into the collection of James West, at whose sale in 1773 it was purchased by John Thane, the printseller.[147] In his hands it regained its rightful identity; the masque was engraved for inclusion in Joseph Strutt's *Manners and Customs of the People of England* and the portrait for the 1808 volume of the *Antiquarian Repertory*.[148] When Thane died in 1814 the picture disappeared for over thirty years until it was rediscovered in an attic of a house in Chelsea in 1847.[149] Later, in 1866, it was exhibited for the first time at the National Portrait Exhibition, when it was owned by Henry Nugent Bankes.[150] On the latter's death, in 1883, it was sold along with the rest of his collection at Christie's,[151] to pass the following year into the possession of the National Portrait Gallery, where it hangs to this day.

Conclusion	THE ELIZABETHAN IMAGE

A Queen, a courtier and an ambassador: all three portraits are 'heroical devices' feeding, as Henry Peacham wrote of his emblems and *imprese*, 'both the mind and eye, by expressing mystically and doubtfully our supposition, either to *Love, Hatred, Clemency, Justice, Piety*, our *Victories, Griefs*, and the like'. All three fulfil this, celebrating in allegorical and emblematic form victory, love and grief respectively. The Procession Picture is a victory, reflecting distantly the triumphs of Roman emperors and the Petrarchan *Trionfi*, a device to parade a symbolic image of Gloriana's court as seen through the eyes of its last pageant-master, Edward Somerset, Earl of Worcester. The *Young Man amongst Roses* is an *impresa* of love, a device to be read in private, ultimately by the Queen herself to whom this knight wishes to express his passion. Sir Henry Unton's memorial is a monument to grief, a vision in painting of the thoughts which evoked those astounding tombs of aristocracy and gentry emblazoned with coats of arms, laudatory inscriptions and *memento mori*. In short, one begins to wonder whether perhaps Elizabethan portraiture is better regarded as a branch of the study of emblematics in the English Renaissance than placed within the conventional textbook niche allocated to it within the history of art.

The three pictures seem at first glance so very different, and yet they are united, not only first and foremost as devices, but in the assumption they work on as to the nature of the painted image. It is essentially a schematic and episodic view of a picture's surface. Inscriptions, emblems, symbolic objects and whole inset scenes are meant to be read separately as well as together; they are not governed by the single perspective viewpoint as re-created by the artists of Renaissance Italy. Ideas and emotions are not expressed through the mask of the face, but transmitted by means of motto and symbol.

All this suggests that a more intensive study of the visual evidence of the Elizabethan age could throw new light on the conventions of literary pictorialism as consistently practised by its writers. Perhaps it will. But here we stand on the brink of the new century. The pictures we have studied were painted about 1601, 1587 and 1596 respectively; by 1620 the visual premises from which they sprang had virtually been replaced. The

first salvo was fired in 1605 when Inigo Jones presented the *Masque of Blackness* for Anne of Denmark, and the court was given its first taste of the picture frame used to embrace a space and present to the fixed eye of the viewer a geometric totality receding into distant perspective. It came in portraiture less suddenly, but by the opening of the second decade it was there. What one wonders most is how this must have struck the average Elizabethan. He was, after all, suddenly being asked to learn a new set of optical principles, not only in the visual arts but, by inference, also in looking at nature around him. The new premises were promoted by a new dynasty, who saw the lines of this geometrical totality converging upon themselves, exalting their divinity to new heights of grandeur. Elizabeth had no need for such lines of false perspective to draw men's eyes to contemplate her. The basic assumptions of Elizabethan vision suited her court style well, above all because it was more comprehensive, diffuse and ambiguous. The strength of the Elizabethan image lay in its capacity to be read and re-read many ways and never to present a single outright statement which left no room for manoeuvre, as did its successors in the new style. All the riches of Renaissance philosophy and learning could be set into it, but, in a way typical of the Elizabethan age, the outward covering was neo-medieval. Each painting achieves its effect by using a multiplicity of images to construct for its subject a three-dimensional world in which the third dimension is that of time rather than of space; and this is a habit of mind essentially medieval, but perfectly adapted to the needs of a post-medieval age. So too was the pageantry of Elizabeth's court, and it is to this that I should now like to turn.

PART TWO

THREE PAGEANTS

R *eserve, sweet spring, this nymph of ours*
E *ternal garlands of thy flowers,*
G *reen garlands never wasting;*
I *n her shall last our state's fair spring,*
N *ow and for ever flourishing,*
A *s long as heaven is lasting.*

Sir John Davies, *Hymns to Astraea*

Introduction THE ROYAL IMAGE

The Elizabethan monarchy did not only need powerful verbal and visual images to hold a divided people in loyalty; it also demanded the development of an elaborate ritual and ceremonial with which to frame and present the Queen to her subjects as the sacred virgin whose reign was ushering in a new golden age of peace and plenty. In order to achieve this, the apparatus of the formal progress through the countryside was deliberately developed. More important still, state festivals were designed which would re-focus pre-Reformation loyalties and enthusiasms in a different direction, not towards God so much as to the Crown, or rather to God through the Crown as embodied in the Queen as the Lord's Anointed. The great events of the Catholic year had been the feast days of the Church, Christmas, Easter, Whitsun and Corpus Christi, which had been marked not only by liturgical splendour but by secular rejoicing. In the new Protestant society of Elizabethan England all this had been swept away, churchgoing becoming a colourless experience as the congregation listened to the word of God and contemplated the whitewashed walls of the church. Secular rejoicing was severely discouraged. But all those natural impulses to celebrate in market square and on village green did not vanish overnight; they needed to be redirected.

In no other country in Europe in the late sixteenth century was this re-focusing so overt as in England, where there was an outright transference to the monarch. Under Elizabeth her Accession Day, 17 November, was deliberately developed as a major state festival, with celebrations on a national scale embracing not only the court but the whole country, town and parish alike, animating the entire community at every level into a united paean in praise of the virgin of reform. Bells rang, bonfires blazed, guns were fired, open house was kept, festival mirth reigned and to the parish churches of England the faithful came to thank God for the reign of their Queen. At court there was a solemn tournament, to which the public had access, where everyone could see Gloriana receive the homage of her knights. And on that day from the government-controlled presses fell prayer books, books of devotion, poems and ballads extolling her virtues. By the middle of the reign the rejoicings began to spread over to

Elizabeth's birthday, 7 September, and after 1588 to 19 November, once the feast day of St Elizabeth of Hungary but now annexed to mark in perpetuity the defeat of the mighty Armada of Spain. More than her legendary progresses, these annual events which spanned virtually the whole reign must have been a powerful influence in creating the sense of the uniqueness of the age. Every single subject once a year was reminded that 17 November 1558 was a turning point in time, and for nearly half a century they were able to express what they felt about this to its living embodiment. What started as propaganda became, in time, a reality.

As in the control of the painted image, the ceremonial one was deliberately and carefully composed. These annual manifestations of Tudor queenship were built up as a liturgy of state unfolding itself across the seasons; and it is to these aspects of *Eliza Triumphans* that I come in what might be described as three pageantry essays. These are examinations of the two most important public appearances in the year of the Queen to her subjects – the first as sovereign of a medieval order of chivalry, the Order of the Garter; the second, and more important, as heroine of her own Accession Day. Both were superbly stage-managed occasions; in both all levels of Elizabethan society could take part as either performers or onlookers. There was never any of the isolation of court from town and country typical of Stuart kingship. At one and the same time Elizabeth could receive rudimentary acclaim as the bringer of peace, justice and the purity of God's word, and have the most abstruse sentiments attired in all the riches of Renaissance philosophy and learning poured forth in her praise. Hester, Deborah and Judith, the Protestant virgin of reform smiting down the Pope of Rome, became the lady and princess, the mistress of the sonnets, the heroine of a thousand romances.

Accession Day celebrations and Garter ritual really give us the key to Elizabethan court fêtes, a subject at once confusing and frustrating. Although John Nichols produced his celebrated three volumes on the *Progresses* in 1823, it remains an aspect of the Elizabethan age dogged by patchy and uneven documentation. Vast tracts of material clearly never survived, and as a result one is feeling towards generalities on inadequate evidence. Nonetheless, the central thread is clearly the political one, and it is remarkably coherent. In these pageantry essays I have therefore attempted to draw out this political aspect, at the same time using it as a basis upon which to suggest the wider implications in respect of the Elizabethan idea of monarchy.

In their enthusiasm for the celebrations of her Accession Day her subjects were enunciating and giving support to a revolutionary view of history, re-cast to sanctify Tudor and above all Elizabeth's own rule. Not only is it an overt manifestation of the adoption of Protestant historiography, but, within a wider context, it promotes Elizabeth as a Queen within an eschatological framework in which she assumes the dimensions of a ruler of the Last Days, whose virtues alone hold back the reign of Antichrist.

In the essays on the tilts and on the Order of the Garter a further dimension of the Elizabeth cult is indicated, again a variant on a European phenomenon of the late sixteenth century, the refeudalization of society. In Protestant England, always on the fringes of the revolutionary humanistic and classicistic movements of Renaissance Italy, this feudal tradition was never really shattered. For Elizabeth it was a continuation and revitalization of the traditions of Burgundian chivalry of her father's court, but intensified. The Elizabethan vision was a neo-medieval one with its mania for genealogy and heraldry, its exuberant enthusiasm for tilts and tournaments, its passion for castle architecture transmuted into terms of glass instead of stone, its delight in romances expressed in the epics of the age. And yet this Protestant neo-medievalism was not at all inimical to the achievements of the Renaissance mind. In England we see these laid over an earlier tradition. Just as the Procession Picture and the *Young Man amongst Roses* use a medieval optical sense to transmit a Renaissance image, rich in allusions, so too do the great fêtes. That doyen of neo-medieval romance at the court of Elizabeth, Sir Henry Lee, retired as Knight of the Crown at the tilt of 1590, not encircled by clouds of Arthurian romance but against an archaeological reconstruction of the Vestal Virgin Temple.

In an exploration of court pageantry we can catch above all the attitudes of the Queen herself. These annual state festivals were essentially hers, and they reflect directly what she demanded and liked. They epitomize the image of the Elizabethan monarchy as her tortuous mind conceived it, complex and full of paradoxes and contradictions. This calculated ambiguity is brilliantly expressed in the multitude of names under which she was celebrated. God's anointed, the guardian of the Gospel, the virtues personified, the biblical ruler returned, she is yet the sovereign of her knights, who not only show their fealty and devotion in the medieval sense but go on to find in her the heroine of their life's romance.

Elizabethan England was a divided society of Catholic, Protestant and Puritan, of new aristocracy and old, of rising and declining gentry, of burgeoning urban classes and depressed peasantry. And yet this isolated kingdom situated on the fringes of Europe was virtually alone in late sixteenth-century Europe in averting the disasters of civil war. A society is held together by the assumptions and images it carries in relation to the nature of power within its hierarchy. The Elizabethan monarchy, by dodging and leaving unanswered many crucial issues, by exploiting – and being fortunate enough to be blessed with – a remarkable woman, was able to cut across this fundamental divisiveness and find in the Crown an ambiguous symbol which held the hearts and minds of all its peoples.

IV NOVEMBER'S SACRED SEVENTEENTH DAY

Spenser, in a letter to Sir Walter Raleigh, explains that the pivot of his epic *The Faerie Queene* is an annual feast:

> . . . I devise that the Faerie Queene kept her Annuall feast xii. dayes; uppon which xii. severall dayes, the occasions of the xii. severall knights, are in these xii. books severally handled and discoursed.[1]

Further information about this feast is supplied by Sir Guyon, the personification of temperance, in the second book. Asked to explain his errand, he evokes a picture of Gloriana, the fairy queen, radiant as the sun, enshrined upon a throne reared up in the midst of the ocean. She is the mistress to whom the knight owes his homage.

> *An yearely solemne feaste she wontes to hold,*
> *The day that first doth lead the yeare around,*
> *To which all knights of worth and courage bold*
> *Resort to heare of straunge adventures to be told.*[2]

Spenser's literary antecedent for such an annual feast was, of course, taken from Arthurian romance, but his use of it strikes a note of reality. He was not the only writer to allude to this yearly institution. The idea of an annual festival in honour of Queen Elizabeth is a recurring one in the literature of the Elizabethan age.[3]

The use of this motif by Elizabethan writers had its basis in reality, in the customary solemnities each 17 November, the day upon which Protestant Elizabeth had succeeded her Catholic sister, Mary.[4] The festivities on Accession Day were both courtly and popular. At court there was a ceremonial tournament in which the Queen received the homage of her lords and gentlemen, who came to the tilt in disguise, often riding upon pageant cars attended by allegorical personages who in prose, verse and song paid the Queen tribute. These we shall come to shortly, in the next chapter. But the Queen's Accession Day was not only a court fête, it was a national festival. All over England Elizabeth's subjects expressed their joy in her government by prayers and sermons, bell-ringing, bonfires and feasting. It is this popular aspect, as opposed to the courtly chivalry of the jousts, which we shall follow here.

The idea of the deliberate institution of an annual anti-papal triumph had
been suggested to Henry VIII in a treatise, probably by Sir Richard
Morison, entitled *A discourse touching the reformation of the laws of
England*. This was back in the fifteen-thirties. He proposed to the King
the creation of a solemn feast in memory of the deliverance of the English
people 'out of the bondage of the most wicked Pharaoh of all pharaohs,
the bishop of Rome'. There ought, he wrote, to be set aside a certain time
each year both for teaching and preaching against the usurped power of
the pope and more especially in defence of the King's title of supreme
head of the Church of England. Further, anti-papal plays ought to be
substituted for the traditional folk mummings, for he shrewdly
remarked: 'Into the common people things sooner enter by the eyes, then
by the ears: remembring more better that they see then that they hear.'[5]
There is no evidence to prove that this tract had any influence upon the
Elizabethan festivities, and yet it reads like a blueprint for them. One can
certainly sense the appeal of this to a Burghley or a Walsingham as just
such a festival sprang up spontaneously to mark the anniversary of
Elizabeth's succession to the throne.

It is impossible to get to the bottom of how it all started, although the
belief late in Elizabeth's reign was that Oxford was the place of origin. In
his sermon in defence of the annual celebrations, preached in 1599,
Thomas Holland said that the first public observance of that day had
been instituted by Thomas Cooper, then Vice-Chancellor of the
university, and later Bishop of Winchester.[6] Before his translation to the
latter, he had held the see of Lincoln, and it was within his diocese that
Accession Day coincided with the feast of the patron saint, St Hugh of
Lincoln.

The Accession Day festivities were thus an adaptation of an old
Catholic festival to the ethos of Protestantism – how typically
Elizabethan! This is further corroborated by an early seventeenth-
century anecdote upon their origin. The story was told to a certain Brian
Twyne, who was collecting information about Lincoln College, Oxford,
by a Mr Widescue on 2 April 1610. Lincoln College was a pro-Catholic
stronghold at the opening of Elizabeth's reign, and popular suspicion
held that it was a Romanist seminary. Annually on 17 November the
college inmates enjoyed a 'gaudy day' in honour of their patron St Hugh.
It so happened, about the year 1570, that some of the revellers went to the
church of All Hallows to ring the bells for exercise. This resulted in the
descent of the mayor, who charged them with popery for ringing a dirge
for Queen Mary – to which one had the wit to reply that, on the contrary,
it was for joy at the present Queen's accession. At this the mayor departed
and ordered as many of the city bells as possible to be rung in the Queen's
honour.[7]

This is not altogether true, because bell-ringing in fact began earlier
elsewhere, but the Oxford city accounts establish that at an unusually
early date grander ceremonies became customary. In 1571 payment was
made for a sermon 'at the triumph of the fourteenth year of the Queen's

Majesty'. The next year's accounts contain entries for a preacher and an organist, besides purchases of bread and wine for a communion service. By 1573 the entries become important enough to be separated from the rest, and in addition to the usual payments there is one for gunpowder, indicating a salute.[8]

The reason for the spread of these observances was, as Camden the historian noted, the wave of popular feeling for the Queen which swelled after the defeat of the Northern rebellion of 1569 and more especially after the papal bull of excommunication issued in 1570.[9] These events were swiftly followed by a dangerous attack of smallpox in 1572, from which the Queen made a remarkable recovery. The crises of these and the ensuing years generated a fervent cult of Elizabeth, which ensured that the Accession Day celebrations, as Holland wrote, 'flowed by a voluntary current over all this Realm'.

Celebrations in town and country

The most essential feature of the annual triumph was bell-ringing. Bells, which many ardent Protestants had associated with popery, were now rung in honour of the Queen instead of the saints. Unlike other more ephemeral aspects, the ringing of bells can be traced through churchwardens' accounts, so that it is often possible to establish when a particular parish began to observe Accession Day. Only an exhaustive survey of the several hundred extant accounts could establish this picture with complete accuracy, but such a study would be repetitive in the extreme.[10] One fact is clear from an examination of many of these accounts: that the spread of the Accession Day solemnities, as they were not based upon government legislation, depended upon local interests and sympathies. Nonetheless, we must imagine the bells of every parish church ringing over the countryside, telling the parishioners that this was the day on which they should give thanks to Almighty God for the peaceful rule of their great Queen.

In the towns more elaborate ceremonies were often inaugurated. Accession Day represented a development of the medieval tradition of combining a feast day of the Church with secular rejoicing. The Reformation had swept away many important Catholic feast days, above all Corpus Christi, which had been the occasion for spectacular processions and pageants organized by civic and guild authorities. The rise of the Queen's Day festivities enabled these energies to be concentrated into a stream designed to glorify the monarchy and its policies. Town officials, anxious for government favours, saw to it that 17 November was observed with public rejoicing.

In Liverpool in 1576 the mayor, Thomas Bavand, ordered a great bonfire to be lit in the market square and gave instructions that all householders should likewise light fires throughout the town. The same evening he and his brethren banqueted, after which they went back to the mayor's house where he liberally distributed sack, white wine and sugar,

'standing all without the door, lauding and praising God for the most prosperous reign of our ... most gracious sovereign'.[11] What a marvellous picture this gives of the Eliza cult in action in an area of England she was never to visit! Payments for a stand from which the mayor and mayoress watched a play occur in the Coventry accounts for Accession Day 1578.[12] The same year in York, seat of the Council of the North, the city authorities ordered that officials should go decently apparelled to a sermon on Sunday, 16 November, in praise of the Queen's government, upon pain of such fine as the mayor thought fit.[13] Oxford, where it all began, continued to build up the festivities over the years. In 1585 money was expended for musicians, a sermon, alms distributed to prisoners and bread to the poor. In 1587 a drum player appears for the first time, and three years later payments for bonfires begin.[14] At the other university town, Cambridge, Accession Day was celebrated with orations in the colleges and bonfires in the courtyards.[15] It was also enacted that doctors on that day were to wear their scarlet robes to add to the solemnity.[16] In Leicester too the wearing of scarlet by the mayor and corporation was extended to Accession Day in 1587.[17] At Maidstone in Kent, Queen's Day was the occasion of ringing, a salute, a firework display and the roasting of venison in the open. It was marked by a pageant which was carried through the streets like the London Lord Mayor's pageants, and in which children acted.[18]

The defeat of the Armada in 1588 signalled the development of these state festivals to new extremes. On Accession Day in London Thomas Cooper, Bishop of Winchester, preached at Paul's Cross before the City Fathers.[19] November 19 was appointed as a solemn day of thanksgiving throughout the country,[20] and in London the city companies assembled again at Paul's Cross to hear a sermon. The climax, however, was the Queen's entry into London. Already on 7 November the city authorities had issued orders that the companies should line the route with their hoods on and in their best clothes.[21] The Queen postponed her visit until Sunday, 24 November, when 'imitating the ancient Romans' she rode in triumph in a symbolic chariot, 'Made with four pillars behind to have a canopy, on the top whereof was made a crown imperial and two lower pillars before, whereon stood a lion and a dragon, supporters of the arms of England, drawn by two white horses. . . .' Behind it rode the Earl of Essex leading the horse of estate, and then came the ladies of honour. It must have looked not so very different from the Procession Picture. The streets were hung with blue cloth, and at Temple Bar the city waits were stationed making music; it was here that the mayor yielded up and received again the mace. St Paul's Cathedral was adorned with the banners of the vanquished Spaniards, and there waited over fifty clergy arrayed in their richest copes to greet the Queen. From a specially constructed closet she heard the sermon at Paul's Cross, and in the evening returned by torchlight to Whitehall.[22] Not to be outdone, other towns also arranged celebrations. Shrewsbury kept 17 November 'holy unto the Lord, that had given her Majesty such victory'.[23] In

120

Nottingham there were bonfires, and in Maidstone a pageant was borne through the streets. The accounts contain payments for its construction and decoration, for costumes for the child actors, for fireworks and for the trumpeters, musicians and torch-bearers who escorted the show on its triumphal progress through the town.[24] Bristol, in line with London, kept the 24th 'with the greatest solemnity', the mayor and city officials attending a sermon and communion service, after which the day was spent in almsgiving.[25]

There was no flagging in these festivities as the reign drew to its close. In 1589 Northampton celebrated Accession Day with an exercise of arms, in which the conduit in the market place was transformed into a castle and the front of the town hall enclosed with a fence and gates. Forces stationed within the castle were besieged over a period of three days, until finally the whole thing went up in smoke.[26] Peele in his *Anglorum Feriae* describes the London solemnities for 1595 in honour of the 'fair Queen of Brut's New Troy':

> *What paeans loud triumphant London sings,*
> *What holy tunes and sacrifice of thanks,*
> *England's metropolis as incense sends.*[27]

The Bishop of London preached at Paul's Cross, after which trumpets and cornets, to which the choristers sang an anthem, sounded from the roof of the nearby cathedral. In addition the steeple was set ablaze with lights, the Tower shot off its ordnance and there were the usual bell-ringings and bonfires throughout the city.[28]

In great households up and down the country similar activities took place. Alms were given and sermons preached, and open house was kept for all comers.[29] Nor were the Accession Day festivities confined only to England. Wherever English ships voyaged there was merrymaking on 17 November. Hakluyt records that Hawkins and Drake, sailing for the coast of Brazil on the afternoon of 17 November 1582, shot off three pieces of ordnance in honour of the Queen.[30] Thomas Cavendish at Puerto Seguro in the South Seas honoured Queen's Day 1587 also with a discharge of ordnance, and in the evening a further salute combined with a firework display. The onlooking Spaniards were overcome with admiration.[31]

Prayers, poems and sermons

Official government action over Accession Day can be traced in the succession of special service books for use in churches on that day. Needless to say, it became a feast day of the established Church. Many churchwardens' accounts contain entries for the purchase of these books, the first of which was published in 1576.[32] Moderate in form, it was a collection of psalms, prayers and readings giving thanks to God for the reign of the Queen, who had delivered the English people 'from danger of war and oppression, restoring peace and true religion, with liberty both of bodies and minds'. Two years later an enlarged edition appeared,

framing Elizabeth against the kings of the Old Testament and ending up with two anthems billing her as the Lord's anointed:

> *Indue her (Lord) with vertue's store,*
> *rule thou her royal rod:*
> *Into her mind thy spirit pour,*
> *and show thy self her God.*[33]

Here we see government officially stepping in at last, a decade or more after the occasion had become a popular feast day.

In 1585 that prolific north country cleric, Edmund Bunny, produced his *Certaine prayers and other godly exercises for the seventeenth of November*, in order to promote the more widespread observance of the day in his area of England. It consisted of the familiar psalms, prayers and readings, but in addition Bunny affixed a commentary to each part of the service. The first two psalms were designed to recall the misery of the Church caused by the enemies of the Gospel. Thus were the people moved to remember how God had delivered them from 'the power of darkness'.[34] The recalcitrant, backward north, with its continued dalliance with Catholicism and the memories of the Northern rebellion still vivid, had good cause to profess conversion to the Elizabeth cult.

Most Accession Days evoked literary tributes in the Queen's honour. Often these were Greek and Latin verses designed for presentation to her on that occasion. In a series of poems presented to her by the High Master and boys of St Paul's School, probably for the 1573 Accession Day, Roman imperial themes dominate. The golden age and the royal Trojan descent are intertwined with the familiar blessings of the Queen's rule, peace and true religion. Elizabeth is hymned as *stella Britannis* and a *rarissima Phoenix*.[35] The Vice-Chancellor of Oxford, Lawrence Humphrey, wrote a *Carmen* for Queen's Day 1577 which dwelt on her restoration of religion:

> *Post tenebras lucem dedit, et post nubila solem.*
> *Illi omnis sit honos, laus et benedictio soli*
> *O metamorphoses grata, o mutatio foelix.*[36]

Roman imperial motifs recur in many of the poems which Robert Twist, alumnus of Westminster School, presented to Elizabeth in 1597: 'redeunt Saturnia saecla/Vltima caelstum terras Astraea revisit'.[37] Verses amongst the Hatfield papers, headed *Soli Angliae* and written for 17 November 1602, use the familiar theme of the Queen as the sun shedding the beams of true religion.[38]

But it is in the popular tracts and ballads that we come closest to the roots of the cult. Edward Hake's 1575 tribute goes straight to the blood-and-thunder language of a present-day Apocalypse. The rule of this pious and virtuous maiden, he says, is like that of David, Moses and Aaron, in contrast to the fire, blood, error and ignorance emanating from the Antichrist of Rome, 'the great beast and whore of Babylon'. God has selected Elizabeth 'that as by a star, the light and influence over things

122

beneath' should be radiated down upon her subjects. While the rest of the earth is wrapped in the thick mists of error, she has delivered them from the wicked Pharaoh of Rome and God will aid her to exterminate him forever.[39] A popular ballad for 1577 thanks God for the good gifts of the Queen's rule:

> *And grant our Queen Elizabeth*
> *with us long time to reign,*
> *this land to keep full long in peace,*
> *and Gospel to maintain.*[40]

On 15 November the following year the Stationers' Register lists a series of anthems and songs thanking God for the peace, both temporal and spiritual, which the Queen's reign had brought.[41] In 1584 there was a psalm of thanksgiving designed to be sung on 17 November,[42] and for 1586 verses sung in triumph at Berwick are extant:

> *Let not the raging rascals rude, of bloody popish band*
> *Molest our noble gracious Queen, or this her little land . . .*[43]

In the next year came *A prayer and thanksgyvings unto GOD for the prosperous estate and longe Contynuance of the Queenes maiestie*,[44] and Maurice Kyffin's *The Blessednes of Brytaine*. A series of excruciating verses praise the Queen as the personification of the cardinal virtues, and he enumerates her many achievements.

> *Adore November's sacred Seventeenth Day,*
> *Wherein our second sun began her shine:*
> *Ring out loud sounding Bells; on Organs play;*
> *To Music's Mirth, let all Estates incline:*
> *Sound Drums & Trumpets, renting Air and Ground*
> *Stringed Instruments, strike with Melodious sound.*

He goes on to describe how the knights jousted and the country folk spent Accession Day in rural pastimes. A marginal note adds that this day was 'more fit to be solemnized than many other days noted in the Calendar'.[45] So the pieces endlessly fell from the presses as the years rolled by. An extant ballad for 1600 shows no flagging in the familiar and by now almost trite themes, with the chorus:

> *The noblest Queen*
> *That ever was seen*
> *In England doth reign this day.*
>
> *Now let us pray,*
> *And keep holy-day*
> *The seventeenth day November;*
> *For joy of her Grace,*
> *In every place,*
> *Let us great praise render . . .*

> *To the glory of God*
> *She hath made a rod*
> *Her enemies to subdue;*
> *And banished away*
> *All papistical play*
> *And maintains the Gospel true.*[46]

One of the most important features of the festivities on Queen's Day was the sermon. Several of these were published. They make pretty turgid reading today, but at the time rapt congregations hung on every word of praise and prophecy. Needless to say they tell us a good deal about how people thought, or rather were made to think, about their Queen. Accession Day 1583 fell on a Sunday, and the Bishop of London celebrated it with great solemnity. Burghley, Leicester and other great officers of state were invited to hear Whitgift preach on that occasion.[47] He attacked those who disliked the annual triumph, for the Bible demanded that subjects render thanks to God for their ruler. Moreover, the Queen had delivered them from the cruelty and tyranny of the Bishop of Rome and opened the door of the Gospel. He digressed at length on the medieval pope–emperor struggle, with examples of popes and their crimes taken from the *Acts and Monuments* of John Foxe to prove the supremacy of the emperor over the pope. He justified the Queen's position as Governor of the Church on the basis of Pope Eleutherius's recognition of the mythical British King Lucius as God's Vicar, and of similar positions held by Constantine the Great and Justinian. Historical precedent as a backing for present innovation meant much to the Elizabethans.

Two undated Queen's Day sermons by Edwin Sandys, Archbishop of York, were published in 1585. The first is an allegory of England as a vineyard wherein flourishes a vine representing the English Church, 'blessed with a learned, wise, religious, just, uncorrupt, mild, merciful, and zealous prince to govern it'. But 'little foxes', the adherents of the Roman pontiff, 'the red bloody dragon' of the Apocalypse, seek to undermine it. Once again the popes are the epitome of wickedness: one poisoned the Emperor Henry IV, another sold himself to the devil. The second sermon takes the form of an exhortation to prayer and thanksgiving for the English Deborah, Hester or Judith, who, like Moses delivering the Israelites from the wicked Pharaoh, has rescued her people from servitude to Rome.[48]

Old Testament kingship revived was how most of the Elizabethans saw their Queen. John Prime, in the sermon which he preached in Oxford on Accession Day 1585, compared her to Solomon. He dwelt, following Foxe's narrative, on the dangers she had undergone as a princess,[49] a theme which was reiterated two years later by Isaac Colfe in a sermon at Lydd in Kent. By this time the cult of the Queen was reaching its apogee: 'Surely never did the Lord make any such day before it, neither will he make any such day after for the happiness of England.' Just as the head rules the body and the sun the heavens, so God has ordained the rule of

One in the commonwealth. Through the rule of this sole authority, the forces of Antichrist decay.[50] In 1588 Prime preached once more at Oxford, dwelling again on the Queen's preservation and comparing her deliverances to those of David. Through her great victory the divine Elizabeth has 'the brightness of God shining upon her'.[51] The next year Thomas White at Paul's Cross took up the theme of Old Testament kingship. 'I do not say she exceedeth these, to flatter her, but I say she resembleth them, to comfort us,' he says guardedly. The Queen, however, has at last drawn her sword against the enemies of the Gospel, for the saints must fight against Antichrist.[52] John King, preaching at York on Queen's Day 1595, compared the Queen to Josiah. The sermon contains the usual examples from Foxe on the pope–emperor struggle, and also the apocalyptic theme, for King foresees an era of chaos and darkness if the Queen dies; the five hundred years in which kingdoms rise and decline have already expired, and only the rule of God's handmaiden keeps disasters at bay.[53]

In many places the enthusiasm for the Queen was such that her birthday, 7 September, became an extension of the Queen's Day festivities, though it was by no means so widely observed. Like 17 November, it was the occasion for bell-ringing; ringing at Lambeth began as early as 1574, but in other churches it started during the eighties.[54] Similarly, sermons were preached. On her birthday in 1586 the Puritan Edward Hake made an oration at New Windsor. The themes used re-echo exactly those of 17 November, and indeed the printed version was designed as an Accession Day tribute. Foxe was once more heavily drawn upon, and the miseries of the Marian régime were rehearsed; but then, said Hake, God sent 'his holy handmaiden', who brought peace and true religion. The virtues of the English Virgin are hymned – above all her clemency, an imperial virtue, in which she excels even her ancestor Constantine. How can Catholics prefer the corrupt Antichrist of Rome to this paragon of the virtues? 'For you have turned yourselves from the Lord, and lifted up your horns against his anointed, your Prince and Sovereign.'[55]

Attack and defence

It is hardly surprising that some thought the excesses of the cult were getting out of hand. The widespread adulation of the Queen on her holy days began to arouse not only enthusiasm, but hostility.

It is unexpected to find dissidents amongst the extreme Protestant party, but one was the Puritan Robert Wright, chaplain to Lord Rich at Rochford in Essex. As a religious malcontent, he was eyed with suspicion by the authorities, and their opportunity to seize him came when he attacked a sermon preached by the local parson urging the celebration of Accession Day, comparing the Queen to Romulus, Alexander, and Lycurgus, 'subjects of idolatrous worship', and saying that 'as their birth-day was celebrated, we ought in like manner to solemnise *Initium Regni*'. After being twice brought before the ecclesiastical commissioners

in October and November 1581, Wright was thrown into prison. He submitted the following year, but his objection to the annual triumph was sharp and to the point. Making 17 November a holy day with a sermon and prayers would make the Queen 'a god'.[56]

For Catholics, the cult of the Virgin Queen enshrined in her festival day seemed a deliberate attempt to supplant the pre-Reformation cult of the Virgin. Edward Rushton, in his continuation of Nicholas Sanders's *De Origine ac Progressu Schismatis Anglicani*, wrote that the Queen's birthday and Accession Day were observed with more solemnity than the great festivals of the Church. In particular the fervent devotion to the English Virgin and the contempt for the Virgin Mary, upon the eve of whose nativity Elizabeth's birthday fell, shocked him.[57] Over a decade later in 1597 another Catholic polemicist, William Rainolds, took up the attack and regarded the celebrations as revivals of the idolatrous festivals of the world of antiquity.[58]

The theologians of the established Church rushed to its defence. The charges of Rushton and Rainolds were answered at some length in a tract which Thomas Holland attached to his 1599 Queen's Day sermon, published in 1601.[59] He saw no reason to believe that the solemnities of that day reduced 'men back to the fearful abomination of heathenish idolatry', for it was a day grounded infallibly upon God's word. 'A day wherein our Nation received a new light after a fearful and bloody Eclipse . . . a day wherein God gave a rare Phoenix to rule this land.' As for the neglect of the nativity of the Virgin, he replied that the real festivities took place in November and not on the Queen's birthday. The Queen's Accession Day was better to be commemorated than the popish St Hugh of Lincoln, and the service used on that day was 'no wise impious'. In an epilogue to this defence of the institution, the familiar backcloth of apocalyptic thought is sketched in: all the great religious changes of the century had been predicted in *Revelation*; Rome was the Beast of the Apocalypse against which each nation had revolted, and the result was a chaotic struggle between the forces of darkness and light. In a sermon preached in defence of the celebrations by John Howson on the last Elizabethan Accession Day at Oxford, attention was drawn to the Masses which used to be celebrated on the birthday and coronation day of Mary Tudor. Moreover, the early Christian emperors had inaugurated such festivities. But the most important argument in answer to the Catholic charges was that 'no man is forced by law to this solemnity'.[60] These defences suggest that the Elizabethans knew perfectly well that they were on theologically thin ice when the feast day of the Virgin Queen assumed the proportions of Christmas and Easter.

Queen's Day and the Elizabethan idea of history

The Queen's Accession Day was therefore deliberately built up as a great national festival, a day on which her subjects were reminded of their deliverance from the powers of darkness, on which a new era dawned for the English Church, a day on which the imperial cause triumphed over

126

the papal. But although it was a celebration of a deliverance from darkness, it was also constantly reiterated that the forces of evil still menaced England both within and without. The chaotic hordes of the Antichrist of Rome were only kept at bay while God's holy handmaiden ruled. Chaos would be let loose if ever she ceased to guide the realm of England. It was an atmosphere charged with these thoughts that generated the fervent cult of the Queen.

The complexities of eschatological and imperial theory were never far away from the Accession Day themes. The doctrine of the Four Monarchies, the Assyrian, Babylonian, Greek and Roman, was stated with renewed vigour; the last of these was the Roman empire, the imperial status of which had devolved, according to the Anglican apologist Bishop Jewel, upon individual rulers of sovereign states.[61] The Reformation in England had been carried through on the basis of the imperial position of the English Crown, and Elizabeth as an empress inherited the role of the restraining power which St Paul mentions in his second Epistle to the Thessalonians. It was her part to restrain the forces of Antichrist, identified in Protestant thought with the papacy.

In England the Protestant concept of history found its most influential exponent in John Foxe. Emphasis has already been laid upon the *Acts and Monuments* as a handbook to the themes which were reiterated with relentless monotony through the literature and sermons.[62] In 1571, coinciding with the rise of the Accession Day festivities, convocation promulgated an order that a copy should be installed in every cathedral church that any might come to read. It was also to be seen in parish churches and noblemen's houses.[63] As a book it was designed for easy reading; at intervals throughout the text Foxe expounded his basic ideas, and for the illiterate there were the numerous woodcuts which expressed the themes in visual terms. Foxe intended his work not only for the learned but more especially for the ignorant who were in need of 'the light of history'. Next to the Bible it was the most influential book in Elizabethan England.

The most important feature was its conception of universal history.[64] This was a drastic reinterpretation made convincing, first by the number of original documents quoted *in extenso*, and secondly by embracing history within the framework of divine revelation, for Foxe applied to human history his solution to the mystical numbers of the Apocalypse. The first three hundred years of the Church's history were years of persecution and purity. The next three hundred were years of peace in which England received the faith, he claimed, from St Joseph of Arimathea or at the very latest under King Lucius. It was a pure primitive Christianity, which reached its flowering under the English Emperor Constantine. Decline followed, marked by the arrival of the popish Augustine, and although Satan was still bound up, yet the way was being prepared for the coming of Antichrist. In book four the 'proud and misordered reign of Antichrist' begins to stir in the Church, especially in the figure of Gregory VII, a 'sorcerer'. In the fifth book

Antichrist, identified with the triumphant papacy, is let loose upon the earth, but God favours England by raising up Wyclif and a climax is reached in the resumption of imperial status by Henry VIII. The book ends with the death of Mary; after lengthy narratives of the sufferings under the Marian régime it finishes on a note of triumph, the accession of Elizabeth. God's holy handmaiden, herself a Marian martyr, has succeeded to the crown. Divine revelation, political and religious history all converged upon the accession of the Virgin Queen, the final victor in the pope–emperor struggle, the restorer of the old pure imperial Constantinean religion, the leader of the battle against the Antichrist of Rome. These are the themes for which the Accession Day stood. The Queen's Day festivities were in reality a glorification of a certain concept of history. The creation and promotion of 17 November as a state festival was much more than a tribute to the achievements of a lonely, ageing woman; it was an affirmation and propagation of a concept of time and truth. Its rituals and literature cast the reign of the virgin of pure reform in a context unrelated to previous historiography. It helped to establish the myth that the Elizabethan age was different – a different era, a new beginning, a *renovatio* of ancient purity long lost. And it helped to create the 'uniqueness' of the reign, not in retrospect but while it was actually being lived. In its cyclical view of history, Elizabethans were taught to view their Queen's reign as a rebirth. In the celebration of 17 November each year they were recognizing such a *renovatio*. By the close of the reign, history for most of them really began on 17 November 1558, and all lines of thought and action converged toward it and diverged from it.

V FAIR ENGLAND'S KNIGHTS
The Accession Day Tournaments

Inserted into the middle of Thomas Campion's *Observations on the Art of English Poesie* there occurs a poem, written in solemn measured verse, evoking a picture of Queen Elizabeth I surrounded by her loyal subjects watching the opening of a stately joust:

> . . . *the knights, in order armed,*
> *Ent'ring thereat the list; addressed to combat*
> *For their courtly loves; he, he's the wonder*
> *Whom Eliza graceth.*
> *Their plumed pomp the vulgar heaps detaineth,*
> *And rough steeds: let us the still devices*
> *Close observe, the speeches and the musics*
> *Peaceful arms adorning.*[1]

Suddenly this brilliant scene is dispelled by a downpour of rain and the magnificently accoutred combatants retire, their plumes bedraggled, from the field. The poet is describing a tournament held on 17 November 1599, Queen Elizabeth's Accession Day, when the weather proved 'so foul' that the festivities had to be postponed for two days.[2] But what, we may ask, were 'the still devices . . . the speeches and the musics' which Campion refers to as adorning these occasions? Recent research has suggested that these tilts exercised a potent influence on the imagination of the Elizabethan age, representing as they did a marriage of the arts in the service of Elizabethan statecraft.[3] Through these festivities the ancient allegiances of chivalry were drawn close to the Crown and there occurred something of an imaginative refeudalization of late Tudor society.

Sir Henry Lee:
Laelius and the tilts

Although evidence is tantalizingly fragmentary, there is no doubt as to who started it all. William Segar, painter and herald, writing at the very end of the Elizabethan age, tells us that the Accession Day Tilts were begun by Sir Henry Lee at the beginning of Elizabeth's reign.[4] Lee's own epitaph likewise lauds him for having raised 'those latter day Olimpiads of her Coronation jousts and Tournaments',[5] while in one of the speeches

129

he wrote for a tilt he refers to himself as the 'first Celebrater, in this kind, of this sacred memory of that blessed reign'.[6]

Who was this Sir Henry Lee, and why is he so important for the myth of Elizabethan chivalry? To place Lee in perspective we need first to reconnoitre back in time.[7] The Lees of Quarrendon were one of those gentry families who had risen to prominence at the end of the Wars of the Roses. The fortunes of the family were laid by Robert Lee, Henry's grandfather, who, after holding various minor offices at court, was knighted in 1522, became a Knight of the Body, sat in parliament as county member and bought extensive estates in the Quarrendon area of Oxfordshire. For his second wife Robert had taken Lettice Peniston, widow of Sir Robert Knowles, thereby laying the foundation of that connection to which his grandson owed so much. Francis Knowles, Lettice's son by her first marriage, married Katherine Grey, daughter of Mary Boleyn, and became thereby cousin to Queen Elizabeth. Lettice's granddaughter and namesake married successively Walter Devereux, Earl of Essex and Robert Dudley, Earl of Leicester. Sir Henry Lee was to have good cause more than once in his life to be grateful for his grandfather's fortunate match.

On Robert's demise in 1539 the Lee estates passed to his eldest son, Anthony, who married Margaret, daughter of Sir Henry Wyatt of Allington Castle, thereby becoming brother-in-law to Sir Thomas Wyatt, the poet. Anthony died in 1549, leaving Henry, his successor, heir at the age of sixteen. The young Henry was brought up in the household of his uncle the poet, a childhood which must have exercised a decisive influence on his literary bent. His epitaph states that he served 'five succeeding princes, and kept himself right and steady in many dangerous shocks and three utter turns of state' – not a bad achievement in Tudor England. Lee owed his survival to connection as much as anything. His marriage in 1554 to Anne, daughter of William, Lord Paget, one of Mary's most trusted advisers, secured immunity through that reign, while on the accession of Elizabeth his connection on the one hand through the Cokes with Sir William Cecil, and on the other hand with the Knowles and Hunsdon families, ensured favour in what were often rival factions at court. Under Cecil's auspices he was employed on various diplomatic missions on the continent during the sixties, thus travelling widely in Germany, Italy and the Low Countries and returning, we are told, 'a well-formed traveller, and adorned with those flowers of knighthood, courtesy, bounty, valour'. We catch a revealing glimpse of him at this period in Antonio Mor's portrait, which shows him staring out 62 full of confidence, good-looking if not classic in feature, with fair curly hair.

The turning point in Lee's career came shortly after this, when he made his entrance as an actor in court festivities. If Sir Christopher Hatton can be said to have danced his way into the Queen's favour, Lee may truly be said to have tilted his, for there remains a fundamental liaison between his festival and court careers. In 1571, the first year he is

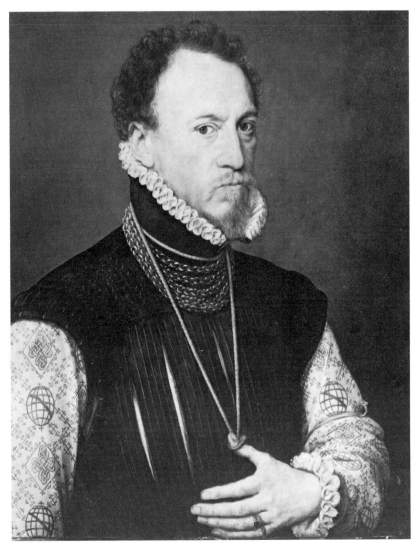

62 Laelius: Queen Elizabeth's Champion at the tilt and the originator of the Accession Day Tilts, Sir Henry Lee, at thirty-three

definitely recorded in the tiltyard (not on Accession Day), he was appointed Lieutenant of the Royal Manor of Woodstock, where the Queen visited him the next year. This was followed in 1574 by the post of the Master of the Leash, and in the same year he received the Queen again at Woodstock. Thenceforward Lee appears in all court fêtes until finally, in 1580, he was made Master of the Armoury.

Segar, as we have seen, believed that the Accession Day Tilts began with the reign; but he was writing in the last year of the old Queen's rule, when already the origins of the tilts had been lost in obscurity. La Mothe Fénélon, the French ambassador, writing in 1572, refers to a fête at court as being customary on 17 November,[8] and other evidence corroborates his statement. Camden states that the tilts started at about the same time

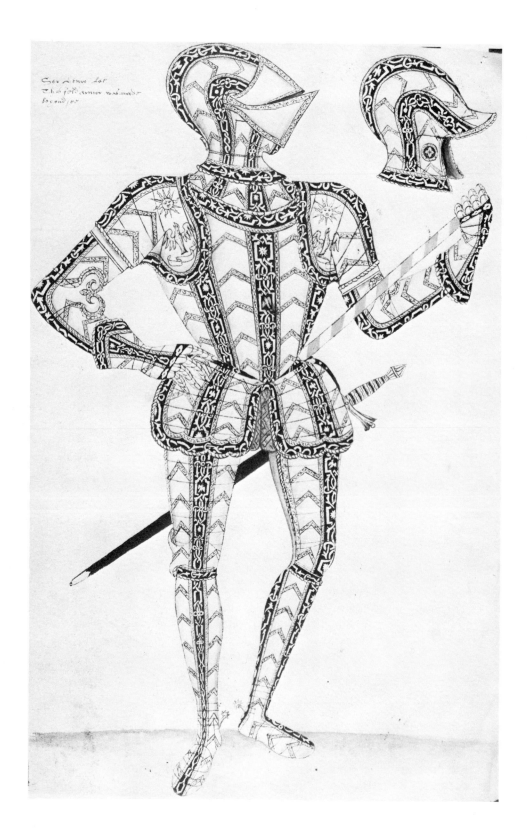

as the popular festivities which began in earnest about 1570.[9] I would think it unlikely that the tilts began much before 1572, and we only really know about them in any detail from 1581 onwards, when the visit of the Duke of Anjou as a prospective bridegroom for the Queen prompted an especially elaborate tilt to impress the French visitors, and for the first time it was held in the tiltyard at Whitehall.[10] All this would suggest that the tilts had begun in a casual way, as an informal joust staged by the gentlemen of the court in the Queen's honour, but by 1581 had been deliberately developed into a gigantic public spectacle eclipsing every other form of court festival.

Of Lee's personal appearance at, and supervision of, the Queen's Day shows from at least 1581 onwards until his retirement in 1590 there can be no doubt, for contemporary jousting cheques (score cards) and tilt lists record his presence in the capacity of Queen's Champion at the tilt. Even after his resignation in 1590 from this post he was still, on the Queen's orders, to be present at every annual joust, 'there to see, survey, and as one most careful and skillful to direct them'.[11] How far he fulfilled this it is of course impossible to say, for Lee spent most of his old age on his country estate at Ditchley near Woodstock in Oxfordshire. We know, however, that he appeared as a Restless Knight at the 1597 tournament, and that the following year his old tiltyard comrade, Essex, forced him to emerge from retirement to help with the staging. Lee was by then reluctant, as he wrote, with 'a white head, a hoary beard', and 'lame and halt', to thrust himself among the young tilters, but nonetheless, if he thought the Queen would be offended by his absence, he would labour to wait on her.[12] Segar refers to him as still taking some part in organizing the Accession Day shows in 1602 – his presence no doubt sorely needed after the fall of Essex – and he makes a final appearance at the age of seventy-one at the first of James I's Accession Day Tilts, on 24 March 1604, when as 'old Sir Henry Lee' he was given a place of honour as one of the judges.[13]

If we want to know what Sir Henry Lee looked like in his prime on these festive occasions, we should look at the drawings for his armour in the Almain Armourers' Album, a record of designs for Greenwich School armour, in the Victoria and Albert Museum. On the pauldrons of one suit golden eagles rise towards the sun. A later one, still extant, is etched with the initials AV intertwined with true-lover's knots – definitely not a suit for close inspection by the Queen, because they refer to Lee's final *amour* with Anne Vavasour, a lady of good family but doubtful character, who lived with the Champion in the country as his mistress in the nineties. Best of all are the glimpses of Lee under the name of Laelius in Sidney's *Arcadia* and in Josuah Sylvester's translation of Du Bartas' *Les Semaines*. In the *Arcadia* Lee tilts against Sidney as Philisides, the Shepherd Knight, and Laelius is described as 'second to none in the perfection of that art'.[14] Sylvester, over two decades later, evokes the doughty knight in retrospect, inserting his tribute when discussing the sun about to enter its course through the heaven:

63

63 Sir Henry Lee's armour

As Hardy Laelius, that great Garter-Knight,
Tilting in triumph of Eliza's right
(Yearly the day that her dear reign began)
Most bravely mounted on proud Rabican,
All in gilt armour, on his glistring mazor
A stately plume of orange mixed with azure,
In gallant course, before ten thousand eyes,
From all defendants bore the princely prize.[15]

The Accession Day Tilts

Any chronological analysis of the Accession Day Tournaments breaks down in the face of the fragmentary nature of the material. In any case, such an account would involve pointless repetition, as they worked more or less to a fixed formula which never varied during the thirty and more years of their history under Elizabeth. We can take as our guide the only full-length eye-witness account of a tilt, that of 1584 by a visiting German, Lupold von Wedel. He was most intrigued by the spectacle, and his description is worth printing in full:

> Now approached the day, when on November 17 the tournament was to be held. . . . About twelve o'clock the queen and her ladies placed themselves at the windows in a long room of Weithol [Whitehall] palace, near Westminster, opposite the barrier [lists] where the tournament was to be held. From this room a broad staircase led downwards, and round the barrier stands were arranged by boards above the ground, so that everybody by paying 12d. would get a stand and see the play. . . . Many thousand spectators, men, women and girls, got places, not to speak of those who were within the barrier and paid nothing. During the whole time of the tournament all those who wished to fight entered the list by pairs, the trumpets being blown at the time and other musical instruments. The combatants had their servants clad in different colours, they, however, did not enter the barrier, but arranged themselves on both sides. Some of the servants were disguised like savages, or like Irishmen, with the hair hanging down to the girdle like women, others had horses equipped like elephants, some carriages were drawn by men, others appeared to move by themselves; altogether the carriages were very odd in appearance. Some gentlemen had their horses with them and mounted in full armour directly from the carriage. There were some who showed very good horsemanship and were also in fine attire. The manner of the combat each had settled before entering the lists. The costs [of such pageantry] amounted to several thousand pounds each. When a gentleman with his servants approached the barrier, on horseback or in a carriage, he stopped at the foot of the staircase leading to the queen's room, while one of his servants in pompous attire of a special pattern mounted the steps and addressed the queen in well-composed verses or with a ludicrous speech, making her and

her ladies laugh. When the speech was ended he in the name of his lord offered to the queen a costly present. . . . Now always two by two rode against each other, breaking lances across the beam. . . . The fête lasted until five o'clock in the afternoon. . . .[16]

This is worth quoting not only because it describes the whole *mise en scène* at Whitehall, but because it records the action itself pretty accurately. Knights came either in pageant cars or on horseback, their servants attired in fancy dress appropriate to the theme of the entry; a squire ascended a staircase before the tilt gallery and in verse or prose explained the knight's disguise, after which he made a presentation to the Queen. What von Wedel refers to as a 'present' was in fact a pageant shield painted with the knight's *impresa*, the device he bore for the tournament; knights did give presents, but this was exceptional.

Score cheques and tilt lists in the archives of the College of Arms tell us all we need to know about who took part in these spectacles. From 1583 onwards there exists an unbroken series of cheques and lists for every tournament, and these establish that the hard core of tilters sprang from the ranks of the Queen's Gentlemen Pensioners. These were men of good family chosen for their handsome looks and manly presence, whose main function at court was one of forming a decorative escort for the Queen on state occasions. We can see them lining the route, halberd in hand, in Robert Peake's picture of Elizabeth going in procession. As the reign progressed, however, there was an increasing tendency to recruit tilters from the ranks of the young nobility, and the two or three lords who appear, along with the Gentlemen Pensioners and others, on the lists and cheques for the eighties rise to as many as nine at a tilt by the very end of the reign. These members of the nobility were men of power, substance and ambition, anxious to impress the Queen with their ability to fight and to turn a courtly compliment at the same time. The lists include the Earls of Cumberland, Bedford and Southampton, the Lords Compton, Howard of Effingham, Windsor, Dudley and Grey.

The chance survival of a note from Edward Somerset, 4th Earl of Worcester, Master of the Horse and hero of the Procession Picture, to Garter King of Arms sheds some light on the practical organization of these tilts:

> Mr Garter, whereas Mr Wrothe [Robert Wroth] hath made request to run with Mr Bellingham [Edward Bellingham], by reason whereof there must be some alteration [to the list?] I gave you, so now I charge you let Mr Morris [John Morris] be joined to Mr Buckley [Richard Buckley] and leave Mr Denton [Anthony Denton] to be last man to run with my Lord of Cumberland.[17]

From this note we learn that the administration of the 1602 tilt had fallen to Worcester in his capacity as Master of the Horse, an office which would seem always to have entailed a considerable part in the practical organization of the ceremonial tilt; previous holders were Essex and Leicester, both prominent figures in the tiltyard in their day.

In the final years of the reign other hands can be traced making their influence felt, particularly that of Sir Robert Cecil, whose tight grip is to be sensed in a series of letters from George Clifford, 3rd Earl of Cumberland, Lee's successor as Queen's Champion. Whatever the real reason, Cumberland wrote entreating to be excused from tilting because he had fallen from his horse and hurt his right arm:[18] possibly the truth of the matter may have been that he was reluctant to foot the bill such extravagant appearances entailed. 'I shall not be able to carry a staff,' he laments to Cecil, 'yet if you find it will draw any hard conceit of me, forbear to urge it, and upon word from you I will be ready to ride alongst the tilt, though I can no more.'[19] Cumberland was actually forced to joust in 1602, so that his appeals for exemption had fallen on deaf ears. Behind this incident one can certainly discern the figure of the ageing Queen, increasingly difficult to placate as the years wore on and ever more ready, in Cumberland's own words, to draw 'hard conceit'.

Accession Day marked the return of the Queen to London for the winter months. Prior to the day itself the court was usually in residence at Windsor, Richmond or Hampton Court at the end of its customary summer progress. Shortly before 17 November the Queen would make her state entry into London in order to reach the palace of Whitehall in time for the staging of the tournament. In 1598 she was met a mile outside London by the mayor and his brethren accompanied by a train of four hundred in velvet coats and chains of gold, and in this manner entered the city.[20] If the preparations in the tiltyard were especially elaborate, the coming of the court might even be delayed.[21] From 1581 onwards the Accession Day Tilts were all held at Whitehall, with one exception in 1593 when, because of the plague raging within the city, the tilt was staged beneath the walls of Windsor Castle, where the Queen's knights 'ran the course of the field' – that is, tilting without a proper barrier.

Of the tiltyard at Whitehall, which occupied roughly the place now taken by Horseguards Parade, we know a considerable amount.[22] At one end stood the tilt gallery, the 'long room' to which von Wedel alludes, which had been erected by Henry VIII and in which the Queen and her ladies sat.[23] From 1589 onwards it became the duty of the officers of the Chamber and Wardrobe to prepare this gallery against the Queen's coming to view the running. Von Wedel likewise records the staircase and scaffold or stage which gave access to it, the construction of which fell within the province of Her Majesty's Office of Works. In 1584 – the year which our German visitor describes – there is payment for constructing the 'stairs and scaffold under the Queen's window', and there are many other entries in connection with their periodic renewal and repair.[24] It was customary for distinguished visitors to sit alongside the Queen and her ladies;[25] the Russian ambassadors in 1600 were greatly impressed that they alone were allowed to join the Queen while, they triumphantly reported to the Tzar, the emissaries of the King of Barbary were relegated to stand below, beneath a canopy with the plebs.[26] Elizabeth, always astute on points of public relations, had issued orders for an especially

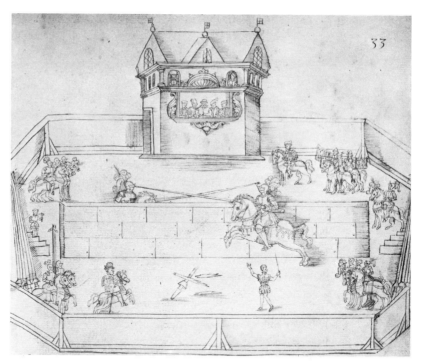

64 The judges seated in their box, keeping the score of lances shattered

solemn joust on that occasion, that they might 'hold it in admiration'.[27] Within the tiltyard there was also a pavilion in which the judges sat; this too was built by the Works and prepared by the officers of the Chamber. College of Arms MS. M 6 preserves the only known drawing of one of these curious structures, within which the judges, attended by heralds, can be seen taking down the score. Surrounding the tiltyard were scaffolds and stands where outsiders could gain admittance to the solemnities for the sum of twelve pence. Edward Alleyn, the theatre manager, records in his account book and diary that on 24 March 1620, James I's Accession Day, he 'rode to see the tilting: paid for a standing 0.1.0.'[28] In the midst of the lists stood the tilt rail itself, along which the knights rode and shattered lances one against the other.

The devices of their entrance

'For jousts, tourneys, and barriers; the glories of them are chiefly in the chariots, wherein the challengers make their entry; especially if they be drawn with strange beasts: as lions, bears, camels, and the like; or in the devices of their entrance; or in the bravery of their liveries; or in the goodly furniture of their horses and armour,'[29] wrote Francis Bacon in his essay *Of masques and triumphs*, recollecting no doubt the many splendid tilts he had seen and helped stage for his early patron, Essex, when he was still an up-and-coming young lawyer. Great was the preparation and great the expense for those who took part in the Queen's Day Tilt. Months before the day itself, work started with a decision by each knight as to his disguise, from which would emerge the symbolic

137

colours for his liveried servants and lance-bearers, the *imprese* for his shield, the props and pageant cars which had to be constructed and the actors who had to be hired. Some wrote and designed their own entries. Lee and the Earls of Essex and Cumberland probably wrote their own speeches, but for many it meant bringing in outsiders. Lee, we know, wrote speeches for the use of other tilters on Queen's Day;[30] Essex's secretary, Francis Bacon, had a hand in the composition of the lengthy literary devices with which the Earl always framed his splendid appearances, and Sir Robert Cecil may have brought in his protégé, the poet John Davies, to write a scenario for Accession Day 1601.[31] An interesting sidelight on this kind of activity is shed by letters in the Sidney correspondence. For the first appearance of Lord Herbert of Cardiff at the Accession Day Tournament of 1600 his tutor, Henry Sanford, had been called upon to exercise his wits, but it was feared that his influence would result in some 'pedantic Invention' unsuited to the entry of a gallant young lord. On this point Rowland Whyte begs the timely intervention of Sir Robert Sidney with some more appropriate device.[32] In the Jacobean period we find the ubiquitous Ben Jonson employed by Sir Robert and Sir Henry Rich to write graceful verses on behalf of 'two noble knights' who tender James I 'their lives, their loves, their hearts'.[33]

Appearance at the tilts was, as von Wedel records, expensive, and nobility and gentry had to dig deep in their pockets; Sir Robert Cary records that his disguise for the 1593 tournament, together with a jewel to mollify the offended Queen (he had married without permission), came to over four hundred pounds. Essex's expenditure on them was prodigious, and Essex after Lee's resignation in 1590 really dominated the tilts. For that same tilt of 1593 fifty-eight pounds was paid for 'necessaries', and Essex spent over a week at Windsor preparing for it. A badly damaged and undated section of his accounts headed 'Tilt' records payments of over eighty pounds 'against the 17th'; four pounds for hats for seven footmen; to the tailor of his sister, Lady Rich, for 'necessaries'; for staves and lances, and armour for a barriers. Under the Queen's successor expenditure rocketed. The accounts of the Earl of Rutland record that the 'charge of my Lord's tilting' on King's Day 1616 came to over a hundred and twenty pounds,[34] while the cost of Prince Charles's solemn entry into the tilt on Accession Day 1620 reached the staggering sum of nearly six thousand five hundred pounds, three times the amount estimated as spent on a Stuart masque.[35]

Sometimes actors had to be recruited. For Accession Day 1594 'certain scholars' were brought by Essex from Oxford. An entry for 'white taffeta to fold the crystal in delivered to Her Majesty 16 November' hints at some preliminary masque or entertainment prior to the Queen's Day pageant. Essex used scholars the following year, this time George Meriton and George Montaigne from Queen's College, Cambridge; Toby Matthew from Christ Church, Oxford; and one Morley, probably Thomas Morley, the famous madrigal composer and gentleman of the

Chapel Royal.[36] The character of Essex's extant devices, which drift sharply towards academic disputation rather than harmless romanticizing, demanded for their performance persons trained in the art of rhetoric. One senses under Essex a sharp professionalizing of the Queen's Day shows. The Lee period, which officially ended in 1590 with his resignation as Champion, was more amateur, more spontaneous in feeling. For the Jacobean period the Rutland accounts refer to the making of caparisons; the work of a painter in embellishing escutcheons, banners and coats; the purchase of apparel for pages and servants; the securing of trumpeters; and, more particularly, the painting of *impresa* shields.[37]

The action of an Elizabethan tournament followed closely that which was general throughout Europe in the second half of the sixteenth century in consisting of a series of triumphal entries into the tiltyard of knights attended by squires, pages and liveried servants. We have seen how von Wedel describes each knight and his train approaching the tilt gallery, and how his page or squire then ascended the staircase beneath the Queen's window to the platform, where he delivered his speech in prose or verse, and presented the Queen with his master's *impresa* shield. George Peele records the action in his *Anglorum Feriae*, evoked by Accession Day 1595:

> ... *his duty done; and large device*
> *Made by his page known to her Majesty.*[38]

There were of course variants on this procedure, particularly when a knight entered on a pageant which demanded dramatic action and parts spoken by several actors. Sir Thomas Gerard presented his own *impresa* shield at the 1602 tilt. It was reported that he was 'well disguised', in spite of the fact that his horse 'was no bigger than a good bandogge' (mastiff), and that his presentation to the Queen 'made her very merry'.

Surviving Accession Day speeches and devices provide a pretty good idea of what the Queen regarded as correct compliment for her at the ceremonial tilt.[39] The picture that they evoke is overwhelmingly romantic in sentiment, but they were also clearly meant to be funny. The Queen and her ladies expected eulogy and amusement, and it is the humour which is the most difficult to discern four hundred years later. Many of Lee's speeches survive in the Ditchley manuscript, now in the British Library. One is on behalf of an Enchanted Knight who cannot tilt, because 'his arms be locked for a time'. It is spoken by the Damsel of the Queen of Fairies, who recalls to the Queen the Enchanted Knight's valiant service 'not far hence' – referring perhaps to the time when the tilts were held at Greenwich – and presents her with a golden Cupid. There is also a sonnet spoken at the 1584 Accession Day on behalf of a Blind Knight, who has been overcome by the Queen, 'best flower of flowers, that grows both red and white'. Another introduces the Black Knight and his companions, the Wandering Knights, who have been cast into melancholy because they were unable to pay their accustomed homage at last year's tilt (evidence that the tilts unfolded a continuous

story), but who come now to 'make short payment of the debts of our hearts for the honouring of this day'. One speech, on behalf of a Knight 'clownishly clad', is for 16 November. It is spoken by a Hermit introducing the Clownish Knight and his companions, who are country folk, making petition at the end of a long rambling tale that on the morrow the rustics might run at tilt, or at least the quintain. Frances Yates has discussed the speech in detail and rightly concludes that it illustrates 'how Protestant chivalry in its religious aspects lends itself to pastoral allegory'.[40] But Lee's imagination sometimes reached beyond this attractive though monotonous romanticizing after more dramatic effects. His remembrance of Sir Philip Sidney, when a horse draped in deep mourning was led in at the 1586 tilt and verses spoken or presented bewailing the loss of that flower of chivalry, must have been remarkably moving. The Accession Day material in the Ditchley manuscript closes with the Restless Knight, whom age had turned from 'a staff to run with, to a staff to rest on'. This is Lee himself probably presenting his adopted son in chivalry, John Lee, son of Sir Henry's heir-designate, to his fellow tilters so that he, like them, might through the solemnities of the joust be led into the path of all virtue. Under the auspices of Lee the tilts may have become a kind of yearly review of the Elizabethan world as seen through the eyes of its unofficial pageant-master.

A similar romanticizing pervades the work of Lee's official successor as Queen's Champion, George Clifford, 3rd Earl of Cumberland. As Knight of Pendragon Castle he came to the 1593 tilt attended by sailors, his squire explaining how this unfortunate knight, returning from a voyage (he had actually been attacking Spanish colonies in the West Indies), had imparted to his crew that he would be returning to his 'interrupted sacrifice'. At this point the sailors had forced the knight to promise to take them to the joust, thus enabling an ancient prophecy to be fulfilled that:

65–6
75

> . . . when the Red Dragon led shipmen on dry land,
> Then blest be the earth for a maid in an island.

Cumberland's appearance at the 1600 tilt as a Discontented Knight was prompted by his failure to obtain the governorship of the Isle of Wight. Woes indeed beset this course, for he has been 'tripped up by Envy, until', his squire acidly informs the Queen, 'those overtake him that undertook nothing'. The knight threatens to retire if royal favour is not forthcoming, and he complains bitterly that he has nothing to show for so many years in Cynthia's service 'save only he is so many years the elder'.

Cumberland was Lee's successor, and the choice of him as the new Champion doubtless lay ultimately with the Queen. But he was entirely overshadowed by Robert Devereux, 2nd Earl of Essex, and if Essex's marriage to Frances Walsingham had not come to light in 1590 then undoubtedly he would have been chosen. As inheritor of the Leicester–Sidney connection, not only socially and politically but in keeping alive the myth of chivalry embodied in Sidney, Essex should

140

have played the role. Lee knew him well,[41] and one of the most precious of his jewels depicted him together with Essex running at tilt.[42]

The only scenario we have for an Essex tilt is that of 1595 which he wrote in collaboration with Francis Bacon and which Sir Henry Wotton, his secretary, referred to as his 'darling piece of love and self-love'. Numerous drafts and finished speeches relating to this performance survive, but its exact sequence is now difficult to divine. One senses above all that it was an extravagant flop. Essex, or, to use his tilt pseudonym, Erophilus, was described as poised between Love and Self-Love or Philautia. In the tiltyard he was wooed by the 'enchanting Orators of Philautia'; these were a Hermit (again a Lee figure), a Soldier and a Secretary who attempted to persuade him to adopt one of these three courses of life representing contemplation, experience and fame respectively. The theme was carried farther by another tilter disguised as a blind Indian prince, who had come from the Americas and was the son of a mighty king who ruled over such an empire there as the Queen herself did in this hemisphere. The prince received his sight at the Queen's hand and in doing so was transformed into Seeing Love, and so bid Erophilus's squire tell his master that since, in his blindness, he had chanced to fix his affection on the Queen, now, by his sight, let him find the way he might serve her best. Finally, that night, the tilting over, the Hermit, Soldier and Secretary re-entered and reiterated their arguments in interminable speeches by Bacon, after which the squire on behalf of Essex spurned them in favour of a life of service to the Queen. The language and metaphor was more than usually high-flown, and the Queen tartly remarked 'that if she had thought there had been so much said of her, she would not have been there that night; and so went to bed'. Added to this, it was widely believed at court that Essex was caricaturing certain prominent personages in the characters he used in his device. Whether or not this was true, Essex was certainly exercising on a grand scale the tilters' prerogative of exhibiting their travails in symbolic and allegorical form. A marginal note to one of the speeches in Bacon's hand explains that it was 'the Queen's unkind dealing which may persuade you to self love'. The 1595 tilt drama must be read as part of the programme of the Essex set to establish their hero on the path to 'domestical greatness'.

An autobiographical element was thus a standard ingredient of the tournament entry. In this way the romantic make-believe of the tilts could become a vehicle for discreet returns to favour. This sometimes took the form of the arrival of an Unknown Knight. In 1593 Sir Robert Cary, in disgrace with the Queen for having married, came as an Unknown Forsaken Knight, casting off his wonted mourning only to honour the holy day of his great mistress. The tilt list for 1600 likewise records the appearance of an Unknown Knight, which can certainly be linked with efforts by the Essex circle to use the tilt as a means for the Earl's return to favour. The attempt failed, but the Hatfield papers preserve the letter which Essex wrote to Elizabeth on that day, for all the world, in both style and content, like an Accession Day Tilt speech.

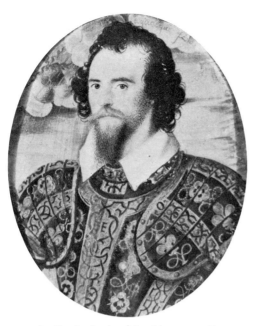

65 Cumberland wearing his armour. In the background is his *impresa*, a fork of lightning and the motto *Fulmen acquasque fero*

66, 67 Cumberland's armour, patterned with roses and fleurs-de-lis linked by true-lovers' knots

Laelius's successor, the Knight of Pendragon Castle, George Clifford, 3rd Earl of Cumberland

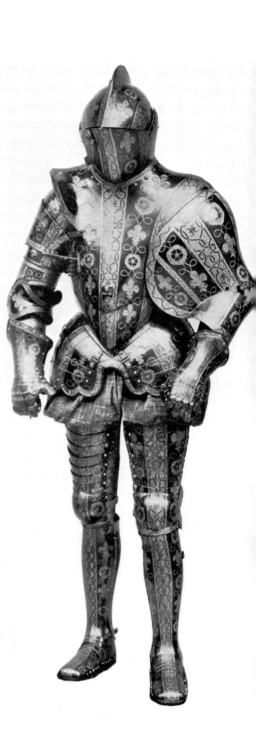

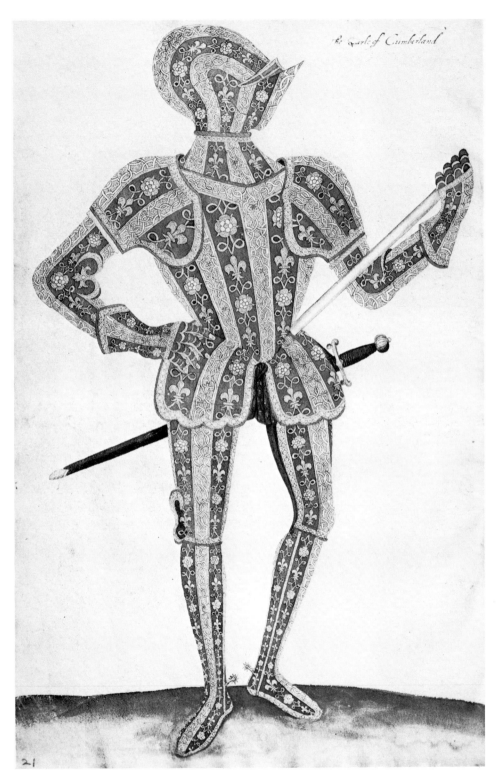

21

There is one final set of clues to evoke for us the magic of Accession Day Tilt pageantry. Each knight's squire yielded up to the Queen a shield upon which his master's *impresa* was painted. These were afterwards hung in a waterside gallery at Whitehall and were shown to every visitor to the palace.[43] Such symbolic shields and devices and their presentation were common to both masque and tournament in the second half of the sixteenth century. John Harington, commenting on the *imprese* in Ariosto's *Orlando Furioso*, was led to remark that it would require a whole volume to consider those used at the annual tournament,[44] and both Camden, the herald and antiquarian, and Henry Peacham, the seventeenth-century emblematist, regarded them as equal to those of the Italians in every way.[45] For Lee and his companions the *impresa*, symbolizing the knight's aim and intention, must have added a gloss of Neoplatonic philosophy to the Queen's Day festivals which was not in any way at variance with the courtly romanticism of the speeches.

Peacham is particularly valuable in this context because he illustrates, in his *Minerva Britanna*, a number of devices we know to have been used on Accession Day. Otherwise, we have to rely for information on two unillustrated collections, the first in Camden's *Remaines* (1605) and the second by John Manningham in his diary (1601).[46] Camden writes that he noted them at tilts which he attended in his capacity as a herald. Most are astrological in theme, concerned with the Queen as an astral body or influence. One knight, who had been born under the star *Spica Virginis*, the brightest in the constellation Virgo, depicted this on his shield to show 'that he lived by the gracious favour of a virgin Prince'. All offer variants on the theme of knight and lady. Camden records a knight who carried a silver shield inscribed *Solus amor depinget*, and another with an eye weeping on to a heart in the hope that this might 'mollify his Mistress' heart'. The devices, like the speeches, remain an enigma unless we happen to know the name of the bearer and the reason for the device. Sir Philip Sidney, heir to the Earl of Leicester, when the latter had a son, bore on his shield at the next tournament *Speravi* 'dashed through, to

Accession Day Tilt
imprese

68 The pen outweighs the cannon

69 A blank shield carried in mourning

70 Philautia or Self-Love

shew his hope therein was dashed'. When the bid for power between Essex and Sir Robert Cecil was at its height the Earl carried an *impresa* depicting a pair of scales, a pen outweighing a cannon, with the motto *Et tamen vincor*. Peacham illustrates this, as well as another device known to have been carried by Essex – a blank shield signifying his grief, probably over the death of Sir Philip Sidney, with the inscription *Par nulla figura dolori*. Earlier in the book Peacham includes an emblem of Philautia, and one speculates whether this was Essex's emblem for the 1595 tilt. Only in these isolated instances do the riddling Accession Day *imprese* take on the dimension they once had and, like the speeches, become pointed and even stinging allusions to the grim realities of court politics.

For the most part, the collections seem so much dead wood, since we no longer know who carried the *imprese*, or why. To re-establish the world of the Accession Day Tilt device I would refer the reader back to Hilliard's *Young Man amongst Roses*. If we removed the young man from his eglantine and placed a garland of this rose encircling a knight in armour on a pasteboard shield, with a scroll bearing the motto *Dat poenas laudata fides*, we would have a tilt *impresa* with its many layers of riddling allusion.

Accession Day Tilt pageantry became so elaborate that the practice emerged of distributing books at the tilts to the Queen and other prominent onlookers, containing in full all the speeches and devices. Philip Gawdy, a Norfolk gentleman, sent his father such a book, which was given him on Queen's Day 1587, and the Revels Accounts two years later record payment 'for the fair writing of all the devices on the 17 day of November . . . in two copies for the Queen'. None of these books has survived, at least as far as we can recognize, which suggests the limited nature of their circulation; nor is it clear that they were compiled for each tilt. From the point of view of the history of the Accession Day Tournaments their loss is irreparable. The ephemeral nature of this material was realized even by contemporaries; by 1590 much had already perished, for it was lamented by the author of the *Booke of Honor and*

Armes, published in that year, of 'all the Speeches, Emblems, Devices, Posies, and other Complements' used at court jousts, that 'for want of observation, or rather lack of some sufficient man to have set them presently down, those things cannot be recovered'.[47]

In spite of the apparent refinement of the tournament into a visual and literary spectacle anticipating in its imagery and form the gentle and peaceful art of the Stuart masques, it remained a manly and strenuous sport. For the onlookers the tilting was the central part of the business, a fact fully borne out by the numerous score cheques where the number of lances broken by each knight in his six courses is meticulously recorded. The tilting on the 17th was solely in honour of the Queen and did not therefore conclude with the customary prize-giving but with Elizabeth thanking the tilters. (This we gather from a letter alluding to the joust of 1599 in which the Queen 'thanked them after [the] old fashion'.) From 1588 onwards, however, the tilting was resumed on 19 November (significantly St Elizabeth's Day) to celebrate the defeat of the Spanish Armada. This often took the form of a challenge issued by one or more of the Queen's Day runners: in 1590 they were Lord Strange and the Earls of Cumberland and Essex, while in 1594 and 1596 the last-named acted as sole challenger against all comers. In 1599 the mantle of the disgraced Essex fell upon Cumberland and it was he who challenged but, being unwell, was unable to fulfil the challenge.

| *Literary allusions* | Of the popularity of the tournaments as a public spectacle we are left in no doubt, for year after year they evoked ballads.[48] Peele's *Polyhymnia* (1590) and *Anglorum Feriae* (1595) are the only surviving examples of this literary genre, and both poems capture something of the romance and colour of royalist chivalry on that occasion when 'fair England's knights' ceremonially tilted: |

> *In honour of their mistress' holiday*
> *A gracious sport, fitting that golden time,*
> *The day, the birth-day of our happiness,*
> *The blooming time, the spring of England's peace.*[49]

But they evoke more. In the midst of the paeans Peele gives us glimpses of what actually happened, of the fantastic pageants which wended their way in tribute to Gloriana across the tiltyard at Whitehall: Cumberland in 1595 astride a dragon, young Sussex beneath a blasted yew tree, Southampton apparently disguised as Bevis of Southampton and Sir Robert Dudley ablaze in celestial globes and golden flames. One can sense the drama, the excitement, the surprise and the delight as the story unfolded itself before the Queen and her ladies. What incredible spectacles they must have been, and what an impact they must have made at the time!

What other Elizabethan literature can we point to which may give us such glimpses into this bizarre world? A minor poem, *The True*

Minerva by Thomas Blenerhasset, is perhaps one example.[50] Published in 1581, it is the earliest printed instance we have of the influence of Spenser's verse, and altogether represents new literary trends. I think it reflects accurately what actually happened at the tilts in the eighties. The poem tells of the loss of Minerva from Earth, and the subsequent search for a successor worthy of being deified. Such a successor is, of course, found in Elizabeth. At the climax there is a tournament watched by the Queen and a hundred fair ladies, by foreign princes and grave counsellors. The tournament is interrupted by the arrival of the gods who descend on a cloud and move in procession across the tiltyard, bearing Neptune's crown in tribute to Elizabeth. Saturn and the Seven Sages, the Nine Worthies, Neptune and his sailors, Apollo attended by Castor and Pollux, Silenus, the rustic god, escorted by five preachers. Mercury, the Nymphs of Flora, the Fairy Queen, the Ladies of the Lake, Diana and her train all are in this tiltyard cortège. It must have looked very like the masque procession in the Unton Memorial Picture, and one may wonder whether Blenerhasset is really giving a highly coloured version of something which actually happened. The mythology is right, even down to the Fairy Queen, a figure who made her first entrance at a show Lee presented to the Queen at Woodstock in 1575 and whom we know to have been part of his tilt mythology from the speech entitled 'The Message of the Damsel of the Queen of Fairies'. Could a whole tilt have been dedicated to Elizabeth as the new Minerva? Perhaps it was. I do not think it improbable, and books, we know, were handed out at later tilts – that of 1589, for example. 58

Peele's repeated allusions in the poem evoked by the 1595 tilt to the Queen as Astraea, the virgin justice, one of Elizabeth's favourite roles, might suggest that in that year an Astraea *mise en scène* was erected in the tiltyard. We know in 1590 Elizabeth was celebrated as a Roman Vestal, and the Vestal Virgin Temple was erected in front of the tilt gallery.

Sidney's *New Arcadia*, written in the eighties, is a marvellous handbook to the Elizabethan image, a mixture of literary pictorialism and emblematics, courtly chivalry and its expression in allegorical pageantry. In Book 1 Philantus holds a tilt in defence of his mistress Artesia.[51] His *impresa* is a heaven full of stars with a motto signifying 'that it was *the beauty which gave it the praise*'. Philantus and Artesia ride in a triumphal chariot drawn by winged horses, preceded by footmen bearing portraits of the beauties whose knights he has vanquished. Amongst them is that of Queen Helen of Corinth, Sidney's allusion to Elizabeth, in whose face there is 'so much beauty and favour expressed, as if *Helen* had not been known, some would rather have judged it the painter's exercise, to show what he could do, than counterfeiting of any living pattern'. The challenge proceeds and eventually Clitophon comes in defence of Queen Helen. He is attired in golden armour and his *impresa* is placed on her portrait: 'It was the *Ermine*, with a speech that signified, *Rather dead than spotted*.'[52] Sidney is describing a portrait of Elizabeth I with an ermine in it alluding to her purity, a device derived from Poalo Giovio's *Imprese*. 72

147

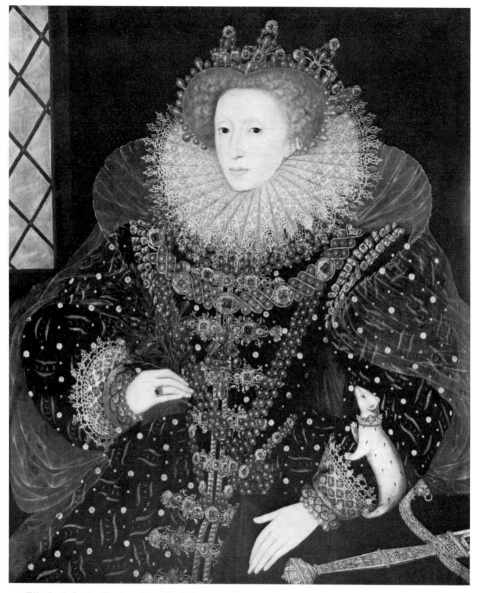

71 Elizabeth I: the Ermine Portrait, 1585.
Elizabeth as Sidney's Queen Helen of
Corinth attended by her ermine of purity

72 The ermine device of King Ferrante of Naples

We have a portrait of Elizabeth with an ermine, the famous picture at Hatfield painted in 1585. *Pax* and *Justitia* are also there in the form of the olive branch and sword. Is this portrait Sidney's Queen Helen, attired in her colours of black and white, attended by her ermine and the emblems of rule, a lady whose 'beauty hath won the prize from all women', a woman who 'in the time that many countries were full of wars . . . yet so handled she the matter . . . that she made her people by peace, warlike; her courtiers by sports, learned; her Ladies by Love, chaste'? The programme of the Ermine Portrait surely belongs to the romance of the *New Arcadia* and the Accession Day Tilts.

Sidney also gives a literal description of an Accession Day Tilt. In Book 2 comes a long account of the annual Iberian jousts to which this year knights came sent by Queen Helen, 'herself . . . a Diana apparelled in the garments of Venus'.[53] He describes the entries of the knights, opening with a famous scene known to everyone in Elizabethan England, the initial entry of the Queen's Champion Sir Henry Lee as Laelius, chained with a nymph leading him. His opponent was Philisides, whose entrance was heralded by bagpipes, his page dressed as a shepherd's boy, his squires disguised as shepherds bearing lances dressed up as sheephooks.

> His own furniture was dressed over all with wool, so enriched with jewels artificially placed, that one would have thought it a marriage between the lowest and the highest. His *Impresa* was a sheep marked with pitch, with this word *Spotted to be known.* . . . The shepherds attending upon PHILISIDES went among them [the ladies in the tilt gallery], and sang an eclogue . . .

Among the ladies there, of course, sat 'the *Star*, whereby his course was only directed'. What Sidney is describing is himself tilting with Lee, paying courtly homage to the heroine of his sonnets, Essex's sister, Penelope, Lady Rich. He also mentions the disguises of some of the other tilters at that Accession Day. One knight came as a Wild Man, 'full of withered leaves, which though they fell not, still threatened falling'; another emerged from the flames of a burning Phoenix; and there was 'the fine frozen knight'. Lee and Sidney tilted against each other certainly in 1581 and 1584, but only in 1584 did they open the proceedings. Surely what we are reading is a description of the tilt of that year? The *New Arcadia* belongs to the story of the tilts as they reached their apogee in the eighties.

There are further elusive references to this pastoral preoccupation in Angel Day's rendering of *Daphnis and Chloe* from the French of Amyot.[54] This, in its interweaving of the praises of the Queen into the fabric of Greek romance, is directly evocative of the *Arcadia*, which Day must have known at least in manuscript. The story here is suddenly interrupted for no reason at all for a long description of 'the celebration of a certain yearly feast, evermore with great and most religious devotion honoured among all the shepherds from the highest unto the lowest of

73

149

73 Score cheque for
Accession Day 1584,
showing Laelius and
Philisides at the head of
the list. The strokes on
the card indicate the
courses run and the num-
ber of lances shattered by
each contestant

150

that Island'. These solemnities, we are told, paid tribute to 'a sage Virgin who had ruled over her land many years in peace and was beloved by all her subjects'. This is obviously Elizabeth, and the day is Accession Day. There then follows an evocative picture of arcadian revelling in honour of this royal maiden:

> The youthful and gallantest troup of them richly trimmed on horseback and on foot, exercised in her honour diverse and sundry feats of activity, the rest, and those that were more ancient, attentively rejoicing and beholding them. Afterwards they altogether came to a public place, to that sole end and purpose, specially of long term reserved, where revelling and sporting themselves universally in all kind of shepherds' pastimes and dances, they sing before Pan and the Nymphs. . . .[55]

The princess's name is Eliza, and the shepherds gather to sing eclogues in her honour. These, which all celebrate the Queen and her divine virtues, are directly imitative of the type of pastoral revels found in the *Arcadia* and, in part, in the *Shepheardes Calendar*. This book could well be the sort of thing which was handed out at the tilts, or at least suggests a direct reflection of what actually went on in the Whitehall tiltyard. Perhaps the whole tiltyard became Arcadia and the knights all came as shepherds.

These literary references suggest that the tilts were an integral part of the aesthetic milieu of the eighties and nineties. Everyone knew about them, everyone had seen them. In fact everyone knew the tilts and their romance so well that direct description was irrelevant. It was more clever – a better 'device', in the words of the tilters – to hide the allusions to them, to translate them into poetic form or allude to them in works of the right mythological content. No wonder that they remain to this day an enigma.

Laelius retires: Accession Day 1590

One tilt – virtually the only one – which is not an enigma is that of 1590. In that year Sir Henry Lee, 'being by age overtaken' – he was actually fifty-seven – resigned his post as Queen's Champion to George Clifford, 3rd Earl of Cumberland. The resignation tilt is the only one for which we have a substantial amount of information. Two accounts of the 1590 Accession Day Tilt are extant: the first is George Peele's poem *Polyhymnia*, from which we learn in addition the disguises of some of the other knights, and the second the description of the actual resignation ceremony inserted by William Segar into his *Honor Military and Civill* (1602). It is worth considering this occasion in a little detail.

The tilt took its accustomed form of a series of triumphal entries by the tilters. Lee, in his capacity as Champion, was the first to enter:

> *Knight of the crown, in rich embroidery*
> *And costly caparisons charged with crowns*
> *O'ershadowed with a withered running vine.*

151

Lee has become a vine withered by age in royal service. A Bodleian manuscript contains verses subscribed 'quoth Sir Henry Leigh' and said to have been used in 'yielding up his tilt staff'. Accompanied by their musical setting they appear in John Dowland's *Second Booke of Songs or Ayres* (1600). The theme of the verses is an appropriate one: they tell of the transience of youth and the coming of old age, and of the knight turning from 'shows, masques, jousts or tilt devices' to 'sighs, tears, vows, prayers, and sacrifices'.

His opponent was his successor, George Clifford, 3rd Earl of Cumberland. Attired in white, he rode upon a pageant car which represented the ancestral seat of the Clifford family, Pendragon Castle. This was some sort of Arthurian disguise and was used by Cumberland again and again in subsequent tilts. Peele goes on to describe the strange accoutrements of some of the others. Ferdinando, Lord Strange, entered the tiltyard accompanied by almost forty squires attired in white and watchet and carrying azure tilting staves. His pageant was a 'costly ship' bearing an eagle, the Stanley crest, which stooped in submission to the Queen. Thomas Gerard wore white and green, the Tudor colours, and then came the fair young Lord Compton, his horse, his plumes, his servants and lances all white, 'the virgin's colours'. Henry Nowell wore black armour and his attendants were clad in tawny; black and tawny were emblematic of sadness and mourning.

The fifth couple were the Earl of Essex and Fulke Greville. Essex's entry was a truly dramatic one, as an Elizabethan funeral cortège seemingly trailed its way across the tiltyard:

> . . . *all in sable sad,*
> *Drawn on with coal-black steeds of dusky hue,*
> *In stately chariot full of deep device,*
> *Where gloomy Time sat whipping on the team,*
> *Just back to back with this great Champion . . .*

This is the Essex famous for his 'heroical devices', and in this staggering entry we return to the world of the *Young Man amongst Roses*. Essex, we know, had married the daughter of Sir Francis Walsingham, Sidney's widow, as part of a deathbed pledge to the Shepherd Knight. When this became known to the Queen in April 1590, Elizabeth was furious – it seemed to shatter forever the idyll of the pining *Young Man*. Lady Essex, of course, was never forgiven, but the Earl skilfully deployed all his 'devices' to retain royal favour. The 1590 tilt was the most extravagant device of them all, and it is surely this moment which Essex records in his 1590 portrait – himself as the 'sable sad' penitent making his contrite way across the tiltyard at Whitehall to implore the Queen's forgiveness. Everyone at the time would have 'read' the layers of meaning this dramatic entry embodied.

The tilting over, there followed Sir Henry Lee's resignation of his post as Champion to the Earl of Cumberland. These two knights came

towards the tilt gallery, in which the Queen, accompanied by the French ambassador, was sitting, and as they did so

> Her Majesty . . . did suddenly hear a music so sweet and so secret, as every one thereat greatly marvelled. And hearkening to that excellent melody, the earth as it were opening, there appears a Pavilion, made of white Taffeta, being in proportion like unto the sacred Temple of the Virgins Vestal. This Temple seemed to consist upon pillars of porphyry, arched like unto a Church, within it were many lamps burning. Also, on the one side an Altar covered with cloth of gold; and thereupon two wax candles burning in rich candlesticks; upon the Altar also were laid certain Princely presents, which after by three Virgins were presented unto her Majesty.

Before the door of the temple there stood a crowned pillar embraced by an eglantine tree, upon which was suspended a Latin prayer 'Of Eliza' in which new notes of ecstasy were struck by Lee in his worship of the Queen whose mighty empire now, in the aftermath of the Armada and the colonization of Virginia, extended into the New World. She had moved, we are told, one of the columns of the Pillars of Hercules, and on her death she would be borne into the heavens where a celestial diadem awaited her. The action was framed by the Dowland song *My golden locks time hath to silver turned*, sung by the famous lutenist Robert Hales.[56] Again the verses fit Lee, now the silver-haired knight saying farewell to 'beauty, strength, and youth' and turning to 'duty, faith, and love':

> *Goddess, vouchsafe this aged man his right,*
> *To be your beadsman, that was your knight.*

Thus Lee entreated the Queen, who was presented by the Vestals with rich gifts, amongst which there was a safeguard embroidered with the *imprese* of various noblemen secured to pillars. Having taken off his armour at the foot of the crowned pillar, he beseeched the Queen to accept Cumberland as her new Champion. This accomplished, Lee armed the Earl and set him upon his own horse, putting upon himself a side coat of black velvet and 'a buttoned cap of country fashion'. For several days after the ceremony Lee wore a crown embroidered on his cloak with a motto, 'but what his intention therein was, himself best knoweth'.

The Vestal set-up, with its overtones of Roman imperialism, was an appropriate one for a Virgin Queen still living in the reflected glory of the Armada defeat. But why, we may ask, were there only three Vestals when the standard Renaissance mythological manuals all referred to four?[57] Lee was surely turning his compliment towards the Queen, whose favourite mythological role we know to have been that of the Vestal Tuccia. Celebrated in a series of portraits of Elizabeth bearing her attribute, the sieve, Tuccia was a Vestal who, on being accused of impurity, had carried water to the temple in a sieve without spilling a drop to prove her purity. The Elizabeth–Vestal imagery stretched back at least to 1579 – the earliest of the portraits bears that date – and in the same

year came the first eulogy of the Queen as a Roman Vestal in Lyly's *Euphues*.[58]

The Vestal theme was the real heart of the 1590 show, but it was complemented by further appropriate devices. The 'imperial' temple was supplemented by an 'imperial' crowned pillar which stood outside. This was a variant on the *impresa* of the Emperor Charles V, the Pillars of Hercules with the motto *Plus Ultra* to express the extension of sacred empire into the New World.[59] It had been used already, immediately after the defeat of the Spanish Armada, in engravings of the Queen, where she appears as a mighty empress with, one might say, universal pretensions. It also referred to the Queen's constancy. Two years later, in another of Lee's entertainments, it was again brought into play:

Constant pillar, constant crown,
Is the aged Knight's renown.[60]

Lee's device of constant loyalty (the pillar) to the Crown as personified in Elizabeth (the eglantine) is but the slightest variant of the imagery of Essex as the *Young Man amongst Roses*.

There is one vision of Elizabeth which relates even more certainly than any of her other portraits to the saga of the tilts – Lee's own picture of his life's heroine, the celebrated Ditchley Portrait.[61] This is Laelius's **74** farewell votive image. Frances Yates has suggested that the Sieve Portrait at Siena may commemorate the 1590 tilt, but the costume is too early.[62] The dress in the Ditchley Portrait, on the other hand, is exactly right in date. And suspended close to the Queen's left ear there is a jewelled armillary sphere. Is this Lee's idea of Elizabeth the imperial virgin as expressed in the prayer on the crowned column in 1590, she to whom fame and empire are promised in this life and a celestial diadem in the next? She stands as an empress on the globe of the world, her feet planted on her realm of England, reflecting in paint George Peele's opening lines describing the retirement tournament:

Elizabeth, great empress of the world,
Britannia's Atlas, star of England's globe,
That sways the mighty sceptre of her land,
And holds the royal reigns of Albion . . .

The clouds part to the left to reveal the dawn of a new age. The Ditchley Portrait remains perhaps the most potent of all the surviving images evoking the romance of the Accession Day Tournaments.

In the midst of a phantasmagoria of cryptic images in praise of the imperial virgin Elizabeth the 1590 retirement tilt drew to a close. What is extraordinary is that we only know a fragment of this material. What would we give for the scenarios of the tilts of the whole reign? Over twenty of these great spectacles, rich in imagery and allusion drawn from the heart of the age, unfolded over the years. Each would have been as extraordinary as that of 1590 in weaving personal biography and public

74 Elizabeth I: the Ditchley Portrait, *c*.1590. Laelius's farewell votive image, perhaps commemorating the celebrated retirement tilt of 1590

154

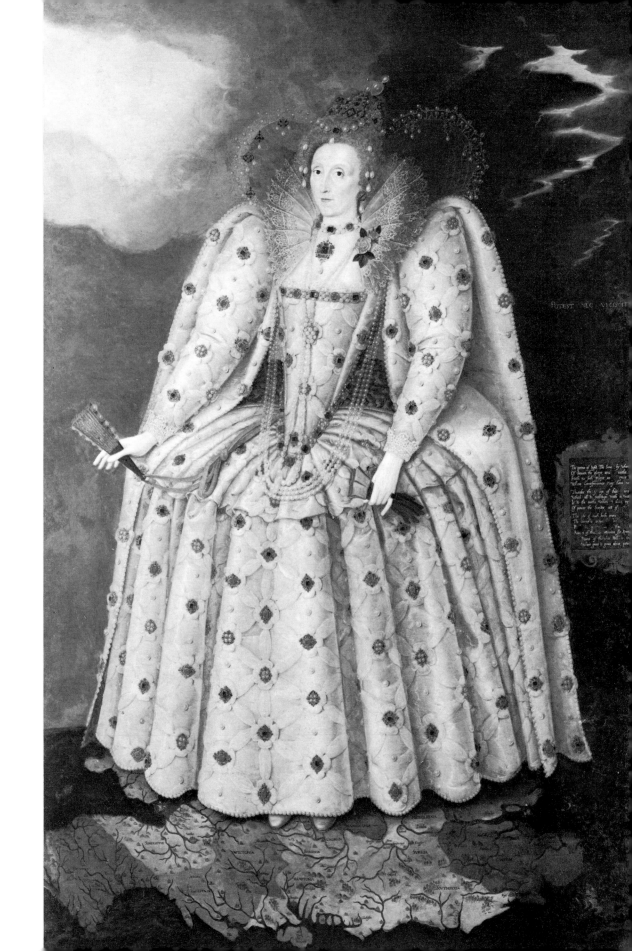

life into a series of set tableaux of the Fairy Queen and her knights. What doors they would have unlocked into the make-up of the Elizabethan imagination, we shall never know.

We have a good idea of how some of these knights looked when they came to render their annual homage to their sovereign lady, for the Elizabethans had a marked predilection for the chivalrous formula in their portraiture. If we wish to visualize these tilts, we cannot do better than to study Nicholas Hilliard's miniature of Robert Devereux, 2nd Earl of Essex or that of George, 3rd Earl of Cumberland. The latter appears as Knight of Pendragon Castle, perhaps alluded to in the distant castle in the landscape background, and he is attired in star-studded armour, with a surcoat patterned on the lining with branches of olive, caducei and armillary spheres, while in his hat he sports the Queen's glove handsomely bejewelled. His pasteboard *impresa* shield, adorned with a sun and moon flanking the central earth and the riddling motto *Hasta quan*, hangs on a tree nearby. The glove in his hat and the gauntlet cast down in the Queen's defence at his feet recall the gauntlet jewel on Elizabeth's ruff in the Rainbow Portrait. 75

Essex, the Queen's beloved Erophilus, cuts a dashing figure in gilded armour; his *impresa*, a diamond with the motto *Dum formas minuis*, is embroidered on the bases he wears over his armour, while behind him a squire, clad in the Queen's colours, is about to lead on his horse. He stands as it were in the wings, waiting to make his entrance. Both here and in a second tilt portrait of the same period he wears the Queen's glove tied to his tilting arm, again recalling the ritual gauntlet in the Rainbow Portrait. Thus Essex appeared at the great tilts of 1594 and 1595. 42

43

If we want to know how a new young tilter would come to the joust there is a portrait of Robert, Viscount Fitzwalter, later Earl of Sussex, as the White Knight in the Tower Armouries. We know he first tilted in 1593, and the portrait bears that date. What his device of entrance was on that occasion we do not know, although his motto was probably that on the picture, *Amando et Fidando Troppo son rovinato*; in 1595 Peele records him wearing 'ravens' feathers by the moon's reflex', and the year after that he employed Francis Bacon to write a doleful story in which as a young knight he makes petition to retire from public life to acquire the virtues of his father. Sights such as Sussex, with his marvellous bejewelled helmet surmounted by pearl-hung feathers, prancing across the tilt yard must have been part of the visual fabric of every tilt.

At the tilt of 1595, the famous Philautia tilt, Peele describes the appearance of a Herefordshire knight, James Scudamore:

> L'escu d'amour, *the arms of loyalty*
> *Lodg'd Skydmore in his heart; and on he came,*
> *And well and worthily demeaned himself*
> *In that day's service: short and plain to be,*
> *No Lord nor knight more foreard than was he.*

75 Cumberland as Queen's Champion and Knight of Pendragon Castle, *c.* 1590. He wears Elizabeth's jewelled glove in his hat and his *impresa* shield is tied to the tree behind him

156

Sir James Scudamore Knt: ob: 1

76 *L'escu d'amour*: James
Scudamore, Gentleman
Pensioner and tilter, poses
in the sylvan Arcadia of
Queen's Day romance

Scudamore tilted each Queen's Day until 1600. The armour he wore on
these occasions, a marvellous Greenwich suit, is now in the Metropolitan
Museum of Art, New York. In the portrait at Kentchurch he wears it 76
accoutred as for Accession Day, lance in hand, bases of velvet thick laced
and fringed with silver, with an orange scarf, perhaps his lady's favour,
fluttering from his shoulder. The painting records his appearance at a tilt,
but as in the case of the Cumberland and Essex miniatures it places him,
not in the actual background of the tiltyard at Whitehall, but in the
emblematic background of his 'idea' of himself as a Knight of the Crown.
It is a romantic sylvan setting, a knight in the shade of the greenwood
tree. The arcadian pastoral stream seems to have been a strong one in the
imagery and legends of the tilts, and Scudamore perhaps directly reflects
a tradition first evolved by Sidney in his role as the Queen's Philisides,
the Shepherd Knight.

Cumberland, Essex and Sir James Scudamore in their portraits seem
to be wearing costumes that, with slight adaptation, would be suitable for
an indoor masquerade. We are here within reach of an understanding of
the sources of the conventions governing male masquing attire. If we
place these portraits side by side with Inigo Jones's designs for masque 77
costumes we can see the same bases or skirt, the same fancy plumed
helmets and often the same breastplate. This is instructive material for
the 'continuity' of one art form into another, and we can study many of
Jones's early undated designs for tilts and barrier costumes as evocative
of Accession Day Tilt pageantry. There are drawings for a lance-bearer,
for a squire, for caparisons, a helmet and an *impresa* shield. One striking
design is actually for a Jacobean Accession Day Tilt.[63] At the 1610 tilt Sir
Richard Preston caused a sensation by coming in a pageant 'which was an
Elephant with a Castle on the back'; and, it was reported, 'it proved a 78
right *partus elephantis*; for it was as long a coming till the running was
well entered into, and was then as long creeping about the Tilt-yard, all
of which while the running was intermitted'. Although this must have
been one of the most unsuccessful instances of Jones's stage manage-
ment, this elephant entry cannot have been so far removed from what von
Wedel saw in the Whitehall tiltyard, a generation before, on 17
November 1584, when knights came in carriages drawn by horses
disguised as elephants.

Elizabethan chivalry

However excessive they now appear, there is nothing very strange in the
tilts in the context of the period. They reflect accurately the thinking of
the age as developed over several decades, and give an interesting glimpse
into what one can only describe as Elizabethan neo-medievalism, the
essence of which was romance. The Elizabethans were obsessed by
romance. It carried all before it; even classical allusion stemmed from the
traditions of early Renaissance romantic antiquarianism.

Sir Henry Lee's 1590 Vestal Virgin set-up belongs to this tradition of
romance: it is the ethos of Renaissance archaeological romance, the

Two designs by Inigo Jones:

77 A squire in antique costume carrying an *impresa* shield

78 An elephant pageant for the Accession Day Tilt of 1610

Hypnerotamachia Polyphili (1499) with its strange ruins, pagan rites of sacrifice and Latin epitaphs, woven into the fabric of a medieval knightly saga. The Accession Day Tilt, like other Elizabethan pageantry, is not governed by any sense of historical distance; antiquity, medieval romance and remote and foreign lands are all drawn upon and freely mingled together without any sense of indecorum. All are wedded to create an illusion of the exotic and the strange. How different from the world of Ben Jonson which was shortly to follow. Here for the first time in England we had the late Renaissance scholar all too aware of historical distance, systematically, even laboriously reconstructing, for instance, the marriage rites of a vanished age, culling his information from the latest and most recondite works on Roman nuptial rites in order to compose his masque *Hymenaei*, which was performed only three years after Elizabeth's death. Lee and his generation, on the other hand, belonged to an era nurtured on romance, whose pageantry, like its painting, depended for its form on multiplicity of incident. The knights wandered in their various disguises across the tiltyard at Whitehall, each with his own story to tell within the overall unity of the Fairy Queen's annual feast, in the same way that knights wander through Spenser's epic. Both Sidney and Spenser intended that their work should be governed by the Aristotelian unities, and basically the *Arcadia* and the *Faerie Queene* are so governed; yet on to a central story they graft innumerable incidents and subsidiary episodes of a moral, martial or amorous nature. The formula for the tilts, with their various incidents each meant to be read in its own right within an overall idea, is exactly parallel to the visual principles governing the Procession Picture. This is the world of Elizabethan romance.

To some historians of the Elizabethan period these shows inspired and organized by Lee and his comrades seem to present nothing more than the spectacle of an ephemeral art form in its final and most decadent phase, without any relevance to the main thought-patterns of the age. Such a view would however be superficial and untrue, for the use and cultivation of the imagery and motifs of legends of chivalry formed an integral part of the official 'image' projected by sixteenth-century monarchs. Through them they were able to surround the actualities of present-day politics with the sanctions of historical myth and legend. In a century of violent political and religious upheaval, of cosmic proportions to those who lived through it, this was of immense importance in preserving an illusion of continuity. As we have seen, the sermons and other literature which marked the popular celebration of the day made it an anti-papal triumph, a day when a pure Virgin Queen ushered in the word of the Gospel and vanquished the impure Pope of Rome and the baneful influence of his adherents. The idea of adorning this with the time-honoured imagery and ceremonial of medieval chivalry was an infinite subtlety of which the organizers were no doubt well aware. It is one of the great paradoxes of the Elizabethan world, one of its touchstones, that an age of social, political and religious revolution

should cling to and deliberately erect a façade of the trappings of feudalism.

I began this Accession Day saga with Spenser's famous letter to Raleigh where he describes the structure of his great epic, *The Faerie Queene*. It centres on the Queen's 'annual feast' and celebrates Elizabeth both as 'a most royal Queen or Empress' and as 'a most virtuous and beautiful Lady'. But the poem itself opens with the story of the Red Cross Knight, 'the true Saint George', and in this we are asked to take a different path, one more overtly religious and deeply theological in its implications: the exaltation of the reformed *Ecclesia Anglicana* and its Governor. This too had its annual feast, when Elizabeth as sovereign of the Order of the Garter processed, attended by her Knights, each St George's Day, 23 April. And this, too, is integral for the myth of Elizabeth.

79 Elizabeth I as sovereign of the Order of the Garter, *c.* 1575

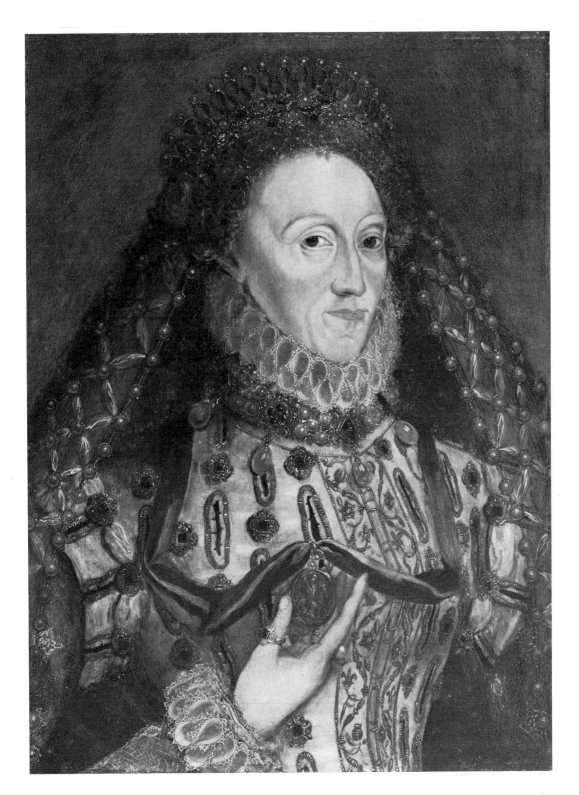

VI SAINT GEORGE FOR ENGLAND
The Order of the Garter

One of the most important facets of chivalry as it manifested itself at the Burgundian court was the foundation in 1430 by Duke Philippe le Bon of the Order of the Golden Fleece.[1] Through this institution he hoped to bind the higher aristocracy of the many states over which he ruled into a common brotherhood of chivalry, united in allegiance to the house of Burgundy. Under Charles V the Golden Fleece performed an even more important task, for it bound a multi-national aristocracy in loyalty to the Emperor. For the French kings, the Order of St Michael played a similar part, followed, in the second half of the sixteenth century, by Henri III's creation of the Order of the Holy Spirit, which aimed not only to promote the Counter-Reformation themes of penitence and charity but to link many of the French nobility to the monarchy, thus averting the disasters consequent upon a renewal of civil war.[2] In this way, orders – a manifestation of chivalry in its most religious aspect – formed an integral part of the mystique surrounding sixteenth-century monarchy. Nor was England an exception, for Elizabeth I was sovereign of the most noble Order of the Garter.

No-one has really gone into this curious by-way of the Elizabethan age, its obsession with and deliberate revival of a fourteenth-century chivalrous order. On first consideration, it seems an extraordinary anomaly. Elizabeth herself holds up the Badge of St George in her portrait, seemingly asking the onlooker to contemplate the image of a popish saint in Protestant England. Her Garter Knights sit for their portraits arrayed in slightly updated medieval cloaks and bonnets, proud that posterity should so remember them. And George Peele in the last decade of the reign gives a memorable glimpse of the Virgin Queen and her Knights moving in solemn procession:

> *Under the glorious spreading wings of Fame,*
> *I saw a virgin queen, attired in white,*
> *Leading with her a sort of goodly knights,*
> *With garters and with collars of Saint George:*
> *'Elizabeth' on a compartment*

79

Of gold in bysse was writ, and hung askew
Upon her head, under an imperial crown.
She was the sovereign of the knights she led . . .[3]

Like the Accession Day Tilts, the Garter offered the Elizabethan age something it badly needed – a reinforcement of medieval hierarchical principles and an affirmation of chivalrous ideals. By the close of the reign this old Catholic order was made to represent something quite different, a band of fiercely Protestant knights bound in union to defeat the dragon of St George, now re-identified as the pope, the Beast of the Apocalypse.

Revival and Reformation

Elias Ashmole, the herald and antiquarian, in his book *The Institution, Laws and Ceremonies of the Most Noble Order of the Garter* (1672), states that it was founded by King Edward III 'to adorn Martial Virtue, with Honors, Rewards, and splendor; to increase Virtue and Valour in the hearts of his Nobility'.[4] It was the earliest of the royal chivalrous orders and its members, twenty-five in number excluding the sovereign, were bound to observe the oaths and statutes and live in faith, peace and amity one with the other. The aim of the Garter would appear to have been primarily military, an effort by the King to pledge important nobles and knights to his policy of territorial expansion in France. The Order had for its patrons the most Holy Trinity, the Virgin and St George of Cappadocia, and its ceremonies were conducted at the Chapel Royal at Windsor where the Knights sat, like canons, in the choir stalls, each with his achievement hung above him.

The early history of the Order has yet to be written, but, apart from a short-lived revival under Henry V, it was not until the end of the fifteenth century that conscious efforts were made to enhance it, efforts prompted no doubt by the glorification of the magnificent Golden Fleece by the Burgundian Dukes. A resuscitation began under Edward IV with the rebuilding of St George's Chapel, Windsor, and the resumption of Garter ceremonial on a splendid scale; this Yorkist restoration of the Order's former glory was sustained by Henry VII, who brought the Chapel to its completion and made the Garter Feasts an important facet of the Tudor revival of the monarchy.[5] The description of the 1488 Feast is a paean in honour of the resurgence of royal power and prestige:

O knightly Order, clothed in robes with Garter:
The Queen's Grace, thy mother, in the same.
The nobles of thy realm, rich in array, after;
Lords, knights, and ladies, unto thy great fame.
Now shall all ambassadors know thy royal name
By thy feast royal. Now joyous may thou be,
To see thy King so flowering in dignity.
Here this day St George, the patron of this place,
Honoured with the Garter, chief of chivalry.[6]

The records for the reign of Henry VII are extremely defective, but now for the first time there appears the great collar of the Order to rival that of the Golden Fleece, and secondly – also in competition with the great Burgundian Order – it was bestowed upon foreign princes and dignitaries.[7] This imitation of the Golden Fleece was brought to completion under Henry VIII, who revised and clarified the statutes and introduced the Lesser George which, like the lesser collar of the Fleece, had always to be worn by member Knights.[8]

The Henrician Reformation had left the Order untouched; with the accession of Edward VI there began successive efforts at Garter reform.[9] In April 1548 an ordinance of the Privy Council was issued stating that 'all such things, as be not conformable and agreeing to his Majesty's *Injunctions, Orders, or Reformations*, now of late prescribed, should be also in that most Noble Order and the Ceremonies thereof left undone, and reformed'.[10] Preliminary expurgations included the requiem for departed Knights, accustomed to be sung on the morning after the Feast, which was replaced by an ordinary Mass, and the old Latin processional, in place of which the English Litany was substituted. Reverences to the altar ceased, and the Knights had to communicate at the solemn Mass on the Feast Day itself. Thereafter the Garter followed in the train of the Edwardian Reformation. In 1550, the year after the first Edwardian Prayer Book, a set of reformed statutes for the Order was issued to Knights of the Garter who were to deliberate upon them at a subsequent chapter.[11] The following January, St George's Day was one of a list of holy days abolished by act of parliament, an event which resulted, three months later, in the appointment of a commission of six Knights to revise the statutes. Several drafts survive, often extremely anti-papal in sentiment and embodying quite ruthless revisions in the Order and its ceremonies. The new statutes which were issued in March 1553 were actually less violent in character.[12] They explain how the Order of the Garter, which had been designed to bind valiant and martial men of rank in unity and concord, had been corrupted by 'that old Serpent Satan' who had filled the statutes with 'many obscure, superstitious, and repugnant opinions'. Henceforward the Order was to be that of the Garter and all connection with St George was to cease. The Feast was transferred to Whitsun, and the Garter George became an armed knight on horseback encompassed by a Garter bearing the usual motto, *Honi soit qui mal y pense*. The King's subsequent illness and death meant that these statutes were never fully put into effect.

On 27 September 1553, just six months after the acceptance of the Edwardian Garter settlement, Mary held the first chapter of her reign in which the new statutes were declared to be 'in no sort convenient to be used, and so impertinent and tending to novelty' that they should immediately be abolished and all reference to the attempted innovations should be defaced from the official records of the Order.[13] Thus under Mary there was a deliberate and immediate return to the old Garter ceremonial as a manifestation of the Catholic reaction. Philip of Spain,[14]

on his marriage to Mary, became joint sovereign of the Order, and his presence is recorded by the diarist Henry Machyn in the splendid ceremonies which marked St George's Day at court, when solemn processions and Masses were once more part of the festivities.[15]

<p style="text-align:left">The Elizabethan
Garter settlement[16]</p>

Elizabeth's accession in 1558 brought, of course, another religious reversal. St George's Day 1559 occurred three days after the passing of the Act of Uniformity, and so the proceedings were scrutinized by Protestants for any significant deviations from Catholic ceremonial, but there were none. Actually the new ritual did not begin in the Chapel Royal until 12 May, and so the Garter solemnities followed their accustomed pattern. The only modifications were those which had been in general use in the Chapel Royal since the previous December: the use of the English Litany for the procession, the Epistle and Gospel in the vernacular and the omission of the elevation in the Mass. The procession was the occasion for some confusion, for it was forced to proceed without processional crosses, in spite of a last-minute effort to secure some from Westminster, and on the following day the Queen made herself conspicuous by her absence from the requiem Mass. The four newly-elected Knights (the Duke of Norfolk, the Marquess of Northampton, the Earl of Rutland and Lord Robert Dudley), moreover, were dispensed from taking the oath on their installation at Windsor, because the Order had not yet been reformed in accordance with the religious settlement.[17]

Elizabethan Garter reform, or rather lack of reform, was determined largely by two factors. In the first place the members of the Order were most of them survivors of the Marian régime, either openly Catholic or sympathizers, in addition to which there was the overwhelmingly conservative nature of the Queen. She had always favoured a return to the first Edwardian Prayer Book of 1549 rather than to the more strongly Protestant version of 1552, and here perhaps more than anywhere can be traced the origin of her personal solution to the religious dilemma of 1558.

The reform followed the precedent set by Edward VI. It began in June 1559 when the Feast was held at Windsor in which the Earl of Pembroke acted as Lieutenant for the Queen, assisted by Lord Hastings and Viscount Montague. On this occasion the Prayer Book was used for the first time and both the High Mass on the Feast Day and the requiem on the day after were replaced by the vernacular communion service.[18] This ritual was followed both on St George's Day and at the Feast at Windsor in 1560, but that year, again in accordance with the pattern of the Edwardian reform, a commission was issued to the Marquess of Northampton, the Earls of Arundel and Pembroke, and Lord Howard of Effingham, for a revision of the Garter statutes.[19] The official book of the Order, the *Liber Ceruleus*, preserves no record that this commission accomplished anything, nor are any draft statutes extant or proposals for a return to the Edwardian settlement. This activity resulted in only one

unofficial alteration made to the Henrician statutes: a substitution in which such words as 'Mass' were replaced by 'divine service'. In practice this Elizabethan modification amounted to a cessation of the celebration of a communion service on the day after the Feast, and the use of the curtailed version, ending with the Prayer for the Church Militant, customary when there were no communicants, on the Feast Day itself. In all other respects the Catholic statutes and along with them St George, so detested by the reformers, survived into a Protestant England. It was a settlement fraught with an ambiguity which led to renewed attempts at reformation in the seventeenth century by both James I and Charles I who, Ashmole writes, 'designed and endeavoured the most compleat and absolute Reformation of any of his Predecessors'; but both of his commissions, like Elizabeth's, failed actually to achieve anything.[20]

Elizabethan
Garter ceremonial

There was little variation in Elizabethan Garter ritual, so that a detailed examination of one account will suffice to indicate the rhythm of the Order's ceremonies throughout the reign. The ceremony of the year 1576, besides being excellently documented, is enriched by the publication in the same year of Marcus Gheeraerts' engraving of a Garter procession. From 1567 onwards the Feasts were held at Whitehall or Greenwich, and that of 1576[21] was held at Whitehall. This abandonment of the Grand Feast at Windsor, lamented by Ashmole as a major disaster,[22] made way for the development of the annual St George's Day ceremonies at court into the great public spectacles they had become by the nineties.

The Feast[23] in 1576 was prorogued, because 22 April happened to be Easter Day, so that the eve of the Feast fell on 23 April. On that day between three and four o'clock in the afternoon, 'as hath been accustomed', the Knights of the Garter, attired in their full robes, assembled in the Presence Chamber. On the appearance of the Queen they proceeded to her Chapel Closet where a chapter of the Order was held and where she appointed her Lieutenant for the Feast, the Earl of Bedford, whose task was to preside over the ceremonies she did not attend in person. This concluded, the Knights descended through the Great Chamber and Hall to the Chapel, which was arranged like the Chapel at Windsor, each Knight having his stall with his scutcheon above it. After the gentlemen and choristers of the Chapel Royal had sung evensong, they rejoined the Queen in her Closet, from which they made their way to the Privy Chamber where supper was served.

The next morning, St George's Day, the Knights reassembled in the Presence Chamber and proceeded to matins, after which they returned to await the entry of the Queen. Elizabeth appeared arrayed in her Garter robes and wearing a diadem of pearl upon her head, the sword of state borne before her by the Earl of Hertford, her mantle supported by the Earl of Northumberland and Lord Russell, and her train carried by the Countess of Derby assisted by the Earl of Oxford. In this manner the

168

Queen and her Knights descended into the Chapel to their stalls and, after a song had been sung by the choristers of the Chapel, the solemn procession was formed. At the head of it was the Sergeant of the Vestry, rod in hand, followed by choristers and then chaplains, vested in copes: it was the task of the clergy and choir to chant the Litany during the procession. Behind them came the heralds and then the Knights and finally the Queen. As the procession left the Hall and went out into the courtyard, Gentlemen Pensioners joined it, flanking the Queen at either side, and a sunshade of green taffeta was provided to shelter her from the sun. On returning to the Chapel the prelate of the Order, the Bishop of Winchester, arrayed in a cope, went up to the altar and 'pronounced' the rest of the service, assisted by a deacon and subdeacon, also arrayed in copes, who 'pronounced' the Epistle and Gospel. The creed was sung by the chaplains, after which came the solemn offering, when the Queen and each Knight in turn descended and placed an offering in a basin held by the Bishop still vested in his cope. After the service the Knights returned via the Hall to the Presence Chamber where a ceremonial banquet was held, at which the heralds proclaimed the Queen's full title. In the evening the Knights went to evensong and on the following morning to matins. With this the festivities came to an end.

The elder Marcus Gheeraerts' engraving of a Garter procession gives a splendid impression of this festival.[24] It was produced under the supervision of Thomas Dawes, Rougecroix Pursuivant, and in the dedication to the Queen he explains that it represents 'the manner of that solemn and triumphant proceeding, used by the Knights of the most honourable Order of the Garter, upon their festival day when as they assemble and meet together at Windsor, in due order, with all officers thereto belonging, or any other person which hath place in that Solemnity'. The engraving was executed in 1576 but a contemporary hand has changed the date to 1578. In 1578, however, the Queen was indisposed and did not take part in the ceremonies. In addition, it is supposed to depict a procession at Windsor, which after 1567 (excepting 1572) was not utilized for the St George's Day ceremonies. Nor is it an exact rendering of the 'triumphant proceeding', for there is the conspicuous absence of the Chapel choristers and the officiating clergy who headed the procession. In other words, like the Procession Picture it is a 'heroical device' which has to be read as an overall emblem of the Garter as an institution.

This procession is led by the Verger of the Chapel of St George at Windsor, who is followed by thirteen aged and grave men wearing mantles and with skull-caps upon their heads. These were the Poor Knights of Windsor, who were finally settled at Windsor in July 1559.[25] These Knights, who were to be men grown old in the wars, spent their time in prayer for the Queen and her Knights of the Garter, 'coming twice a day to the church to service time for that end and purpose'.[26] Behind them come pursuivants and heralds wearing their customary embroidered tabards, and then the Knights: first the English Knights in

80-83

80 The Queen preceded by a nobleman bearing the sword of state

The Garter Procession, 1576

82 *Left to right:* Philip II, Henri III, the Dukes of Savoy and Schleswig-Holstein, the Earl of Arundel, the Duke of Montmorency, the Earls of Lincoln and Sussex

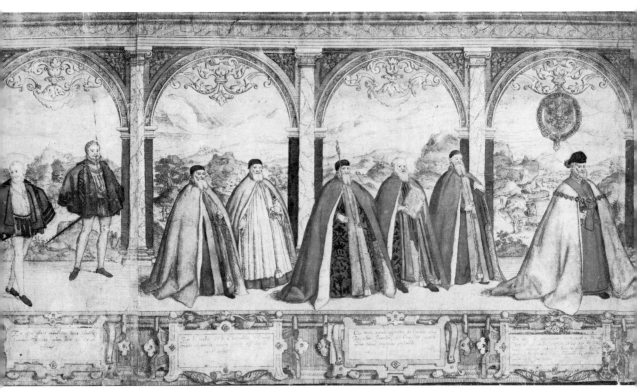

81 *Left to right:* two gentlemen ushers, the Chancellor, the Bishop of Winchester, the
Usher of the Black Rod, the Registrar, Garter King of Arms and the Emperor Maximilian II

83 The Verger of the Chapel of St George at Windsor, followed by two Poor Knights

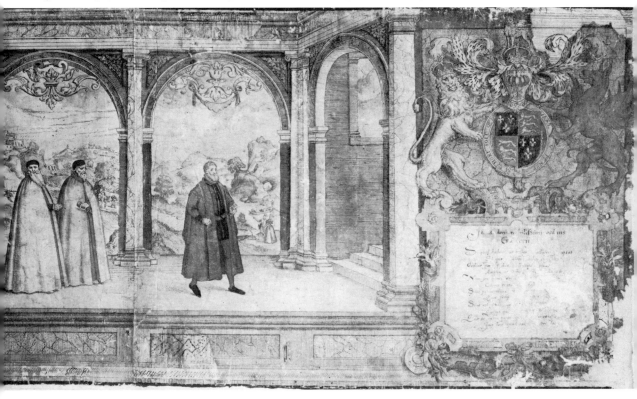

reverse order of seniority, opening with Lord Howard of Effingham, installed in 1576, and closing with Henry Fitzalan, 14th Earl of Arundel, installed as long ago as 1544. Behind them walk six stranger Knights, the Dukes of Montmorency, of Schleswig-Holstein, and of Savoy, the Kings of France and Spain and the Emperor Maximilian II. What an extraordinary alignment! The robes of all the Knights are identical saving for those of Knights-Sovereign, who were allowed trains. After the Knights follow the five principal officers of the Order: the Registrar – a post under Elizabeth generally held by the Deans of Windsor – who acted as a kind of keeper of the records; the Usher of the Black Rod and Garter King of Arms, who were concerned principally with the conduct of ceremonial at the festivals; and finally Sir Thomas Smith as Chancellor, carrying in a bag the Order's signet and Great Seal, and Robert Horne, Bishop of Winchester, as Garter Prelate. Preceded by two gentlemen ushers and a nobleman bearing the sword, Elizabeth walks clasping a large ostrich-feather fan, her mantle trailing behind her.

Like the Procession Picture, which in one aspect it anticipates, Marcus Gheeraerts' engraving of Gloriana and her Knights processing is typically Elizabethan in its total indifference to the unities of time and space. The procession is selective: officials who should be there are omitted, foreign Knights who would not have been there are inserted, train- and canopy-bearers surrounding the Queen are dispensed with. They move, as in the Procession Picture, through fictional architecture, in this case an impossible arcade set high on a hillside looking over an imaginary landscape into which Windsor Castle has been incongruously set. Coats of arms, in a way characteristic of Elizabethan portraiture, are superimposed on to it; we are meant to read it both as a collective image and as a separate series of images. The dedication by the Rougecroix Pursuivant is to Elizabeth, the Garter Sovereign, 'as a thing of right appertaining to your person, hoping that your grace will take some pleasure in viewing thereof'.

Each St George's Day brought a repetition of these solemnities. Sometimes the inclemency of the weather caused the festivities to be curtailed, as in 1579 when a great fall of snow resulted in the absence of the Queen and the restriction of the procession to the Hall.[27] As the reign progressed, however, the ceremonies, like the tilts, became more of a public spectacle and the procession, which was the part seen by onlookers, was deliberately developed. The 1584 narrative contains the earliest reference to a full-scale canopy borne over the Queen by six gentlemen during the outdoor procession.[28] By 1592 the crush of people was so great that the ceremonies were held up awaiting the arrival of Knights who had failed to penetrate the throng,[29] and Philip Gawdy records a similar 'great press of people' at the 1594 festivities.[30] The account of the 1595 solemnities by an envoy of the Duke of Württemberg gives some idea of the immense popularity of the Garter festival by the end of the reign. The Chapel Royal was packed with visitors, and the magnificent procession made its way not once but three times around the

courtyard so that all might see the Queen, who spoke graciously to everyone, even to the common people who fell upon their knees in homage.[31] Here we see Elizabeth's flair for ceremonial and appetite for public adulation in full flight; and we see too the deliberate use of the Garter to create another Day in honour of Elizabeth and her Knights.

Apart from the Feast at court the only other Garter ceremony was the election and installation of a new Knight.[32] Elizabeth showed considerable reluctance throughout the reign to confer the Garter, and only those of the highest rank and position were admitted to the Order. Although the Garter Knights voted for new members, the actual decision rested with the Queen, who gave it the morning after the Feast when the Knights assembled in the Presence Chamber prior to attending matins. In 1592, for instance, she declared the election of the Earls of Shrewsbury and Cumberland. Shrewsbury was fetched from his lodging at Greenwich and brought at once into the presence of the Queen, who placed the George of the Order around his neck with her own hands. The Earl of Cumberland was at Plymouth, but the Queen would not allow the Garter to be conveyed to him, for she wished to confer it upon him herself.[33] The following year, 1593, brought another touching scene when Elizabeth invested old Sir Francis Knowles, 'famed for his sons',[34] not only with the collar of the Order but also with the Garter, an act which moved bystanders to tears.[35]

In the last decade of the reign the ride of the new Knights to Windsor for their installation developed into a spectacular cavalcade.[36] This innovation does not figure in the accounts of the ceremonies before 1592, in which year the Earls of Cumberland and Ormond agreed to meet at Charing Cross, from whence they rode to Windsor. Just outside the Castle their trains were marshalled into processional order so that a triumphal entry could be made.[37] Five years later, in 1597, the newly elected Knights agreed to take only fifty men apiece, 'but now I hear', reported Rowland Whyte to Sir Robert Sidney, 'that my Lord Chamberlain will have 300, and Sir Henry Lee 200'.[38] The ride of Lee and his companions was as splendid as the entry of knights at the Accession Day Tilts. Sir Henry Lee's men were dressed in blue, Lord Mountjoy's in blue and purple, Lord Hunsdon's in orange taffeta and plumes and Lord Howard's in blue faced with 'sad sea colour green' together with feathers and chains of gold.[39] The 1599 cavalcade resulted in similar rivalry, but Lord Cobham's train was 'most bravest', with gentlemen attired 'in purple velvet breeches, and white satin doublets and chains of gold. And his Yeomen in purple cloth breeches, and white fustian doublets, all in blue coats, and faced with white taffeta, and feathers of white and blue.'[40]

For Garter Knights who rebelled against the sovereign of the Order there awaited the dread process of degradation.[41] The Earls of Northumberland and Westmorland, for their part in the Northern rebellion, the Duke of Norfolk, for complicity in the Ridolfi plot, and the Earl of Essex, for his reckless uprising, were each ceremonially ejected

from the Order. The process fell into two distinct parts, the first of which consisted in the snatching of the insignia of the Garter from the unfortunate Knight. In February 1601 the Usher of the Black Rod proceeded to the Tower and removed the George and Garter from the Earl of Essex.[42] In like manner Sir John Fastolfe is degraded in Shakespeare's *Henry VI* for cowardice at the siege of Rouen. Talbot snatches the Garter from his leg and beseeches the young King whether

> *. . . such cowards ought to wear*
> *This ornament of knighthood . . .*[43]

and continues to explain the high ideals of chivalry which Fastolfe has so foully betrayed:

> *When first this order was ordain'd, my lords,*
> *Knights of the garter were of noble birth;*
> *Valiant and virtuous, full of haughty courage,*
> *Such as were grown to credit by the wars;*
> *Not fearing death, nor shrinking from distress,*
> *But always resolute in most extremes.*
> *He then that is not furnish'd in this sort*
> *Doth but usurp the sacred name of knight,*
> *Profaning this most honourable order;*
> *And should – if I were worthy to be judge –*
> *Be quite degraded, like a hedge-born swain*
> *That doth presume to boast of gentle blood.*[44]

Those who had thus dishonoured 'the sacred name of knight' not only suffered this humiliation, but, in addition, had their achievements thrown out of the Chapel at Windsor. Several narratives survive of the ejection of the Earl of Northumberland. On 27 November 1569 the heralds assembled in the Chapel and a ladder was placed against the Earl's stall which Chester Herald ascended. A proclamation was then read by Rougecroix which explained that Northumberland had been guilty of high treason against the sovereign of the Order and as such deserved no longer to rank among 'virtuous and approved' Knights. Immediately this was uttered, Chester Herald 'did hurl down with violence' the Earl's banner, crest, helm and sword, which were thrown out of the Chapel into the castle moat.[45]

The observance of St George's Day

The statutes of the Order of the Garter as revised by Henry VIII made provision for the observance of the annual Feast by Knights absent from court; the Knight was bound to erect the arms of his companions in a nearby chapel or church in the same manner as it was done in the Chapel Royal at court, in imitation of the choir stalls at Windsor. He was further to wear the robes of the Order and to attend services and ceremonies

corresponding to those staged at court.[46] Under Elizabeth these occasions became opportunities for display on a lavish scale, opportunities for a manifestation of the ritual of royalist chivalry in the remoter parts of the realm or even abroad.

Sir Henry Sidney, as Lord Deputy of Ireland and subsequently Lord President of the Council of Wales, observed St George's Day in several places including Dublin, Drogheda, Shrewsbury and Ludlow.[47] The observances in Shrewsbury in 1581 were especially solemn, Sir Henry 'in his knightly robes most valiant' proceeding to St Chad's church attended by gentlemen, knights and town officials in procession. The chronicler records that 'he did as much honour as though the Queen's Majesty had been present'. That evening there was feasting and Sir Henry kept open house.[48] Ashmole records that when he visited Shrewsbury almost a century later an altar cloth embroidered with Garters was still preserved there which had been wrought for that occasion.[49]

Interesting details survive of the 'great triumph' arranged by the mayor of Liverpool in 1577, when the Earl of Derby observed St George's Day there en route for the Isle of Man. On the eve of the Feast, Lord Derby went to evensong attended by yeomen and gentlemen, after which soldiers discharged ordnance in the churchyard and there were similar salutes from ships in the river nearby. On St George's Day itself they came again to church 'very gorgeously' both in the morning and evening, and the Earl's departure on each occasion was the signal for 'great triumph' which included a firework display. The Feast was brought to an end the next day with entertainments including morris dancing. The chronicler records that the town had never before witnessed such spectacle.[50]

The Earl of Leicester kept St George's Day in Utrecht in 1586. The ceremonies were designed, the herald Segar writes, 'to the honour of our nation, in view of so many thousand strangers'. The route to the cathedral was decorated with the arms of the burgesses, adorned with material made like white and red roses. The procession was magnificent, and Leicester himself was attended by an escort consisting of the principal citizens of the town besides fifty of his own men. Sumptuous canopies were erected for the absent Queen, both at the church and the feast, 'as if in person she had been there'. The banquet was accompanied by fanfares of trumpets and the proclamation of the Queen's style, after which the Dutch fell to drinking the health of Her Majesty, Leicester and the United Provinces. The company reassembled in the evening for another great banquet, after which there was fighting at the barriers in which the gallant young Earl of Essex 'gave all men great hope of his prowess in arms'.[51]

Thirteen years later, in 1599, Essex himself was to celebrate St George's Day away from court when he was leader of the ill-fated Irish expedition. At Dublin he typically honoured the Queen by staging a chivalrous display, a colourful impression of which survives in a popular ballad:

In Ireland St George's Day
Was honoured bravely every way,
By lords and knights in rich array,
 as though they had been in England.

Full many a bold renouned Knight,
Well trained to arms and martial fight,
Were seen that day, with great delight,
 to honour St George of England.

With gentlemen of high degree,
Our choicest flowers of chivalry,
As brave a sight as one might see
 to honour St George of England.[52]

On that day knights and gentlemen together with the ordinary soldiers took part in a military parade to pay tribute to St George, patron of the Garter and of fighting men, and to 'that maiden Queen'. The magnificent Essex of the ceremonial tilts thus becomes the splendid Garter Knight of St George's Day. Both aspects are in their way accurate reflections of Elizabethan chivalry and its conventions.

Foreign investitures:
religion and chivalry

The election of a 'stranger Knight' into the Order of the Garter involved the usual ceremonies of election, investiture and installation.[53] It was already an established tradition that the conclusion of peace or of an alliance was marked by an exchange of chivalrous orders, but in the second half of the sixteenth century this was complicated by the religious divisions rending Christendom, for both investiture and installation involved a religious ceremony. The reception of the Garter by a Catholic prince thus raised the whole subject of Catholics and Protestants taking part in a joint religious service.

In spite of the reality of disunity, the idea of some vague unforeseen solution to the catastrophes which had befallen the Christian world attracted intellectual, even if not realistic, speculation.[54] The first decade of Elizabeth's reign coincided with the generation that had produced the demands for reform and the restoration of religious unity at the Council of Trent. In France this liberal Catholic party, headed by Jean de Montluc, Bishop of Valence, Michel de l'Hôpital, Paule de Foix and Catherine de' Medici, and influenced to a considerable degree by the reunionist Christian humanism of the Dutch Cassander, displayed great interest in the Anglican settlement.[55] The *Book of Common Prayer* was sent for and studied by the divines at Poissy, and the demands of that party at Trent were described by the English ambassador as being 'not very discrepant from the Queen's formula in England'.[56] This group and its ideas form the background to the investiture of Charles IX with the Garter in 1564, an act which marked the cessation of hostilities between England and France. The embassy was headed by Lord Hunsdon, who

was instructed that although he could be present at the Mass, nevertheless he was to forbear giving any sign of approving any part of it. Constable Montmorency and the Bishop of Limoges were at pains to explain that Lyons cathedral was devoid of images, that all was sung or said by heart and that only one Mass was said there daily. Peace was sworn after Mass the next day and the young King received the Garter that afternoon, after which they proceeded to evensong.[57] In a similar manner Rambouillet invested Leicester and Norfolk with the Order of St Michael in 1566, an event marked by splendid ceremonial in the Chapel Royal at Whitehall where the altar was adorned, not only with hangings embroidered with angels of gold, but with a cross, a pax, and two candlesticks. Rambouillet in addition attended the Anglican services connected with the installation of Charles IX at Windsor, acting as proxy for his royal master.[58]

We can trace this princely dalliance with religious reunion further in the reception of the Garter by the Emperor Maximilian. Like the French, the imperialists had also presented a programme for reform at Trent, not altogether removed from the Anglican position.[59] Although the gorgeous embassy of 1567 headed by the Earl of Sussex failed in its immediate purpose of cementing an alliance between the Queen and the Archduke Charles, the Emperor received the Garter and attended evensong – Sussex had been forbidden to go to Mass[60] – in which 'censing, prayers to saints and all other matters contrary to your [the Queen's] religion were omitted'. Such incidents shed a sudden flood of light across what we normally accept as the rigid division of Catholic and Protestant. The rites of chivalry could momentarily heal the schism in faith.[61]

Nor did these joint ceremonies collapse in the face of rising violence and hatred. In 1572, when in France the policy of conciliation had reached its apogee in the marriage of Henri de Navarre and Marguerite de Valois, the Treaty of Blois with England was sealed by a series of magnificent festivals, in one of which Constable Montmorency was installed as a Knight of the Garter at Windsor.[62] When Henri III received the Garter in February–March 1585 religious animosity was at its height, yet although the monarchy in France was on the verge of collapse it was still possible – admittedly with elaborate precautions – for Catholic and Protestant knights to walk in procession a short distance to the church of the Augustins in Paris and attend evensong. The splendid embassy led by Henry Stanley, 4th Earl of Derby, was the occasion for the last of the great series of fêtes staged under the influence and direction of the Academies. Soon all was to be swept away, and the reception of the Garter from the English Queen by Henri was to be the subject of derisive and ribald propaganda by the Catholic League.[63] But as the monarchy revived under Henri IV, liberalism found a new saviour. The investiture of Henri IV with the Garter at Rouen (1596) sheds a tiny sidelight on this return to *politique* policy. Although the Earl of Shrewsbury, who brought the Garter, was ordered not to attend Mass, nonetheless Catholic and Protestant knights once more walked in procession to evensong.[64] Four

years later Monsieur de Chattes came to England and was installed at Windsor on behalf of Henri, an event which scandalized the English Catholics.[65] These Garter investitures illuminate a neglected aspect in religious trends in the post–Tridentine period – the survival of the liberal tradition and the extent to which chivalry continued to act as a bridge which crossed the chasm of creed.

Over the investiture of Protestant princes there is less cause to linger. The Duke of Holstein received the Garter on the occasion of his visit to England in 1560 to negotiate for the Queen's hand,[66] and John Casimir, Elector Palatine, was invested with it when he came to confer with Elizabeth early in 1578.[67] The investiture of Frederick II, King of Denmark, was performed by an embassy headed by Lord Willoughby d'Eresby which arrived in Denmark in August 1582. This mission involved many difficulties because the King regarded the Order as being somewhat popish and refused point-blank to wear the robes or to receive the Garter in the name of a saint. At last, on 14 August, he was induced to receive the Garter and the George only – the collar still survives – and the occasion evoked from his secretary a long letter to Sir Francis Walsingham praising the Order and its part in linking rulers in unity with each other.[68]

As a footnote to these foreign investitures there remains the story of the Duke of Württemberg's passion for the Order. This began in 1592 when the Duke visited Windsor Castle, which make a profound impression upon him:

> Sic *FREDERICVS ad has, modo se conuertit ad illas*
> *Regnioras, Windsorae illum unica aura remordet*
> *Windsora ante oculos, Windsora ante ora recurrit.*[69]

In a subsequent audience, he claimed, the Queen promised his election as a Garter Knight. Elizabeth later denied this, but it was the foundation upon which the Duke built his hopes and it resulted in five years of embassies, complimentary letters and gifts until at last, in 1597, the Queen admitted him. A delay in the delivery evoked a second flood of embassies and letters, but it was not until after the Queen's death that the Duke's desire was fulfilled.[70] That the Duke was something of a figure of fun we can gather from the allusions to the visit of Germans to the Garter Inn, Windsor, in Shakespeare's *Merry Wives*, where the Host laments that 'They have had my house a week at command; I have turned away my other guests', and they subsequently make away with the post-horses.[71] The discrepancy between the Duke's passion for the Garter and the English mockery of him and his entourage was ready material for moulding by a great comic genius.

The antiquarian approach

André Favyn, the seventeenth-century expert on matters concerned with chivalry, wrote, in his *The Theater of Honour and Knighthood* (1619), that the Order of the Garter 'had S. George for the Governor, or Patron, Love

178

for the Subject, and the Device French'.[72] He was referring to what was popularly regarded as the origin of that illustrious Order, the gallantry of Edward III in picking up a lady's garter and reproving the lascivious thoughts of bystanders with the famous words *Honi soit qui mal y pense* (evil be to him who evil thinks). The gradual rise of that legend stems back to the official humanist historian of the Tudor dynasty, Polydore Vergil, who first recorded it in his *Anglicae Historia* as being current amongst the vulgar. In his version it is the Queen's garter which is picked up. Polydore himself thought that the origin of the Order was lost in obscurity, but rightly alluded to its military setting in using the patron of soldiers as its protector.[73]

Running directly counter to this appraisal of its foundation was the introduction to the official book of the Order, the *Liber Niger*, compiled at the beginning of Henry VIII's reign. The *Liber Niger* represents a deliberate effort to fabricate a suitable pedigree in the face of the absence of a more legitimate one. It recalls the valiant knights of Troy, of the Old Testament and of the Christian faith, and alludes to the chivalrous English kings who had been images of the knightly virtues. Behind them loom the figures of Arthur and his Knights of the Round Table, and here, for the first time, appears the story of Richard I as the founder of an order of knights who wore garters of blue leather at the siege of Acre. The *Liber Niger* states that in founding the Garter Edward III was merely reviving this order. The introduction further includes lengthy discussions on the symbolism of the insignia: the Garter as a symbol of friendship, sincerity and faithfulness; the great collar as a bond of peace and fidelity; the George as a reminder to the Knights of a valiant soldier of Christ and the robes of purple as emblem of majesty and bravery of mind.[74] Such a pedigree for the Garter was meant firmly to put the Golden Fleece into place as emphatically *nouveau*.

The garter legend was, however, increasingly disseminated as the century wore on – notably by those less concerned with the grave and weighty ideals of the Order and its solemnities. Each successive recording evoked yet further elaboration, and the story grew ever more complex and conflicting. The *Armorie of Nobillitie* (1589) is one of several full-blown examples current in the reign of Elizabeth:

> The King on a time dancing with one of the Maids of Honour, her garter (which was of blue silk) fell from her leg; he, seeing the same, took it up and tied it about his leg, whereat the Queen and others seemed something jealous but he (perceiving the Queen perplexed) having no evil intent therein caused (in token of his innocence) a Garter to be made of blue velvet embroidered with this inscription, *Honi soit qui mal y pense*.[75]

Holinshed offers a variant: the Queen drops her garter on the way to her lodging and Edward orders it to be brought to him and vows to make all men reverence it.[76] George Peele and Sir William Segar also utilized the legend, although the latter preserved Polydore's statement that it was

only popular tradition.[77] The opening of the seventeenth century, and the work of Selden, Speed, Camden and, much later, Ashmole,[78] marked the beginning of a more scientific approach to the mystery of the Garter and its origins. Tudor fabrications were dismissed in favour of a return to the earliest accounts in Froissart and other sources, although as the Order sprang from Edward III's Round Table jousts at Windsor the Arthurian connotation continued to linger.

Over the purpose of the Garter there was complete agreement. Grafton in his *Chronicle* refers to it as the means whereby Edward hoped that 'great amity, friendship and love might grow among the nobles of this realm',[79] and Holinshed similarly praises Edward for making choice 'of the best, most excellent and renowned persons in all virtues and honour'.[80] The herald and antiquarian Camden explains in his *Britannia* (1610) that the Garter was founded to adorn martial prowess with honours, 'the guerdon of virtue', and he, like other commentators, follows the *Liber Niger* in describing the Garter itself as a symbol of concord and unity associating the Knights in a communion of virtues.[81]

Peele's poem *The Honour of the Garter*, written to celebrate the election of Henry Percy, Earl of Northumberland, to the Order in 1593, is an excellent guide to Elizabethan Garter mythology.[82] The poet has a vision – Petrarchan in inspiration – in which he sees the night sky over Windsor Castle filled with a mighty host of armed men together with Edward III, his leg encompassed by a glistening Garter. He tells of the origin of the Order: how Edward in the midst of revels had picked up the Queen's garter and vowed to establish an order with this as its emblem and St George as its patron. There follows a Triumph of Fame, on whose chariot there lies open a book inscribed with the names of all the famous Knights of the Garter. These walk in procession, attended by

> . . . *a number infinite*
> *True knights of all the orders in the world,*
> *Christians and heathens, that accompanied*
> *This worthy king in his procession.*[83]

Peele follows the *Liber Niger* in placing the chivalry of the Garter within a universal context, citing the valiant Trojan knights, those of the Old Testament, the Crusaders, King Arthur, 'the glory of the western world', Jason and the Knights of the Golden Fleece, the Knights of the *Toison d'Or*, of St Iago, of Rhodes and of the Holy Sepulchre. Then

> *A prince of famous memory I saw,*
> *Henry the Eight, that led a warlike band*
> *Of English earls, and lords, and lusty knights,*
> *That ware the garter sacred to Saint George.*[84]

This Triumph of Fame reaches its climax with the vision of Elizabeth and the Knights of her reign, especially those elected in 1593. Each in turn is hailed by Edward III, but at the approach of dawn this celestial vision suddenly fades and the poet awakens from his slumber.

*The theological
approach: the Tudor
cult of St George*

William Caxton in his translation of the *Legenda Aurea* (1483) states that
'the blessed and holy martyr S. George is patron of England and the cry
of men of war. In the worship of whom is founded the noble Order of the
Garter, and also a noble college in the castle of Windsor.'[85] Caxton rightly
discerned three distinct and yet intertwining roles for St George: as
patron of England, of soldiers and of the Garter. Henry VII inherited[86]
and himself promoted a special veneration for St George. One of the
three banners which he bore at the Battle of Bosworth was adorned with
'the image of St George',[87] and there exists the remarkable votive
painting of Henry VII, Elizabeth of York and their children kneeling 84
before the saint who is in the act of slaying the dragon hovering in the
sky.[88] Another painting, a miniature, probably torn from a treaty, depicts
Henry in his Garter robes attended by the Emperor, the King of the
Romans and the Austrian Archduke kneeling before an altar on which
stands St George treading the dragon underfoot.[89] On his death the King
bequeathed a jewelled image of the saint to the Chapel at Windsor to
adorn the high altar on feast days.[90] Similar visual material is extant for
the adoration of the saint by Henry VIII,[91] a cult which was strengthened
by Henry's role as a warrior prince. During this reign the cross of St

84 The Tudor cult of St
George: Henry VII and
his family kneeling in
adoration

George, a red cross on a white or silver ground, was established as the battle flag of England,[92] a fact which may account to a considerable degree for the survival of St George into the England of Elizabeth.

The accession of Edward VI at once brought the saint into difficulties and as early as 1547 poor St George was under fire, finding a strong defender in the conservative Bishop Gardiner.[93] 'If images be forbidden, why doth the King wear St George on his breast?' he sharply inquired.[94] Early revisions of the Garter envisaged the continued use of the saint but, in 1550, young Edward himself turned upon the saint in an anecdote recounted with relish by Foxe:

> ...at Greenwich, upon St George's Day, when he [Edward] was come from the sermon into the presence-chamber, there being his uncle the duke of Somerset, the duke of Northumberland, with other lords and knights of that order called the Order of the Garter, he said to them, 'My lords, I pray you, what saint is St George, that we here so honour him?' At which question the other lords being all astonished, the lord treasurer that then was, perceiving this, gave answer, and said, 'If it please your Majesty, I did never read in any history of St George, but only in 'Legenda Aurea', where it is thus set down: That St George out with his sword, and ran the dragon through with his spear'. The King, when he could not for a great while speak for laughing, at length said, 'I pray you, my lord, and what did he with his sword the while?' 'That I cannot tell your majesty', said he. And so an end that question of good St George.[95]

One of the successive versions of the Garter statutes contains an attempt at allegorization which is a pointer towards the Elizabeth compromise. It was suggested that the Order should have for its emblem a knight on horseback bearing a shield inscribed *Fides* and a sword with *Protectio* piercing a book, *Verbum Dei*.[96] The final statutes provided merely for an armed horseman and avoided commentary on its significance.

St George remained untouched on the accession of Elizabeth and the 'cult' of this saint,[97] like other aspects of the Garter, remained something of an anomaly. It was never formally stated that the Garter badge did not represent the saint, but for both Catholics and Protestants in the second half of the sixteenth century the actual image of St George slaying the dragon became accepted as a sacred emblem or hieroglyph. Interpretations varied from an allegory showing how the civil magistrate through his virtues should deliver the Church from oppression,[98] to a city or state begging the saint's intercession in its struggle against the devil.[99] English allegorizations are late but embody what must generally have been regarded as the meaning of the Garter George. They fall roughly into three groups.[100] The first is the product of the ultra-Protestant approach. John Rainolds, Greek scholar and President of Corpus Christi College, Oxford, in his *De Romanae Ecclesiae Idolatria* (1596), dedicated to the Garter Knight Essex, after referring to the

Calvinistic and Lutheran denunciations of St George states that the George was an emblem designed to incite the valiant Garter Knights to fight the dragon, the dreaded Antichrist of Rome.[101] A Jacobean poem on the Order reiterates this theme:

> *The Garter is the favour of a King,*
> *Clasping the leg on which man's best part stands;*
> *A poesye in't, as in a nuptial ring,*
> *Binding the heart to their liege Lord in bands;*
> *That whilst the leg hath strength, or arm the power,*
> *To kill that serpent would their King devour . . .*
> *God keep our King and them from Rome's black pen,*
> *Let all that love the Garter say, Amen!*[102]

This is not altogether removed from a second, late interpretation by John Boys, Dean of Canterbury in the next reign, who took the Garter George to signify that a valiant Christian knight should always be ready to fight against the dragon, and other enemies of Church and State.[103] But it was also interpreted as an allegory of Christ vanquishing the devil and delivering the Church.[104]

> *Saint George the Dragon, Jesus Satan kill'd;*
> *Saint George the Princess and the Lamb preserv'd:*
> *Jesus the bitter combat hath fulfill'd,*
> *And by the Devil's death his Church reserv'd;*
> *That spotless Dame whose ravishment was sought*
> *By tyrant's rage that bloody ruin brought.*[105]

Thus runs one popular ballad, Richard Vennar's *A Prayer for the prosperous Successe of hir Majestie's Forces in Ireland* (*c.* 1600), which continues to move the allegory on to another level and describes the Garter Knight, Mountjoy, bearing his Saviour's badge, quelling the devilish Tyrone. The Christ versus the Devil theme moves on to a third plane with equal facility in Gerard de Malynes' *Saint George for England* (1601), this time becoming Elizabeth who, as the disseminator of purity of doctrine, had rescued many from the chains of darkness.[106]

The general effect of these interpretations is somewhat kaleidoscopic, but they are of importance in showing how the motif of the knight slaying the dragon could ascend from the struggle of a Christian against the Antichrist of Rome to that of Christ versus the Devil. Although the truth of the dragon-killing story was dismissed it is significant that St George continued to hold his own as a saint, particularly because he could be justified by an appeal to the Greek church,[107] with which, of course, Anglican theologians always liked to associate themselves. He was still the patron of England, the saint who was invoked by the soldier on the battlefield, whose flag was borne by forces both on sea and land.

Book I of Edmund Spenser's *Faerie Queene* contains a large woodcut of St George and the dragon, and Spenser's handling of the George allegory works on all these levels intermingled with a great number of other

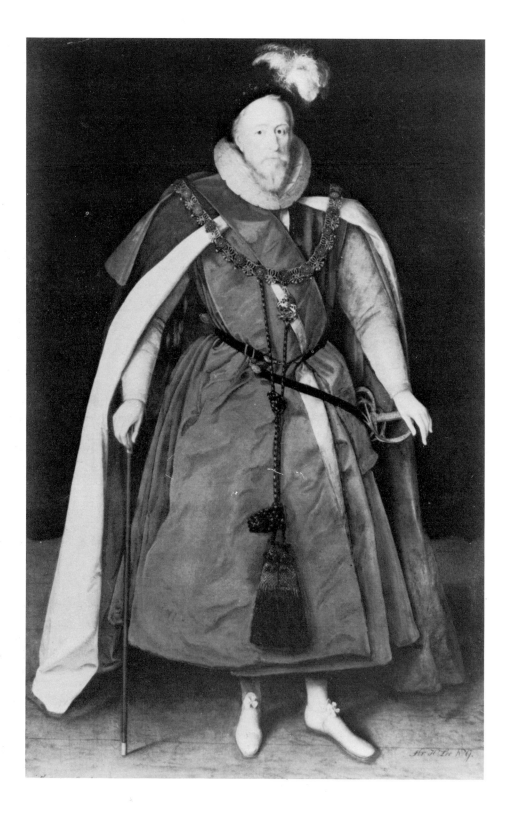

complex incidents. The Red Cross Knight is, of course, specifically alluded to as St George, as a person arrayed in 'the armour of a Christian man', and looming behind it all is the Knight's identification with Christ overcoming the Devil and espousing the true Church, Una.

> *During the which there was an heavenly noise*
> *Heard sound through all the Pallace pleasantly,*
> *Like as it had bene many an Angels voice,*
> *Singing before th'eternall maiesty,*
> *In their trinall triplicites on hye . . .*[108]

In this aspect the Garter George carries within it a mystic and eternal message.

These interpretations of the Garter George are of equal interest in relation to the Queen's portraits, in which she sometimes holds up the Lesser George, clearly with the notion that it is a sacred badge or hieroglyph.[109] She is here the sovereign lady and Governor of the Church of England asking the loyalty of her Knights. Nor should these exegeses be forgotten in relation to the Garter portrait. The ascendancy of the chivalrous formula is reflected as accurately by Knights in their Garter robes as it is by the monotonously popular knight-in-armour formula. Sir Henry Lee in his Garter robes[110] is a typical example of the favour accorded to the Garter portrait by the new aristocracy of the Elizabethan age. These portraits probably owed something to continental trends in iconography – Knights of the Golden Fleece, for example – but they can also be taken as evidence of the renewed vigour of the Order of the Garter in the reign of Elizabeth I. They are demonstrations of royal favour received, of loyalty of knight to lady, as intense in its chivalry as the Accession Day Tilts.

What are we to make of all this? Like so much else in the age of Elizabeth, it represents a deliberate cult and reinvigoration of archaisms. The visual image of the age was feudal and medieval. Portraits and tombs show us knights in armour, stiff and hieratic. Interior decoration revels in ostentatious displays of coats of arms, evidence of the pedigree mania of the new families. Architecture, as it reached its supreme expression in the nineties, looked backwards rather than forwards. Hardwick is King's College, Cambridge, secularized and updated: its sheets of glass, its bold outlines and crenellation are perpendicular. In literature the great epics, the *Arcadia* and the *Faerie Queene*, are romances overlaid by Neoplatonic philosophy with a Protestant gloss. Garter ritual suited a court increasingly given to public appearances by the Queen, almost Byzantine in their splendour. It was a vehicle which enhanced the Crown with ancient feudal glory. It was the Queen as the fount of honour made visible to her people. Above all it was conducive to the religious ambiguity of the Queen herself. In defiance of the rifts in Christendom, monarchs could rise above it all and still show that in the practice of the chivalric virtues they were one.

85

85 'Hardy Laelius, that great Garter-Knight'. Sir Henry Lee in his robes as Knight of the Garter, 1602

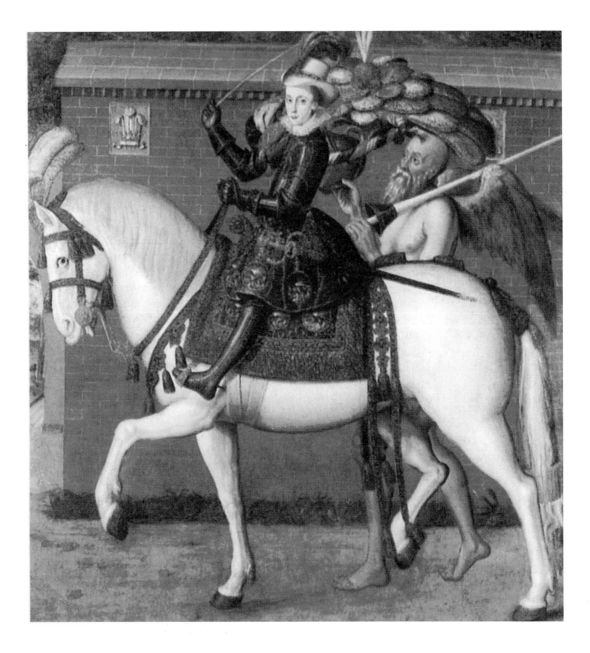

Conclusion ASTRAEA'S HEIR

Henry Peacham's emblem book, *Minerva Britanna*, has been mentioned
more than once in this text. Published nine years after Elizabeth's death, it
looks back with nostalgia to the golden days of Gloriana's knights and
celebrates a world which to all intents had died nine years before, in 1603.
And yet it was not quite dead, for the appearance of this book in 1612 was
prompted by one last fling of Elizabethan romance. The legend of the
Virgin Queen and her knights is thrown into a sharp final focus in the
years 1610 to 1612 in the mythology created for her successor's heir,
Henry Prince of Wales.[1] 86
 James I and his Queen, Anne of Denmark, had deliberately rejected
the mythology of Elizabeth, erecting in its stead one which was harder,
more assertive, and totally unambiguous in its claims. Its images had no
popular base: the Stuart kings had set themselves firmly on the path to
destruction. Those who cherished the old ideals projected their hopes
around the heir to the throne, and in the two years during which he had
his own household it became the focal point for those who wished to put
the clock back to 1603. Gloriana, the fairy queen, was to be seen passing
her sceptre to her godchild, Oberon, the fairy prince. Peacham's book is a
reflection of this revival of Protestant royalist chivalry, anti-Spanish and
anti-Catholic, and the emblem he dedicates to the Prince is that of an
armed knight on horseback. 87

86 Meliadus: Henry,
Prince of Wales, as the
reviver of Elizabethan
chivalry, by Robert Peake,
c. 1611

87 Emblem in honour of
Henry, Prince of Wales,
1612

Thus, thus young Henry, like Macedo's son,
Oughtst thou in arms before thy people shine.
A prodigy for foes to gaze upon,
But still a glorious load star unto thine . . .[2]

The presentation of Henry as a warrior prince, a Spenserian knight, deliberately draws to him the threads of the chivalry of Sidney, of Lee, of the *Young Man amongst Roses*, of the Accession Day Tilts and the Garter processions. And this in its turn was to be updated by applying to it the new mechanical marvels which the Vitruvian architect–engineer Inigo Jones, the Prince's Surveyor, could create.

Ben Jonson's *Barriers*, performed on 6 January 1610, made the initial statement. This was occasioned by Henry's first public appearance bearing arms and was the preface to his creation as Prince of Wales six months later. The whole of the spectacle cast Henry as the reviver of chivalry. The Lady of the Lake appeared amidst the broken obelisks and fallen columns of the House of Chivalry, lamenting such decay:

88

. . . her buildings laid
Flat with the earth that were the pride of time,
And did the barbarous Memphian heaps out climb,
Those obelisks and columns broken and down
That struck the stars, and raised the British crown
To be a constellation . . .[3]

King Arthur came on and prophesied that a knight would restore 'these ruined seats of virtue, and build more', and Merlin arose from his tomb to call forth this fiercely Protestant knight, whose name was Meliadus (*Miles a Deo*): he was discovered flanked by his companions in St George's Portico. Merlin then rehearsed a saga of the warlike kings of England, who foreshadowed the victories to come in the achievements of this young Prince.

89

And what did the audience in the Whitehall Banqueting House actually see? The vision cannot have been so very different from the 1590 Accession Day Tilt with its Knight of Pendragon Castle and its Vestal Virgin Temple; this time it was Lady Chivalry languishing in her cave amidst ruins which ranged from Norman arcading to bastard Gothic, from Trajan's column to one of Michelangelo's Medici tombs, but these were no longer scattered around the tiltyard but brought together and harnessed to an art of perspective illusion unknown to the Elizabethans.[4]

The theme is continued in Samuel Daniel's *Tethys' Festival*, the masque which actually commemorated Henry's creation as Prince in June. The Queen and her ladies, as Tethys, queen of the ocean, attended by the rivers of Great Britain, present him with

. . . this sword,
Which she unto Astraea sacred found,
And not to be unsheathed but on just ground.[5]

188

Inigo Jones's designs for the *Barriers* of 1610:

88 Lady Chivalry languishing in her cave

89 St George's Portico, in which Prince Henry and his companions were revealed in tableau

90 Gloriana, the fairy queen, into Oberon, the fairy prince. Design for Oberon's Palace by Inigo Jones for Jonson's *Oberon, the Fairy Prince*, 1611, the last spectacle of revived Elizabethan romance

Even in 1610 the symbolic presentation of Astraea's sword could have only one meaning. As in the *Barriers*, we are witnessing the transference of the Elizabeth mythology to Prince Henry. It is the legend of Elizabeth as Astraea, the maiden justice, bearing her sword as we see her in so many of her allegorical portraits, which is here being made over to the new Prince of Wales.

The last of Henry's masques, Jonson's *Oberon, the Fairy Prince*, finally transmits from the Elizabethan age the whole saga of fairy embodied in the tilts and Spenser. Gloriana is to be revived in Henry as Oberon. Attended by knights, he comes to pay tribute to his father, cast as King Arthur, and is hymned as the promised messiah: 90

> . . . *he doth fill with grace*
> *Every season, every place;*
> *Beauty dwells but in his face:*
> *He's the height of all our race.*
> *Our Pan's father, god of tongue,*
> *Bacchus, though he still be young,*
> *Phoebus, when he crowned sung,*
> *Nor Mars when first his armour rung*
> *Might with him be named that day.*
> *He is lovelier than in May*
> *Is the spring . . .*[6]

190

But, alas, on 6 November 1612 this hope of the world died.

With the death of Astraea's heir that extraordinary mythology which sustained the Elizabethan world received a blow from which it never recovered. Admittedly it was to re-focus in exile around Oberon's sister, the young Queen of Bohemia married to the leader of Protestant Europe, the Elector Palatine, but this thread takes us beyond the present book.[7] What I have tried to show is the power and importance of these visions of Elizabeth and her court, and how through learning to read them we are tapping the thoughts and assumptions of an age, full of astounding yet comprehensible contradictions. Central to all these images is a message of hope, for they manage to find in one person the salvation of an age, the embodiment of the eternal aspirations of man in the old Europe of the Renaissance. They speak of peace and plenty, of justice and of the virtues returned; they utter a plea for love and reconciliation; they perpetually sing of a golden age, although it is forever betrayed. And all these things they found fulfilled in the physical presence of one extraordinary woman – Elizabeth of England.

NOTES ON THE TEXT

The abbreviations in the notes are those commonly used: *CSP – Calendar of State Papers; DNB – Dictionary of National Biography; HMC – Historical Manuscripts Commission; PRO* – Public Record Office. Of the other manuscripts cited, all are in the British Library except for the Ashmole and Rawlinson which are in the Bodleian Library, Oxford.

PART ONE: THREE PORTRAITS

Introduction: THE LAST PAGEANT

1 All biographies deal in some degree with these events. The best account is L. Antheunis, 'La Maladie et la Mort de la Reine Elisabeth d'Angleterre', *Revue d'Histoire Ecclésiastique*, XLIII, 1948, pp. 148–78.
2 W. Camden, *Remaines ... concerning Britaine*, London, 1870, p. 420.
3 For the funeral see PRO L.C.2/4(4); E.351/3145; A.O.1/2344/30A.
4 Thomas Dekker, *The Wonderful Year 1603* in *Non-Dramatic Works of Thomas Dekker*, ed. A. B. Grosart, London, 1884, p. 88.
5 John Stowe, *Annales*, London, 1631, p. 815.
6 *Henry VIII*, V.v. 61–3.
7 This is gathered in E. C. Wilson, *England's Eliza*, Harvard U.P., 1939, pp. 370–93.
8 John Nichols, *The Progresses of Queen Elizabeth*, London, 1823, III, p. 652.
9 John Hayward, *God's Universal right proclaimed*, London, 1603.
10 Thomas Dekker, *Works*, London, 1873, I, p. 83.
11 John Phillips, *The Reformation of Images: Destruction of Art in England 1535–1660*, University of California Press, 1973, pp. 119–20; Roy Strong, *Portraits of Queen Elizabeth I*, Oxford, 1963, pp. 35ff.

I THE QUEEN: *Eliza Triumphans*

1 On which see Roy Strong, *Portraits of Queen Elizabeth I*, Oxford, 1963, pp. 86–7; *The English Icon: Elizabethan and Jacobean Portraiture*, London, 1969, p. 240 no. 211, where it is first attributed to Robert Peake. In *Portraits* I tended to reject the association of the Procession Picture with the 1600 wedding, but at that stage the nature of the Elizabethan handling of pictorial space had not been grasped.
2 Earl of Ilchester, 'Queen Elizabeth's Visit to Blackfriars', *Walpole Society*, IX, 1921, pp. 1–20.
3 Vertue, *Notebooks*, I, *Walpole Society*, XVIII, 1930, p. 19.
4 Quoted *Walpole Society*, IX, 1921, p. 4.
5 Vertue, *Notebooks*, III, *Walpole Society*, XXII, 1934, pp. 92–3.
6 Strong, *Portraits of Queen Elizabeth*, p. 87.
7 Vertue, *Notebooks*, I, *Walpole Society*, XVIII, 1930, p. 20.
8 Vertue, *Notebooks*, V, *Walpole Society*, XXVI, 1938, p. 84.
9 No. 256.
10 Agnes Strickland, *The Life of Queen Elizabeth*, Everyman ed., pp. 310–11.
11 George Scharf, 'Queen Elizabeth's Procession in a litter to celebrate the marriage of Anne Russell at Blackfriars, June 16th 1600', *Archaeological Journal*, XXIII, 1866, pp. 131–44.
12 Viscount Dillon, 'A Procession of Queen Elizabeth to Blackfriars', *Archaeological Journal*, LXXII, 1915, pp. 69–74.
13 A. L. Rowse, 'Bisham and the Hobys', *Times, Persons, Places*, London, 1965, pp. 188–218; *Diary of Lady Margaret Hoby, 1599–1605*, ed. Dorothy M. Meads, London, 1930, p. 13ff.
14 *Diary of Lady Margaret Hoby*, pp. 18–20.
15 Ibid., p. 32.
16 Whyte to Sidney, 18/19 April 1597, *HMC Penshurst*, II, p. 268.

17 *HMC Hatfield*, VII, pp. 267–8.

18 *HMC Penshurst*, II, p. 312.

19 Whyte to Sidney, *HMC Penshurst*, II, p. 265.

20 Ibid., p. 317.

21 PRO L.C.5/37.

22 Ibid.

23 Whyte to Sidney, 22 and 26 September, *HMC Penshurst*, II, p. 218.

24 Spenser, *Prothalamion*, l. 168–76.

25 For Worcester see *DNB*; *Complete Peerage*, ed. Vycary Gibbs, XII, pt ii, pp. 854–6. There is no proper biography of Worcester, who was a great patron of music, theatre and horsemanship. William Byrd, who appears to have been Master of the Music in the Somerset household, died in Worcester's London house (E. H. Fellowes, *William Byrd*, London, 1963 ed., p. 29). He was a major patron of Thomas Heywood, who dedicated much to him. More dedications extol his role as a master of horsemanship. Virtually all the dedications are post-1603.

26 D. Lloyd, *State Worthies*, London, 1766, p. 469.

27 He was rumoured as in the running for the Lord Presidency of the North, Whyte to Sidney, *HMC Penshurst*, II, p. 203.

28 Whyte to Sidney, 23 January 1598, *HMC Penshurst*, II, p. 308.

29 Essex to the Queen, Jan.–Feb. 1599, *HMC Hatfield*, XIV, p. 106.

30 G. B. Harrison, *The Life and Death of Robert, Earl of Essex*, London, 1937, p. 249.

31 Calendared as a letter from Worcester to an unknown recipient, 13 November 1599, *HMC Hatfield*, XIV, p. 269.

32 J. H. Wiffen, *Historical Memoirs of the House of Russell*, London, 1833, II, p. 58.

33 Whyte to Sidney, 16 May 1600, *HMC Penshurst*, II, p. 462.

34 Wiffen, *Historical Memoirs of the House of Russell*, II, p. 57; Whyte to Sidney, 11 June 1600, *HMC Penshurst*, II, p. 468; Lady Russell to Sir Robert Cecil, June, *HMC Hatfield*, X, p. 175.

35 Ibid., loc. cit.

36 For the wedding see Whyte to Sidney, 23 June 1600, A. Collins, *Letters and Memorials of State*, London, 1746, II, p. 203; *The Letters of John Chamberlain*, ed. N. E. McClure, Philadelphia, 1939, I, pp. 98–9, 101–2.

37 Rutland gave the couple a standing cup, *HMC Rutland*, IV, p. 431.

38 Whyte to Sidney, 14 June 1600, Collins, *Letters and Memorials*, II, p. 201.

39 Whyte to Sidney, 23 June 1600, Collins, *Letters and Memorials*, II, p. 203.

40 *L'Ambassade de France en Angleterre sous Henri IV. Mission de Jean de Thumery, Sieur de Boissise (1596–1602)*, ed. P. P. Laffleur de Kermaingant, Paris, 1886, I, p. 415.

41 Chamberlain to Carleton, 1 July 1600, *Letters of John Chamberlain*, I, p. 105.

42 Lady Russell to Sir Robert Cecil, 8 December 1600, *HMC Hatfield*, X, p. 412.

43 *A Journal of all that was accomplished by Monsieur de Maisse, 1597*, ed. G. B. Harrison and R. A. Jones, London, 1931, p. 93.

44 Boissise, *L'Ambassade*, I, p. 368.

45 Roy Strong, *Tudor and Jacobean Portraits*, London, 1969, I, pp. 235–7.

46 Ibid., I, pp. 57–8.

47 PRO L.C.5/37.

48 For which see Roy Strong, *Splendour at Court: Renaissance Spectacle and Illusion*, London, 1973, pp. 255ff.

49 See p. 120.

50 J. L. Nevinson, 'Portraits of Gentlemen Pensioners before 1625', *Walpole Society*, XXXIV, 1958, pp. 1–13.

51 See William Dugdale, *The Baronage of England*, London, 1676, II, p. 293. I am indebted to Mr W. R. B. Robinson for this reference.

52 I am indebted to John Harris for pointing this out.

53 A. J. Taylor, *Raglan Castle, Monmouthshire*, London, 1950, pp. 17–19.

54 J. Clifford Perks, *Chepstow Castle, Monmouthshire*, London, 1967, p. 11.

55 Mark Girouard, 'The Smythson Collection of the R.I.B.A.', *Architectural History*, V, 1962, p. 34 no. I/17. See also *Surrey Archaeological Collections*, V, 1871, p. 75.

56 See James B. Bender, *Spenser and Literary Pictorialism*, Princeton U.P., 1972, p. 145; Joseph B. Dallet, 'Ideas of Sight in *The Faerie Queene*', *English Literary History*, XXVII, 1960, pp. 87–121.

57 John White, *The Birth and Rebirth of Pictorial Space*, London, 1957, p. 35.

58 *The Works in Verse and Prose of Sir John Davies*, ed. A. B. Grosart, The Fuller Worthies' Library, 1869.

59 See Frances A. Yates, *Astraea: The Imperial Theme in the Sixteenth Century*, London, 1975, pp. 29ff.

60 Edgar Wind, *Pagan Mysteries in the Renaissance*, London, 1958, pp. 74–5.

61 E. H. Fellowes, *English Madrigal Verse, 1588–1632*, London, 1920 ed., pp. 434–5.

62 Francis Davison, *A Poetical Rhapsody*, ed. H. E. Rollins, Harvard U.P., 1931–2, I, p. 236.

63 E.g. Strong, *Portraits of Queen Elizabeth I*, pp. 94–5, miniatures, nos. 13–22.

64 In no discussion of the Rainbow Portrait has the close connection between John Davies and Cecil during the years 1599 to 1602 been taken into account. Frances Yates first rightly connected parts of the picture with Davies's Astraea poems: see Yates, *Astraea*, pp. 216–19. I cannot agree with

René Graziani's interpretation, which misreads some of the attributes and totally ignores any historical context, in respect both of court pageantry and poetry in praise of Elizabeth at the very close of the reign and of the crucial link with Cecil: René Graziani, 'The Rainbow Portrait of Queen Elizabeth I and its Religious Symbolism', *Journal of the Warburg and Courtauld Institutes*, XXXV, 1972, pp. 247–59.

65 Henry Peacham, *Minerva Britanna*, London, 1612, p. 22, depicts a figure with a skirt covered with eyes and ears (no mouths): 'Who sits at stern of Commonwealth; and state/. . . must strongly arm'd against his foes/Without, within, with hidden Patience:/Be serv'd with eyes, and listening ears of those,/Who from all parties can give intelligence/To gall his foe, or timely to prevent/At home his malice, and intendiment.'

66 Nichols, *Progresses*, III, p. 77.

67 Sarah Thesiger, 'The Orchestra of Sir John Davies and the Image of the Dance', *Journal of the Warburg and Courtauld Institutes*, XXXVI, 1973, pp. 277–304.

68 *The Works in Verse and Prose of Sir John Davies*, I, p. 189.

69 Ibid., p. 207.

70 Ibid., p. 226.

71 Spenser, *Colin Clouts Come Home Againe*, l.339.

72 *The Works in Verse and Prose of Sir John Davies*, I, pp. 41–2.

II THE COURTIER: Hilliard's *Young Man amongst Roses*

1 Victoria & Albert Museum Records, pp. 163/1910. There is a note that Fritz Lugt stated that he acquired this miniature along with that of Margaret Lemon by Samuel Cooper (now The Fondation Custodia (collection F. Lugt), Institut Néerlandais, Paris) from a Dutch bourgeois family who had possessed it for several generations.

2 C. H. Collins Baker, *British Painting*, London, 1931, p. 40, pl. 31.

3 C. Winter, *Elizabethan Miniatures*, London, 1943, p. 26, no. VII.

4 Graham Reynolds, *Nicholas Hilliard and Isaac Oliver*, Victoria & Albert Museum, 1947, p. 29, no. 38.

5 E. Auerbach, *Nicholas Hilliard*, London, 1961, pp. 103–4, p. 300 no. 78.

6 D. Piper, 'The 1590 Lumley Inventory II', *Burlington Magazine*, XCIX, 1957, pp. 300–301.

7 See Auerbach, *Hilliard*, pp. 70ff.

8 *L'Ecole de Fontainebleau*, Editions Musées Nationaux, Paris, 1972, no. 146.

9 Sylvie Béguin, *L'Ecole de Fontainebleau: Le Maniérisme à la Cour de France*, Paris, 1960, p. 45.

10 Ibid., pp. 73ff; *L'Ecole de Fontainebleau*, p. 120, no. 130.

11 Ibid., p. 213, no. 239.

12 John Nichols, *The Progresses of Queen Elizabeth*, London, 1823, II, pp. 310–29.

13 Frances A. Yates, *The Valois Tapestries*, London, 1959, pp. 91–3.

14 Winter, *Elizabethan Miniatures*, p. 26, no. VII.

15 Reynolds, *Hilliard and Oliver*, p. 29, no. 36; Auerbach, *Hilliard*, p. 300, no. 79.

16 Reynolds, *Hilliard and Oliver*, p. 29, no. 37; Auerbach, *Hilliard*, p. 301, no. 80.

17 On Hilliard and the Essex circle see Roy Strong, 'Queen Elizabeth, the Earl of Essex and Nicholas Hilliard', *Burlington Mag.*, CI, 1959, pp. 145–9.

18 See Roy Strong, *Tudor and Jacobean Portraits*, London, 1967, pp. 115–17, II, pl. 233; same author's *The English Icon, Elizabethan and Jacobean Portraiture*, London, 1967, p. 297, no. 300.

19 Strong, *Tudor and Jacobean Portraits*, I, p. 116.

20 Vertue, *Notebooks*, II, *Walpole Society*, XX, 1932, p. 13. Noted in May 1726 at Mr Halstead's sale 'the Earl of Essex 1588' among a group of Hilliard miniatures 'with writing about, gold letters'.

21 Strong, *English Icon*, p. 217, no. 175 for references.

22 First identified and attributed to Segar by Piper, 'The 1590 Lumley Inventory II', p. 300. See also Strong, *English Icon*, p. 220, no. 179.

23 Strong, *English Icon*, p. 220, no. 178.

24 A. C. Judson, *Sidney's Appearance: A Study in Elizabethan Portraiture*, Indiana U.P., 1958, pp. 33–7. The miniature was found at Wrest Park, Bedfordshire, seat of the Lords Lucas and Dingwall, by Lord Ronald Sutherland Gower. See also Auerbach, *Hilliard*, pp. 125–6, 304, no. 98.

25 W. Camden, *Remaines . . . concerning Britaine*, London, 1870, pp. 384–5.

26 Judson, *Sidney's Appearance*, pp. 33–7. I have not seen this portrait. Judson records that it is a small panel. It was engraved as Sidney in *Effigies Poeticae* (1824) when in the collection of Charles Cholmondeley Dering.

27 *Faerie Queene*, bk II, V, xxix, 1–5.

28 *The Complete Poems of Richard Barnfield*, ed. A. B. Grosart, Roxburghe Club, London, 1876, p. 14.

29 Much of this material is gathered in E. C. Wilson, *England's Eliza*, Harvard U.P., 1939.

30 Green, *Friar Bacon and Friar Bungay*, l.2071–88.

31 Helen Estabrook Sandison was the first to notice the use of eglantine in honour of Elizabeth in her study of Sir Arthur Gorges, *The Poems of Sir Arthur Gorges*, ed. Helen Estabrook Sandison, Oxford, 1953, p. 226 note.

32 Ibid., p. 125.

33 *The Works of George Peele*, ed. A. H. Bullen, London, 1888, II, p. 344.

34 A. M. Hind, *Engraving in England in the 16th and 17th Centuries*, Cambridge, 1952, I, pp. 265–7; Roy Strong, *Portraits of Queen Elizabeth*, Oxford, 1963, p. 114, no. 30.

35 Strong, *Portraits of Queen Elizabeth*, p. 126, no. 19. It was re-issued in two other books: T. T(ymme), *A Book containing the True Portraiture of the Countenances and attires of the Kings of England . . .*, London, 1597; Philemon Holland, *The Romane Historie written by T. Livius of Padua*, London, 1600.

36 Strong, *Portraits of Queen Elizabeth*, p. 149, Metalwork 2.

37 Ibid., pp. 102–5, no. 10.

38 See p. 153.

39 Peele, *Works*, ed. Bullen, II, pp. 303–20.

40 Nichols, *Progresses*, III, p. 133.

41 Leslie Hotson, *Mr W. H.*, London, 1964, p. 211. Hotson was the first scholar to attempt an in-depth study of the meaning of this miniature and makes an extremely valuable contribution, although I cannot accept his equation of the Young Man with William Hatcliffe.

42 See W. Boys, *Collections for an History of Sandwich*, Canterbury, 1892, II, pp. 691–5; Nichols, *Progresses*, I, pp. 337–40. She was similarly met in Suffolk on the 1578 progress by two hundred gentlemen in black and white velvet, ibid., II, p. 115.

43 Strong, *Portraits of Queen Elizabeth*, p. 21; Hotson, *Mr W.H.*, p. 211. For Elizabeth's use of black and white see *Diary of Henry Machyn*, ed. J. G. Nichols, Camden Society, 1847, pp. 216, 231; *CSP Spanish*, I, pp. 367, 385.

44 Strong, *Tudor and Jacobean Portraits*, I, pp. 256–7, no. 7; Pierre Lefranc, *Sir Walter Raleigh, Ecrivain, l'oeuvre et les idées*, Laval University, 1968, p. 123.

45 *The Countesse of Pembroke's Arcadia*, ed. A. Feuillerat, Cambridge, 1912, pp. 64–5.

46 Hotson, *Mr W.H.*, p. 211 note 4 lists a number of instances which I here cite: Ruscelli, *Imprese Illustri*, 1584, p. 281, *Semper Immota*; Ferro de'Rotarii, *Teatro d'imprese*, 1623, II, p. 592, *Semper Eadem*; Camerarius, *Symbolorum . . . Centuria una*, 1590, p. 19, *Ventis Immoto Superbit*; F. Piccinelli, *Mondo Simbolico*, 1669, pp. 443, 444, 460.

47 Henry Peacham, *Minerva Britanna*, London, 1612, p. 167 with the motto *Nitior in adversum*.

48 J. L. Nevinson, 'English Domestic Embroidery Patterns of the Sixteenth and Seventeenth Centuries', *Walpole Society*, XXVIII, 1939–40, pp. 6–8.

49 William Camden, *Remaines*, pp. 366–7.

50 Piper, 'The 1590 Lumley Inventory II', p. 303 note 18.

51 *De Bello Civili*, VIII, l.485–6.

52 Cited by Hotson, *Mr W.H.*, p. 213 note 2.

53 Sir Arthur Gorges, *Lucan's Pharsalia*, 1614, p. 337; Hotson, *Mr W.H.*, p. 213 note 2.

54 Sir Thomas North, *Plutarch's Lives of the Noble Grecians and Romans*, The Tudor Translations, ed. W. E. Henley, London, 1895, IV, p. 206.

55 For Essex see G. B. Harrison, *The Life and Death of Robert Devereux, Earl of Essex*, London, 1937, ch. I–IV; P. M. Handover, *The Second Cecil*, London, 1959, pp. 17ff; Vernon F. Snow, *The Life of Robert Devereux, the Third Earl of Essex*, University of Nebraska, 1970, ch. I.

56 *Memorials of the Bagot Family*, Blithfield, 1824, p. 39.

57 Ray Heffner, 'Essex, the Ideal Courtier', *English Literary History*, I, 1934, pp. 7–36.

58 Peele, *Works*, ed. Bullen, II, pp. 272–3.

59 This can be discovered by a study of dedications to Essex during the years leading up to 1590 when he was emerging as a major public figure: 1587: Roger Rawlins, *Cassius of Parma his Orpheus . . .* (legal dissertation); Thomas Newton, *An Herbal for the Bible* ('undaunted courage and valour, your surpassing affability and courtly courtesy at home; and (which is most of all) your fervent zeal . . . to the glorious Gospel of Christ', 'lively image and express pattern of nobility'); Robert Green, *Euphues his censure to Philautus* ('courage and valour'); 1588: Anthony Munday, *The Famous, pleasant, and variable Historie of Palladine of England* ('your own love to chivalry'); Alberico Gentilis, *De Jure Bello* (military context); 1589: Thomas Cates, *A Summarie and True Discourse of Sir Francis Drakes West Indian Voyage* (Essex as desirous of 'the bravest of enterprises'); T.D., *A True Discourse of the most happy victories obtayned by the French King . . .* ('respect of your honourable and magnaminous mind, your wisdom and virtuous inclination, and hatred to rebellion'); 1590: Roger Williams, *A Briefe Discourse of Warre* (military context); Thomas Watson, *The First set of Italian Madrigals Englished* (musical context).

60 R.H., *A Theological Discourse of the Lamb of God and his Enemies*, London, 1590, dedication.

61 Sir Robert Naunton, *Fragmenta Regalia*, Arber's *English Reprints*, 1870, p. 51.

62 Heffner, 'Essex, the Ideal Courtier', pp. 16ff.

63 Sir Henry Wotton, *Reliquiae Wottoniae*, London, 1685, p. 165.

64 *The Buzzeinge Bee's Complaynt* in *The Poems of Robert Earl of Essex*, ed. A. B. Grosart, Miscellanies of the Fuller Worthies' Library, 1872, p. 86.

65 Ibid., p. 96. This sonnet and its authorship are discussed in E. H. Fellowes, *English Madrigal Verse 1588–1633*, ed. F. W. Sternfeld and D. Greer, Oxford, 1967, pp. 504, 747. It is attributed to Essex in most manuscripts, and if not to him to his secretary Henry Cuffe, see p. 743 n.VI and article cited Edward Doughtie, 'Sidney, Tessier, Batchelar, and *A Musicall Banquet*', *Renaissance News*, XVIII, 1965, p. 123.

66 *The Queen's Garland*, ed. M. C. Bradbrook, Oxford, 1953, pp. 30–31.

67 Handover, *The Second Cecil*, p. 180.

Sir Henry Unton and his Portrait

1 The only previous study of the picture is C. S. Emden, 'Sir Henry Unton (1557–96), An Elizabethan Story Picture', *Oriel Papers*, Oxford, 1948, pp. 1–18. See also Roy Strong, *Tudor and Jacobean Portraits*, London, 1969, I, pp. 315–19.

2 E.g. the Darnley Memorial: O. Millar, *Tudor, Stuart and Early Georgian Pictures in the Royal Collection*, London, 1963, I, pp. 75–7; II, pl. 31.

3 There is no full-length biography of Sir Henry Unton. The best account is the *DNB*. Brief lives are in A. à Wood, *Athenae Oxoniensis*, London, 1813, pp. 647–8; *The Unton Inventories*, ed. J. G. Nichols, Berkshire Archaeological Society, 1841, pp. l–lxvii.

4 Francis Grose, *Antiquarian Repertory*, London, 1808, II, p. 333.

5 On Anne, Countess of Warwick, see *DNB*, s.v. Dudley, John, Duke of Northumberland; *Unton Inventories*, pp. xxxv–xxxvii.

6 See C. Jugé, *Nicolas Denisot du Mans*, Paris, 1907, pp. 59ff.

7 *Le Tombeau de Marguerite de Valois Royne de Navarre*, Paris, 1551; Latin ed. *Annae, Margaritae, Lanae, Sororum Virginum, Heroidum, Anglorum . . .*, Paris, 1550.

8 *Original Letters*, ed. H. Robinson, Parker Society, 1857, II, pp. 702–3.

9 Ibid., II, pp. 340, 565; *The Literary Remains of Edward VI*, Roxburghe Club, London, 1857, II, p. 273.

10 *Unton Inventories*, pp. xxxvi–xxxviii.

11 Ibid., p. xliv.

12 *CSP Domestic, 1581–90*, p. 74.

13 Bartholomew Chamberlaine, *A sermon preached at Farington in Berkshire, the seventeene of Februarie 1587*, London, 1591, dedicated to Lady Unton.

14 R. H. Gretton, *The Burford Records*, Oxford, 1920, p. 84; on Wychwood see *Oxfordshire Gazetteer and Directory*, 1852, pp. 835–6, 855.

15 On the Unton descent see *The Four Visitations of Berkshire*, ed. W. H. Rylands, Harleian Society, lvii, 1907, II, pp. 221–2; *Unton Inventories*, pp. xviiff.

16 On the Unton tombs see Elias Ashmole, *History and Antiquities of Berkshire*, London, 1719, I, pp. 184–91; *Victoria County History, Berkshire*, IV, pp. 495–7; *Gentleman's Magazine*, lxvi, 1796, pt. ii, pp. 1070–71.

17 See *DNB*, s.v. Dudley, Robert, Earl of Leicester. In 1584 Leicester, on the grounds of the Countess's lunacy, sought the Mastership of Malvern Chase: A. Collins, *Letters and Memorials of State*, London, 1746, I, pp. 297–8.

18 On Sir Edward see *Unton Inventories*, pp. xxxiv–xliv.

19 Gretton, *Burford Records*, p. 415.

20 E. K. Chambers, *The Elizabethan Stage*, Oxford, 1923, IV, pp. 88, 90, 92. This also records visits in 1573 and 1575.

21 J. Nichols, *Progresses of Queen Elizabeth*, London, 1823, I, pp. 379, 391.

22 Printed in A. S. Yeames, 'The Grand Tour of an Elizabethan', *Papers of the British School at Rome*, VII, 1914, pp. 92–113.

23 Wood, *Athenae*, I, p. 647.

24 C. L. Shadwell, *Registrum Orielense*, London, 1893, I, p. 41.

25 G. Aquilecchia, 'Lo Stampatore londonese di Giordano Bruno e altre note per l'Edizione della "Cena" ', *Studi di filologia italiana*, xviii, 1960, pp. 101–2. I am indebted to Dr Frances Yates for this reference.

26 Charles Merbury, *A Briefe Discourse of Royall Monarchy*, London, 1581, 'Henry Unton to the virtuous reader'. They probably met in Italy where Merbury spent a long time in the seventies.

27 PRO S.P.78/7, no. 105. I quote from the translation in *CSP Foreign, 1582*, pp. 87–8.

28 The date is given by Chambers, *Elizabethan Stage*, I, p. 164 note 1, citing Ashmole's *Berkshire*, but I can find no trace of it there. How close the relationship between Dorothy Wroughton and Lady Walsingham was is uncertain.

29 *Unton Inventories*, p. xlviii.

30 Ibid., p. xliii.

31 Ibid., p. xlv.

32 Mendoza to Juan de Idiaquez, 13 February 1583, *CSP Spanish, 1580–6*, p. 443.

33 Wood, *Athenae*, I, p. 647. A passage in *Leycester's Commonwealth* also refers to him as 'servant of Sir Christopher': *Leycester's Commonwealth*, ed. F. J. Burgoyne, London, 1904, p. 203.

34 *CSP Foreign, 1583*, p. 145.

35 Ibid., p. 161.

36 Ibid., pp. 212, 280, 348, 389–91.

37 On Aldred see Conyers Read, *Mr Secretary Walsingham . . .*, Oxford, 1925, II, pp. 425–6; *The Memoirs of Father Robert Persons*, ed. J. H. Pollen, Catholic Record Society, Miscellanea, II, 1906, pp. 33–4, 206; *Letters and Memorials of Father Robert Persons, S.J.*, ed. L. Hicks, Catholic Record Society, 1942, I, pp. 220, 223–4.

38 *CSP Foreign, 1583–84*, p. 66. A report of 2 May 1584 states that Unton has gone to Rome: ibid., p. 481; also *HMC Hatfield*, III, p. 28.

39 Unton to Walsingham, 24 May/3 June 1583, PRO S.P.78/9, no. 110.

40 *CSP Foreign, 1583–4*, p. 476.

41 *CSP Domestic, 1581–90*, pp. 264, 384–5; *Unpublished Documents relating to the English Martyrs*, Catholic Record Society, 1908, I, p. 125.

42 Some he sold to his brother, see p. 101; this can best be followed in the account of the Unton lands

in 1596, PRO S.P.15/33, no. 68; see also E. St John Brooks, *Sir Christopher Hatton*, London, 1946, pp. 306–9.

43 *Acts of the Privy Council, 1586–7*, ed. J. R. Dasent, p. 191.

44 Ibid., 1587–8, pp. 344–5.

45 T. Milles, *Catalogue of Honor*, London, 1610, p. 820.

46 *CSP Foreign, 1583*, p. 423; also Lansdowne MS. XXXVII(55), f. 138.

47 PRO S.P. 78/9, no. 110; *CSP Foreign, 1583–4*, p. 657.

48 *CSP Spanish, 1580–6*, p. 554 includes an 'Umpton' with a train of eight horses and ten servants as part of Leicester's entourage.

49 *CSP Foreign, 1586–7*, p. 151.

50 Ibid., p. 214.

51 *Leycester Correspondence*, ed. J. Bruce, Camden Society, 1844, pp. 415–17.

52 On William Hatton see Brooks, *Hatton*, pp. 23, 70, 113, 322–3, 349, 354, 360; see p. 102 for a dedication which mentions their friendship.

53 *Leycester Correspondence*, pp. 306–8.

54 A. Hind, *Engraving in England in the 16th and 17th Centuries*, Cambridge, 1952, I, p. 134, pl. 63.

55 C. R. Beard, 'English or Flemish?', *Connoisseur*, XCIII, 1934, p. 73. A second version in the Tate Gallery is dated 1586.

56 *Acts of the Privy Council, 1587–8*, p. 121; *1590*, pp. 318–20; *1590–1*, pp. 36–7, 156–7.

57 Ibid., *1588*, pp. 201–2.

58 J. Foster, *Alumni Oxonienses*, Oxford, 1893, III, p. 1530.

59 All the correspondence is printed in *Correspondence of Sir Henry Unton*, ed. J. Stevenson, Roxburghe Club, London, 1847; a photostat of Unton's diary for this embassy, now in the University of Virginia, is deposited in the Berkshire Record Office; other letters are in *HMC Hatfield*, IV, pp. 134, 154, 186–7; see W. Camden, *History of Elizabeth*, London, 1688 ed., pp. 449–50; G. B. Harrison, *The Life and Death of Robert Devereux, Earl of Essex*, London, 1937, pp. 45–68; P. Cheyney, *A History of England from the Defeat of the Spanish Armada . . .*, London, 1914, I, pp. 253–76; J. B. Black, *Elizabeth and Henry IV*, Oxford, 1914, pp. 43ff.

60 The Queen to Sir Thomas Leighton, 2 September 1591, *Unton Correspondence*, pp. 55–7.

61 Thomas Lake to Sir Robert Sidney, 22 November 1596, *HMC Penshurst*, II, 188–9.

62 Unton to Hatton, 6 November 1591, *Unton Correspondence*, p. 129.

63 See letters in Sir Harris Nicolas Harris, *Memoirs of the Life and Times of Sir Christopher Hatton*, London, 1847, pp. 490–93.

64 *Unton Inventories*, pp. lv–lvi, lists the sources in which it appears; first printed in Milles, *Catalogue*, p. 820.

65 J. E. Neale, *Elizabeth I and her Parliaments*, London, 1957, pp. 298–312.

66 PRO S.P.12/244, no. 91.

67 *HMC Hatfield*, IV, pp. 68–9.

68 Ibid., pp. 452–3.

69 Ibid., p. 353.

70 A. Standen to Anthony Bacon, 17 November 1593, Lambeth Palace MS. 950, no. 267.

71 Unton to Sir Robert Cecil, 20 January 1595, *HMC Hatfield*, V, p. 93.

72 He is listed as JP in 1592, *Acts of the Privy Council, 1592*, p. 259; Deputy Lieutenant in 1593, ibid., *1592–3*, p. 31.

73 Chambers, *Elizabethan Stage*, I, pp. 64–5; Unton had failed to obtain the office he was seeking in 1594, *HMC Hatfield*, IV, p. 499.

74 Collins, *Letters and Memorials*, I, p. 382.

75 *HMC Penshurst*, II, pp. 188–9, 195.

76 *HMC Hatfield*, V, p. 280.

77 *HMC Penshurst*, II, p. 197; on the departure, pp. 199, 203.

78 A great deal of the correspondence is printed in J. Murdin, *State Papers*, London, 1759, pp. 701ff.; T. Birch, *Memoirs of the Reign of Queen Elizabeth*, London, 1754, I, pp. 353ff. Items not printed in Murdin are in *HMC Hatfield*, VI and PRO S.P.78/37. See also Camden, *History of Elizabeth*, pp. 496–9; Black, *Elizabeth and Henry IV*, pp. 92–8; M. Prévost-Paradol, *Elisabeth et Henri IV*, Paris, 1863; Cheyney, *History*, II, pp. 122–32; Harrison, *Essex*, pp. 93–5.

79 Birch, *Memoirs*, p. 354; cf. Murdin, *State Papers*, p. 701.

80 Unton to Essex, 7 January 1596, Murdin, *State Papers*, pp. 706–7.

81 Unton to the Queen, 17 January 1596, *State Papers*, pp. 707–11; cf. also 3 February letters to the Queen, ibid., pp. 717–19.

82 Unton to Essex, 4 March 1596, Murdin, *State Papers*, p. 730.

83 Unton to Burghley, 17 March 1596, Murdin, *State Papers*, p. 731.

84 The doctor's account of Unton's death is in PRO S.P.78/37, no. 119.

85 Quoted Cheyney, *History*, II, p. 130.

86 PRO S.P.78/37, no. 112–13; Murdin, *State Papers*, pp. 733–4.

87 Edmondes to Burghley, 22 March, PRO S.P.78/37, no. 117; *HMC Hatfield*, VI, p. 103.

88 Carleton to Chamberlain, 22 March 1596, PRO S.P.78/37, no. 105.

89. *Unton Inventories*, p. lviii.

90 *Funebria Nobilissima ac Praestantissimi Equitis D. Henrici Untoni, ad Gallos bis Legati . . .*, Oxford, 1596.

91 *Lettres missives de Henri IV*, ed. M. B. de Xivrey, Paris, 1848, pp. 555–9.

92 *Gentleman's Magazine*, lxvi, 1796, pt. ii, pp. 1070–71; *Unton Inventories*, pp. lxvi–lxvii.

93 Birch, *Memoirs*, I, p. 423. He states that he must return by Lady Day 'having great payments to make then' (p. 424).

94 On the lands see PRO S.P.15/53, nos. 67, 68, 69; *CSP Domestic, 1595–7*, pp. 315–16; *VCH, Berkshire*, IV, pp. 489ff.

95 Ibid., IV, p. 495.

96 Ibid., IV, p. 493.

97 Ibid., IV, p. 494.

98 *Unton Inventories*, pp. 1–14.

99 *VCH, Berkshire*, IV, p. 493.

100 *Unton Inventories*, p. 10.

101 *Diary of John Manningham*, ed. J. Bruce, Camden Society, 1868, p. 136.

102 *VCH, Berkshire*, IV, p. 495.

103 *Unton Inventories*, p. lxxxiii.

104 *VCH, Berkshire*, IV, pp. 365, 533.

105 Ibid., IV, p. 493.

106 R. Ashley, *L'Uranie*, London, 1589.

107 On Gwinne, see *DNB*; Wood, *Athenae*, II, pp. 415–18.

108 R. Lewes, *A Sermon Preached at Paules Crosse*, Oxford, 1594, dedication.

109 On Wright, see *DNB*.

110 There was much difficulty in obtaining leave from Trinity College for Wright to go: see *Acts of the Privy Council, 1591–92*, pp. 342, 408–9.

111 *Unton Correspondence*, pp. 165–6.

112 Wood, *Athenae*, I, p. 648; *Unton Inventories*, p. liv, note.

113 S. Parmenius Budaeus, *Paean ad psalmum Davidis CIV conformatus*, London, 1582; items by and material relevant to Parmenius are in R. Hakluyt, *The Principal Navigations, Voyages, Traffiques and Discoveries . . .*, Glasgow, 1904, VIII, pp. 23–33, 67, 78–80, 81–84. I am indebted to Professor David Quinn for these references. See his and Neil M. Cheshire's *The New Found Land of Stephen Parmenius*, University of Toronto, 1972.

114 Information kindly communicated by Mr David Greer.

115 *The First Book of Consort Lessons collected by Thomas Morley, 1599 and 1611*, ed. S. Beck, New York, 1959, pp. 18–19.

116 J. Case, *Apologia Musices*, Oxford, 1588, dedication.

117 *Unton Inventories*, pp. lxxi–xiii; several of his children were baptized at Hatford, the last in 1607.

118 *HMC Hatfield*, IV, p. 362.

119 Photostat of the manuscript in the University of Virginia deposited in Berkshire Record Office.

120 Wilkes had interceded for him in 1593: see PRO S.P.12/44, no. 92; *HMC Hatfield*, IV, p. 453.

121 J. Strutt, *Manners and Customs of the People of England*, London, 1776, III, pp. 143, 191, pl. XI.

122 On the masque see R. Withington, *English Pageantry*, London, 1918, I, opp. p. 208; Chambers, *Elizabethan Stage*, I, pp. 163–4.

123 *First Book of Consort Lessons*, pp. 17–18. The masque is reproduced as a frontispiece.

124 Ibid., pp. 23–4.

125 Carleton to Chamberlain, 8 August 1596, PRO S.P.12/259, no. 93.

126 Dorothy Unton appealed to him for favours throughout her life, *CSP Domestic, 1628–9*, p. 506; *1629–31*, p. 299; *1631–3*, p. 155.

127 *Unton Inventories*, pp. lxxxvii–lxxxviii.

128 *Letters of John Chamberlain*, ed. N. E. McClure, Philadelphia, 1939, I, p. 32.

129 *CSP Domestic, 1598–1601*, p. 35.

130 *Letters of John Chamberlain*, I, p. 57.

131 E. P. Shirley, *Stemmata Shirleiana; or the Annals of the Shirley Family*, London, 1873 ed., pp. 83–6.

132 *CSP Domestic, 1598–1601*, p. 44.

133 Shirley, *Stemmata Shirleiana*, p. 85.

134 *Letters of John Chamberlain*, II, p. 437.

135 *Unton Inventories*, p. lxvii note.

136 Ibid., p. 32.

137 Ibid., pp. 18, 25.

138 Shirley, *Stemmata Shirleiana*, p. 93.

139 *Unton Inventories*, p. 31.

140 *VCH, Berkshire*, IV, p. 490.

141 Ibid., IV, p. 497; K. A. Esdaile, *English Church Monuments*, London, 1946, p. 126; *Architectural Review*, C III, 1950, p. 16.

142 *Guide to the Parish Church of All Saints, Faringdon*, ed. P. S. Spokes, Abingdon.

143 T. Fuller, *History of the Worthies of England*, London, 1688 ed., p. 110; Ashmole, *Berkshire*, I, pp. 184–91.

144 *Unton Inventories*, p. 34.

145 *Gentleman's Magazine*, lvi, 1786, p. 293.

146 Vertue, *Notebooks*, V, *Walpole Society*, XXVI, 1938, p. 68.

147 West sale, 1 April 1773, lot 31.

148 *Antiquarian Repertory*, II, opp. p. 333. The plate is dated 1779.

149 Samuel Shepherd, *Proceedings of the Society of Antiquaries*, I, 1849, p. 209. It was then in the possession of Thomas Clater of Whitehead Grove, Chelsea.

150 *Catalogue of the First Special Exhibition of National Portraits ending with the Reign of James II on loan to the South Kensington Museum*, London, 1866, no. 230.

151 24 November, lot 33.

IV NOVEMBER'S SACRED SEVENTEENTH DAY

1 Spenser's letter to Sir Walter Raleigh, dated 23 January 1590, printed at the front of *The Faerie Queene*.

2 *Faerie Queene*, bk II, II, xlii, 6–9.

3 See p. 149 for Sidney. For Drayton, *Works*, ed. J. W. Hebel, Oxford, 1931, I, pp. 55–9; also in *England's Helicon*, ed. H. E. Rollins, Harvard U.P., 1935, pp. 29–31.

4 A short piece on Accession Day and its history by J. E. Neale is in *Essays in Elizabethan History*, London, 1958, pp. 9–20.

5 S. Anglo, 'An Early Tudor Programme for Plays and other Demonstrations against the Pope', *Journal of the Warburg and Courtauld Institutes*, XX, 1957, pp. 176–9.

6 Thomas Holland, πανήγυρις, *D. Elizabethae*, Oxford, 1601.

7 A. Clarke, *Lincoln College*, 1898, p. 45.

8 W. Turner, *Selections from the Records of the City of Oxford*, London, 1880, pp. 344, 350, 356, 376.

9 William Camden, *History of Elizabeth*, London, 1688, p. 152.

10 These are given in considerable detail in the original version of this essay: 'The Popular Celebration of the Accession Day of Queen Elizabeth I', *Journal of the Warburg and Courtauld Institutes*, XXI, 1959, pp. 88–91.

11 J. A. Twemlow, *Liverpool Town Books*, Liverpool, 1935, II, pp. 240–41; see also J. A. Picton, *Selections from the Municipal Archives and Records*, Liverpool, 1883, p. 48.

12 W. L. Woodfill, *Musicians in English Society from Elizabeth to Charles I*, Princeton, 1953, p. 281.

13 A. Raine, 'York Civic Records', *Yorkshire Archaeological Society, Record Series*, CXV, 1950, p. 182.

14 H. E. Salter, *Oxford Council Acts 1583–1626*, Oxford, 1928, pp. 354, 357, 359, 361, 364, 367, 370, 371–2, 375, 377, 379, 380.

15 H. Ellis, *Original Letters illustrative of English History*, 2nd series, London, 1827, III, pp. 160–61.

16 C. H. Cooper, *Annals of Cambridge*, Cambridge, 1843, II, p. 359.

17 M. Bateson, *Records of the Borough of Leicester*, Cambridge, 1905, III, p. 242.

18 *Records of Maidstone*, Maidstone, 1926. Pageants and speeches also marked Accession Day in Ipswich: N. Bacon, *The Annalls of Ipswich*, ed. W. H. Richardson, Ipswich, 1884, pp. 334, 338, 382, 403; *HMC Report*, IX, pp. 251, 255.

19 John Stowe, *Annales*, London, 1631, p. 751.

20 *Acts of the Privy Council*, ed. J. R. Dasent, XVI, p. 334; *CSP Spanish, 1587–1603*, IV, p. 494. See also the letter from the Bishop to the Mayor of Chester ordering the celebration of that day and the shutting of the alehouses, *HMC Report*, VIII, i, p. 374.

21 City of London Record Office, Repertories, XXII, f.2ᵛ.

22 Stowe, *Annales*, p. 751; R. Hakluyt, *The Principal Navigations, Voyages, Traffiques and Discoveries . . .*, London, 1927, II, pp. 400–401; V. von Klarwill, *The Fugger News-Letters*, 2nd series, London, 1926, pp. 184, 185; Camden, *History of Elizabeth*, p. 418; *Letters of Philip Gawdy*, ed. I. H. Jeayes, Roxburghe Club, London, 1906, p. 42.

23 H. Owen and J. Blakeway, *A History of Shrewsbury*, London, 1825, I, p. 390.

24 *Records of the Borough of Nottingham*, London, 1889, IV, p. 217; *Records of Maidstone*, pp. 206–7.

25 S. Seyer, *Memoirs Historical and Topographical of Bristol and its Neighbourhood*, Bristol, 1823, II, p. 252.

26 J. C. Foxe, *The Records of the Borough of Northampton*, London and Northampton, 1898, pp. 472–3.

27 *The Works of George Peele*, ed. A. H. Bullen, London, 1888, II, pp. 346–7.

28 Stowe, *Annales*, p. 770.

29 Harleian MS. 6995, f.149. In 1586 the Earl of Huntingdon wrote that he intended to celebrate Accession Day with Lord Scrope, *CSP Domestic, Addenda, 1580–1625*, p. 192.

30 Hakluyt, *Principal Navigations*, VIII, p. 113.

31 Ibid., p. 237.

32 W. Keatinge, *Liturgical Services, Elizabeth*, Parker Society, 1847, pp. 462, 463, 467. *A fourme of Prayer with thankes gevyng, to be used every yeere, the 17. of November, beyng the day of the Queenes Maiesties entrie to her raigne*, London, 1576, reprinted in *Liturgical Services*, pp. 548–58.

33 *A fourme of prayer with thanks giving to be used of all the Queenes Maiesties loving subjects every yeere, the 17. of November, being the day of her Highnesse entry to her Kingdome*, London, 1578; parts are reprinted in Keatinge, *Liturgical Services*, pp. 558–61.

34 Edmund Bunny, *Certaine prayers and other godly exercises for the seventeenth of November . . .*, London, 1585. A folding chart depicts points which might be made in a sermon. Thomas Bentley, *The Monument of Matrones*, London, 1582, I, pp. 253–62, contains private devotions for Accession Day.

35 Royal MS. 12.A.LXVII.

36 J. Nichols, *The Progresses of Queen Elizabeth*, London, 1823, II, pp. 585–8.

37 Royal MS. 12.A.VIII, f.11.

38 *HMC Hatfield*, XII, p. 475.

39 *Harleian Miscellany*, London, 1812, pp. 123–39.

40 J. P. Collier, *Broadside Black-letter Ballads*, 1868, pp. 16–20.

41 E. Arber, *A Transcript of the Registers of the Company of Stationers of London, 1554–1640 A.D.*,

London, 1875–94, II, p. 341.

42 Ibid., p. 437.

43 Egerton MS. 2877, f. 104ᵛ–105.

44 Arber, *Stationers*, II, p. 479.

45 M. Kyffin, *The Blessednes of Brytaine, or a celebration of the Queenes Holyday*, London, 1587; reprinted in *Fugitive Tracts*, ed. W. C. Hazlitt, London, 1875, no. 28.

46 *The Shirburn Ballads, 1585–1616*, ed. A. Clarke, Oxford, 1907, pp. 177–81.

47 John Whitgift, *Works*, Parker Society, 1853, III, pp. 586–96.

48 Edwin Sandys, *Sermons*, Parker Society, 1842, pp. 55–74, 75–91.

49 J. Prime, *A Sermon Briefly Comparing the estate of King Solomon and his Subjectes togither with the condition of Queene ELIZABETH and her people*, Oxford, 1585.

50 Isaac Colfe, *A sermone preached on the Queenes day . . . at the towne of Lidd in Kent*, London, 1588. See also E. Harris, *A Sermon Preached at Hitchin in the yeare of our Lord, 1587, the 17th day of November . . .*, London, 1590.

51 J. Prime, *The Consolations of David breefly applied to Queene Elizabeth: In a sermon preached in Oxford the 17. November*, Oxford, 1588.

52 T. White, *A Sermon Preached at Paules Crosse the 17. of November An. 1589*, London, 1589.

53 J. King, *Lectures on Ionas*, Oxford, 1599, pp. 685–706. Holland, πανήγυρις. See also W. Leigh, *Queene Elizabeth, paraleld in her Princely vertues, with David, Iosua, and Hezekiah*, London, 1612. There are Accession Day Sermons for 1600 and 1602 in Bodleian MS. Add. A.89, f. 159–67ᵛ; 190–97ᵛ.

54 C. Drew, 'Lambeth Churchwardens' Accounts 1504–1645', *Surrey Record Society*, XL, i, 1940, p. 120 and *passim*; E. Freshfield, *Accomptes of the Churchwardens of the Paryshe of St Christofer's*, London, 1885, p. 3 and *passim*; at St Martin-in-the-Fields in 1584, *St Martin-in-the-Fields: The Accounts of the Churchwardens, 1525–1603*, ed. J. V. Kitto, 1901, p. 364 and *passim*. The Queen's birthday was also an occasion for feasting: Ellis, *Original Letters*, 1st series, II, p. 308.

55 Nichols, *Progresses*, II, pp. 461–79. A prayer for use on the Queen's birthday is in Keatinge, *Liturgical Services*, p. 556 note i.

56 *HMC Report*, VIII, ii, p. 27; J. Strype, *Annals*, Oxford, 1824, III, i, pp. 177–9; III, ii, pp. 228–37; J. Strype, *The Life and Acts of John Aylmer*, Oxford, 1821, pp. 55–6.

57 N. Sanders, *De Origine ac Progressu Schismatis Anglicani*, Rome, 1586, pp. 407–8.

58 W. Rainolds, *Calvino-Turcismus*, Antwerp, 1597, p. 347.

59 Holland, πανήγυρις.

60 John Howson, *A sermon preached at St. Maries in Oxford, the 17. November, 1602 in defence of the Festivities of the Church of England, and namely that of her Maiesties Coronation*, Oxford, 1603. This sermon caused a sensation at the time: *The Letters of John Chamberlain*, ed. N. E. McClure, Philadelphia, 1939, I, p. 185.

61 W. K. Ferguson, *The Renaissance in Historical Thought*, Cambridge, Mass., 1948, pp. 46–57; John Jewel, *Works*, Parker Society, 1847, II, pp. 98–9. See F. A. Yates, 'Queen Elizabeth as Astraea', *Journal of the Warburg and Courtauld Institutes*, X, 1947, pp. 37–46.

62 John Foxe, *Acts and Monuments*, ed. S. R. Cattley, London, 1843.

63 See J. F. Mosley, *John Foxe and his Book*, London, 1940, pp. 118–74.

64 See W. Haller, 'John Foxe and the Puritan Revolution' in R. F. Jones, *The Seventeenth Century*, Stanford, 1951, pp. 209–19.

V FAIR ENGLAND'S KNIGHTS:
The Accession Day Tournaments

Most of the source material upon which this chapter is based is listed in Appendix I, pp. 206–11.

1 *Poetical Works of Thomas Campion*, ed. P. V. Vivian, London, 1907, pp. 225–6, from Campion's *Observations on the Art of English Poesie*, where he states that it was 'made upon a triumph at Whitehall, whose glory was dashed with an unwelcome shower, hindering the people from the desired sight of her Majesty'.

2 See Appendix I, s.v. 1599.

3 Frances A. Yates, *Astraea: The Imperial Theme in the Sixteenth Century*, London, 1975, pp. 88–111; originally in the *Journal of the Warburg and Courtauld Institutes*, XX, 1957, pp. 4–25.

4 W. Segar, *Honor Military and Civill*, London, 1602, p. 197.

5 E. K. Chambers, *Sir Henry Lee*, Oxford, 1936, p. 304.

6 In a speech as a Restless Knight, Appendix I, p. 210.

7 This account of Lee is based on Chambers's excellent biography cited above.

8 *Correspondence Diplomatique de Bertrand de Salignac de la Mothe Fénélon*, London and Paris, 1840, pp. 203–4. See also W. Segar, *Booke of Honor and Armes*, London, 1590, pp. 100–101.

9 W. Camden, *The History of Elizabeth*, London, 1688 ed., p. 152.

10 Appendix I, pp. 206–11.

11 Segar, *Honor Military and Civill*, p. 200.

12 E. M. Tenison, *Elizabethan England*, Leamington Spa, 1953, X, pp. 432–3.

13 H. Foley, *Records of the English Province of the Society of Jesus*, London, 1877, p. 59.

14 J. H. Hanford and S. R. Watson, 'Personal Allegory in the *Arcadia*', *Modern Philology*, XXXII, 1934, pp. 1ff; Yates, *Astraea*, pp. 88–94.

15 J. Sylvester, *Bartas his Devine Weekes and Workes*, London, 1605, p. 135; quoted Chambers, *Lee*, p. 141; Yates, *Astraea*, p. 90.

16 'Journey through England and Scotland made by Lupold von Wedel in the years 1584 and 1585', *Transactions of the Royal Historical Society*, new series IX, 1895, pp. 258–9; V. von Klarwill, *Queen Elizabeth and Some Foreigners*, London, 1928, pp. 330–32.

17 Additional MS. 10110, f. 69ᵛ.

18 *HMC Hatfield*, XII, pp. 459, 574.

19 Ibid., p. 438.

20 *The Letters of John Chamberlain*, ed. N. R. McClure, Philadelphia, 1930, I, p. 53.

21 This happened in 1584: *The Letters of Philip Gawdy*, ed. I. H. Jeayes, Roxburghe Club, London, 1906, p. 22.

22 See 1680 survey of Whitehall by John Fisher published in 1747, *London Topographical Society*, 1900, no. 10. See also W. J. Loftie, *Whitehall*, London, 1895, p. 33; B. Lambert, *The History and Survey of London*, 1806, III, pp. 490, 493–4; E. Sheppard, *The Old Royal Palace of Whitehall*, London, 1902, pp. 73–5; J. Strype, *Stow's Survey*, London, 1720, II, bk. vi, p. 4.

23 J. Stowe, *The Survey of London*, London, 1633, p. 496.

24 The Works Accounts regularly record preparation of the tilt gallery and the construction of the stairs and scaffold beneath the Queen's window, e.g. PRO E.351/3219, 3224, 3226, 3229, 3231, 3234, 3238.

25 E.g. Anjou in 1581, Viscount Turenne in 1590, Count Egmont in 1601 (PRO E.543).

26 *Sbornik Imperatorskago Russkago Istoricheskago Obschestva*, ed. K. N. Bestuzhev-Ryumin, St Petersburg, XXXVIII, 1893, pp. 331–2; J. Stowe, *Annales*, London, 1631, p. 791.

27 *HMC Penshurst*, II, p. 485.

28 F. F. Warner, *Catalogue of The Manuscripts and Muniments of Dulwich College*, London, 1881, p. 183.

29 *The Works of Francis Bacon*, ed. J. Spedding, D. L. Ellis, D. D. Heath, London, 1858, VI, p. 468.

30 He wrote one for the Earl of Arundel for a tilt in 1581, Additional MS. 41499A, f. 6.

31 *HMC Hatfield*, XI, p. 544. It is not certain that this was for Accession Day.

32 A. Collins, *Letters and Memorials of State*, London, 1746, II, p. 216. On Henry Sandford, see F. A. Yates, *John Florio*, Cambridge, 1934, pp. 195ff.

33 *The Works of Ben Jonson*, ed. C. H. Herford and P. and E. Simpson, Oxford, 1947, VIII, pp. 382–3.

34 Stephen Orgel and Roy Strong, *Inigo Jones: The Theatre of the Stuart Court*, London, 1973, I, p. 180.

35 Ibid., I, p. 181.

36 Appendix I, p. 209. See also E. K. Chambers, *The Elizabethan Stage*, Oxford, 1923, IV, p. 212; John Weever, *Epigrammes in the Oldest Cut and Newest Fashion*, ed. R. B. McKerrow, London, 1911, p. 73 and notes on p. 119.

37 Orgel and Strong, *Inigo Jones*, I, p. 180.

38 *The Works of George Peele*, ed. A. H. Bullen, London, 1888, II, p. 349.

39 A full listing of all surviving speeches is in Appendix I.

40 Yates, *Astraea*, p. 101.

41 Chambers, *Lee*, pp. 103, 119–20, 172–3, 182.

42 E. Auerbach, *Nicholas Hilliard*, London, 1961, p. 171.

43 'Journey through England and Scotland', p. 256; von Klarwill, *Queen Elizabeth and Some Foreigners*, pp. 320–21; the gallery is recorded by several visitors: in 1598 by Paul Hentzner, *A Journey into England by Paul Hentzner in the year 1598*, ed. H. Walpole, Aungervyle Society, Edinburgh, 1881, p. 23; in 1599 by Thomas Platter, *Travels in England*, ed. C. Williams, London, 1937, pp. 164–5; in 1602 by the Duke of Stettin-Pomerania, 'Diary of the most illustrious Philip, Duke of Stettin-Pomerania', *Transactions of the Royal Historical Society*, VI, 1892, p. 23.

44 J. Harington, *Orlando Furioso*, London, 1631 ed., p. 349.

45 H. Peacham, *Minerva Britanna*, London, 1612, p. 211; *The Compleat Gentleman*, London, 1634, p. 228.

46 W. Camden, *Remaines ... concerning Britaine*, London, 1870 ed., pp. 373–86; *Diary of John Manningham*, ed. J. Bruce, Camden Society, 1868, p. 305.

47 *The Booke of Honor and Armes*, p. 102.

48 E. Arber, *A Transcript of the Registers of the Company of Stationers of London*, London, 1870, II, pp. 508 (1588), 640 (1593), 664 (1594), III, p. 53 (1595).

49 Peele, *Works*, ed. Bullen, II, p. 299.

50 Thomas Blenerhasset, *A Revelation of the True Minerva*, ed. J. Walter Bennett, Scholars' Facsimiles and Reprints, New York, 1941.

51 Sidney, *The Countesse of Pembroke's Arcadia*, ed. A. Feuillerat, Cambridge, 1912, p. 101ff; on Sidney's *imprese* see Katherine Duncan-Jones, 'Sidney's Personal *Imprese*', *Journal of the Warburg and Courtauld Institutes*, XXXIII, 1970, pp. 321–4.

52 Sidney, *Countesse of Pembroke's Arcadia*, p. 108.

53 Ibid., pp. 282–7; cf. Yates, *Astraea*, pp. 88–94.

54 Angel Day, *Daphnis and Chloe*, ed. Joseph Jacobs, London, 1890, pp. 100–123.

55 Ibid., p. 102.

56 Diana Poulton, 'The Favourite singer of Queen Elizabeth I', *The Consort*, no. 14, July 1957, pp. 24–7.

57 G. du Choul, *Discourse de la Religion des Anciens Romains*, Lyons, 1581, pp. 235–44; Vincenzo Cartari, *Le Imagnini de i Dei degli Antichi*, Venice, 1580, pp. 218–22; N. Conti, *Mythologiae*, Venice, 1567, pp. 263–5.

58 Yates, *Astraea*, pp. 114–17. The association of the Siena portrait with the 1590 tilt cannot be sustained.

59 Yates, *Astraea*, p. 58.

60 Chambers, *Lee*, p. 290.

61 Because the Queen's feet are placed on Oxfordshire close to Lee's house at Ditchley, there has been a greater tradition of associating the portrait with the entertainment he gave the Queen there in 1592: Roy Strong, *Tudor and Jacobean Portraiture*, London, 1969, I, pp. 104–7.

62 Yates, *Astraea*, p. 117.

63 Orgel and Strong, *Inigo Jones*, I, pp. 177–85, nos. 45–52.

VI SAINT GEORGE FOR ENGLAND:
The Order of the Garter

1 O. Cartellieri, *The Court of Burgundy*, London, 1929; J. Huizinga, *The Waning of the Middle Ages*, London, 1924, pp. 74–81.

2 A. Favyn, *The Theater of Honour and Knighthood*, London, 1623, pp. 388–42; Frances A. Yates, *The French Academies of the Sixteenth Century*, London, 1947, pp. 156–67.

3 *The Works of George Peele*, ed. A. H. Bullen, London, 1888, I, p. 333.

4 E. Ashmole, *The Institution, Laws and Ceremonies of the Most Noble Order of the Garter*, London, 1672, p. 182; besides Ashmole the following are also useful guides to Garter mythology: P. Helyot, *Histoire des Ordres Monastiques, Religieux et Militaires*, Paris, 1719, VIII, pp. 298–307; J. Anstis, *The Register of the Most Noble Order of the Garter*, London, 1724; Favyn, *Theater of Honour and Knighthood*, pp. 67–77; Sir N. Harris Nicolas, *History of the Orders of Knighthood of the British Empire*, London, 1841; G. F. Beltz, *Memorials of the Most Noble Order of the Garter*, London, 1841.

5 Sydney Anglo, *Spectacle, Pageantry and Early Tudor Policy*, Oxford, 1969, pp. 104 ff.

6 J. Leland, *Collectanea*, London, 1770, IV, p. 242.

7 Notably (i) the Duke of Urbino (1506) whose election occasioned the visit of Castiglione to England: P. Vergil, *Anglicae Historiae*, Basiliae, 1570, p. 615; (ii) Philip the Handsome, who was installed at Windsor in 1506; R. R. Tighe and J.

Davis, *Annals of Windsor*, London, 1858, I, pp. 434–44; Anglo, *Spectacle*, p. 107.

8 Beltz, *Order of the Garter*, pp. lxxx–xciii; Nicolas, *Orders of Knighthood*, I, pp. 121–69. *Letters and Papers of Henry VIII* contain a great deal of material on the history of the Garter under Henry.

9 See E. M. Thompson, 'The Revision of the Statutes of the Order of the Garter by King Edward VI', *Archaeologia*, LIV, 1894, pp. 173–98. This article is not an exhaustive discussion of this problem. Royal MS. 18.A.I–IV, Rawlinson MS. C.387, f. 22 ff and Ashmole MS. 1119, xiii all contain draft statutes which need consideration in any more detailed study. See also Beltz, *Order of the Garter*, pp. xciii–xcix; Nicolas, *Orders of Knighthood*, I, pp. 170–82; Anstis, *Register*, pp. 438–41.

10 Ashmole, *Order of the Garter*, p. 473.

11 Thompson, 'The Revision of the Statutes of the Order of the Garter', suggests that these must be the ones in Additional MS. 6288.

12 A great many copies of these exist. I quote from Stowe MS. 595, f. 54–69.

13 Nicolas, *Orders of Knighthood*, I, pp. 182–6; see also *CSP Venetian, 1534–54*, p. 431. See also, on the Garter under Mary, Beltz, *Order of the Garter*, pp. c–ci.

14 He was invested with the Order immediately on arrival in England: R. Fabyan, *New Chronicles*, London, 1811, p. 715; R. Holinshed, *Chronicles*, London, 1808, IV, pp. 57, 62; *CSP Venetian, 1534–54*, pp. 524–5.

15 *Diary of Henry Machyn*, ed. J. G. Nichols, Camden Society, 1847, pp. 60, 85, 132–3, 134–5.

16 Generally, see Beltz, *Order of the Garter*, pp. cii–civ; Nicolas, *Orders of Knighthood*, I, pp. 186–209. A list of official accounts and descriptions is given in Appendix II.

17 See Appendix II, s.v. 1559; *Diary of Henry Machyn*, pp. 195–6; *CSP Venetian, 1558–80*, pp. 73–4, 81; V. von Klarwill, *Queen Elizabeth and Some Foreigners*, London, 1928, pp. 52–3. Machyn is a useful supplementary source for these opening years: *Diary of Henry Machyn*, pp. 232, 250, 257, 258, 280–81, 305–6.

18 Appendix II, s.v. 1559.

19 Ibid., s.v. 1560.

20 Ashmole, *Order of the Garter*, pp. 195–8.

21 Appendix II, s.v. 1576.

22 Ashmole, *Order of the Garter*, pp. 474–5.

23 Ibid., pp. 467 ff. has a long section on the Grand Feast but it is not exactly the same as Elizabethan practice.

24 On which see A. M. Hind, *Engraving in England in the 16th and 17th Centuries*, Cambridge, 1951, I, pp. 104–21.

25 On the Poor Knights see E. H. Fellowes, *The Military Knights of Windsor, 1352–1944*, histori-

cal monograph relating to St George's Chapel Windsor, 1944. Also Ashmole, *Order of the Garter*, pp. 158–74; Nicolas, *Orders of Knighthood*, II, pp. 471–83.

26 From Stowe's description of Windsor: see Tighe and Davis, *Annals of Windsor*, II, p. 42.

27 Appendix II, s.v. 1579.

28 Ibid., s.v. 1584.

29 Ibid., s.v. 1592.

30 *The Letters of Philip Gawdy*, ed. I. H. Jeayes, Roxburghe Club, 1906, pp. 81–2.

31 Von Klarwill, *Queen Elizabeth and Some Foreigners*, pp. 375–9.

32 Ashmole, *Order of the Garter*, pp. 262–7 has a long section on installation ceremonies.

33 Appendix II, s.v. 1592.

34 Peele, *Works*, ed. Bullen, II, p. 335.

35 Appendix II, s.v. 1593.

36 Generally, see Ashmole, *Order of the Garter*, pp. 338–42.

37 On the cavalcade and installation see: Ashmole MS. 1109, f. 45–45v; Stowe MS. 595, f. 55; Additional MS. 10110, f. 191v–192v; Cotton MS. Julius F.XI, f. 275v.

38 A. Collins, *Letters and Memorials of State*, London, 1746, II, p. 51.

39 Ashmole MS. 1108, f. 74v–75; Ashmole MS. 1112, f. 16v; Stowe MS. 595, f. 45v.

40 Ashmole MS. 1112, f. 17–17v; Stowe MS. 595, f. 45v.

41 See Ashmole, *Order of the Garter*, pp. 620–23.

42 *Acts of the Privy Council, 1600–1601*, XXXI, p. 180.

43 *1 Henry VI*, IV. i. 28–9.

44 *1 Henry VI*, IV. i. 33–44.

45 College of Arms MS. M 6, f. 83v–86; Harleian MS. 304, f. 84v; J. Nichols, *The Progresses of Queen Elizabeth*, London, 1823, I, p. 263; Ashmole MS. 1109, f. 135–6; Ashmole MS. 1110, f. 75. See also, for the degradation of Norfolk (1572), Ashmole MS. 1109, f. 10.

46 Ashmole, *Order of the Garter*, pp. 613–21.

47 *HMC Penshurst*, I, pp. 413, 416, 429; Ashmole MS. 1112, f. 66–66v; Ashmole, *Order of the Garter*, pp. 617–18.

48 H. Owen and J. B. Blakeway, *A History of Shrewsbury*, London, 1825, p. 371; Nichols, *Progresses of Queen Elizabeth*, I, pp. 304–5.

49 Ashmole MS. 1112, f. 65–6.

50 J. A. Twemlow, *Liverpool Town Books*, Liverpool, 1935, II, pp. 242–6.

51 On which see Roy Strong and J. A. van Dorsten, *Leicester's Triumph*, Leiden and Oxford, 1964, pp. 69–70; Holinshed, *Chronicles*, IV, pp. 658–9; Nichols, *Progresses*, II, pp. 455–7; Ashmole MS. 1110, f. 14v.

52 *The Shirburn Ballads, 1585–1616*, ed. A. Clarke, Oxford, 1917, pp. 321–6; *HMC Hatfield*, IX, p. 144.

53 Ashmole, *Order of the Garter*, pp. 387–455.

54 Yates, *The French Academies of the Sixteenth Century*, pp. 199–235.

55 H. O. Evennett, *The Cardinal of Lorraine and the Council of Trent*, Cambridge, 1930, pp. 105, 242, 244–53.

56 Ibid., pp. 403–4.

57 J. Stowe, *Annales*, London, 1631, p. 657; Holinshed, *Chronicles*, IV, pp. 224–5; *CSP Foreign, 1564–65*, pp. 134, 142, 157, 165–6. See also Ashmole, *Order of the Garter*, Appendix LXV, CXLVI.

58 Stowe, *Annales*, p. 659; Holinshed, *Chronicles*, IV, pp. 229–30; Ashmole, *Order of the Garter*, pp. 369–70, Appendix CXXVII, CXXIX, CXXXIV.

59 Paolo Sarpi, *The History of the Council of Trent*, London, 1676.

60 *CSP Foreign, 1566–68*, p. 277.

61 Additional MS. 37998, f. 11; Harleian MS. 1355, f. 21–21v; Additional MS. 10110, f. 153–53v; *CSP Foreign, 1566–68*, p. 395.

62 Stowe, *Annales*, p. 673; Holinshed, *Chronicles*, IV, p. 284; *Correspondence Diplomatique de Bertrand de Salignac de la Mothe Fénélon*, Paris and London, 1840, V, pp. 19–20; Harleian MS. 6064, f. 40–42; *CSP Domestic, 1547–80*, p. 446.

63 Roy Strong, 'Festivals for the Garter Embassy at the Court of Henry III', *Journal of the Warburg and Courtauld Institutes*, XXII, 1959, pp. 60–70.

64 Stowe, *Annales*, pp. 777–82; Cotton MS. Caligula E.IX, part 2, f. 56–9, 78–82; *CSP Venetian, 1592–1603*, p. 231; T. Birch, *Memoirs of the Reign of Queen Elizabeth*, London, 1754, II, p. 155; Harleian MS. 1355, f. 24–24v; Additional MS. 6298, f. 271–71v; P. Laffleur Kermaingant, *L'Ambassade de France en Angleterre sous Henri IV, Mission de Jean de Thumery Sieur de Boissise*, Paris, 1886, I, pp. 61–3.

65 Collins, *Letters and Memorials of State*, II, p. 190; Kermaingant, *L'Ambassade de France*, I, pp. 388–9; II, p. 136; Stowe MS. 595, f. 47–47v; Ashmole, *Order of the Garter*, Appendix CXXIII, CLI, CLVI; H. Foley, *Records of the English Province of the Society of Jesus*, London, 1877, I, p. 5.

66 Ashmole MS. 1134, f. 18–18v.

67 Stowe, *Annales*, p. 685; *HMC Report*, IV, p. 334; Ashmole MS. 1108, f. 69.

68 *CSP Foreign, 1582*, p. 253; G. Bertie, *Five Generations of a Loyal House*, London, 1845, pp. 67–73; Holinshed, *Chronicles*, IV, p. 495. His Garter collar still survives: Lord Twining, *A History of the Crown Jewels of Europe*, London, 1960, p. 96.

69 J. Assum, *Panegyrici Tres Anglovvirtembergici*

decantantes Heroicum Ordinem Regiae Angliae societatis Garteriorum D. Georgi, Tübingen, 1604, f. 14.

70 E. Cellius, *Eques Auratus Anglo-VVirtembergicus*, Tübingen, 1605, pp. 69–102; transl. W. B. Rye, *England as seen by Foreigners in the Days of Queen Elizabeth and James I*, London, 1865, pp. 3–53; von Klarwill, *Queen Elizabeth and Some Foreigners*, pp. 357–423. On further negotiations see Cellius, *Eques Auratus Anglo-VVirtembergicus*, pp. 103–22; *HMC Hatfield*, XIV, p. 330. General accounts see Rye, *England as seen by Foreigners*, pp. lviii–lxxvi; von Klarwill, *Queen Elizabeth and Some Foreigners*, pp. 347–55.

71 *Merry Wives of Windsor*, IV. iii. 9–10. The argument about this still goes on: see J. Crofts, *Shakespeare and the Post Horses*, Bristol, 1937.

72 Favyn, *Theater of Honour and Knighthood*, I, pp. 67–77.

73 Vergil, *Anglicae Historiae*, pp. 378–9.

74 Anstis, *Register*, I, pp. 1–29; the Richard I legend appears in J. Rastell, *The Pastyme of People*, London, 1811, pp. 216–17.

75 Royal MS. 18.C.XVII, f. 84; Sir William Segar, *Original Institutions of the Princely Orders of Collars*, Edinburgh, 1823, pp. 4–5.

76 Holinshed, *Chronicles*, I, pp. 268–72. Holinshed also alludes to the popular story of the King picking up the lady's garter, II, p. 627.

77 W. Segar, *Honor Military and Civill*, London, 1602, pp. 65–8; *The Booke of Honor and Armes*, London, 1590, pp. 14–18.

78 J. Selden, *Titles of Honour*, London, 1672, pp. 657–9; J. Speed, *The Historie of Great Britaine*, London, 1632, pp. 686–7; W. Camden, *Britannia*, London, 1610, pp. 286–93; Ashmole, *Order of the Garter*, pp. 178–87.

79 Richard Grafton, *Grafton's Chronicle*, London, 1809, I, pp. 358–9.

80 Holinshed, *Chronicle*, I, p. 268.

81 Camden, *Britannia*, p. 287; 'a golden band of unity', Speed, *Historie*, p. 686.

82 Peele, *Works*, ed. Bullen, I, pp. 315–37.

83 Ibid., p. 330.

84 Ibid., p. 331.

85 William Caxton, *The Golden Legend*, Temple Classics, London, 1900, III, p. 133.

86 Some interesting examples are cited by G. Scharf, 'On a Votive Painting of St George and the Dragon', *Archaeologia*, XLIX, 1886, p. 2 ff. See also the miniature in Royal MS. E.15. VI, f. 431 of Henry VI and his Garter Knights adoring St George.

87 Edward Halle, *Hall's Chronicle*, London, 1809, p. 423.

88 Scharf, 'On a Votive Painting', note I.

89 Additional MS. 25698, f. 3; see H. Shaw, *Dresses and Decorations of the Middle Ages*, London, 1843, II.

90 Nicolas, *Orders of Knighthood*, I, p. 120. St George also figured in Henry VII's entry into Hereford: Leland, *Collectanea*, IV, p. 197.

91 Scharf, 'On a Votive Painting', cites examples. An image of St George adorned the altar at the Field of Cloth of Gold, *CSP Venetian*, III, p. 20. See Anglo, *Spectacle, passim*.

92 Viscount Dillon, 'The Tudor Battle Flag of England', *Archaeological Journal*, LXV, pp. 282–6. Dillon fails to go into the mythological ramifications of the flag, which was supposed to have been presented to Arviragus, the first Christian king of Britain, by St Joseph of Arimathea: see e.g. G. Legh, *The Accedens of Armory*, London, 1568, f. 47–48ᵛ.

93 *The Letters of Stephen Gardiner*, ed. J. A. Muller, Cambridge, 1933, pp. 312–13.

94 Ibid., pp. 260–61.

95 *The Acts and Monuments of John Foxe*, ed. S. R. Cattley, London, 1888, VI, pp. 351–2.

96 J. G. Nichols, *The Literary Remains of Edward VI*, Roxburghe Club, 1857, II, p. 523.

97 See Frances A. Yates, 'Elizabethan Chivalry: The Romance of the Accession Day Tilts', *Journal of the Warburg and Courtauld Institutes*, XXI, 1958, pp. 22–3 note 84.

98 Gerard A. Hyperius, *De Theologo seu de ratione studii Theologici*, Basiliae, 1559, pp. 531–2.

99 Caesare Baronio Sarano, *Martyrologium Romanum*, Venice, 1587, pp. 177–80.

100 Useful guides are Selden's commentary to M. Drayton, *Poly-Olbion*, London, 1613, pp. 68–9; Peter Heylyn, *The Historie of that most famous Saint and Soldier of Christ Iesus; St George of Cappadocia*, London, 1633, pp. 331–5; Selden, *Titles of Honour*, pp. 677–8.

101 J. Rainolds, *De Romanae Ecclesiae Idolatria*, Oxford, 1596, pp. 201–9.

102 J. Nichols, *The Progresses of James I*, London, 1828, III, pp. 155–6; Nicolas, *Orders of Knighthood*, Appendix, xliv–xlvi.

103 *The Works of John Boys*, London, 1622, p. 330; cf. the interpretation by the Prince of Orange in 1627: Ashmole, *Order of the Garter*, pp. 418–9.

104 W. Perkins, *Warning against the Idolatrie of the Last Times*, Cambridge, 1601, p. 174.

105 Nichols, *Progresses of Queen Elizabeth*, III, pp. 541–3.

106 Gerard de Malynes, *Saint George for England, allegorically described*, London, 1601, dedication.

107 Heylyn, *Historie*, and Selden, *Titles of Honour*, pp. 659–68.

108 *Faerie Queene*, I, xii, 39.

109 Roy Strong, *Portraits of Queen Elizabeth I*, Oxford, 1963, pp. 62, 64.

110 Lee was elected in 1597.

1 Material on Henry, Prince of Wales is gathered in E. C. Wilson, *Prince Henry and English Literature*, New York, 1946.

2 H. Peacham, *Minerva Britanna*, London, 1612, p. 17.

3 Stephen Orgel and Roy Strong, *Inigo Jones: The Theatre of the Stuart Court*, London, 1973, I, p. 160, l.35–40; p. 163, no. 36.

4 Ibid., I, p. 37, no. 164.

5 Ibid., I, p. 194, l.38–40.

6 Ibid., I, p. 207, l.49–59.

7 See Frances A. Yates, *The Rosicrucian Enlightenment*, London, 1972, ch. I.

APPENDIX I

Sources for the Accession Day Tilts

1581 WHITEHALL
Tilt List
Ashmole MS. 845, f. 165; printed in R. Clephan, *The Tournament, its Periods and Phases*, London, 1919, pp. 132–3; J. H. Hanford and S. R. Watson, 'Personal Allegory in the "Arcadia" ', *Modern Philology*, XXXII, 1934, pp. 9–10. A second list is in College of Arms MS. M 4 and 14. It is undated, but the list is identical and includes comments by the names: 'not' against Arundel, Lord Windsor, Grey, Lee, Sidney, 'sick' against Greville, 'hurt' against Norris and 'will' against Bowes and Knyvet.

Earl of Arundel – Lord Windsor; Henry Grey – Henry Windsor; Sir Henry Lee – Philip Sidney; Sir Thomas Parrott – Thomas Ratcliffe; Fulke Greville – Ralph Bowes; Edward Norris – Thomas Knyvet; Anthony Coke – John Packington; George Gifford – Thomas Kellaway; Robert Alexander – George Goring; Edward More – Henry Brunkerd; William Tresham – Richard Ward; Storey – John Tyrrell; William Knowles – Robert Knowles.

Score Cheque
College of Arms MS. M 4 and 14.

Contemporary References
HMC Hatfield, XIII, p. 20; *CSP Spanish, 1580–86*, p. 222.

1582
There are no records of a tilt in this year.

1583 WHITEHALL
Tilt List
College of Arms MS. M 4 and 14, f. 30.

Earl of Cumberland – Sir Henry Lee; Henry Grey – Lord Willoughby d'Eresby; Edward Norris – Thomas Knyvet; Fulke Greville – Edward Denny; Thomas Ratcliffe – Ralph Lane; Ralph Bowes – Robert Knowles; George Goring – Edward More; George

Gifford – Hercules Meautys; Anthony Coke – Henry Nowell; Thomas Vavasour – Everard Digby; Edward Winter – Richard Ward; William Tresham – John Tyrrell.

Score Cheques
College of Arms MS. Box 37 has four undated and unscored cheques. The list of runners is identical saving the addition of Warham St Leger and Robert Alexander.

1584 WHITEHALL
Tilt List
College of Arms MS. M 4 and 14, f. 31.

Sir Henry Lee – Sir Philip Sidney; Earl of Cumberland – Lord Thomas Howard; Lord Willoughby d'Eresby – Henry Grey; Edward Norris – George Goring; William Knowles – Ralph Bowes; Robert Knowles – Fulke Greville; Thomas Knyvet – Edward Denny; Thomas Ratcliffe – Thomas Vavasour; George Gifford – Edward More; Anthony Coke – Thomas Gerrard; Robert Alexander – Henry Brunkerd; Edward Winter – Richard Ward.

Score Cheques
College of Arms MS. Box 37. Two have annotations. Sir Henry Lee ran in place of Edward More. There is a third scored list on a fragment of paper.

Speeches

Sonnet on behalf of a Blind Knight
Additional MS. 41499A, f. 6; printed in E. K. Chambers, *Sir Henry Lee*, Oxford, 1936, p. 271. The sonnet introduces a Blind Knight (Lee?) to the Queen, 'best flower of flowers, that grows both red and white'. The presenter is referred to as being dumb and therefore the sonnet was presumably presented not spoken.

Contemporary References
Description by Lupold von Wedel, 'Journey through

England and Scotland made by Lupold von Wedel in the years 1584 and 1585'; printed in *Transactions of the Royal Historical Society*, new series, IX, 1895, pp. 258–9; V. von Klarwill, *Queen Elizabeth and Some Foreigners*, London, 1928, pp. 330–32. Printed above, pp. 134–5.

1585 WHITEHALL
Tilt List
College of Arms MS. M 4 and 14, f. 33.

Sir Henry Lee – Fulke Greville; Earl of Cumberland – Lord Thomas Howard; Henry Grey – Robert Cary; Thomas Ratcliffe – Sir William Drury; Robert Alexander – Henry Brunkerd; Robert Knowles – Ralph Bowes; Henry Nowell – Thomas Gerard; George Gifford – William Gresham; Richard Ward – John Vavasour; Robert Cary (again) – John Chidley. Judges: Earl of Sussex, Earl of Ormond.

1586 WHITEHALL
Tilt List
College of Arms MS. M 4 and 14, f. 34.

Sir Henry Lee – Earl of Cumberland; Lord Thomas Howard – Earl of Essex; Henry Grey – Fulke Greville; Sir William Drury – Sir Philip Butler; Robert Cary – William Gresham; Ralph Bowes – Robert Knowles; Henry Nowell – Henry Brunkerd; Thomas Vavasour – Edward Wingfield; Thomas Gerard – John Chidley; Edward Winter – Robert Alexander.

Speeches
Memorial of Sir Philip Sidney
Additional MS. 41499A, f. 7ᵛ; printed in Chambers, *Lee*, p. 272. Three Latin verses headed 'The first', 'The second' and 'Upon the mourning horse'.

1587 WHITEHALL
Tilt List
College of Arms MS. M 4 and 14, f. 35.

Earl of Essex – Sir Henry Lee; Earl of Cumberland – Earl of Essex (again); Sir Henry Grey – Sir William Knowles; Sir William Hatton – Sir Philip Butler; Robert Knowles – Ralph Bowes; Edward Denny – Richard Skipwith; Thomas Gerard – Henry Nowell; John Chidley – William Gresham; Everard Digby – Pexall Brocas; John Needham – William Harvey.

Contemporary References
Letter of Philip Gawdy to his father dated 14 (probably 19) November 1587. He sends his father a book which was given to him at the tilt. He describes the tilt as 'not so full of devices' as usual. A previous letter refers to the great preparations and 'great expectation': *The Letters of Philip Gawdy*, ed. I. H. Jeayes, Roxburghe Club, London, 1906, pp. 22, 24–5.

1588 WHITEHALL
Tilt List
College of Arms MS. M 4 and 14, f. 36.

Sir Henry Lee – Earl of Essex; Lord Strange – Sir Edward Wingfield; Sir William Knowles – John Chidley; Sir Philip Butler – Sir Charles Blount; Robert Knowles – Ralph Bowes; Henry Brunkerd – Robert Alexander; Thomas Gerard – William Gresham; Henry Nowell – Thomas Vavasour; Anthony Coke – Everard Digby; William Harvey – John Needham; Gervase Clifton – Richard Skipwith; Earl of Cumberland – Earl of Essex (again).

Score Cheque
College of Arms MS. Box 37. One.

19 November
The tilting was renewed on St Elizabeth's Day (E. K. Chambers, *The Elizabethan Stage*, Oxford, 1923, IV, p. 103).

1589 WHITEHALL
Tilt List
College of Arms MS. M 4 and 14, f. 37–8.

Sir Henry Lee – Earl of Essex; Lord Thomas Howard – Lord Strange; Lord Burgh – Lord Compton (in place of Pexall Brocas); Robert Cary – William Gresham; Sir Charles Blount – Sir Philip Butler; Sir Edward Wingfield – Thomas Sidney; Henry Brunkerd – Robert Alexander; Henry Nowell – Anthony Coke; John Needham – Richard Acton; Everard Digby – Thomas Gerard; Ralph Bowes – Robert Knowles; Fulke Greville – Sir William Knowles.

Score Cheque
College of Arms MS. Box 37. One.

Contemporary References
Payment to Edward Tilney for 'the fair writing of all the devices on the 17 day of November A° 31 Eliz in two copies for the Queen': Lansdowne MS. 59, f. 40ᵛ.

1590 WHITEHALL
Tilt List
College of Arms MS. M 4 and 14, f. 39.

Sir Henry Lee – Earl of Cumberland; Lord Strange – Thomas Gerard; Lord Compton – Henry Nowell; Lord Burgh – Sir Edward Denny; Earl of Essex – Fulke Greville; Sir Charles Blount – Thomas Vavasour; Robert Cary – William Gresham; Sir William Knowles – Anthony Coke; Sir Thomas Knowles – Sir Philip Butler; Robert Knowles – Ralph Bowes; Thomas Sidney – Robert Alexander; John Needham – Richard Acton; Davers – Everard Digby.

Score Cheque
College of Arms MS. Box 37. One slightly mutilated.

Speeches
(i) *?Verses for Sir Henry Lee's entry*
Bodleian Rawlinson MS. Post. 148, f. 75ᵛ; with its musical setting in John Dowland, *Second Booke of Songs or Ayres*, 1600, nos. vi, vii, viii. Possibly used by Lee for his tilt entry rather than connected with the resignation ceremony after.
(ii) *Speech on behalf of the Earl of Cumberland, Knight of Pendragon Castle*
Printed in G. C. Williamson, *George, third Earl of Cumberland*, Cambridge, 1920, pp. 108–9, from a transcript made in 1661 from the original manuscript

then owned by Robert Hilton of Murton. In 1920 the transcript was at Appleby Castle but it is now no longer traceable. The speech is twice dated 1592, but it specifically refers to Lee's resignation and there was no tilt in 1592. It was spoken by Merlin attended possibly by Uther Pendragon and there was some sort of representation of Pendragon Castle in the tiltyard.

(iii) *Latin Prayer attached to the Crowned Pillar*
This appears in three sources, each with insignificant variations: (i) Additional MS. 41499A, f. IIv. (ii) Additional MS. 28635, f. 88v. (iii) W. Segar, *Honor Military and Civill*, London, 1602, p. 198. The verses were inscribed on a tablet hung on the pillar.

(iv) *Song sung during the resignation ceremony*
The verses appear in the first person only in Segar, *Honor Military and Civill*, pp. 198-9. These alone would make sense on the occasion. The verses are anonymous in Segar, but in two of the versions where they appear in the third person they are attributed to Lee, and there is no reason to doubt that they are his. These are: (i) John Dowland, *First Booke of Songs or Ayres*, London, 1597, no. xviii. Dowland presumably composed the music. (ii) Additional MS. 28635, f. 88v, ascribed to Lee. (iii) Printed at the close of Peele's *Polyhymnia*, in *Works*, ed. Bullen, II, p. 302. (iv) Stowe MS. 276, f. 2, ascribed to Lee. (v) Additional MS. 33963, f. 109, on the fly-leaf of Sidney's translation of Duplessis Mornay.

Contemporary References
The most complete description is in George Peele, *Polyhymnia*, in *Works*, ed. Bullen, II, pp. 286-301. The resignation ceremony is in Segar, *Honor Military and Civill*, pp. 197-9, reprinted many times, notably J. Nichols, *The Progresses of Queen Elizabeth*, London, 1823, III, pp. 41-50.

19 November
The score cheque records that on the 19th the Earl of Cumberland, the Earl of Essex and Lord Strange acted as challengers against Lord Compton, Robert Cary, Sir William Knowles, Robert Knowles, Thomas Sidney, John Needham, Davers, Thomas Gerard, Henry Nowell, Sir Edward Denny, Thomas Vavasour, William Gresham, Sir Philip Butler, Richard Acton and Everard Digby.

1591 WHITEHALL
Tilt List
College of Arms MS. M 4 and 14, f. 40.

Earl of Cumberland – Earl of Southampton; Lord Strange – Sir Charles Blount; Sir William Knowles – Fulke Greville; Sir Edward Denny – Robert Dudley; Sir Edward Wingfield – Everard Digby; Henry Nowell – Thomas Vavasour; Robert Knowles – Ralph Bowes; Henry Brunkerd – Robert Alexander; Earl of Cumberland (again) – William Gresham. Judges: Lord North and Lord Norris.

Score Cheque
College of Arms MS. Box 37. One unscored cheque recording the Earl of Ormond as Earl Marshal.

1592
There was no tilt in 1592, but Philip Gawdy records that Cumberland and Essex issued a challenge for Shrovetide 1593 under the pseudonymn of Amadis de Gaule: *Letters of Philip Gawdy*, p. 67.

1593 WINDSOR
Tilt List
The tilt was held at Windsor due to the plague in London. College of Arms MS. M 4 and 14, f. 42; Ashmole MS. 1109, f. 154v; printed in Clephan, *The Tournament*, p. 133.

Earl of Cumberland – Earl of Southampton; Earl of Essex – Robert Knowles; Lord Fitzwalter – Cary Reynolds; Lord Compton – Henry Nowell; Sir Charles Blount – Sir Thomas Gerard; Sir Unknown (Robert Cary, see above p. 141) – Robert Dudley; Earl of Essex (again) – Sir William Knowles; Earl of Essex (again) – Robert Knowles; Harvey – (blank); Stafford – Anthony Coke. Judges: Earl of Worcester, Lord Sandys, Lord North and Lord Norris.

Score cheques
College of Arms MS. Box 37. Two.

Speeches
Speech by the Earl of Cumberland as Knight of Pendragon Castle
Printed in 1920 in Williamson, George, *third Earl of Cumberland*, pp. 122-3. The manuscript was then at Appleby Castle but is now untraceable. As in the 1590 speech there is a reference to a representation of Pendragon Castle in the tiltyard: 'once removed to Westminster, now strangely erected in Windsor'. Probably this means a re-use of old scenery. The speech casts Cumberland as a seaman returned from a voyage and makes it clear that his entourage were dressed as mariners.

Contemporary references
Standen writes to Anthony Bacon of Essex being occupied a whole week in his arrangements for the tilt: T. Birch, *Memoirs of the Reign of Queen Elizabeth*, London, 1754, p. 131; payments are in the Devereux accounts at Longleat: Declared Accounts, 1592-3, f. 76v and Household Accounts, 1592-3, f. 78-78v. Sir Robert Cary gives an account of his appearance as an Unknown Knight in *Memoirs of Sir Robert Cary and Fragmenta Regalia*, Edinburgh, 1808, pp. 55-7.

1594 WHITEHALL
Tilt List
College of Arms MS. M 4 and 14, f. 43.

Earl of Essex – Robert Knowles; Earl of Sussex – Sir Thomas Gerard; Earl of Southampton – Lord Mountjoy; Earl of Bedford – Sir Edward Wingfield; Lord Compton – Henry Nowell; Sir William Knowles – John Needham; William Harvey – Cary Reynolds; John Stafford – Charles Blount; Earl of Essex (again) – Thomas Vavasour. Judges: Earl of Shrewsbury, Lord

Sandys, Lord Sheffield (annotated 'came not') and Lord Norris.

Contemporary References

A newsletter refers to three captured Spanish flags being presented to the Queen on Accession Day, though it may not have been at the tilt: *The Fugger News-Letters*, 2nd series, ed. V. von Klarwill, London, 1926, p. 262. The Devereux accounts preserve payments made for the elaborate spectacle Essex presented, which included a preliminary entertainment on 16 November and scholars brought from Oxford to act in the tilt device: Longleat, Devereux MSS., Household Accounts, 1594–8, f. 87, 91–91ᵛ.

19 November

The Earl of Essex challenged all comers. Score in College of Arms MS. Box 37. The opponents were: Earl of Sussex, Earl of Southampton, Earl of Bedford, Lord Mountjoy, Lord Compton, Sir William Knowles, Sir Edward Wingfield, Sir Thomas Gerard, Henry Nowell, John Needham, William Harvey, Cary Reynolds, John Stafford, Charles Blount, Robert Knowles and Thomas Vavasour.

1595 WHITEHALL

Tilt List

HMC Various, IV, pp. 163–4 contains a draft list. College of Arms MS. M 4 and 14, f. 48, and Box 37 on the reverse of a blank cheque for a tournament in March 1595.

Earl of Cumberland – Earl of Essex; Earl of Sussex – Sir Robert Cary; Earl of Southampton – James Scudamore; Earl of Bedford – Sir William Knowles; Lord Compton – Henry Nowell; William Howard – Robert Dudley; Sir Thomas Knowles – Robert Knowles; Sir Robert Drury – John Needham; Cary Reynolds – Charles Blount; Henry Cary – Alexander Ratcliffe.

Speeches

The Earl of Essex's device, by Francis Bacon and Essex
There is no complete text of this device but only fragmentary and often conflicting draft speeches. The following list is only a suggested order.

(i) *Speech by Philautia against Love*
PRO S.P.12/254, no. 68. Two draft speeches in the hand of Essex's secretary Edward Reynolds, both in French and both virtually unreadable. Perhaps this represents an opening statement made on the previous day, 16 November, as here Philautia or Self-Love states her case and her reason to hope that Essex will be her devotee.

(ii) *Speech by or letter from Philautia to the Queen*
Lambeth Palace MS. 936, no. 274; printed in *The Works of Francis Bacon*, ed. J. Spedding, L. Ellis, D. D. Heath, London, 1858, VIII, i, pp. 376–7. This is in draft in Bacon's hand. In it Philautia informs the Queen of her visit to Pallas and of her decision to attempt to woo Erophilus from his devotion to the Queen by the wiles of the Hermit, the Soldier and the Secretary. Again perhaps part of an entertainment on 16 November.

(iii) *The Squire's speech in the tiltyard*
Lambeth Palace MS. 933, no. 118; inaccurate transcripts in Nichols, *Progresses*, III, p. 371; *Works of Francis Bacon*, VIII, i, p. 378. This also occurs in the Alnwick Castle, Northumberland MS., f. 47; printed in F. J. Burgoyne, *An Elizabethan Manuscript at Alnwick Castle*, London, 1904, p. 57. Speech introducing the three actors, the Hermit, Soldier and Secretary.

(iv) *Draft speech of the Secretary*
Lambeth Palace MS. 936, no. 274; printed in *Works of Francis Bacon*, VIII, i, p. 376. Short note as preamble outlining what is to happen and then part of a speech by the Secretary to Essex's squire.

(v) *The speech of the Hermit*
Lambeth Palace MS. 936, no. 274; printed in *Works of Francis Bacon*, VIII, i, pp. 377–8. The speech presents the case for a life of contemplation and study and presents Essex with a book.

(vi) *The Hermit's petition to the Queen*
Alnwick Castle, Northumberland MS., f. 69; printed in Burgoyne, *Elizabethan Manuscript*, p. 57. This appears to conclude the tiltyard encounter, petitioning that the Queen might assign a time when they might reappear before her.

(vii) *Speech presenting another tilter disguised as an Indian prince*
PRO S.P.12/254, no. 67; printed in *Works of Francis Bacon*, VIII, i, pp. 388ff. There is no indication as to which of the tilters used this, but it develops the Earl's own entry in its allusions to Blind and Seeing Love. The tilter was initially presented by Essex's squire, after which the tilter's own attendant addressed the Queen. The Indian prince has voyaged from the West Indies in the hopes that his sight might be restored by paying homage and sacrifice to Elizabeth. The Queen restores his sight and he is transformed forthwith into Seeing Cupid and the Queen is petitioned to accept the love Erophilus offers.

(viii) *Speeches for the device after supper*
Lambeth Palace MS. 933, no. 118; inaccurate transcripts in Nichols, *Progresses*, III, pp. 371–9; *Works of Francis Bacon*, VIII, i, pp. 378–86. They also appear in Alnwick Castle, Northumberland MS., f. 47–53; printed in Burgoyne, *Elizabethan Manuscript*, pp. 57–63. Part of the Hermit's speech, translated into French, appears in Lambeth Palace MS. 652, no. 95. Speeches by the Hermit, the Soldier and the Secretary with the squire's reply and final resolution in favour of Erophilus's devotion to the Queen.

Contemporary References

Peele's *Anglorum Feriae* gives an overall account of the tilt: *Works*, ed. Bullen, II, pp. 339ff. Whyte wrote to Sir Robert Sidney on 16 November of the great preparations and of 'such devices promised as our age hath not seen the like': A. Collins, *Letters and Memorials of State*, London, 1746, p. 361. His letter of 22 November also gives the fullest account of Essex's device: *ibid.*, pp. 362–3. An emblem of Philautia appears in Peacham's *Minerva Britanna*, London, 1612, no. 5. This book seems to draw on Accession Day Tilt devices and this could record one used by Essex in 1595.

1596 WHITEHALL
Tilt List
College of Arms MS. M 4 and 14, f. 50.

Earl of Cumberland – Earl of Essex; Earl of Sussex – Sir Thomas Gerard; Earl of Southampton – Sir James Scudamore; Earl of Bedford – Sir William Knowles; Lord Mountjoy – Thomas Vavasour; Lord Compton – Sir Charles Blount; Sir William Howard – Robert Knowles; Sir Richard Buckley – Henry Cary; Sir Thomas Knowles – Sir Edward Wingfield; Sir Robert Drury – Cary Reynolds; Henry Helmes – Henry Goodyere. Judges: Lord Howard, Lord North and Lord Norris.

Speeches
Speech for the Earl of Sussex
Alnwick Castle, Northumberland MS., f. 53–4; printed in Burgoyne, *Elizabethan Manuscript*, p. 64. Probably by Francis Bacon. I do not see why this is a speech to apologize for the Earl's absence (Chambers, *Elizabethan Stage*, III, p. 213). It refers to some future retirement of the Earl to acquire the perfections of his uncle and father. Bacon wrote on 15 October for the loan of a horse and armour for some public show, so that he might have acted in this or Essex's device (Thomas Lodge, *Illustrations . . .*, London, 1838, App. 79).

19 and 20 November
College of Arms MS. M 4 and 14, f. 51 gives the list for the Earl of Essex's challenge. College of Arms MS. Box 37 has a score cheque. His opponents were: Earl of Cumberland, Earl of Southampton, Earl of Bedford, Lord Mountjoy, Lord Compton, Sir William Knowles, Sir William Howard, Sir Edward Wingfield, Sir Thomas Knowles, Sir Thomas Gerard, Sir Robert Drury, Sir Charles Blount, Sir James Scudamore, Robert Knowles, Thomas Vavasour, Cary Reynolds, Henry Cary and Henry Healmes. Judges: Lord Thomas Howard, Lord Norris and Sir Thomas Gorges. First prize to the Earl of Southampton and second to Henry Cary.

1597 WHITEHALL
Tilt List
College of Arms MS. M 4 and 14, f. 52.

Earl of Cumberland – Lord Mountjoy; Earl of Southampton – Sir Robert Dudley; Earl of Bedford – Sir Edward Wingfield; Lord Howard of Effingham – Robert Knowles; Lord Compton – Sir Robert Cary; Lord Dudley – Charles Howard; Lord Windsor – Sir Thomas Gerard; Sir Charles Blount – Henry Cary; Sir Thomas (? James) Scudamore – Edward Howard; Sir Alexander Ratcliffe – Sir John Lee; Cary Reynolds – John Needham.

Speeches
Speech by Sir Henry Lee as the Restless Knight
Additional MS. 414A, f. 1–1ᵛ. Also with minor variants in the Hamper MS; printed in Nichols, *Progresses*, III, p. 197. It is undated but clearly after Lee's retirement in 1590. Chambers suggested 1593 with Cary Reynolds as the 'son' in chivalry (*Lee*, p. 150), but the tilt list records

the presence of a John Lee. Although Sir Henry's own son John had died there was a John Lee, Fellow of St John's, Oxford, who would fit the bill. He was the illegitimate son of Cromwell Lee, Sir Henry's heir-designate, and took his BA in 1591, held two livings in Lee's patronage and died in 1609 (Chambers, *Lee*, p. 223). The speech is not directly to the Queen but to an assembly of lords and gentlemen by 'your fellow in arms and first celebrater in this kind of this sacred memory of that blessed reign'.

1598 WHITEHALL
Tilt List
College of Arms MS. M 4 and 14, f. 53.

Earl of Cumberland – Sir Thomas Gerard; Earl of Bedford – Sir Thomas Knowles; Lord William Howard of Effingham – Sir John Lee; Lord Grey – Henry Cary; Lord Mountjoy – John Needham; Lord Windsor – Sir Charles Blount; Lord Compton – Sir James Scudamore; Charles Howard – Cary Reynolds; Edward Howard – Edward Bellingham; Lord Grey – Richard Buckley; Robert Knowles – Earl Marshall. Judges: Lord Henry Seymour, Lord Sandys, Lord De la Warr and Sir William Knowles.

Contemporary References
John Chamberlain to Carleton, 22 November: *Letters of John Chamberlain*, ed. N. E. McClure, Philadelphia, 1939, I, p. 53. There is a letter from Lee to Essex excusing himself from the tilt: E. N. Tenison, *Elizabethan England*, 1953, X, p. 433.

1599 WHITEHALL
Tilt List
College of Arms MS. 4 and 14, f. 54ᵛ–55. This contains a proclamation abandoning the tilt and asking the spectators to reassemble on the 18th. It was eventually held on the 19th.

Earl of Cumberland – Robert Knowles; Earl of Sussex – Sir Thomas Gerard; Earl of Bedford – John Needham; Lord William Howard – Robert Knowles (again); Lord Grey – Sir Henry Cary; Lord Mountjoy – Charles Howard; Lord Compton – Edward Howard; Sir James Scudamore – Edward Bellingham; Henry Alexander – Sigismund Alexander. Judges: Lord Thomas Howard, Lord Henry Seymour, Lord Sandys and Sir William Knowles.

Contemporary References
HMC Penshurst, II, p. 417, referring to the bad weather. Philip Gawdy alludes to Elizabeth thanking them after the 'old fashion': *Letters of Philip Gawdy*, p. 96. The fullest account is in Whyte's letter to Sir Robert Sidney of 23 November, recording Lord Compton's entry as a fisherman in a net: Collins, *Letters and Memorials of State*, II, p. 142.

November 21
College of Arms MS. M 4 and 14, f. 54ᵛ, 55ᵛ and 56. In his speech on Queen's Day Cumberland had issued a challenge, but due to illness was unable to fulfil it, so that the tilting was renewed on 21 November on the lines of the 19th.

Earl of Sussex – Sir Thomas Gerard; Earl of Bedford – John Needham; Lord William Howard – Robert Knowles; Lord Grey – Sir Henry Cary; Lord Mountjoy – Charles Howard; Lord Compton – Edward Howard; Sir James Scudamore – Edward Bellingham; Henry Alexander – Sigismund Alexander. Judges as on Queen's Day.

1600 WHITEHALL
Tilt List
College of Arms MS. M 4 and 14, f. 57.

Earl of Cumberland – Robert Knowles; Earl of Sussex – Sir Thomas Gerard; Earl of Bedford – Francis Manners; Lord Herbert of Cardiff – Sir Robert Dudley; Lord Howard of Effingham – John Needham; Lord Grey de Wilton – Sir Henry Cary; Lord Compton – Edward Howard; Lord Compton – Sir Thomas Gerard; Francis Norris – Sir James Scudamore; Sir Robert Drury – Sir Cary Reynolds; Richard Buckley – Edward Bellingham; Unknown Knight (?Essex) – Robert Knowles. Judges: Lord Henry Seymour, Lord Sandys, Lord Sheffield and Sir William Knowles.

Speeches
Speech by the Earl of Cumberland as a Discontented Knight
The speech is from a manuscript, no longer traceable, which was last recorded at Bolton Castle (a Clifford seat) in 1872 and first printed in T. D. Whitaker, *History and Antiquities of Craven*, London, 1812, pp. 274–5. It is reprinted in Nichols, *Progresses*, III, pp. 522–6; Williamson, *George, third Earl of Cumberland*, pp. 242–3. The manuscript was attached to a letter to Sir Robert Cecil complaining that the governorship of the Isle of Wight had been bestowed elsewhere, which doubtless explains the discontent of the Knight with royal service.

Contemporary References
The tilt in 1600 was especially elaborate to impress foreign ambassadors: Whyte to Sidney, 3 October, *HMC Penshurst*, II, p. 485; John Stowe, *Annales*, London, 1631, p. 791. Gawdy refers to 'very great and brave shows': *Letters of Philip Gawdy*, pp. 101, 104–5. Whyte's letters to Sidney deal with Lord Herbert of Cardiff's appearance: *HMC Penshurst*, II, pp. 488, 489; Collins, *Letters and Memorials of State*, II, pp. 215–16. Great efforts were made to include Essex, but they failed: R. Winwood, *Memorials of Affairs of State*, London, 1725, I, pp. 271, 274.

1601 WHITEHALL
Tilt List
Additional MS. 10110, f. 68ᵛ.

Earl of Cumberland – Robert Knowles; Earl of Sussex – Sir Thomas Gerard; Lord Howard of Effingham – Sir Thomas Somerset; Lord Grey – Sir Henry Cary; Lord Dudley – John Egerton; Lord North – Sir Cary Reynolds; Lord Compton – Edward Howard; Lord Norris – Sigismund Alexander; Charles Howard –

Henry Alexander; Earl of Cumberland (again) – Henry Alexander.

Score cheques
HMC Hatfield, XI, p. 540; Additional MS. 10110, f. 68ᵛ.

1602 WHITEHALL
Tilt List
Additional MS. 10110, f. 69ᵛ, draft; Harleian MS. 5826, f. 128, draft.

Earl of Cumberland – Robert Knowles; Earl of Sussex – Sir Thomas Gerard; Lord Howard of Effingham – Thomas Somerset; Lord Grey – Henry Cary; Lord Compton – Edward Howard; Lord Norris – Sir Cary Reynolds; Charles Howard – Sir Robert Dudley; John Egerton – Thomas Terringham; Buckley – John Morris; Edward Stanhope – Henry Alexander; Robert Wroth – Edward Bellingham; Earl of Cumberland (again) – Anthony Denton.

Score Cheques
Harleian MS. 5826, f. 128; Additional MS. 10110, f. 68; both unscored.

Contemporary References
Chamberlain to Carleton, 19 November, gives the fullest account: *Letters of John Chamberlain*, ed. N. E. McClure, Philadelphia, 1939, I, p. 121. There is an anecdote in *Manningham's Diary*, ed. J. Bruce, Camden Society, 1868, pp. 86–7.

UNDATED SPEECHES
(i) *Speech of apology by the Damsel of the Queen of Fairies for the Enchanted Knight*
Additional MS. 41499A, f. 1–1ᵛ. It also appears in Hamper MS (with minor variants); printed Nichols, *Progresses*, III, pp. 198–9. The speech is made on behalf of the Enchanted Knight by the Damsel of the Queen of Fairies. She alludes to an earlier Accession Day Tilt held 'not far hence', perhaps one held at Greenwich, and presents Elizabeth with a golden Cupid. Presumably by Lee.
(ii) *Speech on behalf of Wandering Knights and a Black Knight*
Additional MS. 41499A, f. 6ᵛ–7. Presumably by Lee, and following the verses for 17 November 1584. This could be for the 1584 tilt. The Black Knight states that he was at last year's tilt, but not his companions, the Wandering Knights, who have now, after an absence, returned to pay their accustomed homage.
(iii) *Speech by a Hermit on behalf of a Knight clownishly clad*
Additional MS. 41499A, f. 2–3ᵛ. Presumably by Lee, and if so used before 1590 when he retired. At one point the knight is addressed by initials read by Chambers as 'C.H.' and Frances Yates as 'C.L.', but the identification of the knight as Lee surely springs from the references to his vow to tilt annually before the Queen. This could only fit Lee. The speech was part of an entertainment on 16 November when the Hermit introduced the Clownish Knight with his rustic company who petition to run at tilt or the quintain with the jousters on the 17th.

(iv) *Temple of Peace Tournament*

Additional MS. 41499A, f. 7–7v contains speeches for a tilt and tourney spoken by the Priestess of the Temple of Peace ('not that in Rome consumed'). She introduces two knights, one following desire and innocency, the other truth and constancy (perhaps Sir Henry Lee, whose motto was *Fide et Constantia*), each of whom has a following of other knights. The knights had fallen out on the way to the Temple, whose High Priest had enjoined a penance in the form of a journey to the island of Terra Benedicta, ruled by a princess, 'the greatest friend to peace in the world'. The knights are escorted into Elizabeth's presence by Priests of the Temple of Peace, and the speeches indicate that an altar to peace may have been part of the tiltyard décor. The knights present their *impresa* shields, after which there is running at the tilt on the first day and a tourney on the second, when the knights are promised entry to the Temple. It is conceivable that this is the scenario for an early Accession Day Tilt and that within this overall theme individual knights would, as was customary, have had their own disguises and *imprese*.

APPENDIX II

Official accounts and descriptions of Elizabethan Garter Feasts

The official records of the Garter Feasts are preserved in the *Liber Ceruleus*, of which a transcript is in British Library Additional MS. 36768, and which is here referred to as LC.

1559
St George's Day: Whitehall
LC, f. 8–8v.
Ashmole MS. 1134, f. 6v–9.
Windsor Castle: Feast and Installation
LC, f. 9.
Ashmole MS. 1134, f. 9–11v.

1560
St George's Day: Whitehall
LC, f. 9–9v.
Ashmole MS. 1134, f. 11v–14v.
College of Arms MS. XLVII, f. 103.
Ashmole MS. 1110, f. 87–9.
Windsor Castle: Feast
LC, f. 9v–10.
Ashmole MS. 1134, f. 15–17.
College of Arms MS. Arundel XLVII, f. 103.

1561
St George's Day: Whitehall
LC, f. 10v–11.
CSP Domestic, 1547–80, p. 239.
Windsor Castle: Feast and Installation

LC, f. 11.
CSP Domestic, 1547–80, p. 239.

1562
St George's Day: Whitehall
LC, f. 11v–12.
CSP Domestic, 1547–80, p. 239.

1563
St George's Day: Whitehall
LC, f. 12–12v.
CSP Domestic, 1547–80, p. 239.
Windsor Castle: Feast and Installation
LC, f. 12v.
CSP Domestic, 1547–80, p. 239.

1564
St George's Day: Windsor
LC, f. 12v–13v.
CSP Domestic, 1547–80, p. 239.

1565
St George's Day: Whitehall
LC, f. 13v.
Windsor Castle: Feast
LC, f. 13v–14.

1566
St George's Day: Greenwich
LC, f. 14–14v.
Ashmole MS. 1114, f. 67–8.
Windsor Castle: Feast
LC, f. 15.
END OF THE FEASTS AT WINDSOR

1567
Whitehall
LC, f. 15–15v.
Ashmole MS. 1114, f. 68v–69.

1568
Greenwich
LC, f. 15v–16.
Ashmole MS. 1110, f. 90–91.

1569
Whitehall
LC, f. 16–16v.

1570
Hampton Court
LC, f. 16v–17.

1571
Whitehall
LC, f. 17–18.

1572
Greenwich
LC, f. 18–18v.

1573
Greenwich
LC, f. 18v–19.

1574
Greenwich
LC, f. 19–19v.

1575
Greenwich
LC, f. 20.

1576
Whitehall
LC, f. 20v.
Ashmole MS. 1109, f. 89v–91.
Additional MS. 10110, f. 121–3.

1577
Whitehall
LC, f. 20v.
Ashmole MS. 1109, f. 85v–87.
Additional MS. 10110, f. 108–9.

1578
Greenwich
LC, f. 21v.
Additional MS. 10110, f. 110–11.

1579
Whitehall
LC, f. 21v–22.
Ashmole MS. 1109, f. 87v–89, 91v–92v.
Additional MS. 10110, f. 136–7.

1580
Whitehall
LC, f. 22v–23.

1581
Whitehall
LC, f. 23–23v.

1582
Greenwich
LC, f. 24.
Additional MS. 10110, f. 112 (account breaks off in the middle).

1583
Greenwich
LC, f. 24v–25.
Ashmole MS. 1108, f. 60v (note only).

1584
Greenwich
LC, f. 25–26v.
Ashmole MS. 1108, f. 60 61v.

1585
Greenwich
LC, f. 26v–27v.
Ashmole MS. 1108, f. 62–62v.
Harleian MS. 304, f. 147, 155–6.

1586
Greenwich
LC, f. 27v.
Harleian MS. 304, f. 149, 156v–57.

1587
Greenwich
LC, f. 28.
Harleian MS. 304, f. 150–2, 157–57v.

1588
Greenwich
LC, f. 28v–29v.
Harleian MS. 304, f. 154, 157v–158v.

1589
Whitehall
Ashmole MS. 1112, f. 9.
Harleian MS. 304, f. 159–60.

1590
Greenwich
LC, f. 30v–31.

1591
Greenwich
LC, f. 31.
Harleian MS. 304, f. 161–2.

1592
Greenwich
LC, f. 31v–32.
Ashmole MS. 1109, f. 89.
Harleian MS. 304, f. 166v.

1593
Whitehall
LC, f. 32–32v.
Additional MS. 6298, f. 88.
Harleian MS. 304, f. 168.

1594
Greenwich
LC, f. 33–33v.

1595
Whitehall
LC, f. 33v–34.
Additional MS. 6298, f. 87.
Additional MS. 10110, f. 23.

1596
Greenwich
LC, f. 34–34v.
Ashmole MS. 1108, f. 62v (note only).
Additional MS. 6298, f. 88v.

1597
Whitehall
LC, f. 35–35v.
Ashmole MS. 1108, f. 63 (note only).
Additional MS. 6298, f. 90–90v.
Additional MS. 10110, f. 159 (account breaks off in the middle).

1598
Whitehall
LC, f. 35v–36.
Ashmole MS. 1108, f. 63v (note only).
Additional MS. 6298, f. 92–92v.

1599
Greenwich
LC, f. 36–36v.
Ashmole MS. 1108, f. 63v (note only).
Additional MS. 6298, f. 92v–93.

1600
Greenwich
LC, f. 37–37v.
Ashmole MS. 1108, f. 64.
Additional MS. 6298, f. 94–94v.

1601
Whitehall
LC, f. 37v–38.
Ashmole MS. 1108, f. 64 (note only).

1602
Greenwich
LC, f. 38v.
Ashmole MS. 1108, f. 64v.

LIST OF ILLUSTRATIONS

Dimensions are given in inches and centimetres

215

6 Detail of pl. 1

7 Nicholas Hilliard, *Charles Howard, Lord Howard of Effingham, Earl of Nottingham*, 1605
Miniature, 2 × 1⅝ (5.1 × 4.1)
National Maritime Museum, London

8 Detail of pl. 75

9 Nicholas Hilliard, *George Carey, 2nd Lord Hunsdon*, 1601
Miniature, 1⅞ × 1½ (4.8 × 3.8)
Trustees of Berkeley Castle
Photo Courtauld Institute of Art, London

10 Artist unknown, *Gilbot Talbot, 7th Earl of Shrewsbury*, 1596 (detail)
Oil on panel
Mr Robert Manuge, Halifax, Nova Scotia
Photo National Portrait Gallery, London

11 Detail of pl. 1

12 Attributed to Sir William Segar (d. 1633), *Edward Somerset, 4th Earl of Worcester*, c. 1590 (detail)
Oil on panel, 22¼ × 17 (56.5 × 43.2)
The Lord Petre; custody of Essex County Record Office, Ingatestone Hall
Photo Essex County Record Office

13 Artist unknown, *Edward Somerset, 4th Earl of Worcester*, c. 1620
Oil on panel, 41 × 33 (104.1 × 83.8)
The Duke of Beaufort, Badminton
Photo Courtauld Institute of Art, London

14 Francesco Laurana (c. 1430–c. 1502), detail of sculpture over the entrance to the Castelnuovo, Naples, showing Alfonso the Great entering Naples in 1443
Photo Anderson

15 Detail of pl. 1

16 Artist unknown, *Henry Somerset, Lord Herbert of Chepstow, 5th Earl and 1st Marquis of Worcester*, c. 1620 (detail)
Oil on panel, 35 × 30½ (88.9 × 77.5)
The Duke of Beaufort, Badminton
Photo Courtauld Institute of Art, London

17 Artist unknown, *Anne Russell, wife of the 5th Earl and 1st Marquis of Worcester*, c. 1600 (detail)
Oil on canvas, 35¼ × 23½ (89.5 × 59.7)
The Duke of Beaufort, Badminton
Photo Courtauld Institute of Art, London

18 Artist unknown, *Elizabeth Hastings, Countess of Worcester*, c. 1600 (detail)
Oil on canvas, 32 × 30 (81.3 × 76.2)
The Duke of Beaufort, Badminton
Photo Courtauld Institute of Art, London

19 Marcus Gheeraerts, *Katherine Somerset, Lady Petre*, 1599 (detail)
Oil on panel, 44 × 35½ (111.8 × 90.2)
The Lord Petre; custody of Essex County Record Office, Ingatestone Hall
Photo Essex County Record Office

20 Artist unknown, *Elizabeth Somerset, Lady Guildford*, c. 1625 (detail)
Oil on canvas, 65 × 42 (165 × 106.7)
The Duke of Beaufort, Badminton
Photo Courtauld Institute of Art, London

21 Hans Vredeman de Vries, architectural fantasy from *Variae Architecturae Formae*, 1601
Engraving, 6¼ × 4½ (15.9 × 11.4)

22 Detail of pl. 1

23 The ruins of Chepstow Castle
Photo Crown copyright, reproduced with permission of the Controller of Her Majesty's Stationery Office

24 The ruins of Raglan Castle
Photo Crown copyright, reproduced with permission of the Controller of Her Majesty's Stationery Office

25 George Gower (fl. 1570–96), *Elizabeth I* (the Armada Portrait), c. 1588
Oil on panel, 41½ × 52½ (105.4 × 133.5)
From the Woburn Abbey Collection, by kind permission of the Marquess of Tavistock and Trustees of the Bedford Estates

26 Nicholas Hilliard, *Queen Elizabeth I*, c. 1600
Miniature, 2½ × 1⅞ (6.4 × 4.8)
Victoria & Albert Museum, London. Crown copyright

27 Nicholas Hilliard, *Queen Elizabeth as Cynthia*, c. 1600
Miniature, 2⅝ × 2½ (6.7 × 6.4)
Victoria & Albert Museum, London. Crown copyright

28 As page 8 (detail)
Photo Courtauld Institute of Art, London

29 Andrea Mantegna (c. 1431–1506), *The Triumph of Caesar*, c. 1485–92
Oil on canvas, 108⅝ × 108⅝ (274 × 274)
Reproduced by gracious permission of Her Majesty Queen Elizabeth II

30 Nicholas Hilliard (1547–1619), *Young Man amongst Roses*, c. 1587
Miniature, 5⅜ × 2¾ (13.7 × 7)
Victoria and Albert Museum, London. Crown copyright

31 Francesco Primaticcio (1504–70), *Hercules being dressed as a Woman by Omphale*, c. 1535 (detail); drawing for the fresco for the Porte Dorée at Fontainebleau
Pen, ink and wash, 8⅞ × 17 (22.7 × 43.2)
Albertina, Vienna

32 Francesco Primaticcio, detail of stucco decoration in the room of the Duchesse d'Etampes, Fontainebleau
Château de Fontainebleau
Photo Giraudon

33 Antique statue
Vatican Museums
Photo Anderson

34 Maître de Flore (fl. second half of 16th century), *The Triumph of Flora*, c. 1560
Oil on panel, 51⅝ × 43¼ (131 × 110)
Private collection, Italy

35 Artist unknown, *Allegory of Love*, c. 1560–70
Oil on panel, 51⅝ × 38 (131 × 96.5)
Louvre

36 Nicholas Hilliard, *Young Man Aged Twenty-Two in 1588*
Miniature, 1⅝ × 1¾ (4.1 × 3.4)
Metropolitan Museum of Art, New York, Fletcher Fund, 1935

37 Nicholas Hilliard, *Young Man*, c. 1588
Miniature, 1¾ × 1⅜ (4.4 × 3.4)
The Duke of Rutland, Belvoir Castle
Photo Victoria & Albert Museum, London. Crown copyright

38 Marcus Gheeraerts, *Robert Devereux, 2nd Earl of Essex*, c. 1596
Oil on canvas, 84 × 50 (213.4 × 127)
From the Woburn Abbey Collection, by kind permission of the Marquess of Tavistock and Trustees of the Bedford Estates
Photo Paul Mellon Centre

39 William Segar, *Robert Devereux, 2nd Earl of Essex*, 1590
Oil on panel, 44½ × 34½ (113 × 87.7)
National Gallery of Ireland, Dublin

40 Attributed to William Segar, *Robert Devereux, 2nd Earl of Essex*, c. 1590–92
Oil on panel, 44½ × 34 (113 × 86.4)
Museum of Fine Arts, Boston

41 Attributed to William Segar, *Robert Devereux, 2nd Earl of Essex*, c. 1590–92
Oil on panel (curved top), 34½ × 21⅝ (87.7 × 55)
The Earl of Jersey
Photo Johnson & Johnson

42 Nicholas Hilliard, *Robert Devereux, 2nd Earl of Essex*, c. 1593–5
Miniature, 9⅞ × 8 (25 × 20.3)
Private collection
Photo Warburg Institute

43 Artist unknown, *Robert Devereux, 2nd Earl of Essex*, c. 1593–5
Panel, 13⅞ × 10¾ (35.2 × 27.3)
Mr C. O. V. Keinbusch, New York
Photo National Portrait Gallery, London

44 Detail of pl. 30

45 Glass painting of the flowers of Elizabeth I
Diameter 7 (17.8)
J. R. More-Molyneux, Esq., Loseley House
Photo Courtauld Institute of Art, London

46 Artist unknown, frontispiece to Henry Lyte, *The Light of Britaine*, 1588
Wood engraving, 2⅝ × 3¼ (6.7 × 8.3)
Photo Warburg Institute, London

47 Artist unknown, *The Phoenix Jewel*, c. 1574
Enamelled gold, diameter 2 (5.1)
Trustees of the British Museum

48 William Rogers (fl. 1589–1605), *Queen Elizabeth I as 'Rosa Electa'*, c. 1590–1600
Engraving, 9⅛ × 6¾ (23.2 × 17.1)
Photo National Portrait Gallery, London

49 George de la Mothe, title page to *Hymne to Elizabeth I*, 1584
Illumination, 8¾ × 7¾ (22.2 × 19.7)
Bodleian Library, Oxford

50 Attributed to the monogrammist H (fl. 1588), *Sir Walter Raleigh*, 1588
Oil on panel, 36 × 29⅜ (91.5 × 74.5)
National Portrait Gallery, London

51 Emblem of constancy from Henry Peacham, *Minerva Britanna*, 1612
Wood engraving, 2 × 2⅞ (5.1 × 7.3)

52 *The Shepheard Buss*, c. 1590
Black work embroidery, 44.5 × 38 (113 × 96.5)
Victoria & Albert Museum, London. Crown copyright

53 Artist unknown, memorial portrait of *Sir Henry Unton*, c. 1596
Oil on panel, 64¼ × 29⅛ (163.2 × 74)
National Portrait Gallery, London

Oil on canvas, 86 × 54 (218.4 × 137.2)
By permission of the Worshipful Company of
Armourers and Brasiers
Photo National Portrait Gallery, London

86 Attributed to Isaac Oliver, *Henry, Prince of Wales*, c. 1610
Oil on canvas, 90 × 86 (228.6 × 218.4)
From the collection at Parham Park, Sussex

87 Emblem in honour of Henry, Prince of Wales, from Henry Peacham, *Minerva Britanna*, 1612
Wood engraving, 2 × 2⅞ (5.1 × 7.3)

88 Inigo Jones, *The Fallen House of Chivalry*; design for *Barriers*, 1610
Pen, ink and wash, 9⅝ × 10⅝ (24.5 × 27)
Devonshire Collection, Chatsworth. Repro-
duced by permission of the Trustees of the
Chatsworth Settlement
Photo Courtauld Institute of Art, London

89 Inigo Jones, *St George's Portico*; design for *Barriers*, 1610
Pen, ink and wash, 10¾ × 12¾ (26.4 × 31.4)
Devonshire Collection, Chatsworth. Repro-
duced by permission of the Trustees of the
Chatsworth Settlement
Photo Courtauld Institute of Art, London

90 Inigo Jones, *Oberon's Palace*; design for Jonson, *Oberon, the Fairy Prince*, 1611
Pen, ink and wash, 13⅛ × 15½ (33.3 × 39.4)
Devonshire Collection, Chatsworth. Repro-
duced by permission of the Trustees of the
Chatsworth Settlement
Photo Courtauld Institute of Art, London

INDEX